AFRICAN ROCK ART

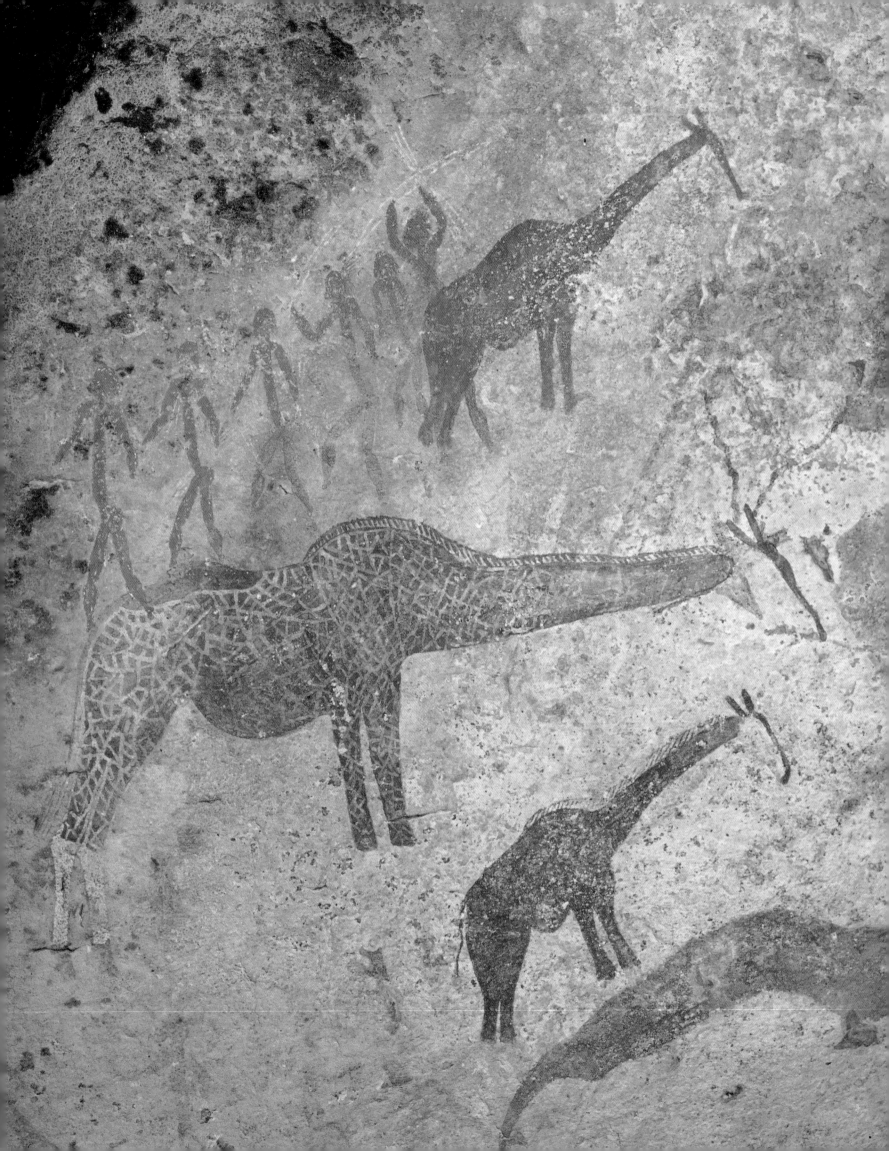

AFRICAN ROCK ART

PAINTINGS

AND

ENGRAVINGS

ON

STONE

DAVID COULSON AND ALEC CAMPBELL

HARRY N. ABRAMS, INC., PUBLISHERS

TO DEBORAH AND JUDY

Who saw us disappear for months on end, and when we were at home,
spend all our time putting together this book.

Editor: Ellen Nidy
Designer: Madeleine Corson Design, San Francisco

Library of Congress Cataloging-in-Publication Data

Coulson, David.
 African rock art / paintings and engravings on stone / David Coulson, Alec Campbell.
 p. cm.
 ISBN 0–8109–4363-8
 1. Rock paintings—Africa.
 2. Petroglyphs—Africa.
 3. Art, Prehistoric—Africa.
 4. Africa—Antiquities. I. Campbell, Alec. II. Title.

GN861 .C68 2000
709'.01'13096—dc21 99–053255

Printed and bound in Japan
10 9 8 7 6 5 4 3 2

Harry N. Abrams, Inc.
100 Fifth Avenue
New York, N.Y. 10011
www.abramsbooks.com

PRECEDING PAGE FIG. 1 **Part of a large, painted panel in Mashonaland, Zimbabwe depicting giraffe, characterless dancing men, and the tail of a large snake. Stylistically, the dancing men are associated with the upper giraffe, and one man's foot superimposes the middle giraffe. The lower legs of all the giraffe are painted in white. The scene may involve rainmaking, as snakes and giraffe are considered to be important rain animals.**

CONTENTS

A NOTE ON TARA

FIG. 2 A figure of a bowman about 8 inches (20 cm.) high, running to the left and looking back over his shoulder; painted on an otherwise bare expanse of rock in Tassili n' Ajjer, Algeria. His lithe black body suggests the Negroid or Nilo-Saharan race rather than ancestral Berber. It dates from the Pastoral Period, approximately 5,000 years ago.

The Trust for African Rock Art, TARA, was founded in 1996 by David Coulson with the support of two of his friends, Dr. Mary Leakey and Sir Laurens van der Post. The idea of TARA originated from a discussion between Leakey and Coulson in 1992. Mary was concerned about the way in which the rock paintings in Tanzania, some of which may be many thousands of years old, were being damaged by graffiti and vandalism. She had a special interest in the paintings that she and her husband, Louis, had studied in the 1950s. Two other friends, Tom Hill and Bruce Ludwig, helped to make TARA a reality.

Recognizing that African rock art is not just an African but a world heritage, TARA's mission is to create a greater global awareness of the importance and endangered state of Africa's rock art; to survey sites, monitor status, and be an information resource; and to promote and support rock art conservation measures.

With the above aims in mind, David Coulson and Alec Campbell have put together the first major definitive illustrated book on Africa's rock art.

Through TARA, funds have been raised for the many expeditions across Africa that have made this book possible. The Getty Conservation Institute was an early sponsor and has been helpful on the photographic side. The Institute also has established an archive in California using Coulson's original photographs. Other major sponsors have included the Anglo-American and De Beers Chairman's Fund of South Africa, the National Geographic Society, the Robert and Ann Lurie Foundation, and Jennifer Small of Washington, D.C. TARA's first serious supporter was Seymour Marvin of Rio de Janeiro.

The Trust for African Rock Art can be contacted at the following addresses:
Post Office Box 24122
Nairobi, Kenya
Telephone/Fax: 254–2–884467
E-mail: tara@swiftkenya.com.

In the United States, contact:
Tom Hill
320 East 57th Street, Suite 12F
New York, NY 10022
Telephone/Fax: 212–980–5320.

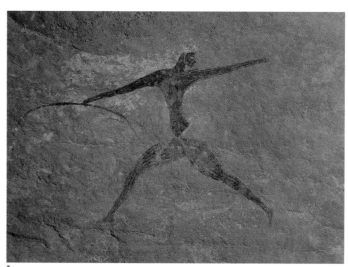

2

FOREWORD

Rock art is Africa's greatest and least known art form. The continent has the richest variety of rock art anywhere on earth. The oldest art may go back possibly as much as 26,000 years, yet up to now no book has been published that attempts to both place into perspective the entire continent's rich heritage of prehistoric art and to display it in full color.

I myself became interested in rock art when I visited the caves in southwestern France with my parents in the 1920s. My father was a landscape painter and while he painted I explored the caves. I have many vivid memories of these times and of the remarkable images we saw together. It was at this time that I first became interested in archaeology and prehistory.

Later, in the 1950s, my husband, Louis, and I were awarded a grant to study the rock paintings in Kondoa, Irangi, central Tanzania. We spent three exciting months deciphering and making detailed tracings of these remarkable paintings, many of which may be thousands of years old (fig. 3). It was during this time that I first became aware of the vulnerability of rock art and the many threats to its preservation. Since then the threats have become more real. With Africa's rapidly increasing population and expanding tourist industries, many sites across the continent are being vandalized. As Africa's network of roads expands and urban areas need greater supplies of water, rock art sites are being destroyed by quarrying and construction of roads and reservoirs. In some areas mass tourism poses serious threats, while in others ancient engravings have been damaged by Kalachnikov rifles.

I have known David Coulson for a number of years and admire the books he has produced. In 1992 I suggested to him that together we should do a photographic book on the Tanzanian paintings. With this in mind, he visited some of the Kondoa sites and came back with a remarkable collection of photographs. At this stage he asked me if I would be interested in collaborating on a bigger book on Africa as a whole, but I reluctantly declined on the grounds of advancing age.

Even so, I told him he must go ahead. Most people know little or nothing about rock art and are quite unaware how fragile it is and how easily destroyed. A book like this one, written in a universal language, will make the nature of the art more accessible to a host of people. As Coulson and Campbell travel they also are documenting, sometimes for the first time, sites across the length and breadth of Africa. Many of the photographs taken form the nucleus of a rock art archive being established by the Getty Conservation Institute. Documentation of Africa's rock art and the need to establish its importance are top international priorities.

My fervent hope is that this book will help publicize the art's beauty, antiquity, uniqueness, and value as an integral part of the world's heritage and that more care will be taken to ensure future generations will be privileged to enjoy it as I have.

– Mary Leakey, 1996

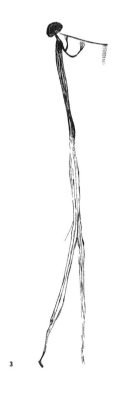

FIG. 3 **A painting of a slender human figure 34 inches high (86 cm.) holding a musical pipe to its mouth. A series of dashed lines falls from the end of the pipe. Mary Leakey found it on the ceiling of a rock shelter in Tanzania and wrote of it, "The head, arms, and upper part of the body are filled in with full red, but the lower part is drawn in vertical lines."**

3

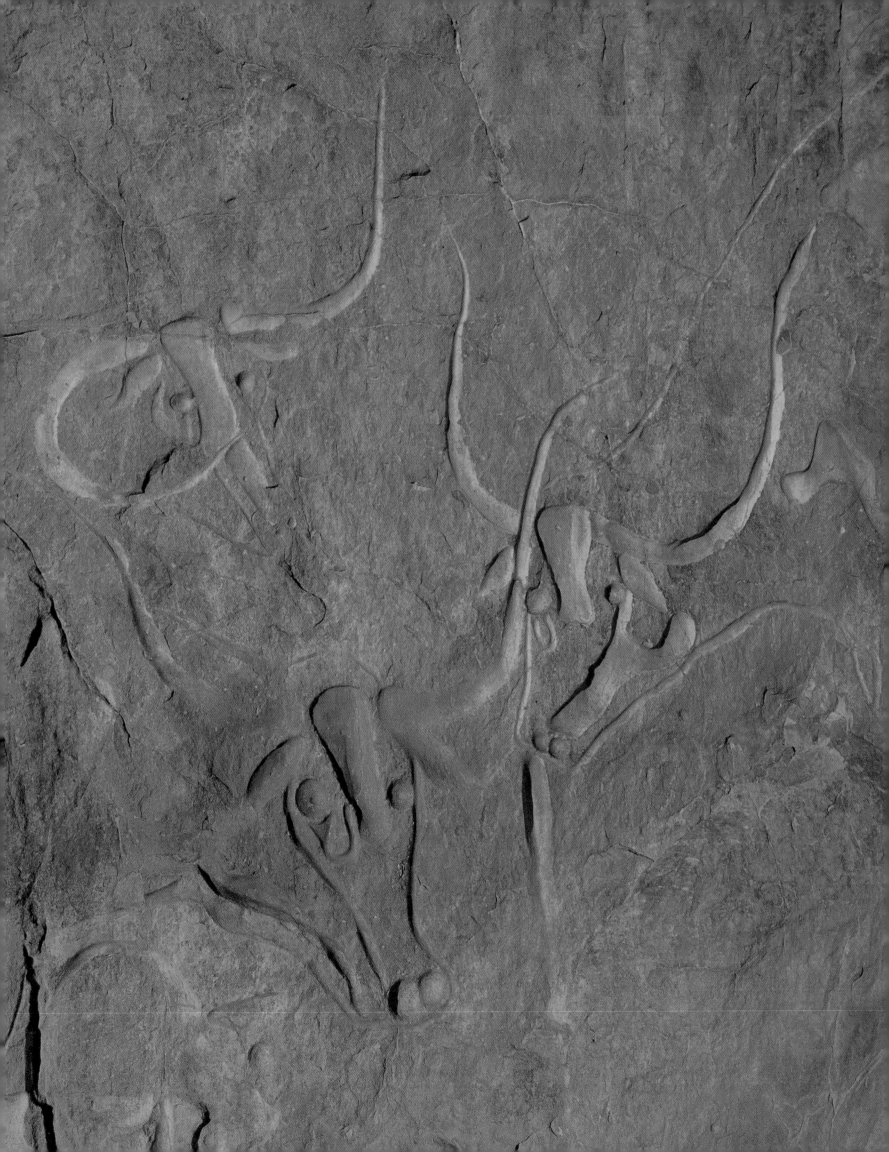

My own interest in rock art was something that developed slowly over a long period of time during the course of many trips into the southern African bush and desert. During the 1980s, I worked on three books on southern Africa: *Mountain Odyssey*, a collaboration with James Clarke; *The Lost World of the Kalahari*, with Laurens van der Post; and *Namib*, my own book on Namibia's coastal desert and the Skeleton Coast. Each of these books took me to remote areas where I was often exposed to rock art.

It was my friendship with Laurens van der Post that gave me an insight into the deeper spiritual and mythological dimensions of Bushman rock art. Through him I began to see how studying rock art

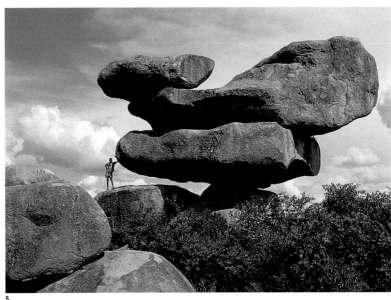

5

can give us glimpses into our ancestors' beliefs and open windows onto vanished worlds where supernatural and natural beliefs coexisted. Through him I saw that this was not merely an art form but a heritage of incalculable value.

In 1992 a friend of mine, the late paleontologist Dr. Mary Leakey, introduced me to the rock paintings of central Tanzania. She and Louis Leakey had studied them in the 1950s, and she later produced a book on the paintings entitled *Africa's Vanishing Art*, which reproduced many of the tracings she had made in the 1950s. Mary was very concerned about the increasing vandalism in this region, especially graffiti. She encouraged me to do what I could to protect the sites and to create an awareness of the threats. She also invited me to produce a photographic book with her on eastern African rock art.

Tempted as I was, my real interest lay in doing a book on the whole continent. When I proposed this, Mary said, "I'm afraid I'm too old for that!" It was at this point that I turned to a longtime friend, Alec Campbell, founder of the National Museum and Art Gallery in Botswana, who is passionate about rock art. We had worked before on rock art articles, and I knew I wanted to resume my cooperation with him on this great venture. Fortunately, he felt the same.

The more we talked about the book we wanted to do, the more daunting it seemed. Africa is enormous: there were so many countries to go to, so many thousands of miles to travel. It would take years to get to those places. Who would tell us where to go and how would we get there? Of course, the biggest question was how to fund such a massive project.

Around this time we realized it might be wise to form a trust. Ever since Mary Leakey had encouraged me to draw attention to the vulnerability of African rock art I had wanted to find a way of doing so. Now we saw that a trust also could be an effective way of raising funds for our work. At this stage, two friends from America stepped in to help me convert this idea into a

OPPOSITE FIG. 4 An engraving of four magnificent wild cattle, named Les Vaches qui Pleurent (The Cows that Cry), carved at the base of a small inselberg in southern Algeria. The rock surface has been skillfully utilized and the lines engraved so that evening light suggests the shape, color, and movement of cattle coming down to drink at a depression in the rock that still fills with water.

FIG. 5 Balancing rocks at Epworth, Harare.

reality, Bruce Ludwig of California and Tom Hill from New York. Both enjoyed a deep interest in old Africa and early man and both immediately saw the importance of what we were determined to do. In February 1996, we met in Kenya's Chyulu Hills overlooking Mt. Kilimanjaro and brainstormed the whole idea. Tom came up with the name TARA, and later that year I set up the Trust for African Rock Art. Tom is on our advisory board and both he and Bruce have played a major role in helping us to raise the money to produce this book. Two other friends who helped and gave a lot of support and advice during this time are Damon de Laszlo and John Robinson of the Bradshaw Foundation. Both Damon and John are members of TARA's advisory board.

From the outset, one of the most exciting aspects of this project was the opportunity it afforded to travel to the Sahara Desert, one of the richest rock art regions on earth. For years I had dreamed of visiting such places as the Tibesti Mountains in Chad and the Tassili n' Ajjer Mountains in Algeria. Neither Alec nor I had ever been there but we knew it was important to go. Fortunately, a German friend, Eckhard Klenkler, whom I had known in Namibia in the late 1980s, had traveled all over the Sahara.

As soon as I had sold the book idea to Abrams, I went to see Eckhard in Germany and he introduced me to Rainer Jarosch, who specialized in Saharan travel. Rainer had a Tuareg partner, Cheikh Mellakh, and our first Sahara trip was in Niger's Aïr Mountains and later in the Tadrart, in southern Algeria. It was just after the end of the Tuareg rebellion, and we traveled through the Aïr with an escort of around twenty heavily armed ex-rebels. The leader of our escort was the rebel leader Rhissa Ag Boula, now minister of tourism, and we were privileged to see some remarkable rock art on this trip.

Our next Saharan trip was to Chad, this time with Italian friend Pier Paolo Rossi of Spazi d'Avventura. Pier Paolo took us on a wonderful adventure to the Tibesti Mountains and also to the Ennedi, through the vast open spaces of Chad. Northern Chad is exceptionally rich in rock art, but the threat of land mines left behind by the retreating Libyans in 1994 still restricts travel in this region.

The following year we traveled with Pier Paolo back to Niger and Algeria, but to different areas. Early in 1998, Spazi d'Avventura organized our trip to southwestern Libya, one of the richest rock art regions in the Sahara.

The photography for this book has been challenging on several levels. Rock paintings are normally found under overhangs or in shallow caves, often in poor light. They are frequently faded, so diffused, subtle lighting usually works best. At times we used reflectors to bounce light off cave roofs and walls. Inevitably, great patience was required. Engravings are typically found on exposed rock surfaces and often require "raking" sidelight to bring them to life. Without such lighting, most engravings appear flat and uninteresting. Added to these difficulties is the ever-present problem of airborne sand that plays havoc with cameras and lenses. Sandstorms can sometimes blow for days on end.

I would like to end with a special word of thanks to my coauthor, Alec Campbell. When we started this project I knew very little about African rock art, and most of what I now know I have learned from Alec. His exceptional knowledge, coupled with his natural modesty, has added hugely to my enjoyment of the whole experience. Enthusiastic and determined, he has been a tower of strength.

When I think of the many days and weeks we have spent climbing in far-flung African mountains, and all those nights in the desert sitting around the campfire under the stars, sharing experiences, I realize how fortunate we have been. It has not always been easy. There have been moments of danger, and times of anxiety and extreme discomfort. But the principal memory I carry with me is of Alec's patience, understanding, and unselfishness. Perhaps most of all, he has been a soulmate with whom I have shared my love of Africa's wildest places, not to mention the beauty and the mysteries of its magnificent rock art heritage.

– *David Coulson*

FIG. 6 **Looking west into the sunset at Marmar, Chad. Huge sandstone inselbergs rise hundreds of feet above the desert floor. The tiny figure walking into the distance, at right, is Alec.**

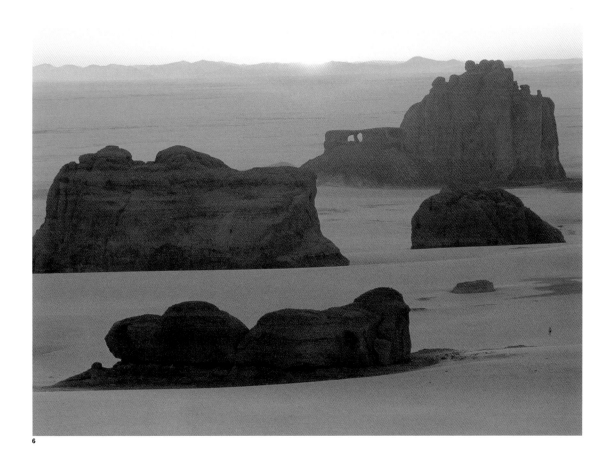

6

I t was the renowned paleontologist Mary Leakey who first made David Coulson fully aware of the fragile state of Africa's rock art. She and her husband, Louis, had traced rock paintings in Tanzania in 1951 and then stored the tracings in the archives of the Coryndon Museum in Nairobi, believing the art on the rocks would last forever. But as the years passed, she realized that human developments were jeopardizing the paintings. In 1980 her daughter-in-law, Maeve, resuscitated copies of the tracings and Leakey wrote *Africa's Vanishing Art: The Rock Paintings of Tanzania*, hoping to make people more aware of the paintings' beauty and fragile nature. By 1992 she accepted that more needed to be done. She intended to rewrite her book using David Coulson's photographs, but age overtook her and she told David to go ahead without her and to do the book on a broader scale.

When we first discussed writing this book (is "writing" the correct word for compiling a book whose illustrations must say more than the words?), we little realized just how complex the art is, how wide its distribution (map 4), and how varied its nature. Nor did we fully appreciate how much has already been published in languages we find difficult, or almost impossible, to read.

We recognized the need for a simple book that would cover as much of the art as possible but would not dwell on long technical discussions of chronologies, art styles, styles within styles, and various complex interpretations of the artists' intentions. We wanted the book to rely heavily on visual imagery and, for this reason, have included some small drawings to supplement the photographic illustrations.

In the last half century numerous well-illustrated books and a plethora of journal articles on Africa's rock art have been published in many languages. However, most of these deal with the art of either individual countries or regions; only Alex Willcox, in *The Rock Art of Africa* (1984), has made a serious attempt to tackle the art of Africa as a whole, and he was severely limited by the lack of knowledge at the time and by the number of color plates he could use. While more recent works, usually in English and concerned with the art of southern Africa, have made determined efforts to understand the art's "meaning," most of the earlier books merely provide records of the art. In any case, many of these books are now out of print and expensive to obtain, and much of the technical information is hidden in scientific journals.

The purpose of this book is to bring the rock art of Africa together in one accessible publication and to make a large audience more aware of the art's unique qualities, universal value, and vulnerable state. We particularly want to create greater awareness of rock art in the English-speaking world, which tends to know little about the rock art in northern and eastern Africa.

We have no idea how many individual depictions have been engraved or painted on the rocks of Africa, but the art occurs in almost every country (map 4). One estimate puts the images of South Africa alone at between one and two million; ten million images for the whole continent may be a conservative figure. To cover all of Africa in one book is an almost impossible task and we have had to be very selective in choosing what to illustrate and what to say about the art. While we do not intend for this to be a scientific book, we do include

certain background information to put the art in context; for if the art were judged on aesthetic values alone, much of it would be meaningless.

We visited fifteen countries and almost every important concentration of art on the continent, except the one in eastern Zambia. David took more than 30,000 photographs. We have tried to present the art in its actual setting with illustrations showing the people and landscape. We have provided short essays on the African landscape, human evolution and history, and population movements, and have included all the recent research regarding proposed dates and interpretations of which we were aware and believed relevant.

In trying to cover as many aspects of the art as possible we have relied on drawings prepared from transparencies and notes taken at the site to supplement the photography. Even so, there is only one truly reliable way to reproduce rock art and that is to trace the images on the rocks

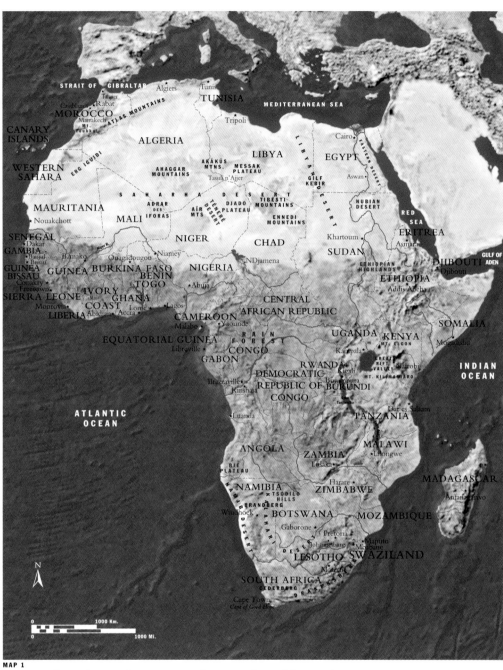

MAP 1

themselves; photographs always create some distortion and anyone tracing a projected image is sure to make a few mistakes. We hope that readers will forgive us the mistakes we may have made—if we have presented a fair picture of the art, then we have achieved our aim.

Finally, what is art? Should geometric designs (fig. 9), handprints (figs. 8,128), and carefully engraved tracks of animals (fig. 114),be included in the definition of art? Can writing (fig. 10) be described as art? Can any ancient engraving or rock painting, made for unknown reasons, be called art? Many archaeologists and some art historians are reluctant to use the term because

MAP 1 **Africa with its political boundaries, arid and semi-arid areas, higher-rainfall areas, and mountains.**

they say the depictions were not made for art's sake but for specific purposes, such as creating or contributing to some happening; alleviating the impacts of adverse conditions; communicating and teaching; recording events; enhancing personal prestige; and serving as symbols of ownership. In other words, they argue that the depictions should be seen as tools and today regarded as images rather than as art.

Much depends on how the word "art" is defined. If it is used to refer to visual creative expression that has the power to move us emotionally, then many of the rock depictions are art. We have asked ourselves whether handprints and geometric shapes can be termed art: it is difficult to call them art, although some are designed, or placed, in such a manner that they

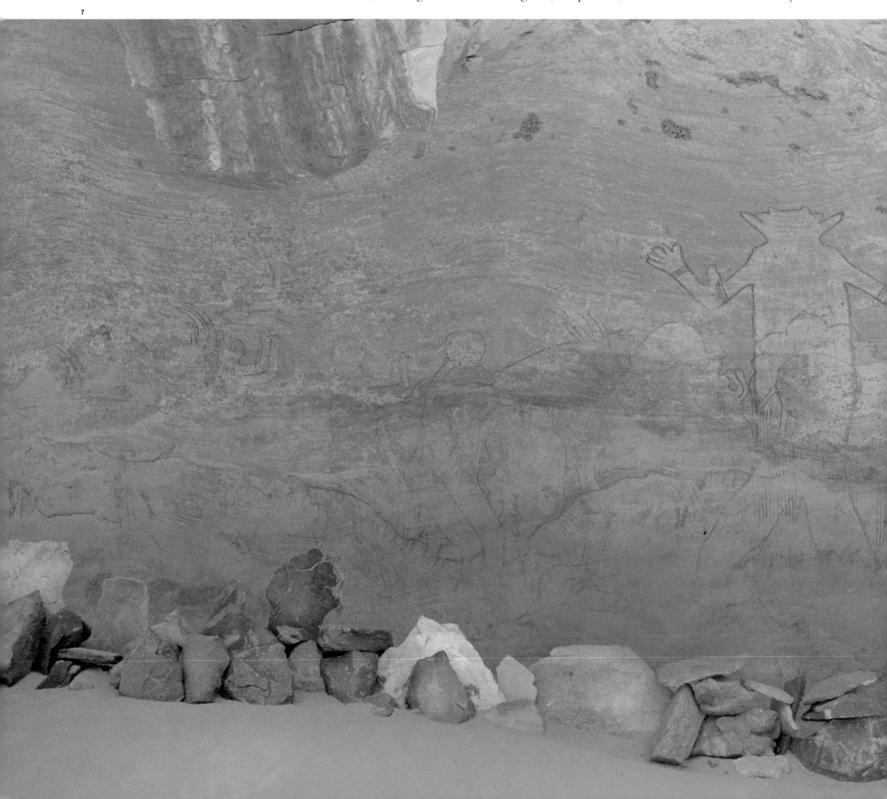

approach it. It is, after all, the innate aesthetic beauty of the depictions that has the greatest importance to most of us; thus, we believe it is simpler and more understandable to call all the paintings and engravings art, and we have done so in this book.

A second, but less important, problem has been the use of the word "prehistoric" to describe the art's age. Certainly, much of the art was made at a time before local histories were recorded in writing. However, many new nations understand prehistoric to be a derogatory term inferring a lack of education and a time of "savagery." While this was not the original meaning attached to the word, to some extent "prehistoric" can imply a lack of education, so we have decided not to use the term.

8

FIG. 7 **Le Grand Dieu de Sefar (The Great God of Sefar) in Algeria was named by Henri Lhote in the mid-1950s. The central male figure stands over 10 feet (3.25 meters) high and is surrounded by women and animals. On the right, a reddish-brown sable antelope superimposes a supine woman with a distended stomach and raised arms. These images overlie earlier paintings now barely discernible. Lhote ascribed the frieze to the "Decadent Phase of the Round Head Period" (about 8,000 years ago), describing it as ". . . no doubt a magic one . . . connected with some fertility cult." Fabrizio Mori aptly records the women as "pervaded by what can only be described as a religious feeling, their blank faces conveying a sense of intentional and intense mystery."**

FIG. 8 **Engraved handprints, Namibia.**

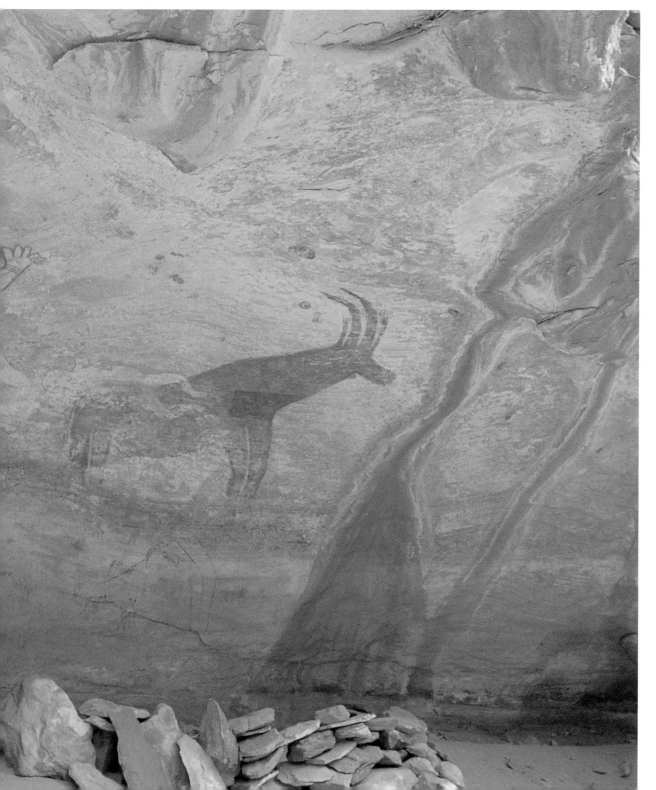

FIG. 9 **Geometric design, Niger.**

FIG. 10 **Ancient script, Egypt.**

FIG. 11 **Found in central Tanzania, these paintings in white and ocher of giraffe, antelope, rhinoceros, and people superimpose earlier geometric paintings in red. White paintings such as these are attributed to Bantu-speaking farmers who settled among foragers and are believed to reflect aspects of rites-of-passage rituals involving initiation, fertility, and rainmaking ceremonies.**

THE ART'S IMPORTANCE

The earliest of Africa's remaining rock art (some may have disappeared long ago, destroyed by sun, wind, and rain) is very old, perhaps dating back 12,000 years, and may turn out to be much older. It is almost certainly the earliest African form of human communication left to us today and is possibly more graphic than any written text could be.

Archaeological excavations can tell us a certain amount about past lifestyles, such as when people lived, what they made, ate, and even traded, whether they owned livestock, moved seasonally, and buried their dead; but we also need to learn about the other side of the coin, about their social activities, cognitive systems, esoteric and abstract thoughts, perceptions of morality, and concepts of reality, the very things that give our lives meaning. Archaeology tells us little about how they perceived their worlds. Rock art is just about all that remains to give us insight into the earliest ways in which our ancestors thought and survived in a world in which they were merely a part of nature, not above it as we see ourselves today. The art informs us how imagery was used to portray abstract interpretations of reality and, thus, how it became the basis from which writing evolved. These artists were our ancestors, and from their skills and cognitive patterns our own were born. It may be only through a better understanding of the origins and early development of those cognitive systems that we will fully appreciate our modern perceptions of what we believe to be reality.

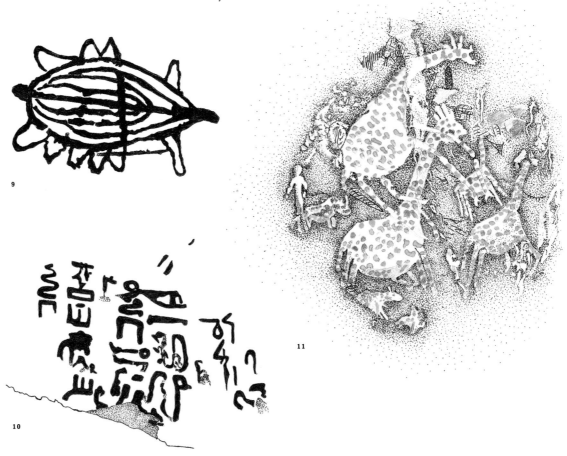

9

10

11

One area in which we have already felt the impact of this art, which was unrestrained by the modern age of technology, is in the new life and impetus it gave to European art in the early twentieth century (along with Oceanic and Native American arts), freeing it from bonds of conventionality and thereby influencing modernism. Much of this art, the powerful masks, statuettes, and ornamentations of the sub-Sahara, must derive from central Saharan rock art, which was carried south as the desert dried up and peoples moved to less arid environments. We have only to look at the rock art in southern Algeria to see the antecedents of sub-Saharan art reflected in the paintings of figures and masks painted on rock (fig. 65).

These incredible rock art paintings and engravings have, in general, not made a great impression on Africa's white population, which often has viewed them merely as the work of "primitive" peoples. Although settler governments in the early twentieth century passed laws protecting rock art from theft and vandalism, they were rarely enforced. African archaeologists were initially reluctant to incorporate rock art into their mainstream studies. Until the 1960s, rock art had found little or no place in the art history courses of South Africa's universities, nor had much of it seen the inside of that country's art galleries. Walter Battiss, a controversial and remarkable South African artist, was one of the first to recognize and embrace rock art for what it is, writing in 1948 in *The Artists of the Rocks*, "Have I not been proud when some masterpiece of ancient art spoke to me of new discovered beauty! Here indeed is one of our richest heritages, for South Africa possesses a splendid panoramic history of art." Others, such as Cecil Skotnes, have followed his lead, but only in fairly recent years. It is only since the 1950s that African rock art has begun to find its place alongside the Paleolithic cave art of Europe, while its uniqueness and value are still not fully recognized by many African governments.

Rock art reminds us, in this modern world where technology tends to rule, that we are in danger of losing our once uninhibited perspective of the natural world around us, as well as our ability to express that world in terms unalloyed by modern arrogance. We should remember that rock art was created by peoples with no knowledge of metallurgy, peoples who made tools of bone and stone yet who employed graphic techniques for expressing what they considered to be the essence of things rather than the obvious physical form.

For the art itself, time is running out. Mining, the spread of agriculture, and the construction of roads and dams all take their toll. Tourism expands every year and more people are visiting the Sahara and southern Africa. As visitors to the rock art increase, so do threats to its future existence. People touch the paintings, run their hands down engraved lines, douse paintings with water to make them more visible, scrawl graffiti across them and add bawdy details, steal engravings on loose stones, chop paintings from the rock face, and scramble over engraved panels to see those above. The sheer volume of human visitors will eventually impact the very environments where the art occurs. We would like to see governments put more money into maintaining their archaeological sites: they could become major tourist attractions tomorrow and next week be lost forever.

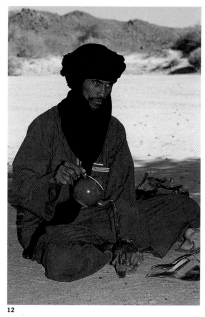

12

FIG. 12 **Drinking tea is an important ritual that emphasizes harmony. Whenever an opportunity arises, Tuareg prepare strong, thirst-quenching green tea. The leaves are brewed with sugar in small teapots on hot coals and then poured from one pot into another, raising a froth on the surface. After tasting it, the brewer pours it again, from a height, into tiny glasses.**

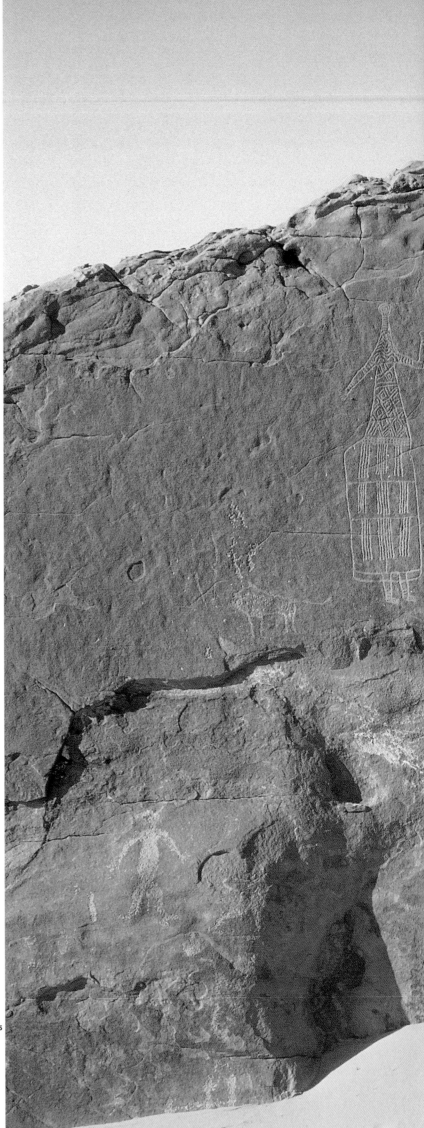

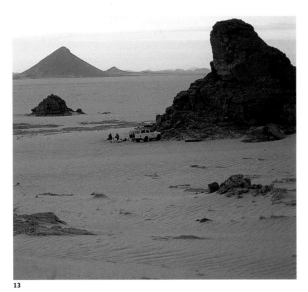

13

14

FIG. 13 **Looking northwest to a huge natural pyramid of rock rising from an ancient lake bed at the upper end of the Ténéré Desert in southern Algeria. We made camp under the cliff, warmed by the evening sun, and an alcove provided shelter from the wind. In the morning we followed the trail of a horned adder that had slid in darkness past our beds.**

FIG. 14 **Some sites were not easy to reach. This one in Chad required a climb up the rock face and a traverse along a narrow ledge.**

FIG. 15 **This panel dating from the Pastoral Period of intricately decorated human figures more than 6.5 feet (2 meters) tall, is one of five such panels located in a six-square-mile area of eastern Chad. In Tubu, the local language, they are called Niola Doa (Beautiful Ladies) and, although they are most likely female, their sex is uncertain. The patterns polished into their bodies are reminiscent of body painting still practiced today elsewhere in Africa. At a later period, vertical grooves were ground between the figures; such grooves appear throughout Africa and even on Egyptian temple walls where women rub them to increase their fertility.**

15

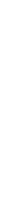

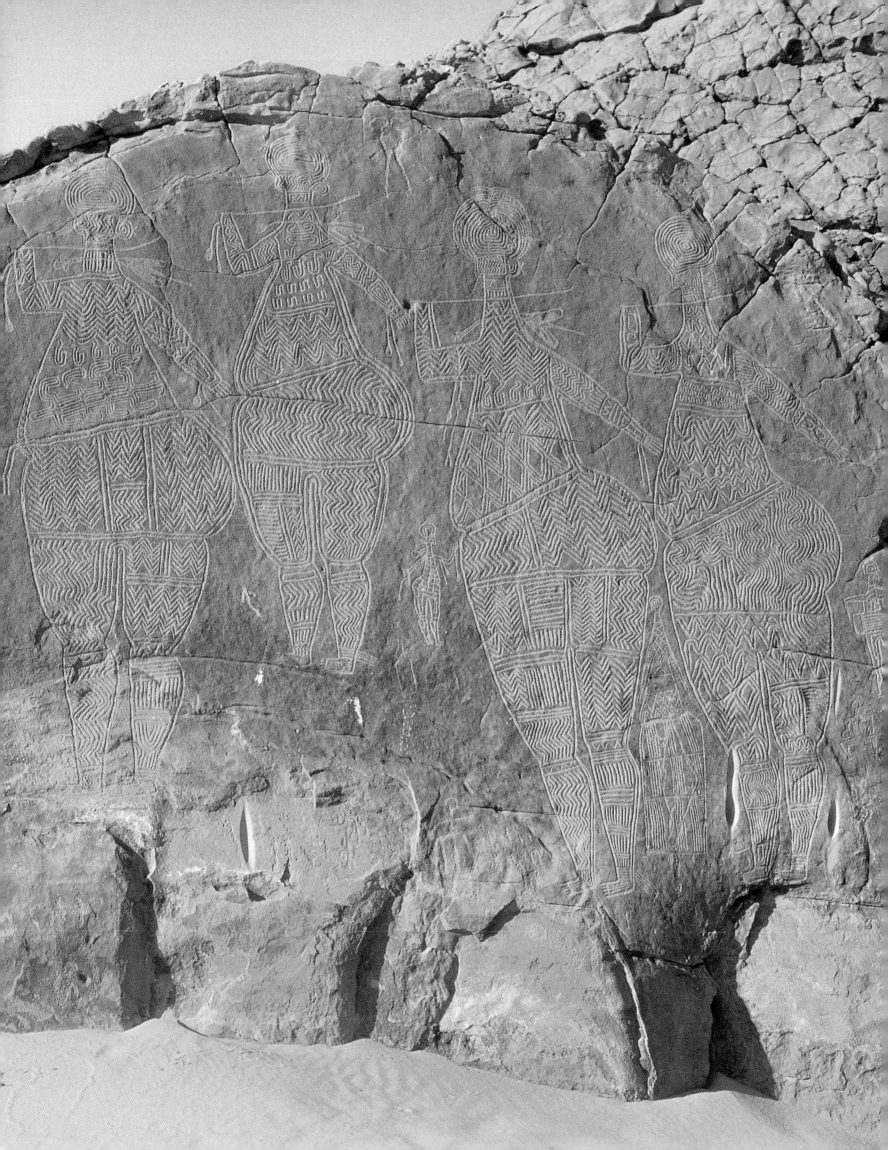

TRAVELING THE CONTINENT

We had hoped to visit twenty countries, but funds and time ran out; we eventually reached only fifteen of them, although we visited some more than once. Our primary destinations were the three main concentrations of rock art: the central Sahara, central Tanzania, and southern Africa. We succeeded in visiting Algeria, Botswana, Chad, Egypt, Ethiopia, Kenya, Libya, Morocco, Namibia, Niger, South Africa, Tanzania, Tunisia, Uganda, and Zimbabwe. We also had wished to visit Angola, Cameroon, Congo, Mali, and Zambia, but funds proved insufficient.

In southern and eastern Africa we used our own transport, camping at night and cooking our own food, but in northern Africa we relied on professional organizations and almost everywhere we went were required to take local guides, who proved incredibly useful; their knowledge of Saharan routes (many cannot be called roads), sometimes many hundreds of miles from their homes, is amazing.

We drove through mountain valleys; sped frantically up sand dunes to reach the top and then slammed on the brakes in case the wind had carved a sheer drop on the other side; often dug ourselves out of soft sand; crossed the Ténéré Desert twice, an endless expanse that feels like an arid inland sea but is actually the remains of an ancient river valley and is visible from space; climbed the Tibesti Mountains and followed a narrow path down the inside cliff of a volcano to bathe in the warm spring on the crater floor; tried to find sheltered places to put our sleeping bags for the night; and photographed rock art as the wind hurled sand against the cameras.

Our first visit to Niger was made just after the civil war ceased in 1995. Bandits were still operating, so we were given an escort composed of recent "freedom-fighters," armed with machine guns and a rocket launcher, which took us far into the desert. In Chad we were

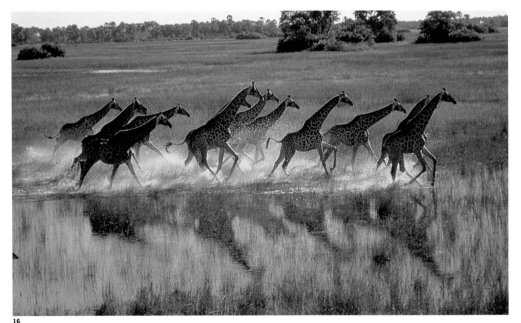

16

forced to detour around long stretches of track that still bristled with land mines, unexploded rockets and shells, and the occasional burned-out remains of tanks and armored trucks. In Egypt we had to join an army convoy to travel between Luxor and Aswân.

Everywhere we went we met roadblocks manned by army or police. Permits were needed to travel through remote areas and special visas were required to enter many places including northern

Chad, where we were "invited" to report to the provincial governor. Wondering what was now needed, we removed our shoes and entered his office to be greeted in perfect French, seated comfortably, and offered cold drinks. When he asked us if there were forests in Botswana, Campbell told him in English that the Kalahari Desert covers much of the country. "You are in Chad," he said in excellent English, "and here you must speak French." It turned out that Campbell's Botswana passport had intrigued him and he had wanted to chat with people from another African country.

In Libya we reported our presence to a remote army camp in the desert, west of the Messak plateau. "Passport, passport," they demanded. We climbed onto the roof of our vechicle and got our passports from our bags. "Search, search," they demanded, and we opened our bags. "Come, come," they said. We followed them to an immense carpet spread on the sand where we were seated and given small glasses of green tea and fresh dates.

We met officialdom that was almost always tinged with kindness and people who were as helpful as they could be within their small means. We drank camel's milk and cup after cup of green tea, ate endless dates, and accompanied volunteers into a high and remote valley of the Aïr Mountains to see rock paintings, which turned out to be natural markings on the rock.

We crisscrossed Africa from Addis Abeba to Marrakech and from Cape Town to Cairo. We climbed to the summit of the Brandberg in Namibia and spent ten days following donkeys across Algeria's Tassili n'Ajjer. We carried heavy packs up South Africa's Drakensberg and slept in a cave to avoid rain. We spent weeks and months trying to get visas, which, on two occasions, arrived less than twenty-four hours before we were due to fly.

The huge granite kopjes of Zimbabwe, the deep blue of Lake Turkana, the evening colors of the Sahara's ocher dunes, and the snowcapped peaks of Morocco's High Atlas will live in our minds forever. But, of all of our experiences, standing before Le Grand Dieu de Sefar (fig. 7), high in Algeria's southern mountains and feeling the atmosphere of peace and tranquillity emanating from this magnificent painting that towers almost twelve feet high was perhaps the most profound experience of all.

17

OPPOSITE FIG. 16 **Giraffes galloping across a floodplain on Chief's Island, Okavango Delta, Botswana. Once their range covered most of Africa, extending from South Africa as far north as Morocco. Giraffes are probably the most pictured wild animal in rock art across the African continent. Numerous giraffe engravings throughout the Sahara Desert testify to wetter times in the past when its sands were covered by grass pains interspersed with dry savanna. (Photo by Tim and June Liversedge.)**

FIG. 17 **We never became seriously stuck although we had many nasty moments, such as this one in Tadrart, Algeria. The vehicle would race at a steep wall of sand, climb the dune, and then jerk to a halt as the undercarriage caught on the ridge. Some tedious digging under the body freed the back axle, and a heave from behind helped it on its way.**

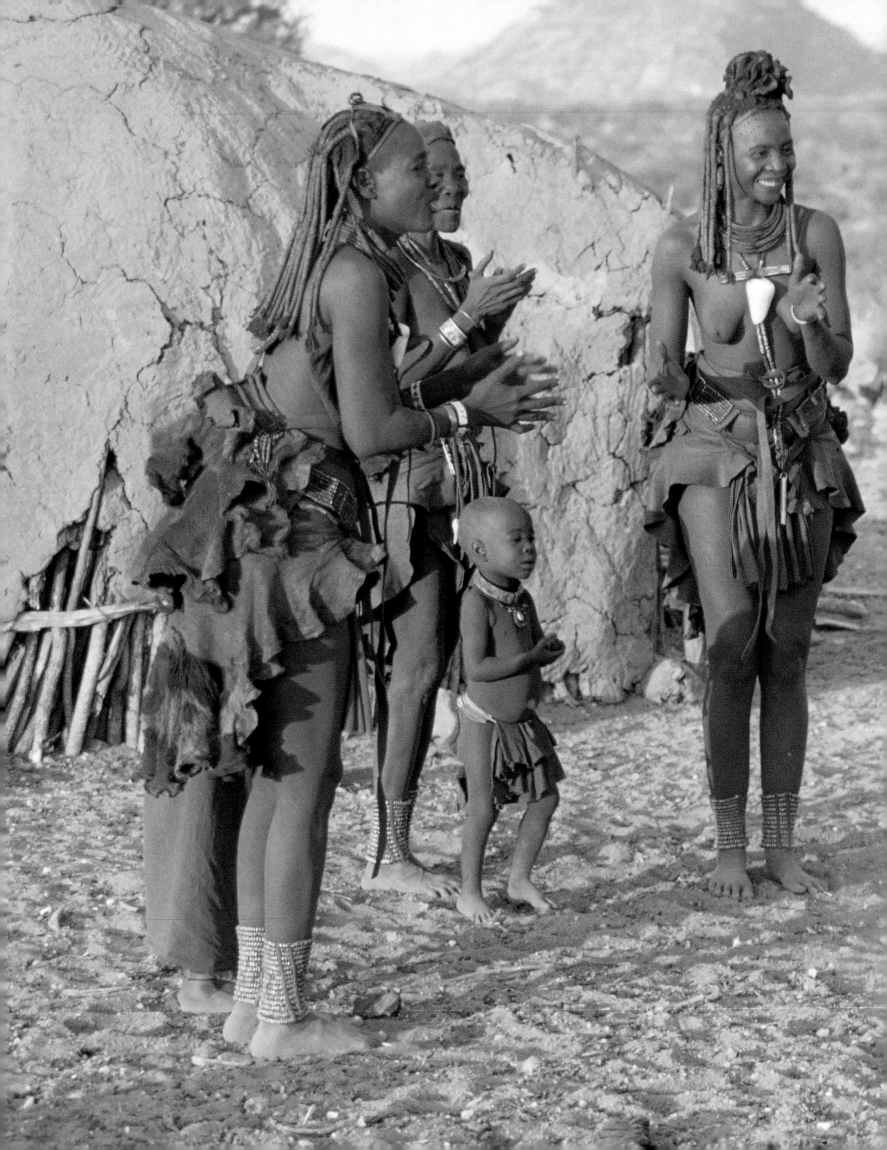

AFRICA: THE LAND AND THE PEOPLE

PRECEDING PAGE FIG. 18 **Himba girls dance in northwestern Namibia. The Himba are Bantu-speaking pastoralists who maintain their traditional lifestyle. The girls wear wigs, headdresses, copper anklets and bracelets, and jewelry made of iron beads decorated with cowrie shells. Between their breasts hang large conus shells. They smear their skin with red ocher as "protection against the sun and to prevent wrinkling."**

OPPOSITE FIG. 19 **A Sandawe woman with typical facial tattoos in Kwamtoro, Tanzania.**

Africa is a land of great contrasts, poor in soils but rich in minerals, a land of incredible long-term changes in climate, and a land with a wonderful diversity of wildlife. It is also the continent that gave birth to the human race.

THE SECOND LARGEST CONTINENT, Africa is vast, covering about one-fifth of the world's land surface (map 1). Narrow coastal lowlands surround a central rock plateau. Over many millions of years and alternating humid and dry periods, rain, wind, heat, and cold have eroded the plateau's surface, sweeping sand across its rocky face. During long dry periods in the Sahara vegetation shrank back to the highland and areas with higher rainfall, leaving vast tracts of barren sand, stone, and rock. As vegetation disappeared, water-requiring animals such as the elephant, buffalo, hippopotamus, and crocodile gave way to dryland species such as the giraffe and kudu and later to desert dwellers such as the gazelle and ostrich. With the return of humid conditions, rivers again flowed, lakes formed, savanna spread its mantle over the dry dunes, and animals slowly moved outward following the new vegetation.

Today the plateau is generally flat in the west, with a few isolated mountain ranges in the Sahara, and rift valleys and fertile highlands in the east created by faulting and volcanic activity. Apart from the eastern highlands, there is little to encourage rainfall; thus, there are only the fairly broad climatic bands lying north and south of the equator to influence humidity and vegetation. The equatorial forests give way first to woodlands and savanna, then to drier country with poor and scattered vegetation, and finally to belts of only winter rainfall at the far ends of the continent.

HUMAN HISTORY

Human history is older in Africa than anywhere else on earth. In fact, all of us living today, whatever our nationality, have our deepest roots in Africa. However distant it may be, we are all related.

Between about seven and five million years ago, about the time the Mediterranean basin reflooded, several species of ancestral apes were roaming the African forests when some extreme natural phenomenon, an ice age or an interglacial period, created changes in climate and environment, causing one species to split into two or more separate groups, among which were our human ancestors and ancestors of modern chimpanzees.

By about two million years ago our ancestors, *Homo erectus*, had begun to look a bit like us and had learned to make simple tools, such as those of stone that survive to this day. A million years later, our ancestors looked even more like us: they were tall, walked upright, had quite large brains, could in some way communicate, and were making carefully shaped stone tools. By

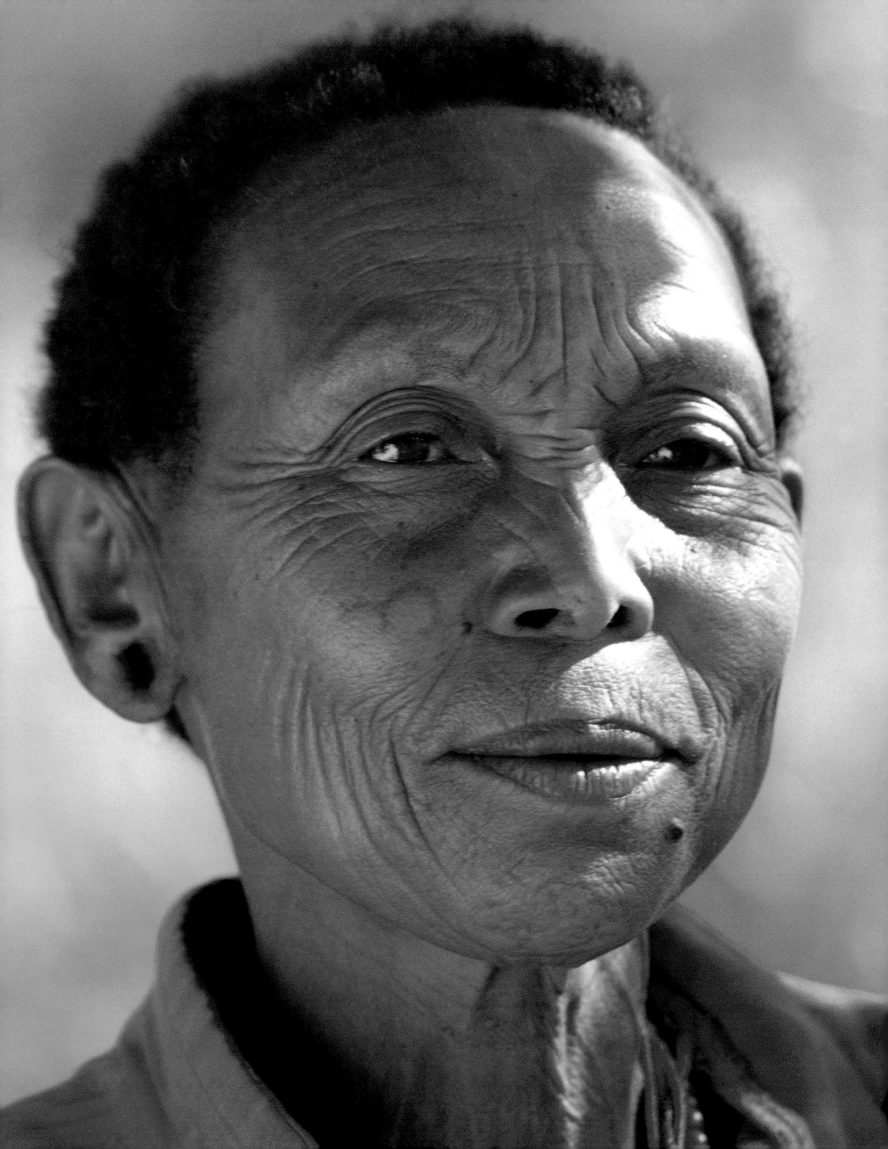

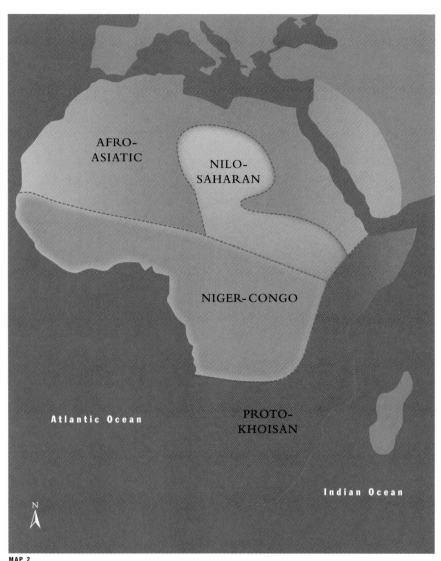

MAP 2

MAP 2 **Possible distribution of African language groups about 6,000 years ago.**

this time some of them had migrated out of Africa into Europe, Asia, and Indonesia.

Homo erectus continued to evolve and by about 500,000 years ago was learning to talk, use fire, and produce a wider variety of tools for different purposes. They probably looked much as we look today and some of them would not stand out in a modern crowd. What occurred between about 200,000 and 150,000 years ago remains a subject on which not all scientists agree. The out-of-Africa theory holds to the belief that, in Africa, *Homo erectus* developed into *Homo sapiens*, who then migrated into Europe and Asia, eventually replacing all other hominids on earth. The multiregional theory holds to the belief that *Homo erectus* who had migrated out of Africa earlier continued to evolve into modern people. Evidence from DNA testing tends to support the out-of-Africa theory.

There was one final human migration approximately 40,000 years ago when Cro-Magnon people—named after the site in France where their bones were first identified—are believed to have traveled from northern Africa and southwest Asia to western Europe, where they settled among the existing Neanderthal populations. The shape of their skulls and the tools they made are more reminiscent of peoples from Africa than of any other place. The Cro-Magnon people were, without doubt, those responsible for the magnificent cave art of Europe, such as the incredible wall paintings of the Chauvet Cave, some of which date to 32,000 years ago (fig. 20).

The Ice Age in the Northern Hemisphere, which peaked about 20,000 years ago, caused widespread changes in climate, sea level, and the distribution of plants and animals. Shorelines were about 400 feet lower than they are today; large areas of inland northern Africa changed from green pasture to desert, much as it is today; eastern Africa was much drier, with Lake Victoria a mere puddle; and average temperatures over southern Africa were cooler by about seven degrees Fahrenheit. Most of the continent received less rainfall than today, except for the southern interior plateau, where it appears to have been wetter.

By 12,000 years ago peoples throughout Africa were making objects that were fairly similar. Stone tools were mostly small and made for mounting in wooden handles, which suggests a wider variety of uses than had been employed in the past; bone was carved into both implements and jewelry; and beads were made from shell, stone, and ostrich egg. This does not necessarily reflect an underlying similarity among different cultures; rather, it means people were developing new and more varied ways to live. People were becoming more practical and, perhaps, developing new attitudes and new ways of thinking.

THE PEOPLES OF AFRICA

Most of the peoples of modern Africa can be separated into four major language groups: Khoisan, the click languages of the Hottentots and Bushmen; Niger-Congo, the languages spoken by Negroid peoples, including Bantu-speakers; Nilo-Saharan, the languages spoken by Negroid peoples, including Maa-speakers; and Afro-Asiatic, comprising Semitic, Egyptian, Berber, Cushitic, and Chadic languages (map 2). The hyphothesis is that proto-Khoisan peoples once inhabited the whole of southern and most of eastern Africa; Niger-Congo peoples, both Bantu-speakers and Pygmies, occupied western and central Africa; Nilo-Saharans have their

roots in the Sahara but have shifted back and forth between the central Sahara and the northern lakes of eastern Africa; and Afro-Asiatics, who are related to Caucasians and who currently occupy most of northern Africa, originated east of the Nile, perhaps on the plains of Sudan and across the Red Sea in southwest Asia. The ancestors of each of these peoples, over the last 12,000 years, have been responsible for the great bulk of Africa's rock art.

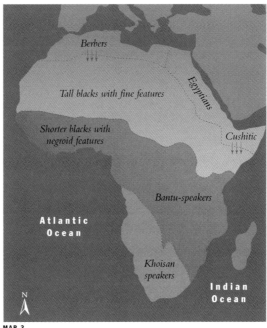

MAP 3

Forager peoples, who were once the sole inhabitants of southern Africa, are believed to have created a large part of Africa's early rock art in the regions south of the equator. Their decendants include the Bushmen of southern Africa (fig. 21), the Sandawe (fig. 19) and Hadza of Tanzania, and the Twa, who have descendant groups in central and southern African countries, although they have lost their traditional cultures. Twa is a Bantu term for foragers and is used in languages from Uganda to South Africa to describe foraging peoples whom Bantu-speakers met on their migrations into eastern and southern Africa. The Twa were short and usually hairy peoples who hunted with large bows and were avid honey collectors. The term was, and still is, applied to Pygmies and, in southern Africa, to Bushmen.

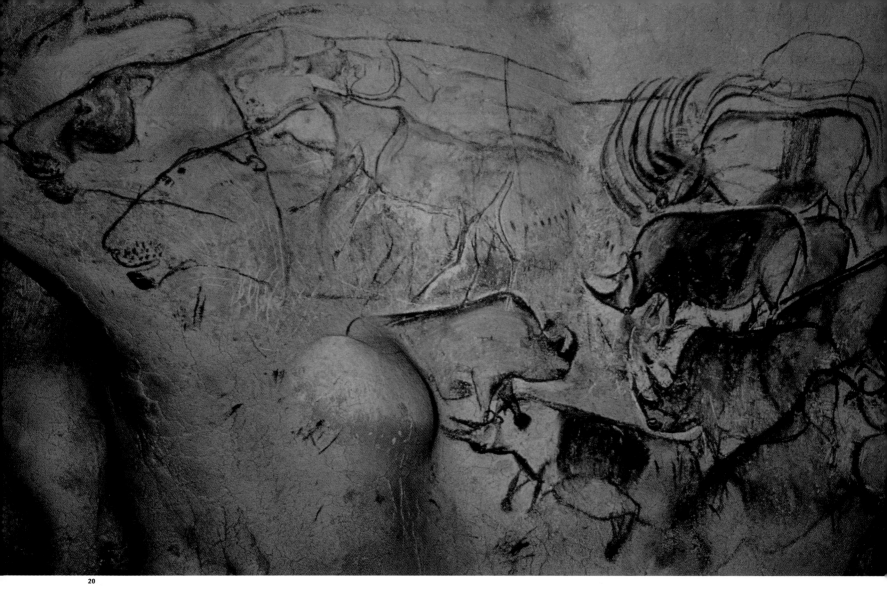

20

FIG. 20 **A painting of rhinoceros in the Chauvet Cave in southern France. The cave is deep and painted areas are in total darkness, which provides protection from weathering. Charcoal, bone, and human footprints found in the sand floor and dates obtained from pigment have supplied archaeologists with information about the artists and the oldest known date for rock art, which is about 32,000 years. Photograph by Jean Clottes.**

Today the Twa have nearly vanished, largely through the adoption of Bantu languages and culture. Although the Twa disappeared in Uganda and Kenya about 300 years ago, small groups survived in Zaire, Angola, and Zambia into this century. Other peoples who may be descendants of Twa and who practiced foraging economies into the twentieth century include the Akafula of Malawi, Tjimba of Namibia, Doma of Zimbabwe, and Ngona of South Africa.

Bantu-speaking farmers encountered the already established forager groups in their original migrations east and south (map 3). Archaeology suggests that early contact between them was probably amicable. Each had things to offer the other: The farmers understood iron-working and had long-distance trade links while the foragers knew the country and its resources and had access to its spirits, who were believed to control the cycles of nature. How long amicable relations lasted is unclear. However, by the nineteenth century the remaining foragers occupied an inferior position to Bantu-speakers, often serving as herdsmen and domestic servants in the areas where their land was occupied. Those who remained free had been forced to permanently inhabit less desirable land, such as mountain ranges and arid bush veld, where they attempted to sustain themselves in a traditional fashion; unfortunately, with their hunting grounds settled by farmers, they were often reduced to stealing domestic stock instead of killing wild animals.

Bantu-speakers have always recognized Twa and Bushmen as the autochthones, or original inhabitants of the land, and ascribe to them a primeval relationship with the soil that imbues them with natural abilities to enter the land's supernatural environment and control natural phenomena. For this reason Bantu-speakers in the past regularly employed Bushmen and Twa to make rain. However, Twa also has the connotation of a "master-servant relationship." Oral histories of both forager tribes and Bantu-speakers outline this historic relationship: Twa and Bushmen were scorned as being without property and relying on the veld for food, yet their supernatural powers were respected and needed to ensure rain and environmental vitality.

In eastern and central African countries such as Uganda, Angola, and Zambia, Bantu-speakers' oral histories describe the Twa and related foragers as having been responsible for many of the early paintings and engravings in their countries (fig. 176). The Hadza and Sandawe claim their ancestors made at least some of the paintings in Tanzania. Modern Bushmen do not claim that their ancestors were artists, but nineteenth-century records of European settlers in South Africa unequivocally attribute the art to Bushmen.

FIG. 21 Bushman trance dances may take place before or after sunset, sometimes lasting until after the sun has risen. Women sit and clap, chanting special potent songs. Men, sometimes joined by women, follow each other dancing around and outside the women. Hyperventilation helps some men (and, more rarely, women) to enter a state of trance. Bushmen who achieve trance say that entering this state is a terrifying experience, but believe the help they render their communities while in trance far outweighs the fear and pain they experience.

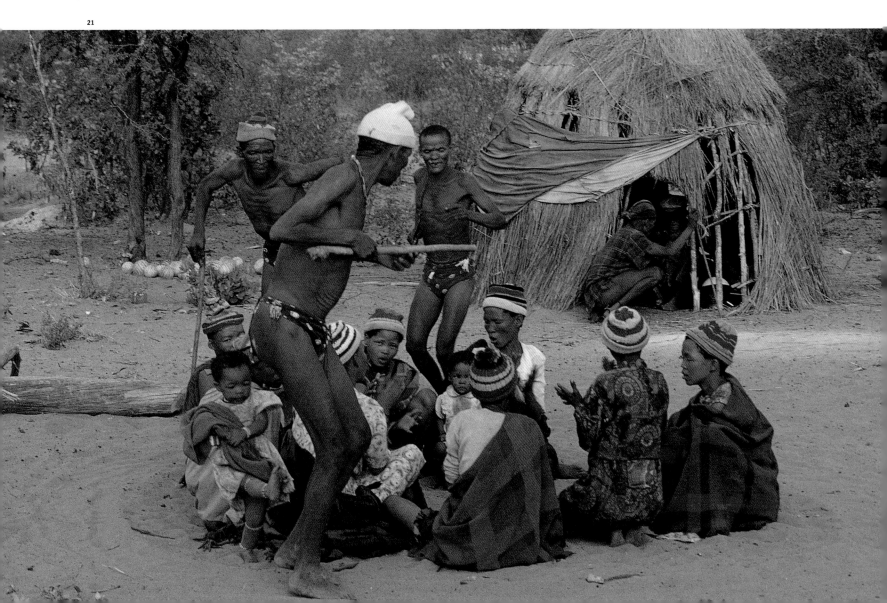

BUSHMEN

Bushmen are the oldest inhabitants of southern Africa. The type of tiny stone tools they were still making in the Drakensberg in the mid-nineteenth century date back as far as 8,000 years and have been found throughout eastern Africa and as far north as Eritrea. Archaeological finds and DNA tests suggest that direct ancestors of Bushmen once inhabited most of Africa's eastern lands, from the Red Sea to the Cape. Nilo-Saharans, ancestral Twa, and Bantu-speaking peoples moved south and east into their areas; thus, ancestral Bushmen were split apart and absorbed into new cultures, leaving only tiny remnant populations such as the Sandawe and Hadza of Tanzania. Most of South Africa's free-roaming Bushmen disappeared during the nineteenth century, the last of them surviving in the upper Drakensberg until about 1900, although one man living with Xhosa farmers in the eastern Cape continued to paint until the 1920s.

Bushmen speak several mutually unintelligible languages, each with various dialects, collectively called Khoisan, which employs as consonants fifteen or more differently articulated click sounds. There are still more than 100,000 people living in Botswana, Angola, and Namibia who speak Khoisan, or click languages. In addition, many southern African Bantu-speaking peoples, including the Zulu, Xhosa, Sotho, Ngologa, Mbukushu, and Yei, have Bushman genes, use up to nine Khoisan clicks in their languages, and share with Bushmen various aspects of their mythologies.

Early white settlers in South Africa recognized two different groups of people, Bushmen and Hottentots, both of whom spoke languages employing large numbers of click-sounding consonants. They perceived Bushman as foragers without political organization or property and Hottentots as recognizing central authority and owning sheep and cattle. As they both spoke similar-sounding languages, the settlers tended to confuse them. Scientists have used these languages, which are not mutually understandable, to divide Bushmen into three groups, sometimes called Southern, Northern, and Central.

Southern Bushmen once occupied all of South Africa and spread into southern areas of Botswana and Namibia; Northern Bushmen lived in Angola and spread south into Botswana and Namibia; Central Bushmen pose a much greater problem of identification as they include both Bushmen and Hottentots speaking related languages. In addition, some Central Bushmen, such as the Tshu-Kwe, Dete, Khoe, and Gcanikhwe, have genes much more closely related to Africa's black populations than to Bushmen. Today these so-called Black Bushmen are found in a narrow band stretching from the northwest corner of South Africa through northern Botswana to the Western Caprivi of Namibia. It is thought that some Central Bushmen were the first to acquire livestock, which filtered down from the north about 2,000 years ago, and that a few of them moved south with their livestock until white settlers met them at the Cape in the seventeenth century and named them Hottentots.

After 200 A.D., Bantu-speaking farmers began to penetrate their lands, bringing with them knowledge of metallurgy and agriculture. Mixing and intermarriage must have taken place, and most areas saw hunter-gatherers slowly replaced by farmers. Bushmen survived in the drier areas of southern Africa, but their lifestyles became more settled: some owned stock, grew

crops, and traded skins and jewelry, but most worked as herdsmen for cattle owners. For a very few Bushmen the hunter-gatherer lifestyle survived until the 1960s.

Traditional Bushman lore envisages a world combining the natural and supernatural, with both realms existing within each other at the same time, but with the supernatural realm being seen only by those who know how to step into it, although all experience the problems it can create, such as sickness, hail, and drought. The religious and everyday activities of Bushmen are completely integrated. God is recognized as a difficult character with human attributes who is sometimes clever and sometimes irresponsible. According to Bushmen, God created all life and initially animals, humans, and plants could all communicate, for people were animals and animals were people. The earth from which all life springs has mystical power. Thus, neither humans nor animals own the land, rather, the land owns them, and they have the rights to only as much of its bounty as they need to survive. Later, God separated the animals, such as the eland, lion, elephant, and antelope, from humans. They could still communicate, but only when humans moved from the physical into the intangible realm. Physical time moves on, but is paralleled by spiritual time in which past and present are one.

Certain animals, such as the eland, giraffe, elephant, hippopotamus, and kudu, are valued both for their metaphysical properties and for their meat. They possess a force that helps humans to administer health, harmony, the weather, wild animals, and human rites of passage. Botswana's Bushmen view eland and giraffe as the most important of these animals: it is both a great joy and a sorrow to kill them. They carry meat and fat that bring harmony to those who eat them. The symbol of the eland is used during ceremonies for girls' and boys' initiation ceremonies into adulthood: it unites the sexes and the activities of men as procreators and hunters and women as bearers of children and providers of food. The giraffe's (fig. 23) power is instrumental in creating rain and bringing health to the land.

One means of utilizing animal power is through special dances when men, and sometimes women, achieve a trance state, pass through the little death, leave their bodies, and enter the supernatural realm (fig. 21). Trancers can be

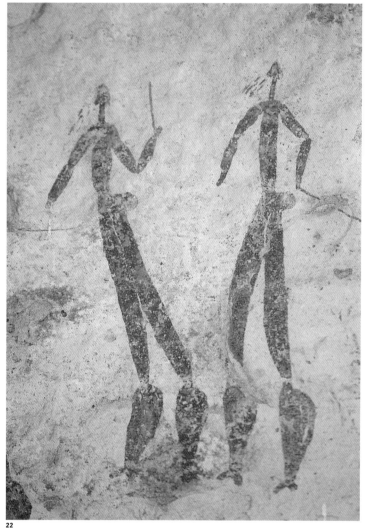

22

FIG. 22 **Two men with elongated legs apparently bleed from their noses in the Eastern Free State, South Africa. Feelings of elongation accompany trance states, suggesting that these men are in trance. Nineteenth-century Cape Bushmen are recorded as saying that people in trance sometimes bled from the nose and that the blood was a potent medicine, which trancers would rub on sick people to heal them. Modern Bushman trancers have not been observed to bleed from the nose but say this sometimes occurs (Butler, 1997). One researcher suggests that nineteenth-century trancers in South Africa may have rubbed an herb on their noses to cause such bleeding. On the other hand, the depictions could indicate some form of power emanation from the head rather than nasal bleeding.**

imbued with animal form and travel below ground to waterholes, where they seek help from spirits. They can draw mythical rain-animals to the sky above their lands to bring rain, and they channel supernatural healing to their communities. The trancer's spirit leaves the physical body and travels to the home of God, where he argues for the health of sick people, for rain, and for harmony in the community. As a means of entering the supernatural realm, the trance dance is the Bushman's most important activity: it provides an understanding of the world's intangible aspects and offers a way to control otherwise inexplicable problems.

It is participation in this dual reality, this double vision of the world, that ensures the ordered process of Bushman society. An understanding of the way in which Bushman view their world is fundamental to any interpretation of Bushman rock art.

BANTU-SPEAKERS

About 4,000 years ago Negroid peoples living in the area of the modern Nigeria–Cameroon border spoke related languages, made ground stone tools and pottery, grew root crops and oil palm, hunted and collected wild foods, and fished. Their languages—forms of which are found in some 900 related languages covering a huge area (maps 2, 3)—have collectively come to be known as Bantu, after their common word for people.

Bantu-speaking farmers learned how to smelt and work iron less than 3,000 years ago and, at about the same time, began expanding eastward along the northern fringes of the equatorial forest to reach the Great Lakes area of eastern Africa and southward through the forests to settle below the Congo River. By 200 A.D. some had crossed the Limpopo River and occupied the southeastern coastal areas of southern Africa.

Their migrations carried them into and through areas already occupied by forager tribes, such as ancestral Sandawe and Hadza in eastern Africa, Pygmies in the Congo forests, and ancestral Bushmen in southern Africa. Today in southern Africa many Bantu-speakers have Bushman genes, share some traditional beliefs, and use clicks in their languages.

Although Bantu-speakers are now widely spread, the structures of their societies and their religious beliefs reflect somewhat similar patterns. Their religion involves a benign supreme being who created all and a world somewhere below ground occupied by ancestor spirits who continue to exert influence on the health and well-being of their living descendants. Ancestors also influence rainfall and the vitality of the environment. Human life is divided into phases: childhood, adulthood before marriage, the married state, old age, and life after death. At each step ceremonies involving forms of ancestral approval move people from birth to death and beyond. Fertility is considered of paramount importance: people must have children to become ancestors, and rain must fall to give life to crops, livestock, and natural resources. Much of the later finger-painted white rock art, found from Tanzania to South Africa, is attributed to Bantu-speakers and is believed to have formed an important element of their rituals.

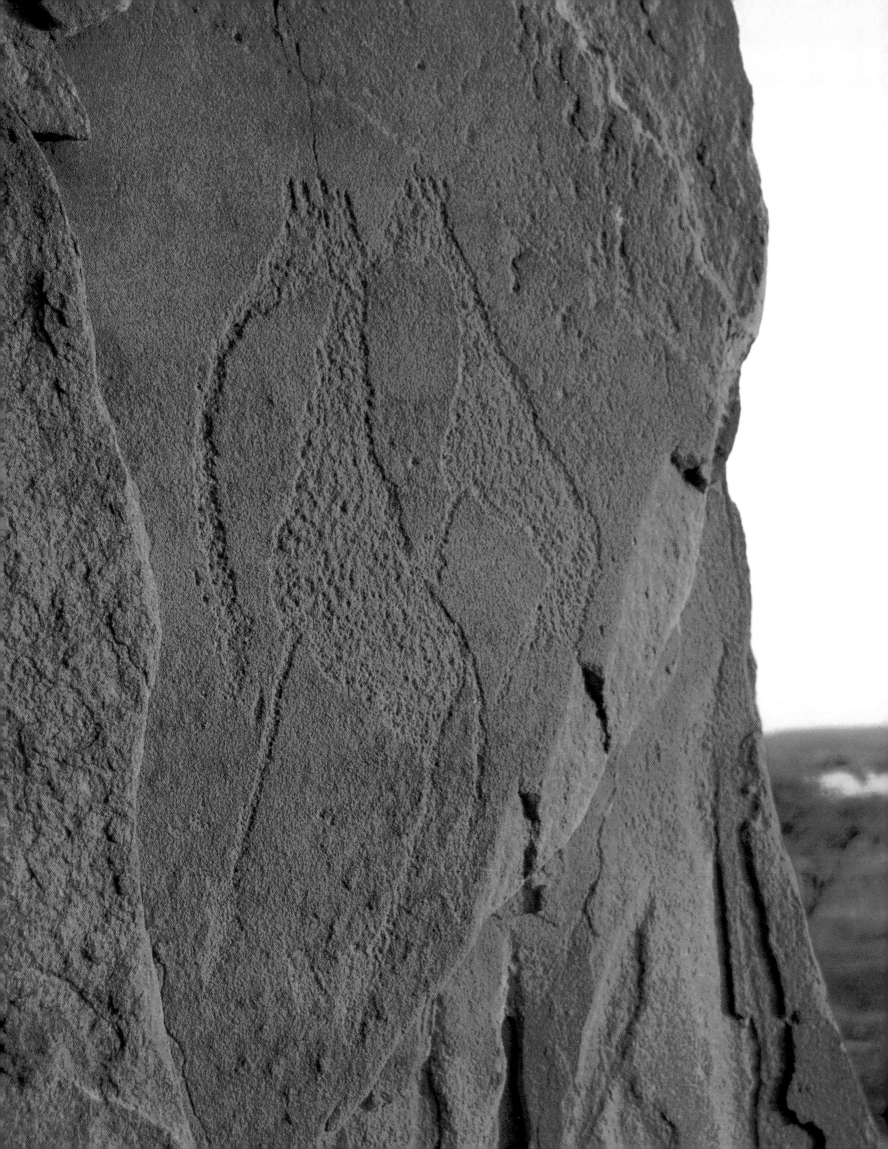

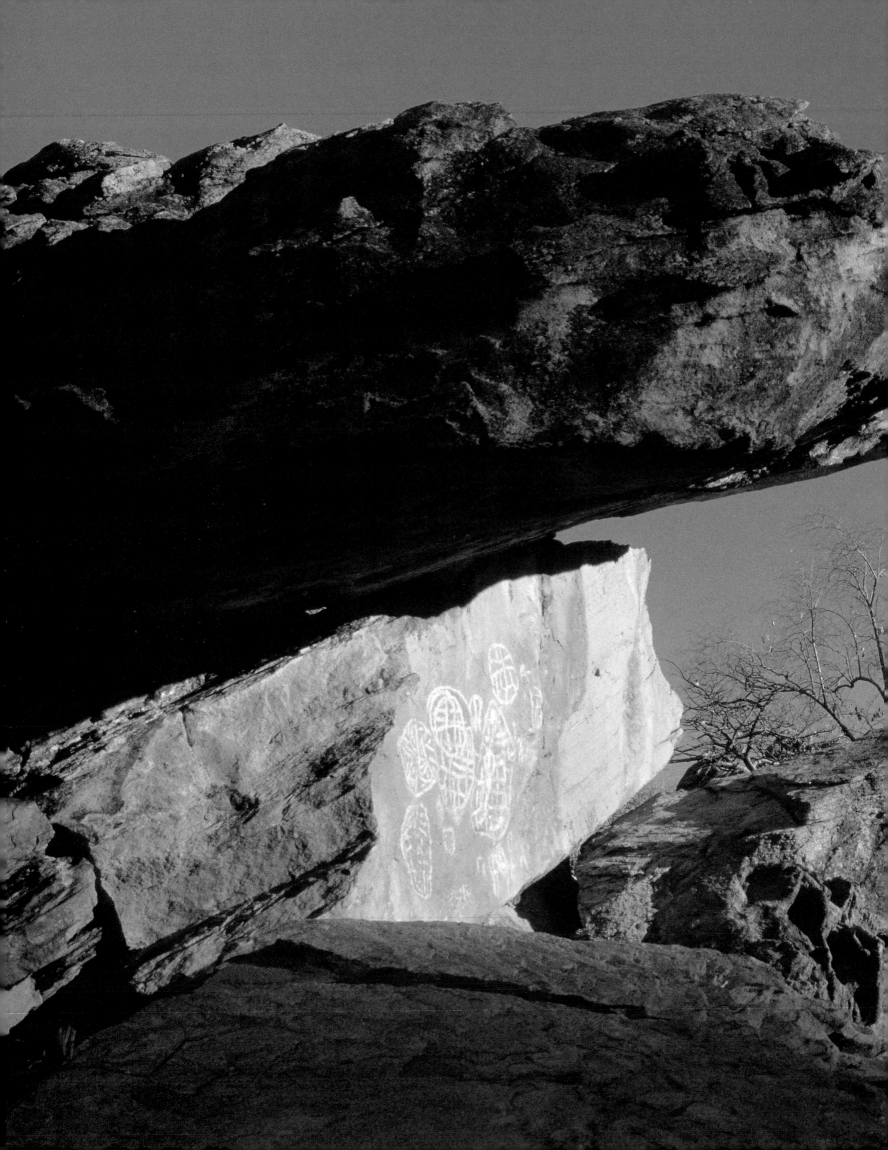

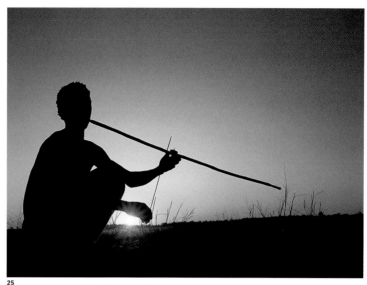

25

FIG. 24 The western sun lights up intricate Late White geometrics painted on a smooth protected surface in the Tsodilo Hills, Botswana. The large left-central geometric superimposes a somewhat similar and earlier painting in red.

FIG. 25 A Bushman plays a hauntingly sweet tune on his hunting bow, perhaps one of Africa's oldest musical instruments.

FIG. 26 Paintings of red geometric designs in northwestern Botswana. Geometric designs like these are described by David Lewis-Williams as entoptics, or visions seen while in altered states of consciousness. Their similarity to mandalas also has been noted.

26

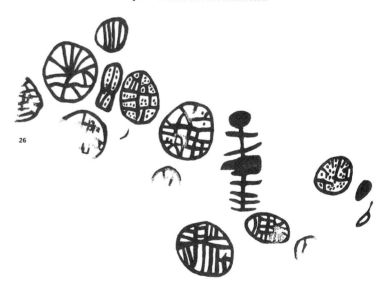

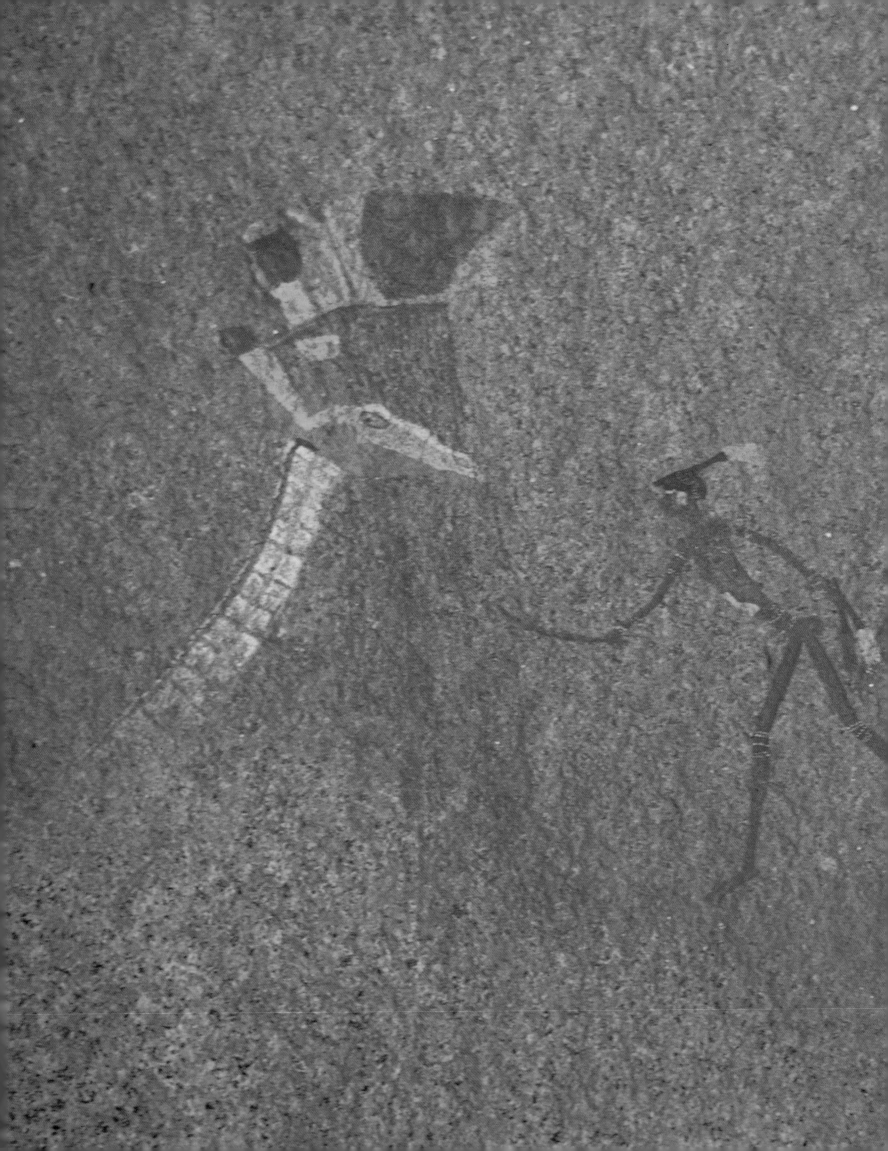

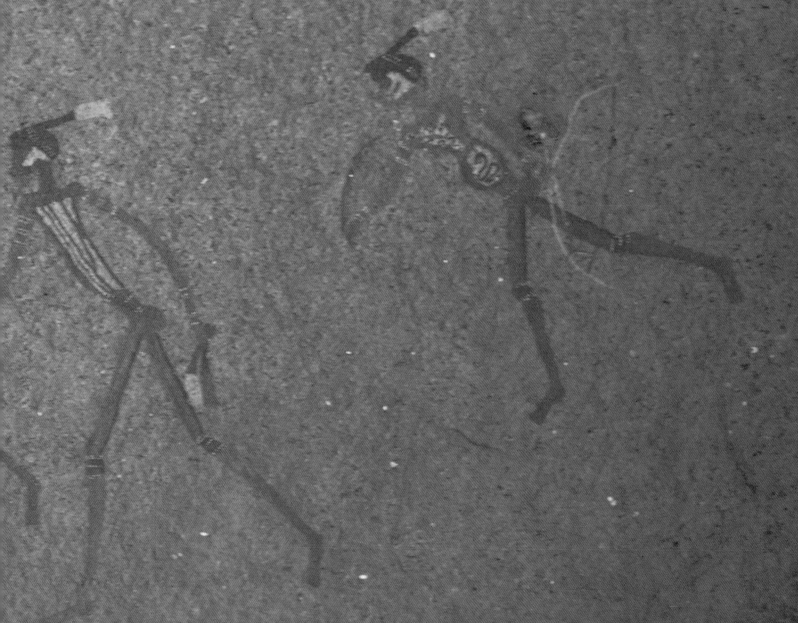

THE DISCOVERY OF ROCK ART

PRECEDING PAGE FIG. 27 **In** this painting from the Brandberg, Namibia, the head and white neck of a giraffe rise through a curtain of red rain into a cloud. The giraffe is approached by three male figures, one decorated in white with a red snake painted on his stomach and a red lizard on his chest. Note his bow with a crescent-shaped stone head.

Although rock art is found in nearly every country on earth, it remained almost unrecognized by the scientific and even the art communities until the nineteenth century, and even then its "discovery" made little impact. It was still, for the most part, amateurs in Africa who were the recorders of the art and the authors of the publications and who formed rock art societies devoted to recording, studying, preserving, and increasing the public's awareness of the art. Archaeologists often have avoided studying rock art because, although it is important in interpreting past peoples' belief systems, its interpretation tends to fall outside the traditional archaeological objective of mapping the broad sweep of human history by excavating artifacts.

UNTIL QUITE RECENT YEARS, many Europeans thought African art was a European invention that spread, or was taken, into Africa; they found it hard to believe that ancient Africans could have discovered how to make art on their own or that they could have their own developed artistic sensibilities. Many Europeans originally held patronizing attitudes toward the indigenous peoples of Africa, believing that their cultures and lifestyles were static and that the remarkable buildings and rock frescoes must have been the work of foreigners, not the local population.

In southern Africa the existence of rock art was first noted by Europeans traveling in the drier areas of the Cape in the mid-eighteenth century. They simply ascribed it to Bushmen and paid no further attention to it. Over the next century, a number of European travelers (figs. 28, 29, 30) included drawings of rock art in their books and published diaries, describing them as curiosities rather than as works of art.

In the Sahara, at the other end of Africa, the mid-nineteenth century saw visitors such as Heinrich Barth and Dr. G. Nachtigal, who published books with copies of rock art. Barth recorded art from the Aïr Mountains, in modern-day Niger, and from the Fezzan in Libya, recognized the skill of the engravings, and theorized that the images illustrated ancient mythological subjects (fig. 32). In the 1920s Francis Rodd recorded the engravings in the Aïr Mountains and wrote a scientific paper about them.

The first recordings that were to lead to a better understanding of the art were made in the 1860s in South Africa by George Stow (fig. 31) and Joseph Orpen. Orpen questioned Bushmen about the paintings he was shown and recorded what he was told, although he did not understand the art's significance. Stow recognized that some of the art had spiritual importance, but his main concern was to record works of beauty that he feared would be destroyed by time. Stow and Orpen's copies were sent to a German linguist, Wilhelm Bleek, and his sister-in-law,

28

31

29

30

32

FIG. 28 On November 16, 1777, the explorer Robert Gordon copied rock paintings on a journey to Sneeuberg, Cape Province, South Africa. He wrote of the paintings, "Some were reasonable, but on the whole they were poor and exaggerated. They had painted various animals, mostly in black, also red and yellow, and some people." (Raper and Boucher [eds], 1988.) The original drawing is in the Rijksmuseum, Amsterdam.

FIG. 29 In 1849, Alfred Dolman passed through Kuruman, South Africa, on his way north. Somewhere in the area he copied rock paintings, which he attributed to "Bosjiemen," but the site has not been found. (Dolman, 1984.)

FIG. 30 In 1877, A. A. Anderson crossed the Limpopo River near Buffelsdrif on his way to Shoshong in Botswana. Here he recorded seeing numerous engravings on a round rock, well rubbed by elephant and rhinoceros. Anderson was somewhat prone to exaggeration and his copies have been romanticized. Also, engravings do not exist in the place described by him, although on his journey north he had passed through areas that did contain engravings. (Anderson, 1988.)

FIG. 31 In the late 1860s, George Stow, a geologist, made copies of rock paintings and engravings in South Africa that he showed to an old Bushman, 'Ko-ri'na, and his wife, 'Kou-'ke, the only survivors of a once large band that Stow described as having been "annihilated." Both immediately claimed the paintings belonged to their people. (Redrawn from Stow, 1905.)

FIG. 32 On July 6, 1850, Heinrich Barth camped in Wadi Elghom-ude (River Valley of the Camel), Fezzan, Libya, where he noted numerous rock "sculptures," of which he wrote, "No barbarian could have graven the lines with such astonishing firmness, and given to all the figures the light, natural shape which they exhibit." Barth thought this engraving was taken from "native mythology" and represented "two divinities disputing over a sacrifice." (Redrawn from Barth, 1857.)

FIG. 33 **A tracing of the White Lady of the Brandberg (fig. 34) by Harald Pager in about 1980. Pager's tracings include every detail and, in this instance, indicate clearly that the White Lady is male.**

Lucy Lloyd, who were working with Bushman convicts held in Cape Town to record their language, lore, and customs.

Bleek showed copies of the art to his Bushman contacts, recorded their interpretations, and recognized that the painted images involved much more than their apparent representations—they were symbolic aspects of Bushman religious beliefs. Unfortunately, Bleek died shortly after he received the copies; but he and Lloyd had managed to record some 12,000 pages of Bushman custom and lore, some of which has been published and much of which has been vital to interpretations of the art.

In the years leading up to World War II there was an upsurge in European interest in African rock art, and visits by prominent scholars increased. Perhaps the most famous researcher was the Abbé Henri Breuil of France, at that time the world's most eminent authority on prehistoric art because of his studies and publications on Paleolithic cave art in Europe. He worked tirelessly in Europe and northern and southern Africa, tracing literally thousands of images and publishing numerous books.

Breuil returned to southern Africa in 1947 to examine a painting in Namibia he had long wished to see. He called it the White Lady of the Brandberg (fig. 34) because he was convinced it depicted a girl dressed as an ancient Cretan bull jumper. In fact, the painting reflects neither a woman nor a Caucasian; it represents a man and is typical of numerous other painted figures that are clearly Bushmen (fig. 27). Even so, Breuil was so well established in the academic world that when he declared the "White Lady" represented an ancient visitor to southern Africa, the statement was questioned only by scientists.

Dr. Leo Frobenius, a renowned German explorer and ethnographer, recorded rock art both in the Sahara and in southern Africa. In Zimbabwe Frobenius recognized many features of the paintings that were important to their interpretation and proposed that the art was symbolic and mystical; but his desire to attribute it to ancient cultures of southwest Asian origin resulted in his failure to give it any genuine meaning, and his interpretations were disregarded.

It was not until the late 1950s that a European scholar gave Africa's rock art the prominence and dignity it deserved. Henri Lhote, a Frenchman, first visited Algeria's Tassili n'Ajjer in the 1930s and was amazed by the extraordinary paintings he saw. He returned with a major expedition in 1956, traced many paintings in the upper plateau shelters, and proposed chronological sequences. Not only did he recognize the art's grandeur, unique qualities, indigenous nature, and ancient origins, he also realized that the paintings reflected the "spiritual and religious existence of the different peoples which followed on, one after another. . . ." Although Lhote's publications are, for the most part, records of rock art lacking in serious discussion of the art's meaning, he did much to inspire new investigative approaches.

In northern Africa, Fabrizio Mori visited the Akākūs Mountains in Libya in 1955 locating and recording a wealth of early rock art. Mori formed "La Sapienza" at the University of Rome, a group that has spent more than thirty years researching in the Sahara. Another important group working in the Sahara and in Namibia is the Heinrich-Barth-Institut of the University of Cologne, which has published books on the archaeology of the Sahara and the rock art of Namibia. Fred Wendorf of Southern Methodist University, Dallas, and his colleagues have researched the onset and spread of agriculture in the eastern Sahara, thus providing dates for early Pastoral Period art. Alfred Muzzolini, working alone, has traveled throughout the Sahara, writing copiously on its art and suggesting an alternative chronology, which dates the earliest engravings to only 7,000 years ago.

Other early researchers included Cran Cooke, who excavated many rock art sites in Zimbabwe, recorded innumerable paintings, and was the first to publish on the art of southern Africa as a region, and Alex Willcox, who recorded rock paintings throughout southern Africa, published a number of books on specific areas such as the Drakensberg, and compiled an exhaustive work on the rock art of the whole continent. Cooke and Willcox were followed by many others, mostly amateurs, who recorded thousands of paintings and wrote about the art. Important among them were Bert Woodhouse, Neil Lee, Ernest Scherz, Gerhard and Dora Fock, and Harald Pager. Pager spent much of his adult life recording rock paintings in the Drakensberg and Brandberg, tracing upward of 100,000 images and publishing many of them. These researchers' works provide an incomparable record of southern Africa's rock art.

WHO WERE THE ARTISTS?

Early European researchers tried to back their theory that African art was done by Europeans by pointing to similarities between the early rock art of Europe and Africa; but they overlooked the fact that within millions of depictions, some images will have similar features. To definitely link the art of Europe and Africa we would need numerous common examples and broadly similar dates, all of which are lacking.

Some researchers have seen similarities between Levantine rock paintings of southeastern Spain (fig. 37) and paintings in the Akākūs Mountains of Algeria and Libya. The paintings of both areas are fairly small, often depicted in red, and reflect people and wild animals; but there the similarities cease. Had Levantine art been diffused to Africa, we would find its traces along the route from Spain to the Akākūs, but there are none; the few rock paintings in Morocco resemble neither the art of Spain nor the Akākūs.

Engravings of weapons in the upper pastures of the High Atlas in Morocco (fig. 38) are similar to images of weapons in Spain that are attributed to the Bronze Age, approximately 3,000 years ago. But while there was certainly a Bronze Age in Spain, it has never been proven that there was one in Morocco where far fewer (probably less than fifty) copper and bronze objects have been excavated. Also, archaeology suggests that the earliest rock art of Morocco

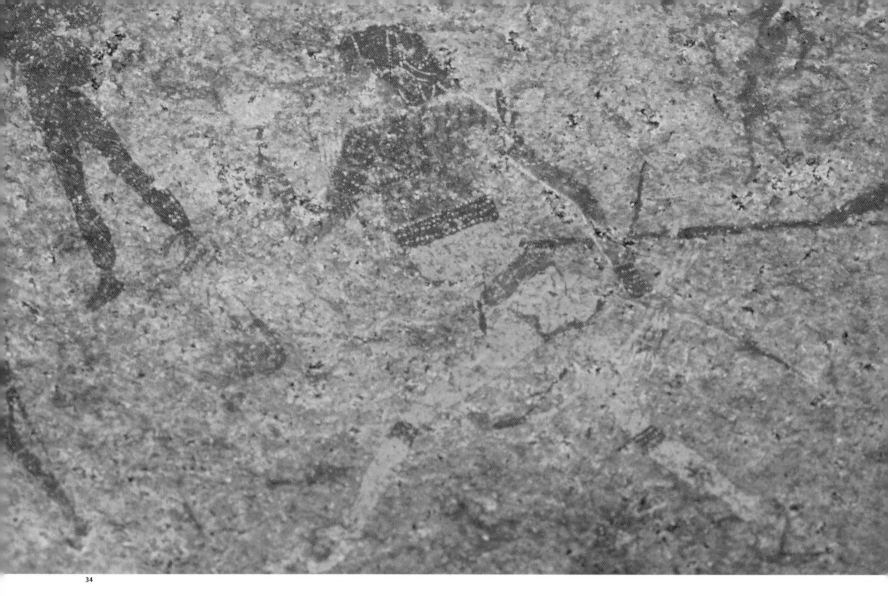

FIG. 34 **A detail from the Maack Shelter, Brandberg, showing the famous White Lady painting. Anatomically, the figure appears to be male rather than female. Its date is uncertain. Today, repeated washing to brighten the colors for photography has destroyed much of the detail, reducing the painting to a shadow of its former magnificence.**

was made by pastoralists living to the south of the Atlas Mountains perhaps 6,000 years ago, and that the rock art spread from the southeast, out of the Sahara. The Bronze Age art may have an origin in Europe, but the Tazina engravings are definitely African in nature. It even seems doubtful that the weapons themselves were imported into Morocco; rather, the symbols were reproduced there and may not even have been recognizable to the ancient locals as knives and axes.

In Zimbabwe Breuil, along with others, identified "Persians" among human figure paintings, strengthening beliefs that art and stone-wall towns such as Great Zimbabwe were made by foreigners and not by Africans. Another expert has claimed that a geometric in South Africa's Cederberg represents a Phoenician boat (fig. 39). Had any of the artists been foreigners, remains of their settlements would have been found by now. As it is, not the slightest evidence of Phoenicians, Sumerians, Indians, or any of the other proposed foreigners has ever been found.

Nor has firm evidence ever been found to show that the earliest African rock art was not a spontaneous initiative by Africans. We have yet to learn how, and in what places, the practice of rock art started, for the earliest art found in the Sahara, central Tanzania, and southern Africa all has the appearance of evolved skill and not of first attempts by people learning to use graphic design on rock.

RECENT RESEARCH ON THE MEANING OF ROCK ART

In an attempt to re-create ancient peoples' thoughts and ways of expression, many researchers have turned to studying the lifestyles and beliefs of modern peoples whom they recognize as closest to the original artists, such as Bushmen, Sandawe and Hadza, Pygmy, Bantu-speakers, and Tuareg (descended from Berbers). The question is, can modern ethnographies explain cultural activities undertaken thousands of years ago? This method could be effective for studying recent South African rock paintings since Bushmen with fairly similar cultures to the artists are alive today, but it is much harder to use the same ethnographies to interpret Zimbabwean paintings, which, although undoubtedly the work of ancestral Bushmen, were made 2,000 or more years earlier. Even so, if it is possible for us to interpret the art of the last 2,000 years by studying the cultures of modern peoples who are linked to the art through their ascendants, the perceptions we gain can provide useful analogies for interpreting the much older art.

Since 1970, important research in this field has been undertaken, particularly in southern Africa, by Patricia Vinnicombe, Tim Maggs, and David Lewis-Williams. Vinnicombe recognized that certain animal species, especially the eland, dominated Drakensberg art, and Maggs realized that some scenes painted in the Cederberg repeated themselves and he examined Bushman ethnographies to learn what activities the scenes might represent. Following their lead, Lewis-Williams used the nineteenth-century work of Bleek and Lloyd, and twentieth-century

35

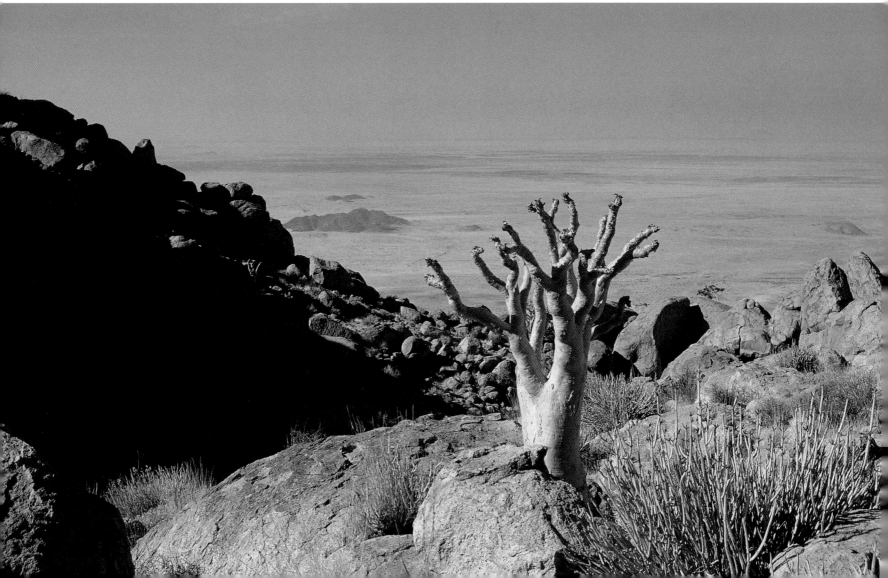

research that has been done among modern Kalahari Bushmen to determine the symbolism Bushmen use to portray abstract notions of reality. He found that the key to interpretation lay in understanding Bushmen's perceptions of reality and their use of visual imagery to sustain themselves in the natural world. Another researcher, Peter Garlake, has concluded that the rock art of Zimbabwe portrays three major concepts: people's roles in life; the relationships among people, animals, spirits, and the environment; and the "supernatural energies inherent in almost all living things." Other researchers in southern Africa are now building on these foundations; however, elsewhere in Africa current research is only now probing these areas.

In northern Africa, most of the research has concentrated on determining the styles and their distribution, constructing chronologies, and providing detailed descriptions of the art, which results in useful classification and dating systems, but little else; only recently have serious attempts been made to interpret the art. Long ago, Leo Frobenius and Henri Lhote postulated that the art had religious implications, but they never managed to explain what they were. Fabrizio Mori proposed that the art elucidates man's changing relationships with nature. He explained it as follows: initially, a world existed in which animals dominated man, but changing ideologies, and shifts toward food production and property ownership, saw man creating a world of spirits formed in his own image, and, ultimately, man was no longer merely a part of nature, but was outside it, above it, and able to control it. For some time it has been recognized that much of the art is symbolic and probably of a religious nature.

36 37 38

Recently, Jean-Loïc Le Quellec has postulated that much of the art is symbolic. Working over a considerable area, he has recorded how earlier engravings were made and has compared Saharan images with modern ethnographies and universal structures of believed sacred entities—the moon, earth, rock formations, rebirth—in an attempt to determine the artists' intentions. The act of engraving may have been as or more important than the resulting images, and the art may have symbolized early concepts of sanctity. Since 1980 researchers have also

toyed with shamanism as a basis for interpretation of earlier Saharan art, although recent thinking suggests that images could as easily depict states of ecstasy as shamanic practices.

In Zambia Benjamin Smith has shown that the earlier art can be divided between men and women artists, with women producing geometric designs similar to contemporary art painted on bark cloth, and almost certainly involved with rainmaking ceremonies. Smith has also shown that a broad band of early art reaching across central Africa clearly separates southern African Bushman paintings from the somewhat similar art of central Tanzania, and has cautioned against applying southern African interpretation to Tanzanian paintings.

Can interpretations for one type or locality of art be applied to the art of other regions? The answer is almost certainly no, since we are looking at totally different peoples in different environments and at different times in their cultural evolution. Even so, possible interpretations from one area can inspire new ways to look at the art of other areas. Recently, Jean Clottes and David Lewis-Williams, basing their ideas on interpretations of southern African art, have postulated that much early art made by peoples with forager economies is shamanistic: that is, it portrays aspects of a reality visited while in the trance state, and involves the harnessing of supernatural powers for human benefit. Verifying this theory, however, may be difficult or impossible.

A modern Zhu Bushman living in a rock art area said the art was "painted by God." Later, he added that a Ncaekhwe (Central Bushman) may have held the paint, but God guided his hand. We must be wary of automatically assuming that modern peoples, even if they are

39

FIG. 36/37 **Compare the scene of men hunting a sheep with dogs in the Akākūs Mountains, Libya (left), with a man hunting stags in southern Spain (right). Such similarities in style and subject between paintings found in Libya and Spain led early researchers to postulate a diffusion of art from Europe to Africa; yet the distance between these two countries is great and lacks intermediate links.**

FIG. 38 **Engravings of daggers from Mt. Bego, Spain (top), and the High Atlas, Morocco (bottom). Engravings of Bronze and Iron Age weapons are common in Spain, France, and Italy, where actual metal weapons have been excavated; however, such weapons have yet to be found in Morocco, which suggests that the symbols, rather than the weapons themselves, were introduced from Spain to Morocco.**

FIG. 39 **Geometric designs from the southwestern Cape. Such designs are believed by many researchers in southern Africa to be entoptic phenomena seen by people entering the trance state and are described as nested curves. This painting also has been believed to represent a Phoenician boat.**

Bushmen who still occasionally hunt and collect wild food, have perceptions and values in some way similar to those of their ancestors. Ethnographies of modern Bushmen may help us to interpret rock art painted in southern Africa during the last few centuries, but how far can it help interpret the art of past millennia in other areas of the continent?

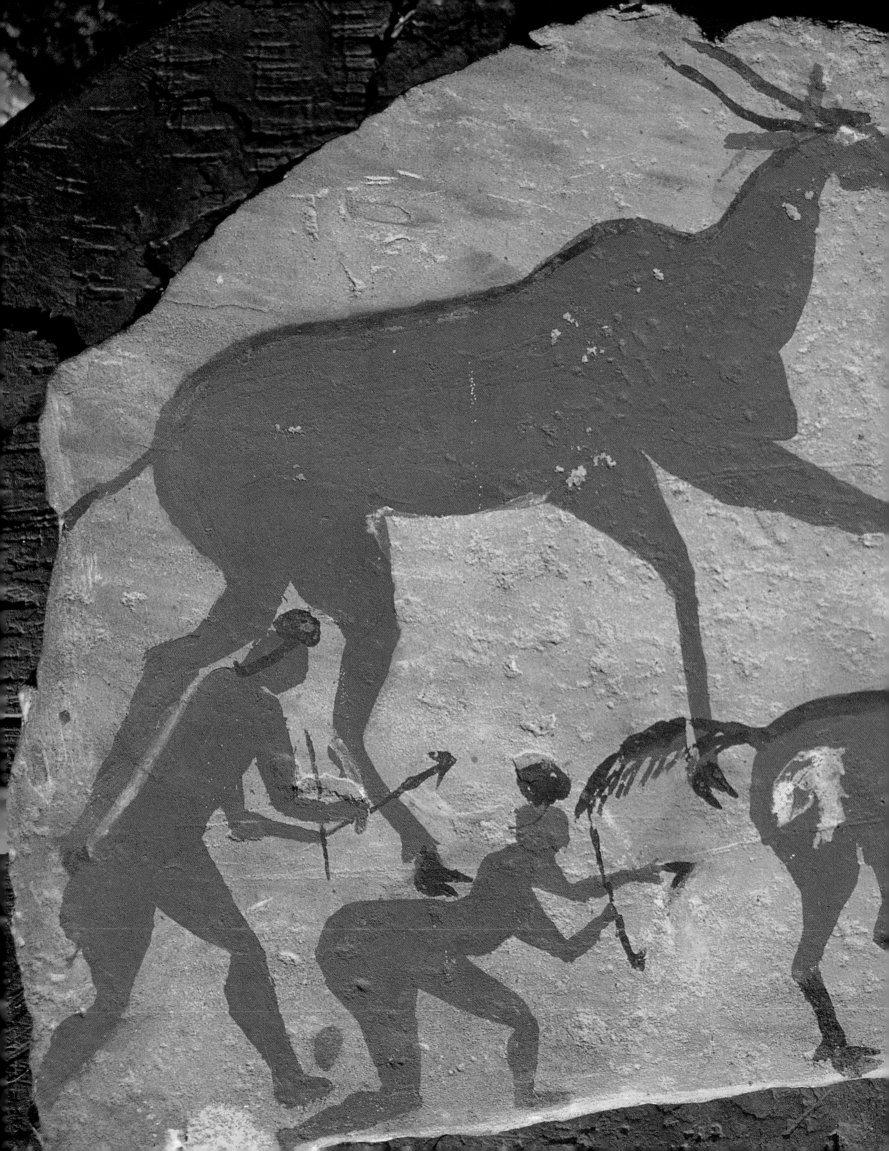

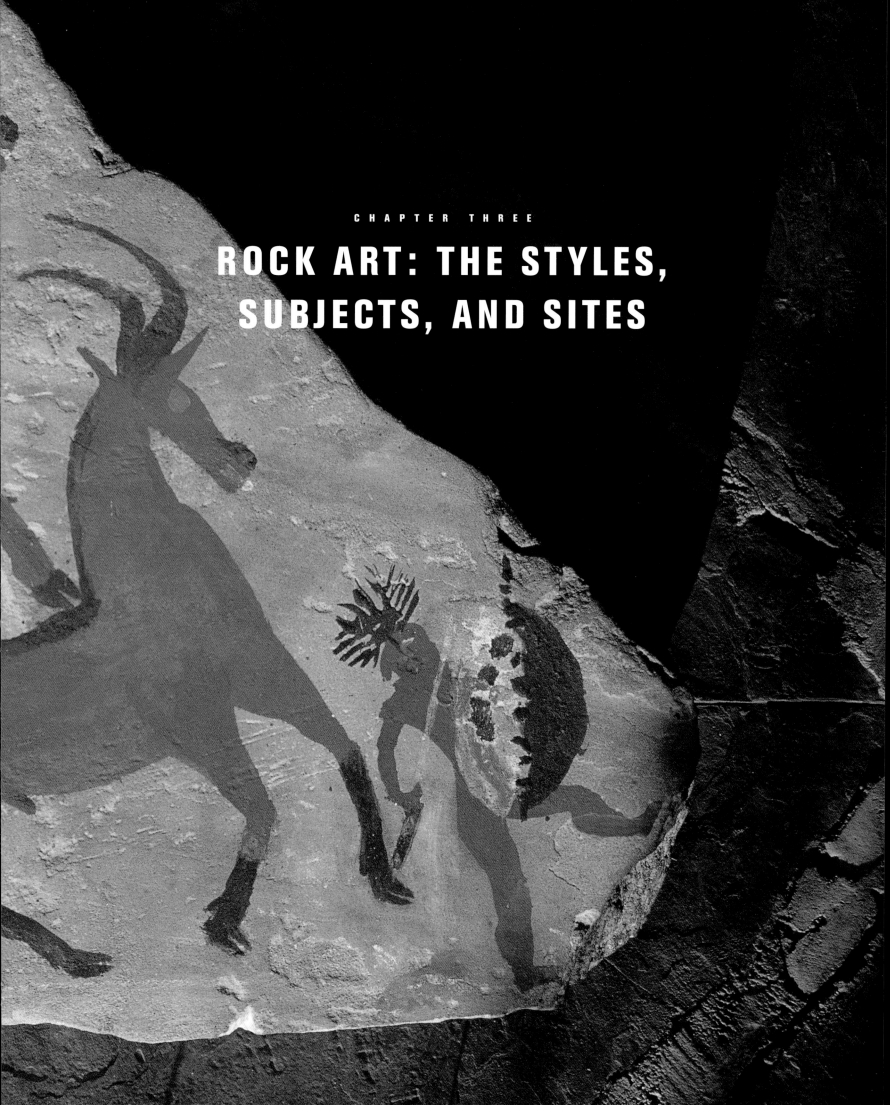

ROCK ART: THE STYLES, SUBJECTS, AND SITES

PRECEDING PAGE FIG. 40 A modern-day
Sotho with Bushmen half-brothers
produced this painting to demon-
strate how Bushmen mixed their
pigments and painted; he was not
trying to produce a painting in the
traditional Bushman style.

OPPOSITE FIG. 41 A very
small bichrome brush painting
from central Namibia in red and
black of a man with a headdress
holding a hunting bow and arrows.
His hips and legs are twisted to his
right, while his head is turned
to his left.

We have divided Africa into three rock art regions: northern Africa, which includes the Sahara, Morocco, and Ethiopia, and stretches south to the southern end of Lake Turkana in Kenya; eastern Africa, which lies between Lake Turkana and the Zambezi River and includes Zambia, Angola, and Zaire; and southern Africa, or the area south of the Zambezi River including Namibia. Apart from paintings in the Irangi area of Tanzania, which bear some similarities to southern African paintings, the art's form in the three regions is relatively distinct.

UNTIL THE END OF THE 1960s, research in northern and southern Africa concentrated on recording images and compiling chronologies; there were no adequate techniques for dating. Then a major breakthrough occurred in South Africa when it was recognized that much of the art, which appears to have a common ancestral Bushman framework, is symbolic and can, to some extent, be interpreted by comparing it to nineteenth-century recordings of Bushman ethnographies and recent twentieth-century investigations of living Bushman cultures.

Unfortunately, northern African rock art tends to be much less unified than that of the south, and there is no obvious direct relation to the cultures of living peoples, except for the most recent works. Consequently, researchers in northern Africa have tended to try to interpret the art in terms of their own, usually European, cultures and not in relation to the cultures of the artists themselves. Ostriches surrounded by a circle have been called "ostriches in a pen" (Brentjes, 1965) and scenes with people holding animals, such as giraffes, have been interpreted to reflect domestication. However, a Tuareg saying told to Alec Campbell by Mohammed Ag Boula suggests giraffes were not domesticated: "Giraffe asked Camel why he is large and looks like him, yet has allowed himself to be domesticated by puny man."

Because of the differences in the art and in the various levels of possible research, the format for discussion varies from area to area. Southern Africa is described in terms of general areas, which tend to coincide with countries, while eastern and northern Africa are described more in terms of chronology than regional variation.

There are certain similarities throughout Africa; for instance, early and fairly incontestable dates for ancient art in both southern and northern Africa extend back more than 10,000 years. There are as yet no early dates for Tanzanian art, but some of it is probably also 10,000 years old or even more. However, if the very early date of between 27,000 and 19,000 years ago ascribed to the art in the Apollo 11 Cave in southern Namibia proves correct, these dates may have to be revised.

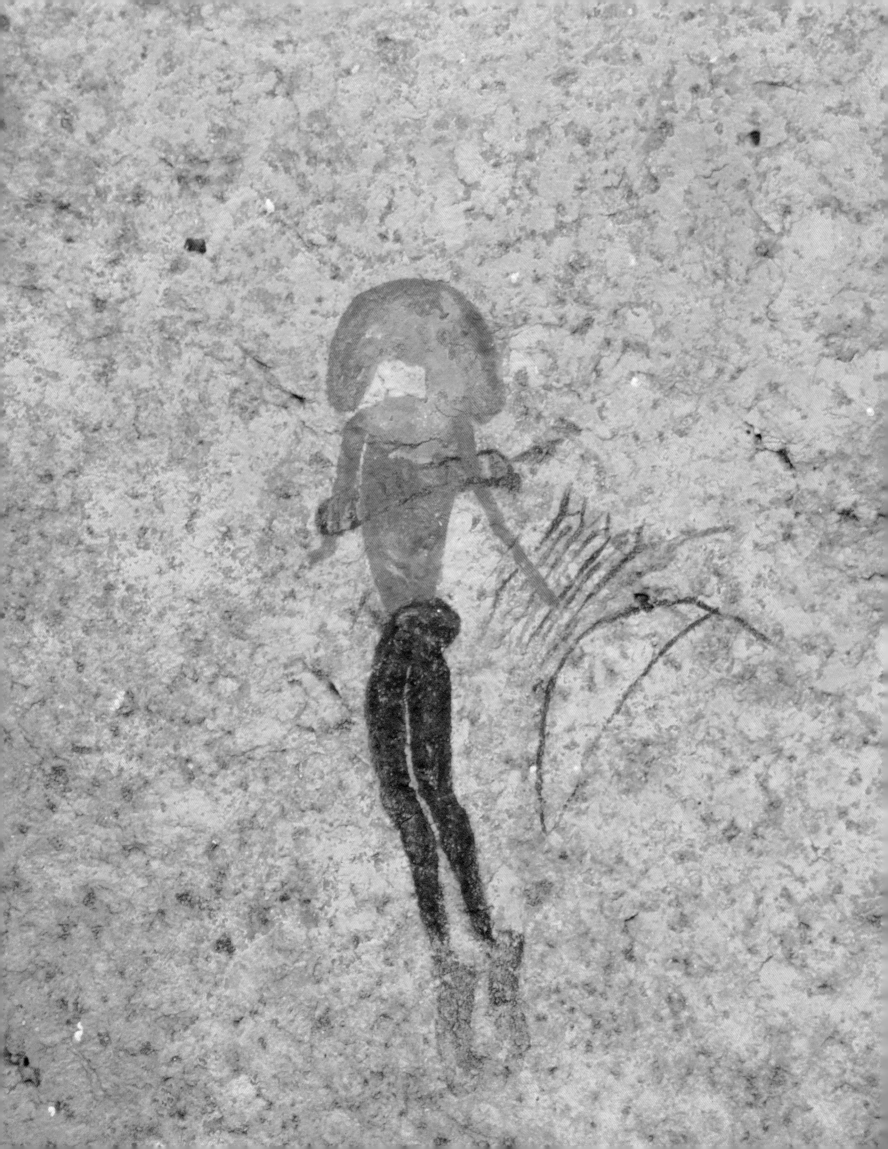

Subject matter throughout Africa tends to be similar, with a preponderance of large animals such as giraffe, ostrich, elephant, rhinoceros, and antelope, along with characterless human figures. Depictions of plants, except in Zimbabwe, are rare. Backgrounds are nonexistent and Western ideas of perspective are lacking. Scenes, except for some paintings in northern Africa, tend not to reflect domestic activities and are difficult to interpret. Deliberate superpositioning of one image over another occurs throughout the continent. Everywhere, artists chose to paint or engrave on specific sites for reasons known to themselves, although today we may consider nearby areas more appropriate for the art.

In southern Africa paintings, especially fine-line paintings, dominate all the earlier (more than 2,000 years old) art. The artists' conceptual views, both of time and space, are the same for the whole region, leaving little doubt that the greater part of the art was made by ancestral Bushmen: changes in the art are immediately obvious north of the Zambezi River.

Eastern Africa's rock art can be divided into two types (excluding the art of pastoralists and Bantu-speakers): the paintings of central Tanzania, which are ascribed to the ancestral

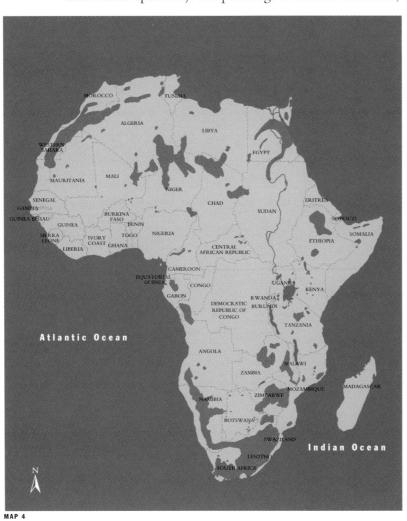

MAP 4

Sandawe; and Twa art, made by ancestral Pygmies or peoples related to them. Twa engravings are found mainly in Zaire, Angola, and western Zambia, while Twa paintings are concentrated in eastern Zambia, spreading east across the continent to form a barrier between southern African and the main body of eastern African art. The earliest art occurs in central Tanzania: it includes large images of animals and appears to develop through fairly recent times into fine-line painting. But while central Tanzanian paintings look similar to Bushman art, and may even share distant common roots with it, they have been separated from southern African art for thousands of years by the band of Twa paintings and cannot be termed Bushman.

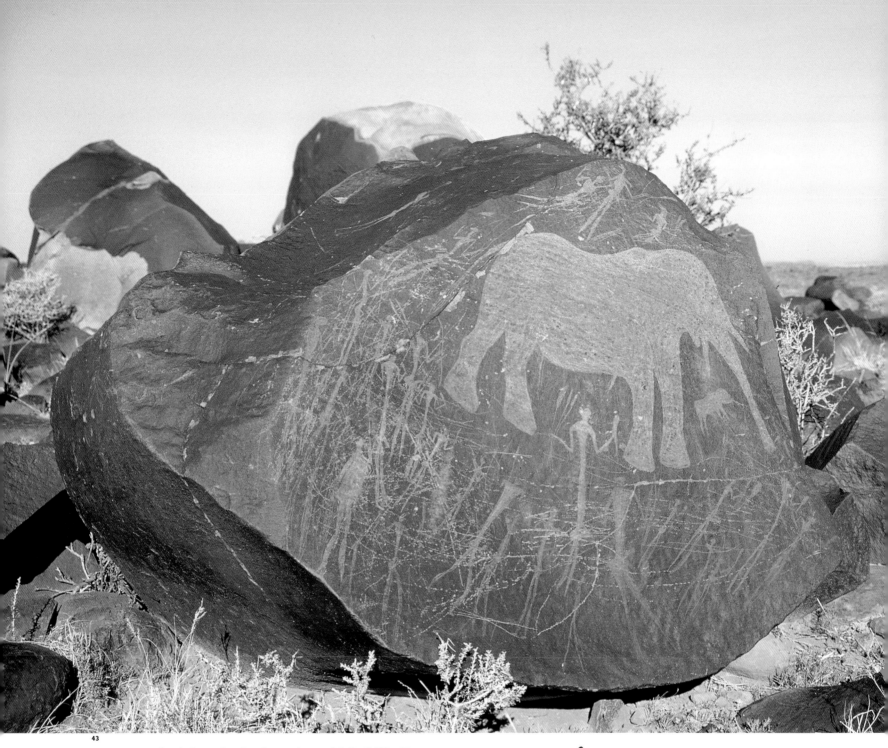

43

OPPOSITE FIG. 42 **A pecked engraving of a zebra on a loose rock in South Africa. The animal's head, flank, and legs have been lightly pecked to give emphasis to its shape, while its outline and stripes are deeply incised.**

MAP 4 **Distribution of rock paintings and engravings in Africa.**

FIG. 43 **A scraped engraving found on a ridge in the northern Cape of South Africa. A large elephant with her calf protected by her trunk is surrounded by more than twenty-five human figures, some with animal heads. The people are facing forward, rather than in the more normal profile position, and hold fly whisks in their hands. At some time, perhaps about 1925 according to a name and date carved into a nearby rock, somebody deliberately scratched lines through the exposed penises of every man in an attempt to obliterate them. This scene does not reflect a hunt, but may reflect a rainmaking ceremony.**

FIG. 44 **A painting from northwestern Botswana of an antelope with her young, probably made by applying wet pigment to the rock with the fingers.**

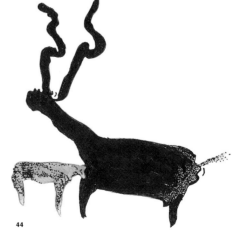

44

OPPOSITE FIG. 45 **A large engraving about 5 feet (150 cm.) high of dancing women found just below the summit of a ridge in Niger. The main figure has been ground and colored in black and white. The age of the original engraving is unknown, but the grinding and painting are recent. Local reports state that modern people rub in more coloring while asking for gifts, such as cloth or livestock. Another source said that the painting was done during the civil war of the early 1990s; indeed, the engravings are surrounded by bullet holes. Laurent Tepelos, who worked in the Aïr in 1989, told us that Tuareg said caravans on their way to Bilma marked the engravings for luck.**

The art of northern Africa probably originated some 12,000 years ago in the central Sahara and over the next few thousand years spread west to the Atlantic, east into Egypt and Ethiopia, and south into Kenya. A clear chronology can be distinguished from the early forager art up to the most recent art of the Camel Period, which began in the East about 2,200 years ago. While northern African art of the Pastoral Period has spread as far south as Malawi, earlier Saharan and eastern African art are separated by thousands of miles and cannot easily be related to each other.

THE STYLES

Rock art can be divided into two major categories: paintings, sometimes known as pictographs, and engravings, also known as petroglyphs. As we shall see, each of these categories is subdivisible. There is a third category that we will briefly touch on, carved or ground rock objects, but it has little importance to the theme of this book.

PAINTINGS Paintings are sometimes known as pictographs because most have been drawn rather than painted (as we understand the term today). However, for simplicity's sake we will call them all paintings.

Paintings were made with a brush (fig. 41), a spatula, or the fingers (fig. 44), the wet pigment applied directly onto the rock. It seems that artists would normally first draw an outline and fill it in and add details later. Many paintings employed only one color, normally red, although some consisted of two, three, and even four colors. The paintings that contain more than one color usually consist of an image with different parts painted in different flat colors, although sometimes shading is used.

Paint was made from coloring substances mixed with a liquid binder. The most common color is red or shades of red ranging from pink to orange to purple. Other colors include yellow, black, white, and, very occasionally, green and blue. The coloring substance, or pigment, was made from ground, and probably burned, stone. Red was made from soft rocks containing oxidized iron (hematite or ocher); yellow was made from limonite; black was made from charcoal, manganese oxide, and occasionally specularite (a form of hematite); white was probably made from gypsum or lime; and green and blue pigments may have been made with malachite. Different ground pigments appear to have been mixed to create shades.

The liquids used to make the binder are still being investigated: they may have been made from water (least likely), blood, egg white, plants, urine, animal fat, or even honey and, in the Sahara, possibly milk. In Lesotho in the 1930s a Sotho named Mapote, who had Bushman half brothers, reported that eland blood was used; and a Botswana Bushman who claimed his ancestors painted said that fat from around an ox's heart was used to form the binder.

An interesting story regarding Mapote suggests that the paints used to create rock art may have a particular value—perhaps they contain magic ingredients that may be considered dangerous or valuable. He made a painting on a movable rock for a European woman named

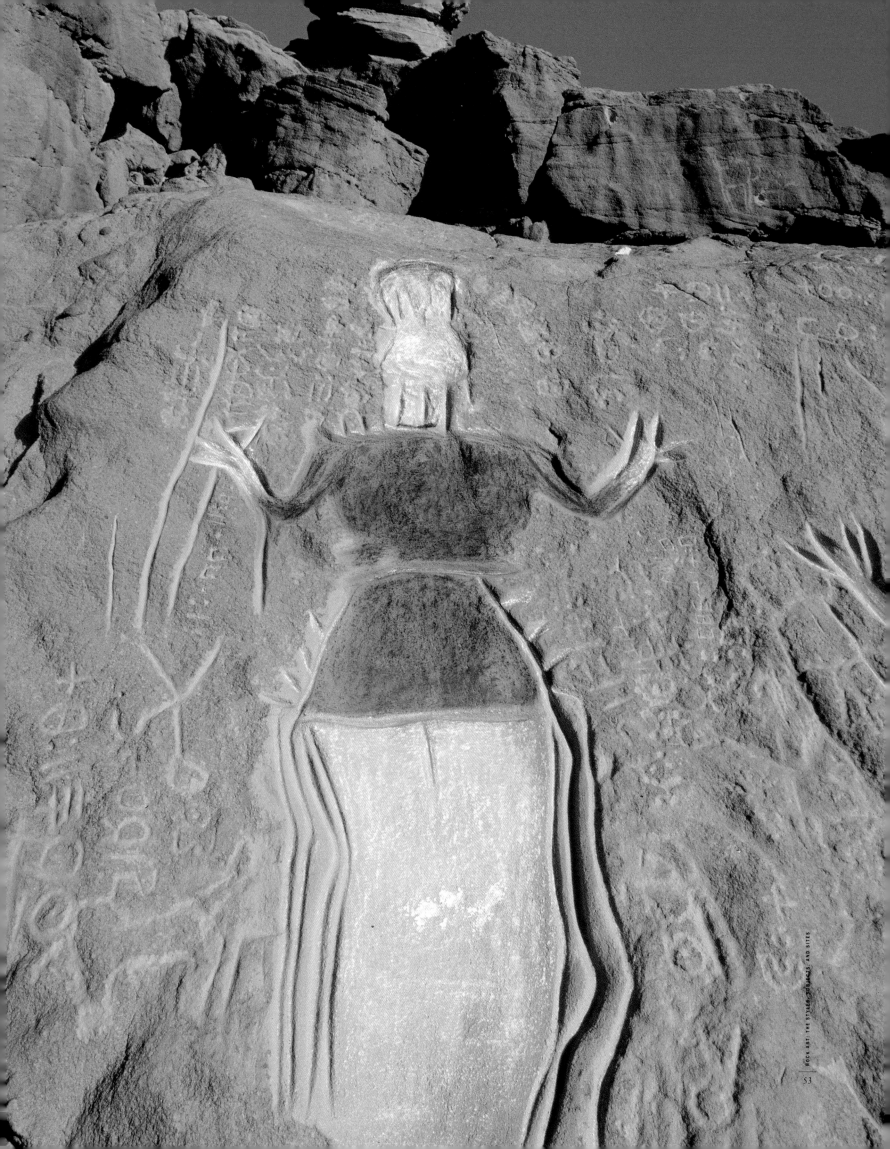

Mrs. How using materials provided by her (fig. 40). She was due to leave Lesotho the next day by train and packed the paints and brushes in a trunk, which was put on the train. During the night the trunk was forced open and the paints and brushes—and nothing else—were stolen, suggesting these were all the thief wanted.

Paintbrushes may have been made from feathers, hair, a stick, or even a bone spatula; unfortunately none has ever been found. The paint itself may have been held in small antelope horns: one strung on a belt has been found abandoned in a cave in the Drakensberg of South Africa, and another set was discovered in the nineteenth century when a Bushman, shot in a raid, was found to have paint horns strung on his belt.

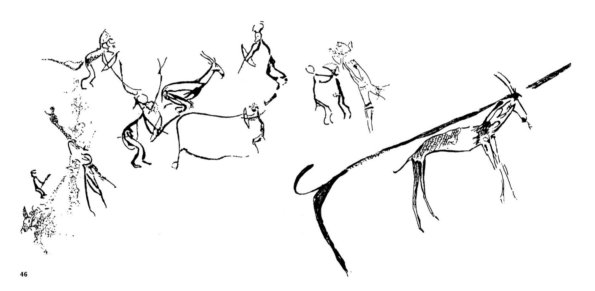

46

ENGRAVINGS Engravings, which are sometimes called petroglyphs or rock carvings, are usually made by chipping small pieces out of a rock face to form the image. We call all images engravings that have been cut, pecked, scraped, or ground into a rock face.

Engravers worked in several ways. In the method known as pecking, the engraver would hold a fairly heavy hard stone, pointed at one end, and use it as a pick, striking repeatedly against the rock face, chipping out tiny pieces of stone (fig. 42). A different pecking method involved the use of two stones: a hard point, perhaps quartz or chert, was held against the rock and a heavier stone was used to hammer it into the rock, which removed small outer pieces. The engraver would probably first scratch the outline of the image into the rock surface and then laboriously chip it out by hammering the pointed tool into the rock. In northern Africa such engraving tools are sometimes still found lying near engravings, but in southern Africa these tools are absent—possibly they have been deliberately removed.

The lines of some engravings have first been chipped and then carefully ground smooth by running an abrasive stone along the chipped groove (fig. 47). Another less common method

was to scrape the black patina off a rock, leaving a pale image exposed against the dark surface (fig. 43). Some rock faces were prepared before engraving started by grinding a flat stone on the surface until they were fairly smooth. After the introduction of metal, perhaps as long as 3,200 years ago in the Sahara, some engravings were made with a metal spike, which may have been hammered with a stone or used as a pick (fig. 46).

Most engravings employ only one technique, either pecking, grinding out lines that have already been pecked, or scraping; however, a few engravings use two or even all of the techniques, such as ground outlines with internal areas shaded by pecking and/or smoothing (fig. 47). We have seen only one engraving that also was painted, in Ennedi, Chad, but this may

OPPOSITE FIG. 46 **One of a group of three small engravings, probably made with a metal spike, on a loose rock in Morocco. An antelope is surrounded by men holding bows with arrows fitted for firing.**

FIG. 47 **An engraving, using several techniques, of a small animal, perhaps a calf or antelope, in the Messak, Libya. Before outlining the image, the engraver lightly polished the rock surface. Lines were pecked deep to create maximum shadow within them for much of the day and then ground smooth. Texture was added by pecking certain areas to prevent reflection. As the sun moves across the sky from dawn to dusk, the image alters, coming alive.**

47

indicate that other engravings also were painted and that the paint has since disappeared. We found an engraving in Niger that had been recently colored in black and white (fig. 45). One source believed that local people painted the engraving expecting to have their wishes for material objects fulfilled by this act, while another said that soldiers had painted it during the civil war of the early 1990s (we noted that it had been used for rifle practice). In northeastern Niger we also found an engraving of a cow superimposed by a line of painted human figures.

OBJECTS

The category of object includes what have previously been described as stone tools, which were labeled such because they look like tools and some date back hundreds of thousands of years. Europeans orginally did not believe humans of this age to be capable of artistic appreciation and therefore they assumed the objects must have been tools, created out of necessity, for usefulness. Objects also include beads made from crystals and colored stones and stones ground into aesthetically pleasing shapes.

FIG. 48 **This exceptional stone object, ground carefully and sculpted on one side, was found on the floor of an ancient lake bed that may have held water at the time the artifact was made. It measures about 14 inches (35 cm.) in length and weighs about 6.5 pounds (3 kilograms). The stone must date to a time when most of the Ténéré Desert was still an inhabited grass plain, probably more than 4,000 years ago. Only about sixty of these ground stones have ever been found. Its use is unknown.**

FIG. 49 **A small scene, about 10 inches (25 cm.) long, from Tassili n' Ajjer, Algeria, of two people copulating. Scenes of copulation, between humans, human and animal, therianthrope and animal, or just between animals, occur in African rock art but are not common.**

48

49

Perhaps the most interesting objects are the so-called hand axes (fig. 50) from the stone-tool category. They were made by roughly shaping a stone, then striking flakes from along its faces and edges with a tool made of wood, bone, or soft stone. The resulting shape looks a bit like an ax blade; thus, these tools, which do not appear to have been mounted in a handle, were termed hand axes. Looking at these hand axes today we can see that primitive man was perhaps not quite as primitive as we once thought—their symmetry and aesthetically pleasing shapes lend them a beauty that far outstrips the needs of any tool. In many ways we regard these "tools" as the earliest art form. We have no idea how they were used; they may have been tokens of some kind, but hand axes they almost certainly were not.

We once saw an extraordinary ground stone in the Ténéré Desert in Algeria, found on the floor of an ancient lake bed that must have dried up at least 4,000 years ago. It was in the shape of an elongated tear, engraved on one side with a raised rib running from end to end (fig. 48). How it was used, whether as an implement or as a ritual object, remains a mystery. Certainly, its beautiful lines qualify it as art.

50

FIG. 50 **A "hand ax" found lying on the sand in southwestern Libya. Often beautifully made, these objects exhibit far more care than need be taken in making an effective tool and may have been items of exchange or made for some ritual purpose. The age of this hand ax is unknown but could exceed 250,000 years.**

SUBJECT MATTER

Although rock art varies enormously from one end of Africa to the other, it tends to revolve around three subjects: characterless human figures; animals; and designs or geometric shapes. Numerous other objects are depicted, such as chariots, riverboats, nets, weapons, clothing, jewelry, digging sticks, carrying bags, animal harnesses, ladders, and even canoes, but these objects, with a few exceptions such as plants, are mostly adjuncts to the human and animal figures rather than subjects in and of themselves.

Human figures are shown in many postures: standing, running, dancing, sitting, walking, copulating (fig. 49), bending forward, and even, apparently, flying or swimming. The figures are caricatured with bodies conforming to specific patterns; rarely do they depict actual individuals (fig. 51). Animals are sometimes depicted in a stylized form emphasizing the essentials of physical character, as in Zambia, but they often appear in naturalistic form. Only certain animals are commonly depicted, with larger species being more common than smaller ones. In South Africa the eland is the most common species depicted (fig. 54), although over much of Africa the giraffe (fig. 52) and ostrich predominate, followed by antelope, elephant, rhinoceros, and zebra. Birds are normally confined to those species that walk on the ground such as the ostrich, flamingo (fig. 53), stork, bustard, and guineafowl. There are depictions of mythical animals and therianthropes (human figures with animal heads and hooves; fig. 55), and, less commonly, animals standing erect with human heads.

Plants (figs. 67, 69, 83, 86) are occasionally depicted, more often in the art of Zimbabwe than elsewhere, but rarely do they occur in an obvious scene. The only scene known to us, found in Zimbabwe, is a painting of a kudu feeding off a small tree (fig. 56). Some plants are incredibly naturalistic while others are often difficult to determine: are they plants or something else?

Geometric patterns and designs include a huge range of shapes that have, for ease of reference, been described by recorders as "circles and concentric circles, ladders, shields, suns, zigzags, nests of curves, finger marks, grids, grids in circles (figs. 24, 26), chevrons, filigrees, clusters of dots" (Willcox, 1984) and many other terms. We also have found shapes of handprints and engravings of human feet (fig. 61), sandals (fig. 58), and animal tracks (fig. 53).

Scenes tend to be limited to certain activities such as dancing, rainmaking, and ceremony; they do not depict eating, collecting wild food (except perhaps honey), building shelters, playing games, and other generally domestic activities. What constitutes a scene as such is not always easy to define: images appear scattered on the rock face without apparent perspective, and there is no background landscape to draw the figures together. Scenes, although they occur sporadically throughout the continent, are found more among paintings than engravings and more in southern Africa and central Tanzania than elsewhere.

Superimpositions, an image deliberately positioned over another one, occur throughout the continent. In some areas superimpositions appear to follow rules; for instance, animals are never placed over geometrics, it is always geometrics over animals (figs. 52, 57); people are superimposed over animals, but geometrics are never put over people. Every region had its conventions, to which artists strictly adhered.

51

52

53

ROCK ART SITES

Rock art is found throughout the African continent, from Cape Town in the south to Tunis in the north, and from the Horn of Africa in the east to the Atlantic coast in the west. Literally hundreds of thousands of individual sites are known where rock art occurs and many have been recorded, but every year enthusiasts report finding previously unknown sites or, rather, sites that may have been known to local people but were not publicly or officially recognized. Wherever rock occurs, there is usually art. Even so, the art tends to be concentrated into certain areas: the massive rock outcrops in the Sahara Desert, central Tanzania, eastern Zambia, and southern Africa (maps 7, 6, 5).

Paintings are found almost exclusively on vertical rock faces and almost always in protected positions, often in shallow or deep shelters of eroded sandstone and granite, but they also are sometimes seen on exposed cliffs and on the sides of boulders that are protected from the elements. Frequently, human refuse is found in the earthen floors of painted shelters, suggesting past occupation.

Engravings in northern Africa are usually found on vertical faces, although some are cut into pavements. Moving south, engravings occur more on horizontal slabs rather than vertical, often on flat rocks in and beside riverbeds, and on exposed boulders along the crests of low ridges and hill slopes.

FIG. 51 **A rare painting in dark purplish black from Namibia depicting actual people rather than the usual depersonalized human caricatures.**

FIG. 52 **Engraving of a giraffe in Messak, Libya. The image superimposed on the giraffe has been described variously as a sun wheel and a trap; however, its real function is unknown.**

FIG. 53 **Engravings of flamingo, antelope, and animal tracks in Namibia. Engravings of birds, mainly ground-walking species, are fairly common throughout Africa. Because of their erect posture and gait on two legs, the artists may have visualized them as humans seen in another dimension.**

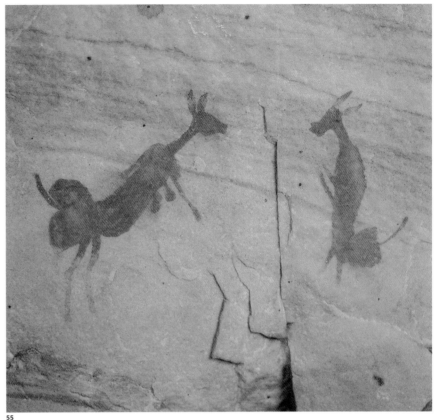

55

FIG. 54 **Shaded painting of an eland, South Africa. Meticulous attention has been paid to details such as the shape of the hooves, head marking, horns, and dewlap. Modern Bushmen still employ the symbolism of the eland to provide enabling potency to rituals.**

FIG. 55 **Male and female therianthropes, with antelope heads, face each other in a shelter adorned by handprints and ostriches in the southwestern Cape. The left figure displays human breasts, remarkable steatopygia of the buttocks, and a tail. The other figure, wearing a kaross, has raised arms but lacks breasts and therefore appears to be male. Some researchers believe these figures may represent people of the Bushman's "early race."**

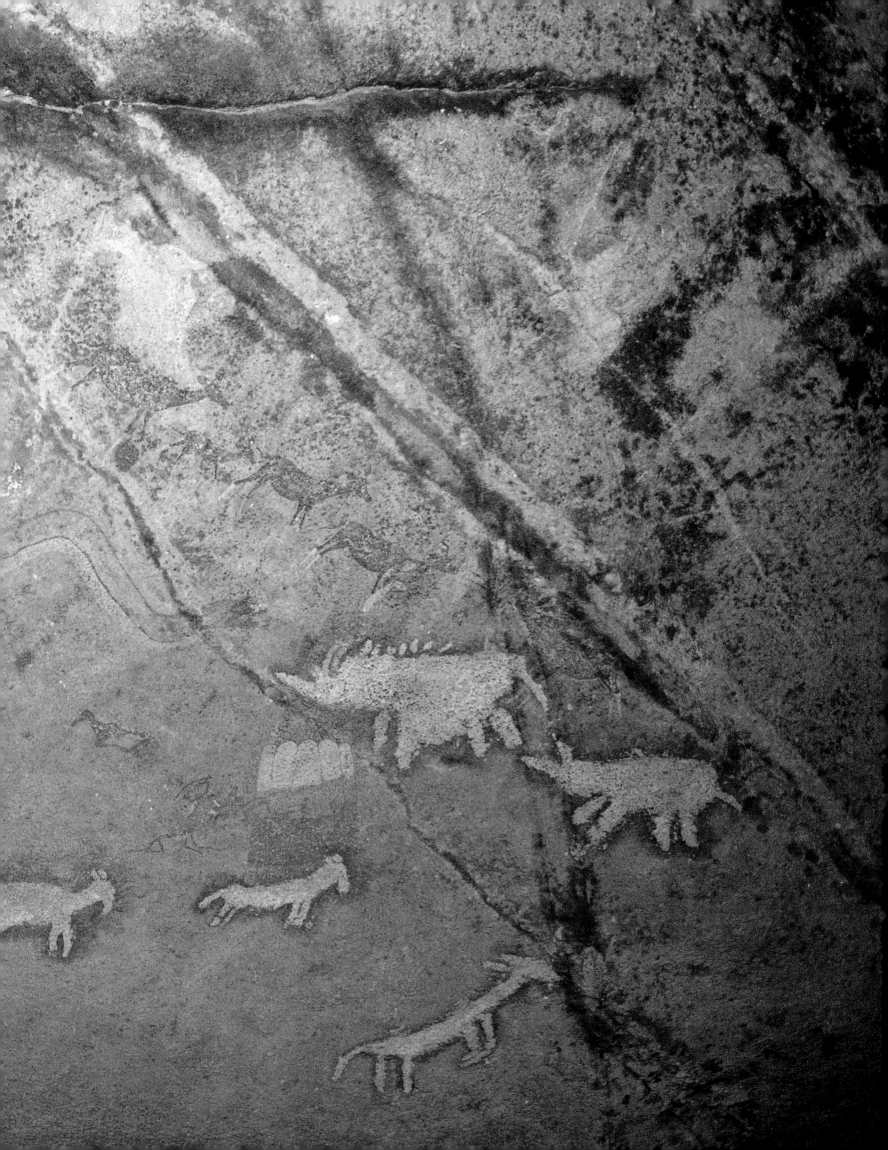

In suitable areas several or even many sites may be located close to each other. For instance, in an area of just over five square miles in Botswana there are more than 400 sites containing more than 4,000 paintings and at another site in Namibia about 5,000 engravings occur in an area measuring less than two square miles. The same is true in the Sahara where more than 1,000 engravings are found at each of several sites in Niger. Walking through areas of dense rock art, one sometimes sees paintings and engravings in what appear to be most unsuitable places, while smooth and protected rock is bare of art.

The sites themselves are important, serving as both canvas and frame for the art. Each location has been chosen for a reason that we may never learn; for example, one recorder in a European cave whistled while he traced and noticed that the rock face resonated where art was painted, but was silent in areas between decorated panels.

In southern Africa, locations of paintings and engravings tend to be separated: engravings are found on the plains of the drier southwestern plateau, while paintings occur in the mountainous and rocky areas around the coast and northward through the higher country of Zimbabwe. From central Tanzania northward, sites are scattered until the mountains of the Sahara, where each range carries its own concentrations of art.

THE APPEARANCE OF ROCK ART TODAY AND LONG AGO

Rock paintings and engravings are still being made today, although most modern works bear little resemblance to those of long ago. Images of Nyau masks and characters were painted in rock shelters in Zambia and Malawi until 1964 (fig. 59) and appear to have faded little since the day they were made. There is a large, absolutely fresh engraving of a white man holding a gun with a date from the 1960s pecked into a Namibian riverbed pavement (fig. 60). Paintings in the Cederberg, South Africa, of men riding horses, wagons drawn by oxen and mules, and women wearing long dresses, cannot be more than 250 years old, although they are already fading (fig. 63). In the Drakensberg Bushmen were still painting in the mid-nineteenth century, and some of their paintings of eland have deteriorated little since the day they were painted, although similar paintings nearby have already lost much of their color (perhaps due to human interference, such as visitors sponging them with water for photography).

Seeing these recent engravings and paintings gives us some idea of how earlier art once looked and of the changes in their appearance that have taken place over time. Today many paintings lack their original sparkle as their colors have faded, sometimes completely disappearing, leaving an image with some bare patches of rock where once several colors were represented.

Engravings survive better than paintings, but even they suffer from exposure, rain, blowing sand, freezing temperatures at night, and hot sun during the day. Oxides of manganese build up patina, darkening engraved areas until they fade into the parent rock, making it sometimes

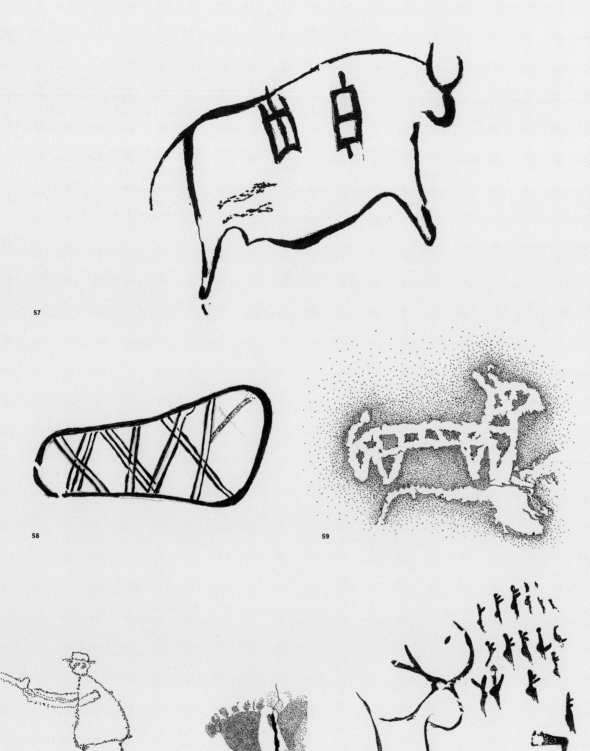

57

58

59

60

61

62

FIG. 57 A red painting of a domestic cow superimposed by two red geometric designs in Botswana. Such superimpositions were deliberate, perhaps serving to enhance or alter the purpose of the underlying images.

FIG. 58 Engraving of a "sandal" in the Nile Valley, Egypt. Engravings of sandals, often in pairs, are found from the Nile to Morocco. Their purpose is unclear, but they may take the place of footprints, which are common in southern Africa but rare in the Sahara.

FIG. 59 A Chewa painting in white from Malawi of a Nyau symbol that represents a costume used during ceremonies performed at initiation rites of youths and at funerals. The painting is probably less than 100 years old. (Redrawn from Lindgren and Schoffeleers, 1978.)

FIG. 60 An engraving on a flat riverbed in southern Namibia of a white man holding a gun. Two such engravings, together with a number of freshly cut geometric designs, have a date from the 1960s carved next to them.

FIG. 61 Engraving of human footprints in the western Kalahari Desert, Botswana. Human footprint engravings in Botswana generally are attributed to the first Tswana man who emerged from his world below the earth and left his tracks in the soft rock.

FIG. 62 A painting of a cow, a geometric design, and caricatured people in the Tsodilo Hills, Botswana. A number of people, men marked by erect penises and women by two breasts, appear to dance. Other similar scenes at Tsodilo suggest this image portrays some ceremony.

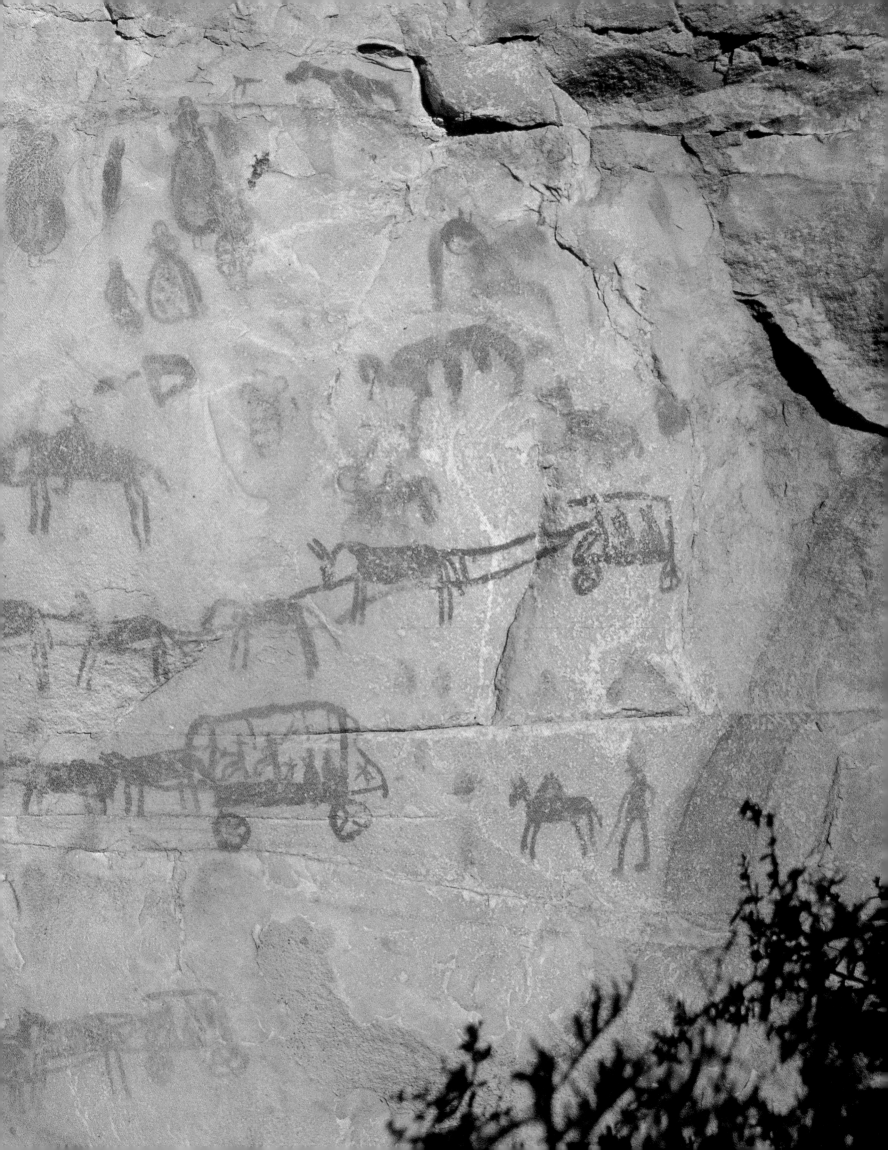

PRECEDING PAGE FIG. 63 A south-western Cape site comprises three painted recesses in a cliff base. The ground is littered with fresh stone flakes, sherds of imported porcelain, and glass, which suggests recent occupation by stone-working, Khoisan-speaking people, probably Bushmen. Numerous finger paintings include wagons hauled by mules, horsemen holding guns, and women wearing bonnets and long dresses. The subject matter depicts white people, most likely Boers, trekking during the eighteenth or early nineteenth century.

FIG. 64 A painting of a woman in the southwestern Cape. Two breasts clearly indicate her sex. The steatopygous shape of her backside suggests she is Bushman. Note that the white pigment used to paint her face has almost disappeared.

difficult or impossible to see their outlines. Careful examination shows that some paintings have been touched up and repainted, perhaps several times (fig. 65), and that engravings have been deepened and altered (fig. 219). We must accept that the images we see today are not often the same as they appeared the day they were made long ago.

VIEWING THE ART

Often first views of painted or engraved panels can be bewildering or disappointing when we are uncertain what we are looking for and the images can look strange and difficult to comprehend. The subject matter is circumscribed by conventions that we often do not understand: animals, people, and geometric designs, conforming to prescribed patterns of form, are presented starkly on rock faces without obvious backgrounds to give them perspective.

Animals are most often painted in profile and are easy to identify, but their heads may be drawn in twisted perspective with two horns and two ears, one behind the other rather than side by side. Sometimes animals have only two legs, one back and one front. People are depicted without character, often all looking the same. A penis can indicate a man (figs. 77, 79), and two breasts, one above the other, mean a woman (figs. 62, 64). For years researchers thought that a bar drawn through a penis meant infibulation, a stick thrust through the penis head, but have recently realized that it more probably symbolizes a prohibition on sex.

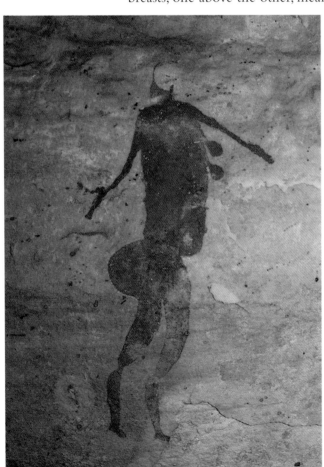

Individual images that, grouped together, could form related scenes, appear isolated from each other, out of proportion, executed in different styles, and sometimes superimposed upon one another in many layers (fig. 67). People standing side by side can have different heights, one being twice the size of another—do they relate to each other? Superpositioning, when one picture partially covers another, often appears to be deliberate as empty space nearby remains uncovered. What does superpositioning mean? All this must be taken into account before trying to understand the art.

There is really only one way to look at rock art: first, stand back and get an overall view of a panel, particularly if the images on it are many and appear to be integrated into a scene; then move forward as close to the rock as possible and make a detailed inspection of each image. With paintings, look carefully at people's heads, hands, feet, waists, and buttocks. Often details such as caps, wigs, fingers, facial marking, loincloths, and jewelry are faint,

64

but can be seen by careful inspection, especially with a magnifying glass. Move back to view the whole panel again; these details unseen before may now make the art easier to comprehend.

Paintings are often best seen in the shade since they can completely disappear in bright sunlight. Direct light, which creates no shadows, often makes engravings look dull compared to the effects of strong side lighting; and the same engravings can look very different when seen in the differently angled light of dawn and dusk.

65

66

These images are unlike most of the art we know and cannot be understood simply by applying our own cultural impressions. For example, a three-meter high image of a giraffe carved into a solid rock face suggests to us "giraffe" because that is what we recognize (fig. 23); however, for the artist, a giraffe may have been both an animal and a symbol for "a ladder to the sky," or "a rainstorm," or "a spirit guide," or "health." A few archaeologists and art historians, and many amateur enthusiasts, have spent more than a century trying to puzzle out what the images mean and why the artists made them. Their answers have ranged from place markers, recording of events, and depictions of mythology to sympathetic magic, religious beliefs, shamanism, and, simply, art for art's sake.

We will probably never fully understand the images we see. For one thing, we have no idea if the art was an entity on its own, or a small part of some greater activity involving action, dialogue, song, touch, medication, presentation of gifts, or sacrifice. The organic ingredients—blood, fat, or plant juices—used in the paint may have had medicinal values and portions may have been consumed before or during the act of painting. Perhaps the very act of painting or engraving was more important than the finished product. Numerous activities could have taken place about which we will never know. Is it then possible today, or even important, perhaps thousands of years after the images were made, to try to understand them? We believe it is important, for without at least some understanding, we are unlikely to put real value on the art, and if it has no value it will not be treasured and will, therefore, eventually be allowed to disappear.

Whatever we individually think, and whatever the original artists wanted to convey, the art still speaks to us, but now in our language rather than in theirs. In attempting to understand the art, three principles must be kept in mind: ancient communities did not see reality in the way we see it today; at any one time throughout history communities across the continent did not understand their worlds in the same way; and ideologies are not static, but change with transforming environmental and economic conditions.

FIG. 65 **One mask in a row of three from Algeria. The paintings are faint, but all have been retouched or repainted at least once and perhaps more. The tops of the "ears" have been repositioned, the top of the cap raised, and the dark stripe in the right ear changed. The stripes in some ways reflect those on pharaonic masks, such as the mask of Tutankhamen.**

FIG. 66 **A painting of a man with his goat in the Akākūs, Libya. The character given to the human face and detailed markings on the goat suggest a portrait of a particular person and a favorite animal. Perhaps Fulani traditional beliefs will provide an explanation of the scene.**

FIG. 67 One of the most involved of all rock art scenes, this painting from Zimbabwe presents a kaleidoscope of shapes and colors layered upon each other in endless profusion. Below are huge dark animals painted in reds, orange, and yellow. A waterbuck in brownish red stands at the top left; kudu in bichrome red and ocher fill much of the middle space, while a leafy branch rises above a series of ovals at the bottom. Note the two superimposed red spirals at either side, which must be the most recent paintings (fig. 266).

DATING ROCK ART

69

In the past, dating rock art has depended largely on simple human intelligence and guesswork. Researchers have used a variety of techniques to date the art, such as assessing the degrees of patination on engravings, using the superimposition of images to construct a chronology of the rock art, and comparing different styles of art, using the known dates of when the subject matter of the images—whether they were animals such as the crocodile, cattle, or camels, or man-made inventions such as chariots and metal weapons—were known to be in the area. By 1960 some general chronologies had been constructed for the Saharan rock art, but for most of Africa the art was thought to be fairly recent, 2,000 or 3,000 years old.

THE DATES THAT ARE FIXED within the chronologies provide a time scale of the history of the rock art, even if we must still guess when people first started to paint and engrave on rock. It is not easy to know how to relate the rock art to the tools and bones excavated in its vicinity; however, excavations sometimes determine how long ancient peoples occupied areas, whether they were foragers or agriculturalists, and to which race they belonged. When archaeological remains found in areas indicate single cultural identities extending over long periods, it is sometimes possible to postulate relationships between these remains and the art. For instance, we can be fairly certain that rock art containing no images of domestic livestock was made by foragers, particularly if no cattle or sheep bones are found in their vicinity.

How old is African rock art? For a long time there was no satisfactory answer to this question. When Paleolithic cave art in France and Spain came to the public's attention in the late nineteenth century, nobody thought it could be really old. Recently, radio-carbon dating has revealed that the oldest known frescoes, in France's Chauvet Cave, were painted about 32,000 years ago (see fig. 20). The earliest art still visible on Africa's rocks is probably about 12,000 years or a little older, but new finds of buried portable art and new dating methods may extend this period back by many, many millennia.

The last half of the twentieth century has seen major progress in developing methods to date rock art. It is now possible, although exceedingly difficult, to analyze pigment and rock varnish to determine their components, which, in turn, can sometimes be carbon dated. This is a technique to measure the remaining volume of carbon-14 isotopes in organic matter to determine when it died. In every case, small samples of material must be removed and analyzed in a laboratory.

Generally, this means that a sample of pigment is taken from a painting and particles of rock varnish are taken from an engraving's surface. In the early days of scientific dating samples had to be large, but advanced techniques now require only tiny quantities. Even so, many problems remain.

While it has proven relatively easy to use carbon dating to obtain dates from charcoal, bone, and pigment left in places such as the Chauvet Cave, which was naturally sealed a short time after the artists left, it is far harder to obtain dates for paintings and engravings on exposed rock at sites that have been open to human use for thousands of years. For example, dating chunks of ocher in substrata below a painting does not necessarily provide a date for the painting itself as the ocher may have been used for body decoration long before or after the time when the painting took place. The only really satisfactory method is direct dating of the art, which is done by taking a sample from the image itself.

INDIRECT DATING

Pieces of shelter wall chip off, fall to the ground, and become buried. Archaeologists excavating shelters sometimes find bits of painted rock buried in levels that also contain charcoal and bone. Dating the charcoal gives an approximate date for when the rock fell from the wall and a minimum date for the age of the paint. A thin spall of rock bearing fine-line paintings of human figures was excavated in a western Cape shelter and dated to 3,500 years ago by means of associated charcoal.

Karl Butzer noted that certain engraved riverbed rock in South Africa's northern Cape had periodically been covered by silt. Using geomorphological techniques to date channel erosion, he was able to determine periods when the rock was exposed and thus available for engraving. As a result of his work, he believes that pecked engravings commenced before 3,000 years ago and that an explosion of geometrics took place between 1,200 and 800 years ago.

Peter Beaumont and David Morris have used yet another method to date some of South Africa's Karoo engravings (fig. 70). They compared degrees of patination on engravings and on stone tools lying on the surface of archaeological sites of known date and found that pecked and scraped engravings commenced about 2,000 years ago, at the same time pottery was first introduced in the Karoo.

Although the techniques used by Butzer and Morris have produced different dates for the commencement of pecked engravings in the Karoo, they tend to agree on the fact that much of the engraving took place less than 2,000 years ago. Future research will iron out these differences.

70

71

72

FIG. 73 **A drawing of a predator on a plaquette excavated by Eric Wendt in the Apollo 11 Cave, Namibia, radio-carbon dated to between 27,000 and 19,000 years ago. Other plaquettes excavated in the cave at the same level include zebra and rhinoceros images.**

DATING PAINT

The paint used in rock art contains organic matter that can be carbon dated, such as charcoal, which is used in the colorant, and substances such as blood, fat, and vegetable juice, which are mixed with the pigment as binders. However, almost invariably little to no actual pigment remains on the rock and the problem has been obtaining sufficient paint to do direct dating without destroying large areas of painting. Happily, carbon-dating techniques now require only a tiny fraction of the paint originally needed and will make direct dating of paintings more available in the future.

Recently, Aaron Mazel and Alan Watchman succeeded in direct dating a Drakensberg painting. They analyzed ten paint samples taken from different paintings and found they contained various substances including gypsum, magnetite, clay, hematite, calcite, feldspar, and plant fibers. The fibers were separated and dated by accelerator mass spectrometry (AMS), a form of carbon dating that requires only a small amount of carbon. Only one absolutely satisfactory date was obtained from the ten samples taken: a painting of a polychrome eland was dated 1443–1653 A.D.

DATING ENGRAVINGS

The direct method of dating engravings is even more difficult than dating paintings. Varnish, or patina, which slowly builds up on engravings, contains substances such as calcium and potassium. The ratio of potassium to calcium decreases with age and this ratio can be established by measuring the cation of the substances in the patina. The problem with the cation-ratio dating technique is that varying climatic conditions may have repeatedly altered the varnish during its lifetime, making any date highly unreliable.

AMS also can be used to date engravings and is a more satisfactory, although still not totally reliable, method. Apart from minerals, the patina on rocks also contains tiny particles of wind-borne plant pollen fixed into it by manganese. The pollen, which is organic, can be dated, thereby giving a minimum date for the engraving; but the pollen also may have been severely altered by past climatic conditions.

EARLY AFRICAN DATES

The earliest date obtained for African rock art, between 19,000 and 27,000 years ago, relates to small plaquettes bearing paintings of animals excavated by Eric Wendt in the Apollo 11 Cave in southern Namibia (fig. 73). The date comes from charcoal found in the layers of sediment

surrounding the plaquettes. Some scientists believe this very early date should be viewed with caution, and would feel more confident if a similar early date had been obtained for at least one other rock art site. The earliest incontestable date for African rock art, 10,200 years ago, is for the deepest and oldest engraved stones excavated by Francis and Anne Thackery and Peter Beaumont in the Wonderwerk cave of South Africa (fig. 71).

Another early and somewhat contentious date has been proposed by Emmanuel Anati for exposed rock paintings in Tanzania. Anati has tentatively dated early paintings to 29,000 or more years ago, basing his estimation on two factors: dates obtained for scarred pigment excavated at painted sites; and similarities between Tanzanian paintings and the art on the Apollo 11 Cave plaquettes. Even so, doubts remain because the excavated pigment cannot definitely be ascribed to any of the existing paintings; it could have been used for body paint or for tanning skins, as Anati indicates, or even for paintings no longer visible today. Also, the Apollo 11 Cave art must await substantiation before it can be used as a firm basis for date comparison. Nor is it certain how fast exposed granite and sandstone weathers, although estimates for granite suggest a millimeter might disappear every 4,000 years under exposed conditions; sandstone weathers at a faster rate.

The earliest northern African rock art, often known as Bubalus Period art (fig. 74), probably dates to about the end of the Sahara's arid period, approximately 12,000 years ago when people and large animals such as elephant, rhinoceros, giraffe, and aurochs spread out across the desert following the regrowth of vegetation. It is unlikely to be any earlier, as these large animal species are prominent subjects of the art and are not thought to have survived in the central desert through the arid period, even though hunter-gatherers may have remained in better-watered highland areas.

In Zimbabwe excavated nodules of pigment have been found in human refuse deposits dated to more than 125,000 years ago, and stained stone palettes have been dated to 40,000 years ago. Although finds like these cannot be ascribed to actual rock paintings, they do indicate very early use of pigments. The oldest reasonably secure dates for rock art paintings in Zimbabwe—about 10,000 years old—have been obtained from layers of sediment containing small pieces of painted rock that fell from shelter walls. But such dates give only minimum ages, not the actual ages, because they measure when the painted fragments chipped off from the wall and the painting itself may have been old when the rock exfoliated.

The real problem lies in the fact that much of Africa's earliest art, particularly the painted art, has probably disappeared through the effects of climate. If the painted plaquettes in the Apollo 11 Cave date to 19,000 or more years ago, it is almost inconceivable that other rock shelters were not being painted at the same time. If this is true, the earliest Tanzanian paintings could also date from a similar, or even earlier, period.

Future archaeological research and improved dating methods will undoubtedly provide new evidence, but it is unlikely to prove that Africa's rock art originated outside the continent; on the contrary, it may well suggest a wider number of areas on the continent from which it could have originated, as well as a wider range of time.

FIG. 74 **An engraving of a Bubalus, Bubalus antiquus, an extinct member of the African buffalo family from Libya. Bubalus has given its name to the earliest known rock art period in the Sahara, commencing 12,000 or more years ago and lasting for some 4,000 years. This period is remarkable for huge engravings of elephant, rhinoceros, giraffe, and other large fauna.**

74

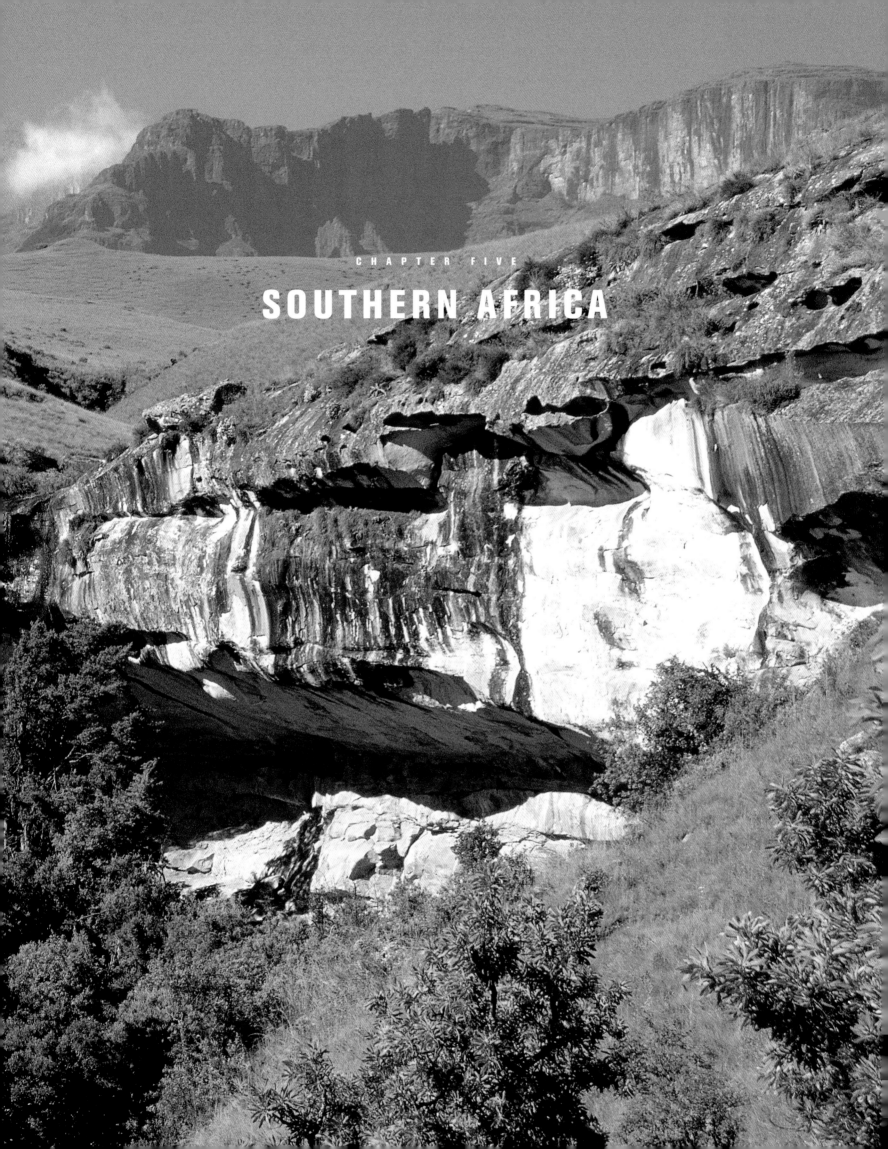

CHAPTER FIVE

SOUTHERN AFRICA

PRECEDING PAGE FIG. 75 **In the upper Drakensberg, a waterfall plunges over the roof of a huge natural shelter containing more than 1,600 indiviual paintings (fig. 150).**

OPPOSITE FIG. 76 **Engravings of an eland, flying birds, and geometric design on a ridge near Klerksdorp, South Africa. Engravings, and even paintings, of flying birds are uncommon. If the eland symbolizes a shaman in trance, the birds may represent his out-of-body travel to a spiritual plane.**

n southern Africa it is believed that ancestral Bushmen were responsible for all rock art except for some finger paintings and a very few engravings. There are four reasons for believing that the southern art derives from a single ancient race of people: 1) stone tools dating back to 8,000 years ago show remarkable consistencies over time and space, with only small variations from area to area, perhaps resulting from their makers's ecological adaptations; 2) the art recognizes a single conceptual vision of reality; 3) the art shares similarities in choice of subject matter and methods of expression; and 4) the art shares similar painting and engraving techniques. The Bushmen are the only people in southern Africa who were there that long and who have descendants there today.

THE ART OF SOUTHERN AFRICA can be divided into three major expressions: early fine-line paintings executed with a brush or similar implement (fig. 81); later paintings known as "Late Whites" or "finger paintings" (fig. 77); and a fairly wide range of engravings (fig. 76). We are interested primarily in the paintings, particularly the fine-line paintings, which have the longest history and were still being made in the Drakensberg in the nineteenth century (fig. 78).

Although variation in subject matter occurs from region to region, it invariably tends to involve human figures lacking individual character, sometimes portrayed in a trance state (fig. 85) and sometimes elaborately accoutred (fig. 80); large antelope (fig. 81), giraffe (fig. 81), and elephant (fig. 109), and a few depictions of predatory animals; and varieties of geometric designs including animal tracks. Human figures act out rituals such as dancing (fig. 135), initiation, and rainmaking, while scenes involving hunting are rare, and domestic activities are absent.

Based on the differences between the earlier art, southern Africa can be divided into five regions (map 5): Zimbabwe (with adjacent areas in Mozambique and Botswana); central Namibia; the southwestern Cape; the southeast of South Africa centered on the Drakensberg and Maluti Mountains; and the flat inland plateau of southern Africa.

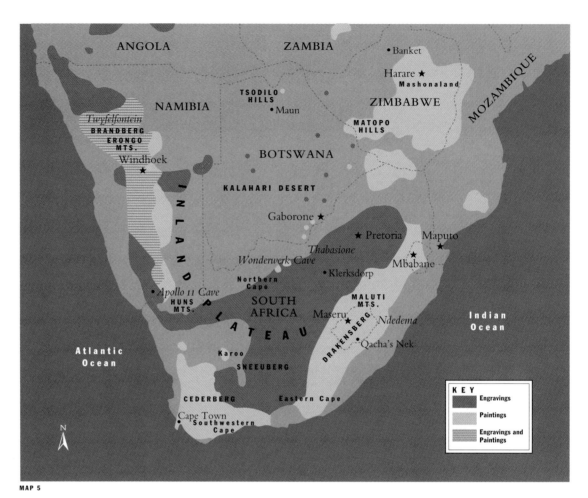

MAP 5

MAP 5 **Distribution of engravings and paintings in southern Africa.**

FIG. 77 **Late White paintings of a large man with an erect penis, two smaller human figures, and a geometric all superimposed over earlier red paintings of antelope. Large areas of the shelter wall are free of paint, which suggests deliberate superimposing. This shelter, which has a concealed entrance and is isolated high on a Mashonaland granite kopje, may have been used by farming people to perform rites-of-passage ceremonies involving initiation into adulthood.**

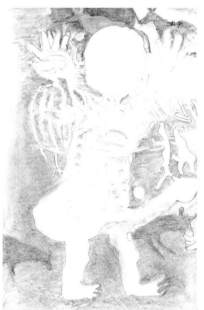

77

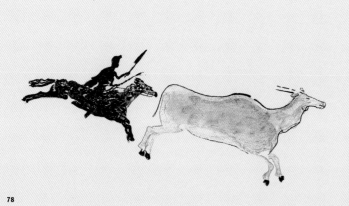

78

78A

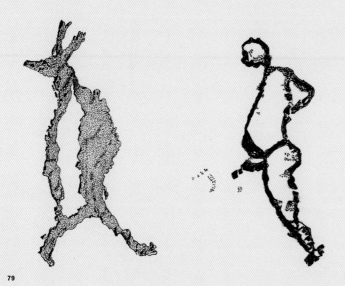

79

FIG. 78 AND 78A **Details from a larger panel in the Drakensberg, South Africa, depicting many polychrome eland apparently being hunted by horsemen armed with spears and painted in black. Horses did not reach the area until after 1820, and they may be a later addition to an earlier frieze of eland (see fig. 54, which depicts the eland in this illustration).**

FIG. 79 **Three engraved figures: A) therianthrope, northern Cape; B) man with one arm drawn back, Klerksdorp, South Africa; and C) "penguin," southern Namibia. All three engravings may represent humans while in a trance state.**

FIG. 80 **Part of a larger panel depicting an adult woman leading a line of seven wigged and bejeweled girls, with a ninth outline figure bringing up the rear. The girls carry men's hunting bows and have lines descending between their legs, perhaps indicating menstruation. The rear outline female figure is probably complete and could depict a spirit. A springbok leaps above the human figures, and a giraffe's neck and head (which is all that was originally painted) tower over all.**

OVERLEAF FIG. 81 **Paintings of giraffe, zebra, and large antelope in the Matopo Hills, Zimbabwe. Bits of pigment and a stained palette excavated in this shelter date to 40,000 or more years ago.**

80

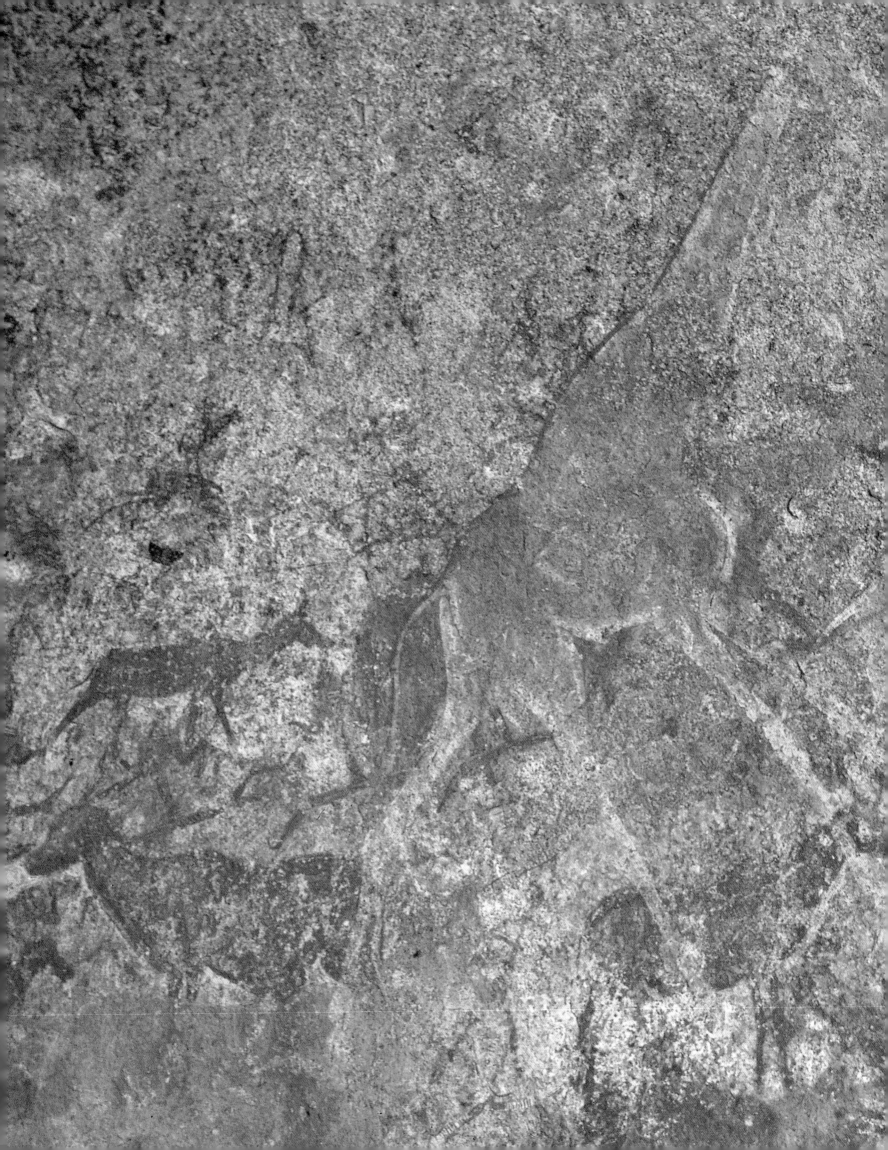

FIG. 82 In this painting from
Zimbabwe, two women with breasts
move to the left. The larger woman,
with hand raised to her head, carries
a stick and wears a short front and
long back apron, while the smaller
woman wears similar aprons and
has a cloak over her shoulder. Lines
descend between both women's legs
suggesting a possible issue of
menstrual blood.

ZIMBABWE

Surviving fine-line paintings in Zimbabwe (fig. 81) have been dated by Nick Walker from
about 8,500 years ago to shortly after the arrival of Bantu-speaking farmers, perhaps to 500
A.D. in the Matopo Hills region, and possibly a little later in areas further north. Peter Garlake
believes that Zimbabwean paintings have their own individuality that separates—but does
not divorce—them from fine-line paintings across the rest of the subcontinent. He writes:
"the art remains . . . concerned with daily life, not as a record of how it was lived but in
idealised, abstracted and generalised statements of its value, its economic, social, moral and
spiritual worth."

The art here is more complicated than in other areas and uses a greater variety of images,
including more plants (figs. 67, 83, 86), than found elsewhere. Images of trancing are rare,

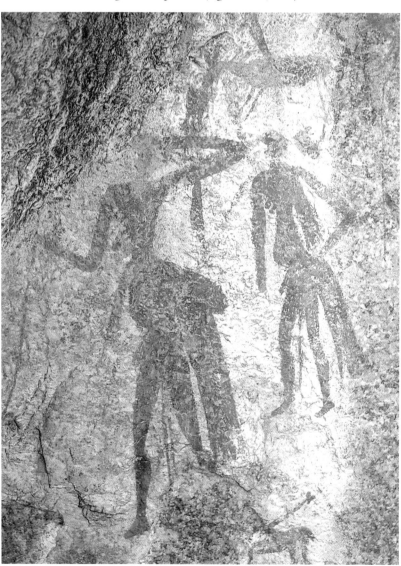

82

but depictions of ovals, or clusters
of ovals (figs. 90, 98), are common,
and are not found elsewhere. They
are believed by Garlake to identify
the seat of human and animal
potency (fig. 98). Large antelope,
particularly females, play a very
important role, with kudu being
the most common species depicted.
Paintings of eland, which are
common in South Africa, are rare
in Zimbabwe. Garlake describes
the art as having a "single shared
significance" created by the artists'
belief that sources of natural
power, or potency, exist in all
things and enable them to attain
the supernatural.

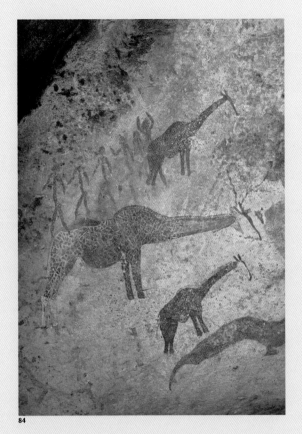

83

FIG. 83 A female duiker superimposes human figures and a plant in Zimbabwe.

FIG. 84 Part of a large painted panel in Mashonaland, Zimbabwe depicting giraffe, characterless dancing men, and the tail of a large snake. Stylistically, the dancing men are associated with the upper giraffe, and one man's foot superimposes the middle giraffe. The lower legs of all the giraffe are painted in white. The scene may involve rainmaking as snake and giraffe are considered to be important rain animals.

FIG. 85 David Lewis-Williams interprets this dance group as involving mainly women shamans, some lying on the ground and one bleeding from the nose. A man at the right holds a white line encircling the group. Two white geometric patterns and a white bird have been added later, but their positioning suggests an intended association between the different paintings.

84

85

FIG. 86 **A shrub with berries along its stems in Zimbabwe.**

FIG. 87 **A granite landscape in Mashonaland, Zimbabwe. Huge domes of granite, sometimes hundreds of feet high, reach toward the sky. In the foreground, plants bloom green in the rainy season. Even today, rocky areas in Botswana attract Kalahari Bushmen who believe they are imbued with ancient power. Some say that the rocks themselves live, which may explain why paintings and engravings decorate so many of southern Africa's rocky landscapes.**

86

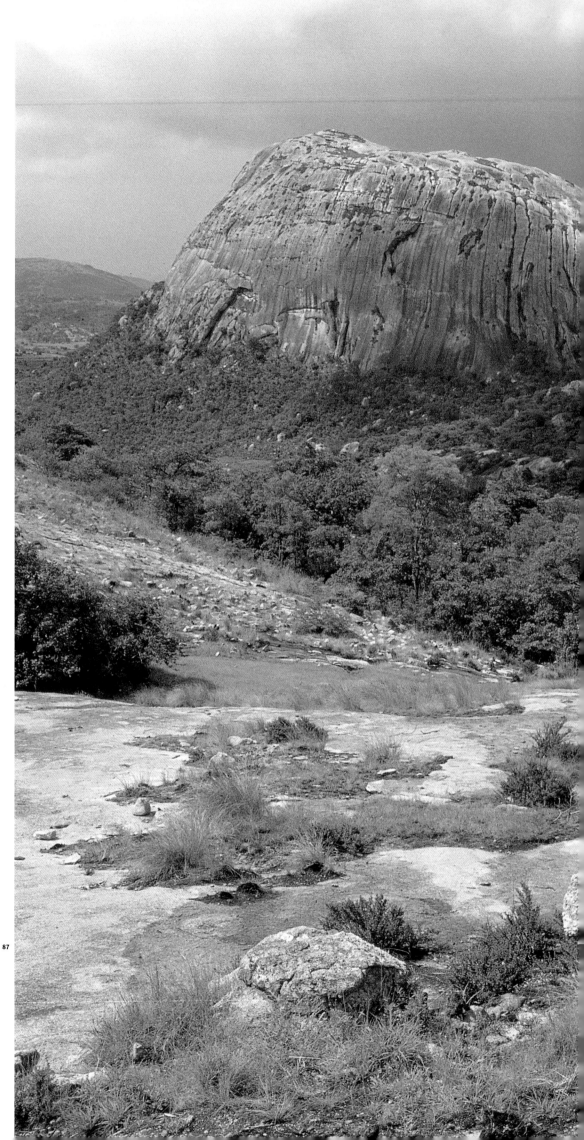

87

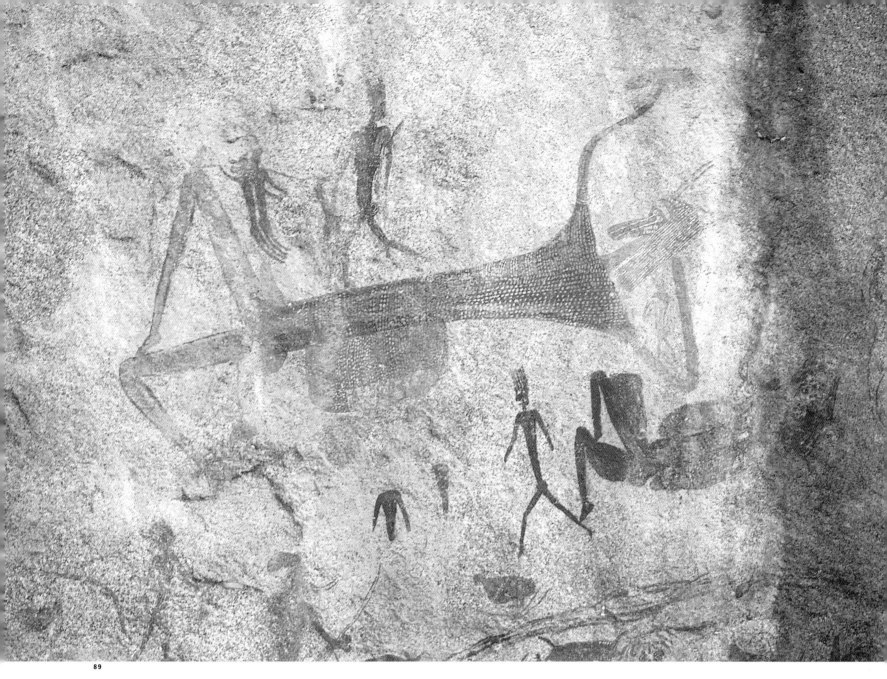

89

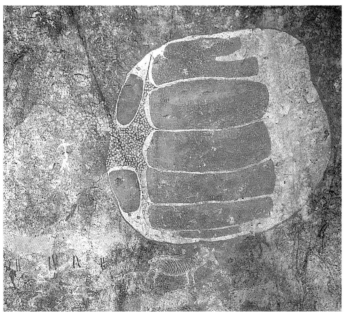

90

OPPOSITE FIG. 88 Some of Zimbabwe's best preserved paintings (fig. 89) adorn this rock, which is curved like a hooded cobra about to strike, in Rusape. On a rugged kopje rising behind it, a stone-wall passage leads to terraced platforms above, providing a sacred site constructed long after the paintings were made. It appears inconceivable that agriculturalists who built the stone walling did not incorporate the paintings in their religious activities.

FIG. 89 A detail from a huge panel (fig. 88) covering more than 85 square feet (8 square meters). Peter Garlake describes the recumbent figure as an "archetypal trancer" and notes the figure's obvious consciousness, dots of potency on the body, and the oval below the abdomen. In the 1960s, before Bushman ethnographies had been studied, Erich von Daniken described this figure as wearing "chainmail" and said it was "an astronaut receiving supplies." Another local interpertation suggested it might represent the " burial of a king."

FIG. 90 An oval design in a granite shelter in Mashonaland, Zimbabwe. Peter Garlake believes oval designs represent "the abdominal wall" and that the "arrow" or "bird shapes" and "flecks" escaping through the orifice suggest potency in an active form "boiling," "rising," and "bursting forth," which is how modern Kalahari Bushmen describe potency developing in their bodies while in the trance state. Another possible interpretation put forward by Garlake proposes that the grouped ovals reflect the entire potent community of trancers. Others have proposed that ovals represent beehives and that the "arrows" are bees, a suggestion also accepted by Garlake.

FIG. 91 **In this detail taken from a huge panel in Zimbabwe, a yellow female kudu, red antelope, human figures, and a series of ovals are all superimposed by a leafy tree branch. Although painted at different times, the final composition may form a single scene.**

FIG. 92 **Fine-line paintings of porcupines in Mashonaland, Zimbabwe. These paintings, obviously deliberately concealed by the artist, were found along a high narrow ledge leading to the middle of a cliff face. The porcupine's habit of digging roots for food has led Tswana diviners to believe they represent herbalists.**

FIG. 93 **Finger painting in shades of red, northeastern Botswana. Two large mythical animals (rainmaking animals) box in a domestic cow. Finger marks may represent rain falling through the rain animals and emerging from the right udder in streams of milk, which descend into geometric designs. Rain, rain animals, milk, and cattle suggest the panel may have been used for rainmaking rituals (see also fig. 130).**

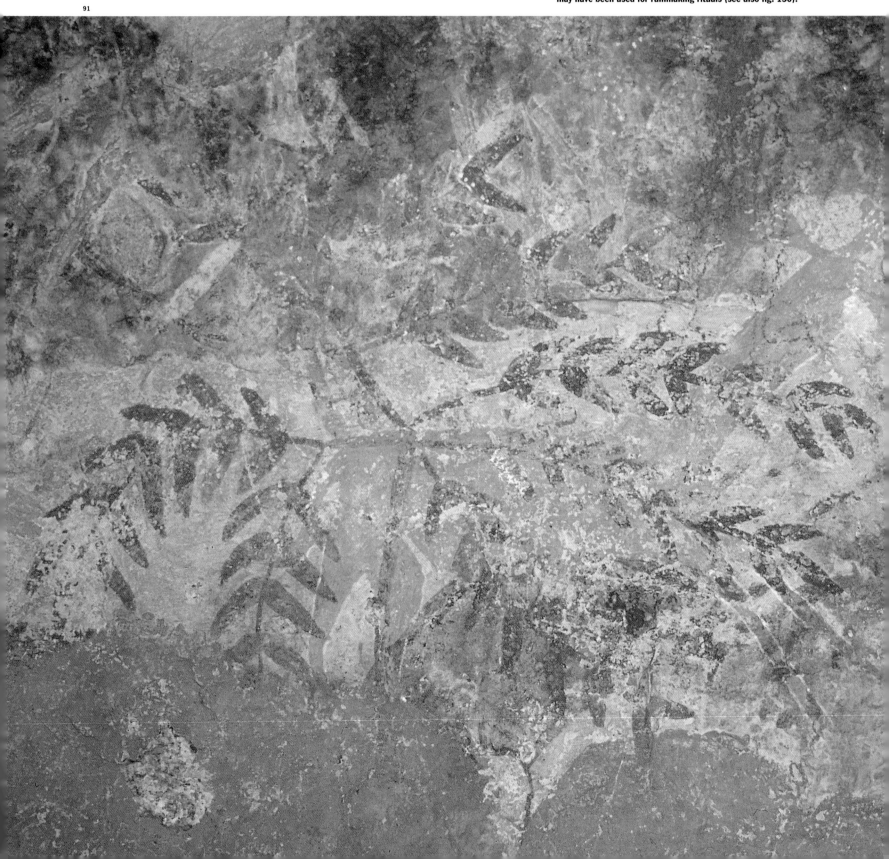

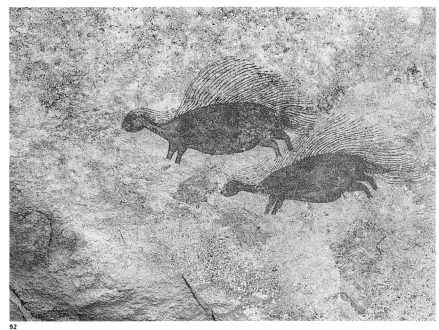

92

93

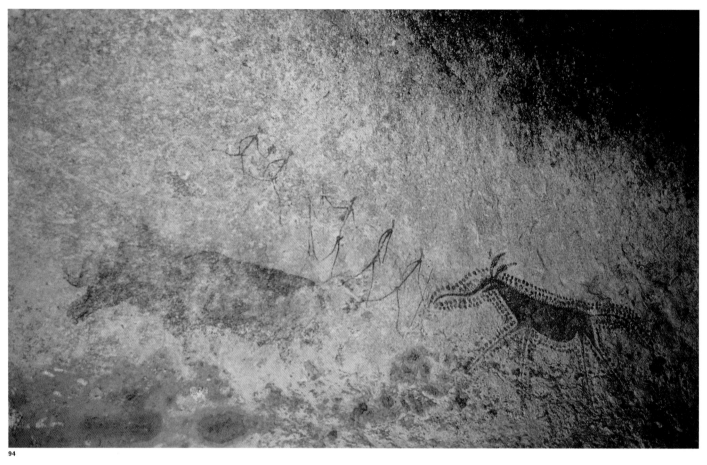

94

FIG. 94 **Access to this Mashonaland cave involves a frightening climb down a rock face and a crawl across a slippery, sloping ledge with a sheer drop to rocks far beneath. The smooth cave floor slopes upward and inward to a narrow cavity, now the home of fierce African bees. Three groups of paintings across the back wall include an antbear (aardvark), six men, and a buffalo; another antbear (fig. 95); and a small hunting scene. The hidden nature of the cave, its cavity housing bees (perhaps for thousands of years), and the dangerous approach all suggest a secret place. Antbears are recognized as secretive and powerful night animals that live below ground. Bantu-speakers associate antbears with supernatural powers.**

FIG. 95 **The second antbear from fig. 94. The body is surrounded by lines of thick dots that may represent the animal's potency.**

FIG. 96 **A remarkable small panel of antelope depicted in a circle in Banket, Zimbabwe. The levels of skill employed and styles of painting suggest more than one artist. Smaller antelope are skillfully painted in dark brown, while the large unfinished red antelope below is less cleverly executed. The layout, with antelope forming a circle around a central animal, is unique. It is uncertain whether the steenbok was painted with two heads or if the artist, or another artist, added the second head later.**

OPPOSITE FIG. 97 **Human figures dance above two antelope lying on their backs in Mashonaland, Zimbabwe. Below, other human figures, painted in the same style, superimpose faded zebra. Style and coloring suggest that most paintings group together to form a single scene.**

95

96

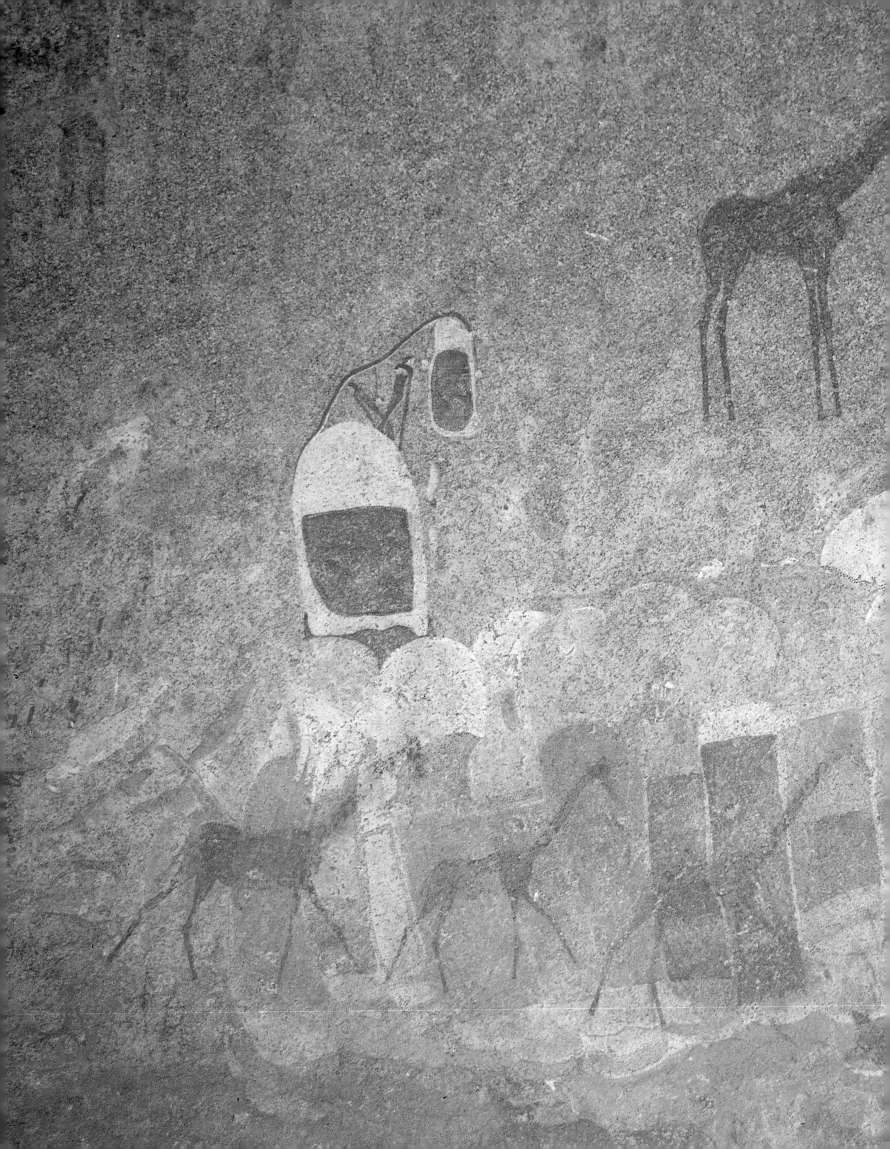

FIG. 98 A panel from a large shelter wall depicting zebra, giraffe, eland, kudu, sable, tsessebe, wildebeest, ostrich, bushpig, duiker, hare, fish, insects, and human figures, as well as the largest set of ovals in Zimbabwe. Peter Garlake believes this series of stacked shapes is symbolic of the "summation of the potency of a whole community." The elongated mulberry-colored figures with strange birdlike heads have been called "avemorphs" by Nick Walker and are probably many thousands of years old.

FIG. 99 A detail from fig. 90. On the left, a female figure with one arm raised and wings somewhat similar to a bee's appears to direct the flow of arrows as they enter and exit the oval. Perhaps this figure, like a queen bee, is the very core of potency.

99

98

100

FIG. 100 Paintings of two mulberry-colored, robed, and hatted figures, holding sticks in their left hands, from Matopo Hills, Zimbabwe are a mystery, leading some early investigators to believe they represent people from ancient Persia. They are perhaps more than 6,000 years old. Faded yellow fish swim across the legs of the left-hand figure.

FIG. 101 One of the most enigmatic paintings in the Matopo Hills, Zimbabwe. Above a wavy line, a powerful figure dominates the center, ankles crossed and birds in his hair. Two figures at either side leap toward him. The space below the line is colored in yellow and overlays earlier white shapes. In it, human figures, some missing limbs or a head, appear to swim or float lifelessly. Bushmen believe they may lose parts of their spiritual bodies during trance states. The wavy line may denote the division of realities, with the scene above portraying men approaching God and the scene below depicting people in out-of-body states.

FIG. 102 A detail from fig. 101. Note the birds in the seated figure's hair and the lines emanating form his head and armpit. The birds may express potency rising from the figure's head. Modern Bushmen believe that sweat from a trancer's armpits has special curative powers, a possible explanation for the lines.

FIG. 103 A painted male figure playing a musical pipe in Mashonaland. People playing pipes or flutes are not common, but do occur throughout Africa (figs. 3, 189). Musical flutes are still played in many parts of Africa, normally by adult men. Once they may have been associated with rituals, but today their use is general. (Traced by W. van der Elst.)

101

102 103

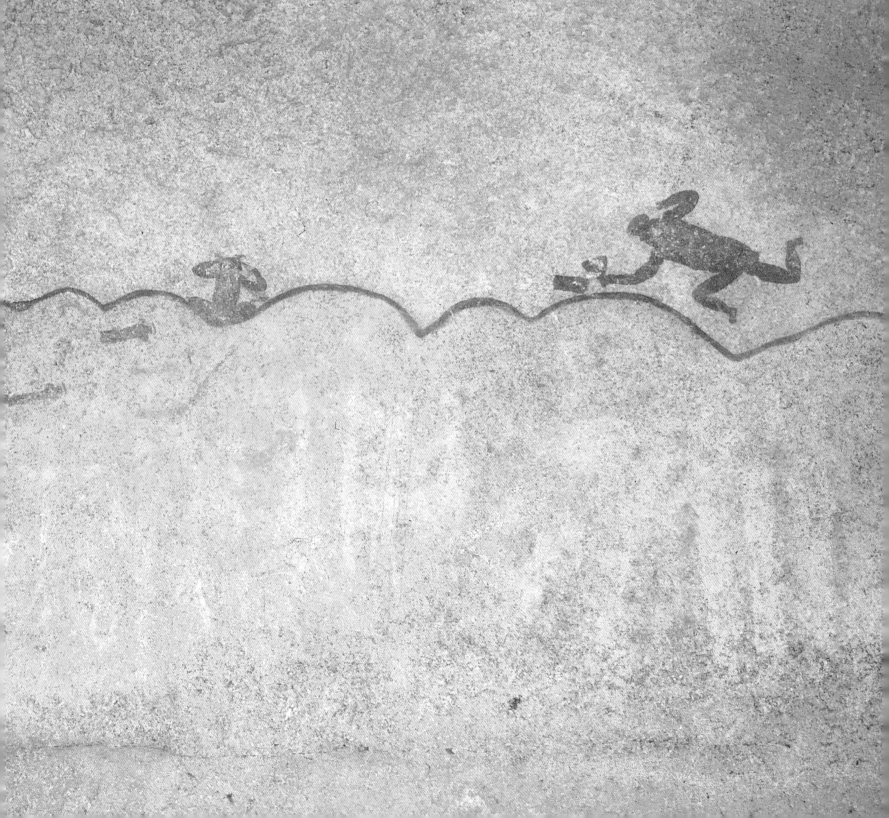

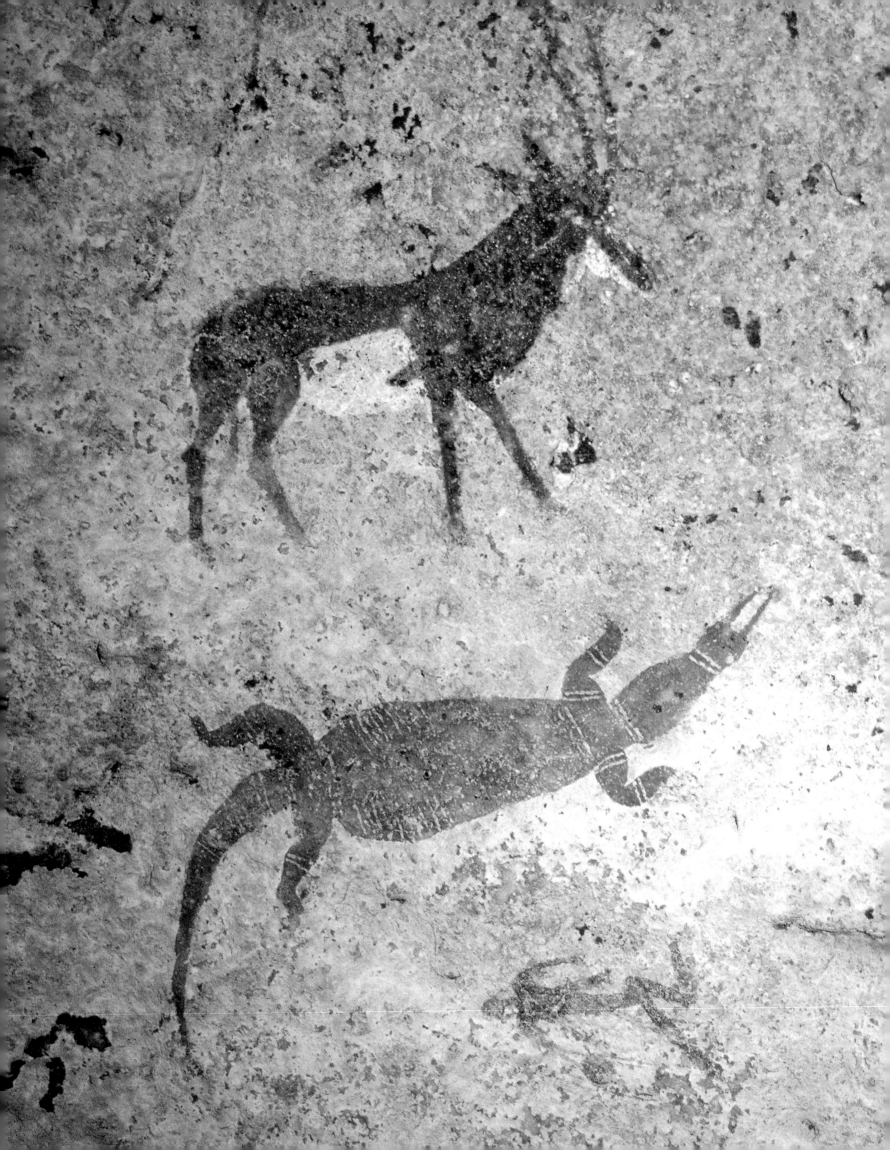

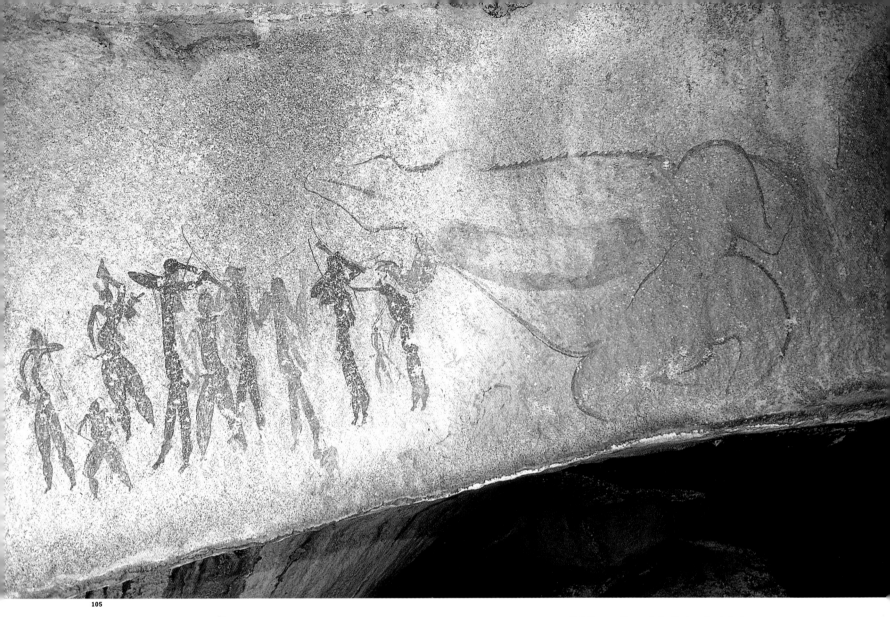

106

107

108

Paintings on the roof of a Mashonaland shelter, Zimbabwe. Above, a sable antelope is depicted with a naturalistic pose and coloring. Below, a crocodile is viewed from beneath or lies belly upward with jaws typically painted in profile. Brown-and-white bands decorate its neck, chest, wrists, and biceps as though it were adorned with human jewelry. White lines on the body and tail give the impression of scales. Below, a human figure trailing "strings" floats on its side as though passing by the crocodile.

FIG. 105 On the right, a bloated crocodile, almost 5 feet (about 1.5 meters) long, lies on its back, a red stream issuing from its thigh. A thick geometric shape covers its otherwise bare belly. Ten men stand in a row, some holding or wearing arrow quivers, while others hold bows or sticks. One man may be masked. This scene from Zimbabwe appears to represent a ritual rather than a hunt. In southern Africa, both Bantu-speakers and Bushmen credit crocodiles with great knowledge and power.

FIG. 106 Painting of two hippopotamuses, one superimposed by small animals and surrounded by groups of people. The human body positions, one figure leaning forward and others lying on their backs, suggest trance dancing. Hippos, with their affinity for water, are known as rain animals, suggesting the scene may involve rainmaking.

FIG. 107 A ground-walking bird, probably an ostrich, from Mashonaland, Zimbabwe.

FIG. 108 A steenbok with head atypically turned to the rear in Mashonaland.

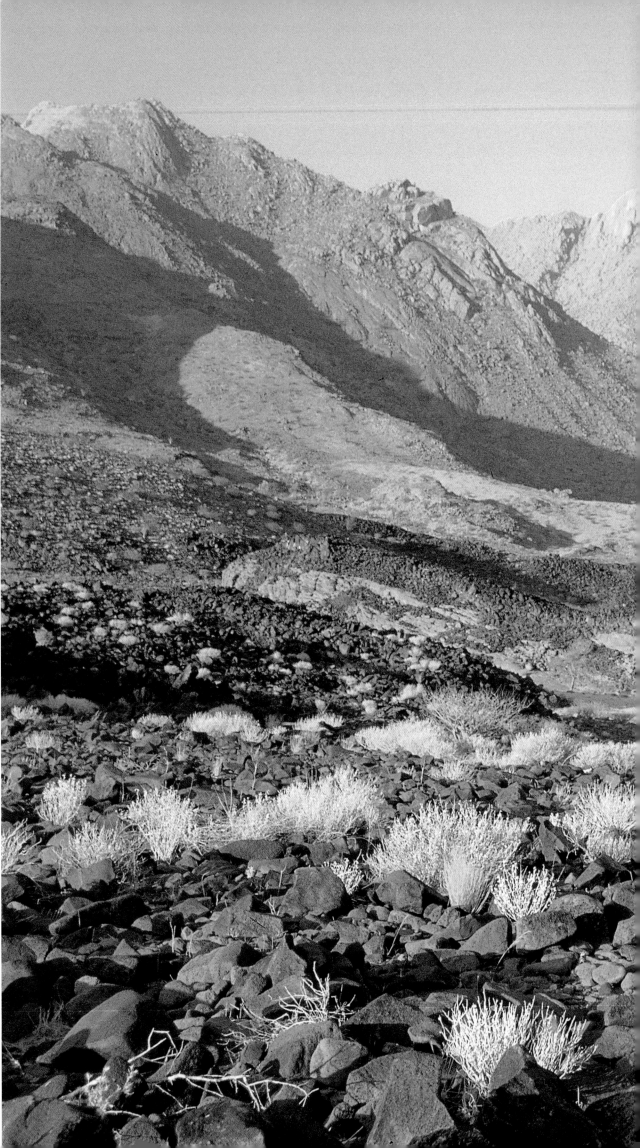

FIG. 109 **A detail of an elephant and giraffe in a much larger panel, Namibia. The style of engraving, degree of patination, and position of the two animals face-to-face suggest they are associated.**

FIG. 110 **The Brandberg (Burnt Mountain) rises to more than 9,000 feet in central Namibia. A bottle tree (Pachypodium lealii) partially hides a dry riverbed in the Tsisab (Leopard in the Nama language) Ravine, which becomes a swollen torrent after rain. The Maack Shelter and the famous painting of the White Lady are higher in this ravine.**

109

110

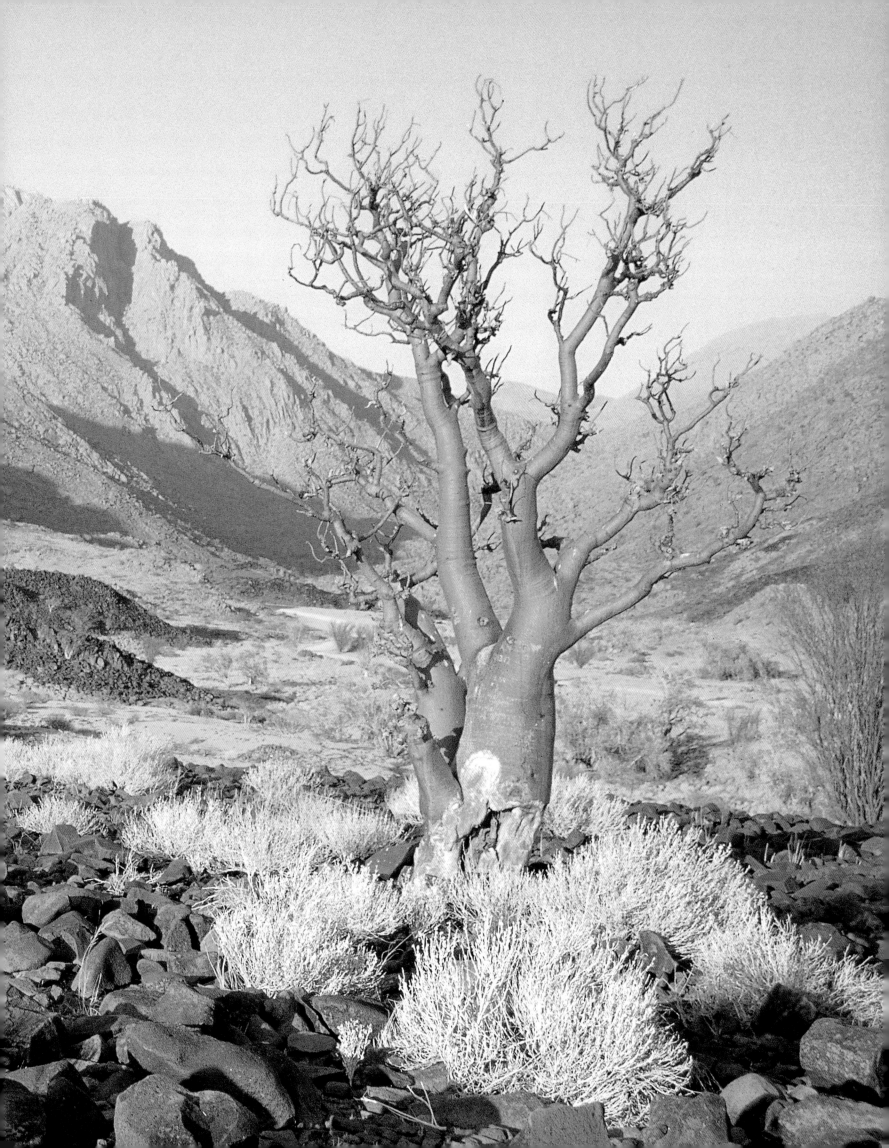

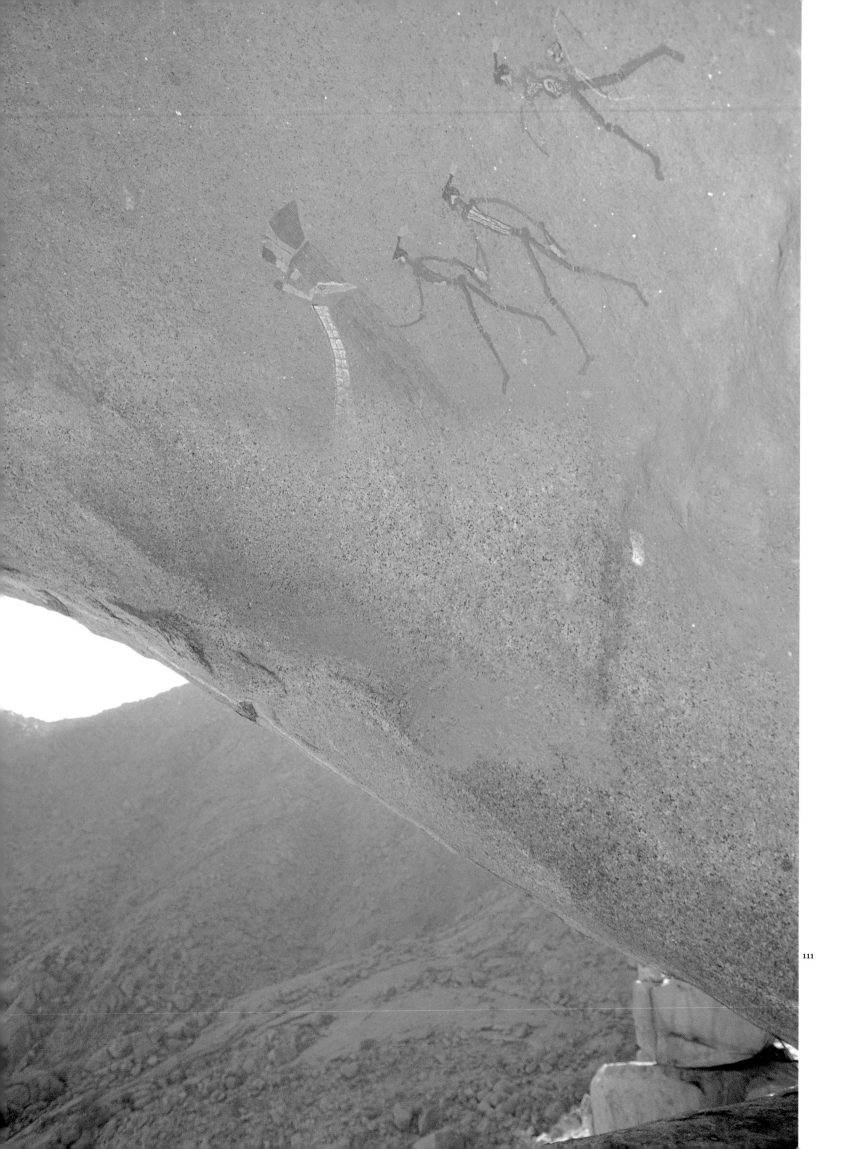

NAMIBIA

The earliest art, found on plaquettes, was excavated in Apollo 11 Cave and dated to between 27,000 and 19,000 years ago (fig. 73). The earliest extant parietal rock art has not been dated, but must be thousands of years old. John Kinahan has determined early occupation of rock art sites at between 4,500 and 5,000 years ago, when painting may have commenced, and believes the art ceased in some areas as recently as about 300 to 600 years ago.

The diversity of images and activities depicted is low compared to other areas. Among paintings, scenes arc fairly common with human figures numbering four-fifths of all images. Engravings comprise mainly individual animals and geometric shapes; obvious scenes and human figures are rare.

Kinahan sees the earlier paintings as reflecting religious concepts and social values, but believes a change took place with the advent of pottery into the Namib area about 2,000 years ago. Paintings of men in a new style (fig. 33) appear superimposed over the earlier art, sometimes with long hair or wigs, which led some researchers, including Abbé Breuil mentioned in Chapter Two, to believe the figures depicted foreigners. The most commonly painted animals are antelope, particularly springbok, and giraffe (fig. 23).

The Namib's forager population began to acquire domestic stock and by about 1,000 years ago many foragers had shifted to pastoralism with its new basis for economic wealth. Kinahan believes that during this period specialist shamans were developing and able to grow rich by providing rainmaking facilities for the new pastoralists. He notes a shift in the purpose of rock art from merely providing a reflection of social and religious values to one in which the art was being actively used to bring rain and create wealth for individual shamans (fig. 113).

114

FIG. 111 **A long, narrow shelter high in the Brandberg, Namibia, consists of little more than a thin ledge above a sheer drop (see detail, pp. 36–7). This scene may represent men seeking a mythical giraffe's help, perhaps for rain.**

FIG. 112 **This geometric over 11 feet long has been interpreted by John Kinahan as two mythical animals. Both images, facing right, may represent the legs and belly only of elephant, with multiple parallel lines descending through and between their legs depicting rain. Women standing clapping on the left suggest trance involvement. Kinahan believes the painting is recent and was used by a professional shaman to make rain.**

FIG. 113 **The rain animals from fig. 112, reproduced from a tracing made by John Kinahan.**

FIG. 114 **The paw marks of a predator, possibly a leopard, in central Namibia. Numerous engraved tracks of rhinoceros, giraffe, pangolin, antelope, and predators occur on low rocks at this site. The rocks in this area have been found suitable for road construction, and the farm owner is negotiating to save the engravings.**

112

113

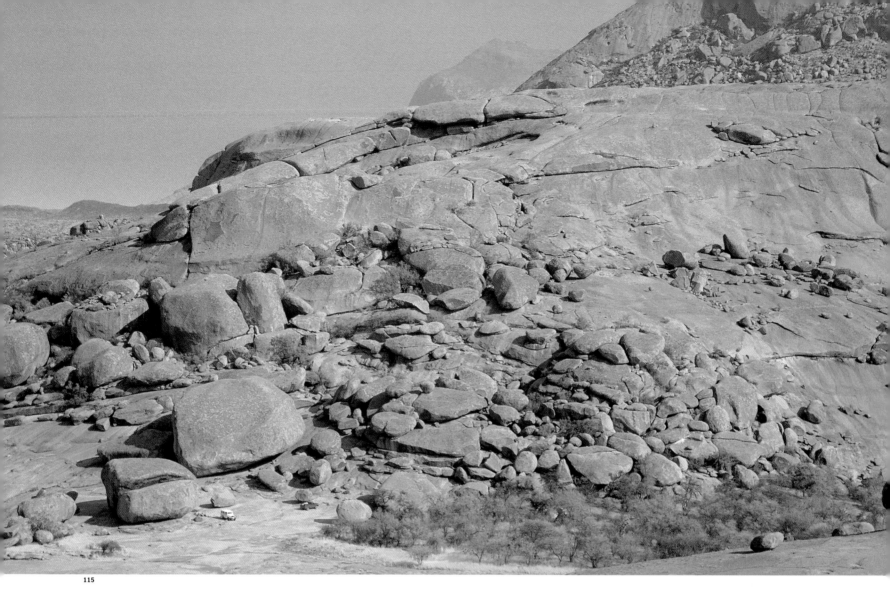

115

116

FIG. 115 Looking across Namibia's Erongo Mountains, where rocky folds and shallow cavities conceal many important decorated shelters. The vechicles on the bottom left give scale to the massive granite landscape.

FIG. 116 About 125 miles from southern Namibia's Atlantic coast, a dry river winds down a valley, bending against low cliffs. At the base of one cliff, water has eroded a long, deep undercut where red paintings, including the tail of a fish or whale, occur on the low roof and back wall.

FIG. 117 An engraving of a lion with a graded pecking inside the body to portray shape at Twyfelfontein, Namibia. The animal's tracks have been engraved where its paws should be and a further pugmark is used for the tail's tuft. The pugmark has five, instead of four, small pads fronting the large pad, similar to the human hand or foot. This engraving may represent an evil shaman who takes on a lion's form.

FIG. 118 Painting in red of a naked man holding a bow, Erongo Mountains, Namibia. Many interesting details here are easily overlooked. Note the lines painted on the face and the indications of a headband. A skin may be wrapped around his stomach.

FIG. 119 Looking up the rock-strewn side of the valley at Twyfelfontein,Namibia. This sprawling site contains almost 5,000 engravings, ranging from simple geometrics to complex friezes of animals. Human images are surprisingly lacking. In the foreground, a boulder displays birds, a zebra, and various antelope, one superimposing a wildebeest. The engravings are thought to be around 7,000 years old.

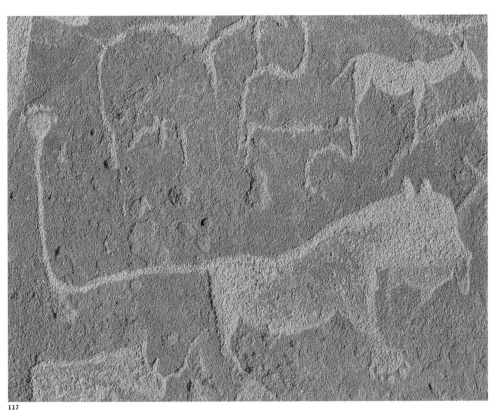

117

118

119

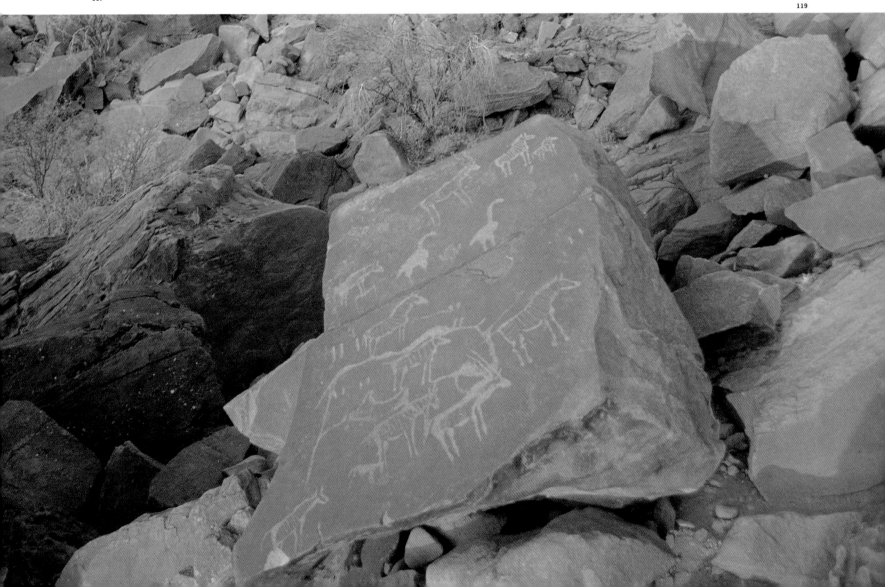

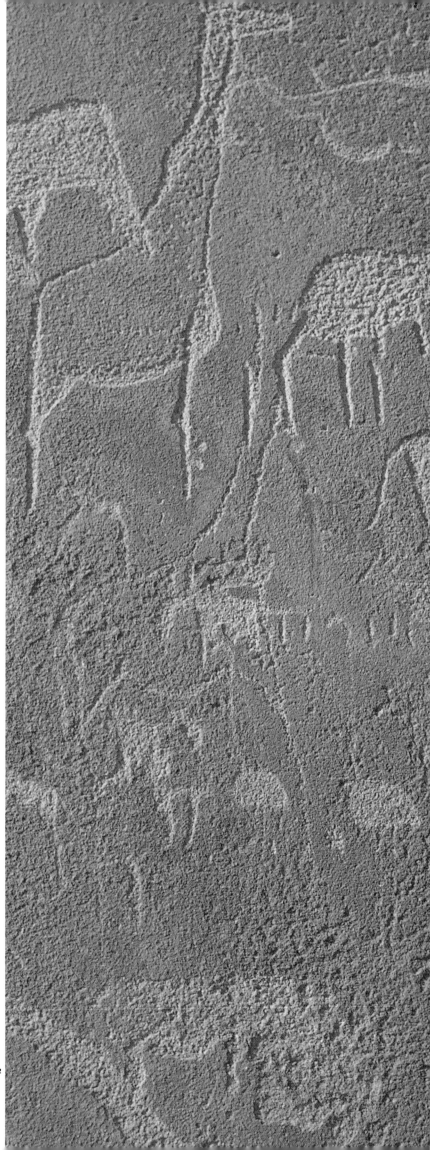

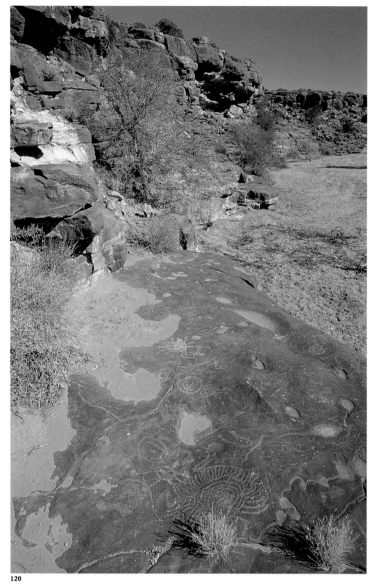

FIG. 120 Engravings of geometrics on a slab of rock beside a dry river in southwestern Namibia. Such engravings are common throughout large parts of Namibia, but painted geometric designs are virtually nonexistent.

FIG. 121 A painting of a graceful antelope, possibly an oryx, with immensely long horns appears to sail through the air in the Erongo Mountains, Namibia.

FIG. 122 A section of a major Twyfelfontein (Doubtful Spring in Afrikaans) panel depicts a variety of engraved animals in various styles, some completed and some possibly deliberately unfinished. The animals include giraffe, antelope, stripeless zebra, ostrich, hyena, antbear, wildebeest, and a superb rhinoceros with a human footprint just touching its front foot. Note two rhinos, one outlined but unfinished, and the careful positioning of engravings that either touch or superimpose others.

121

122

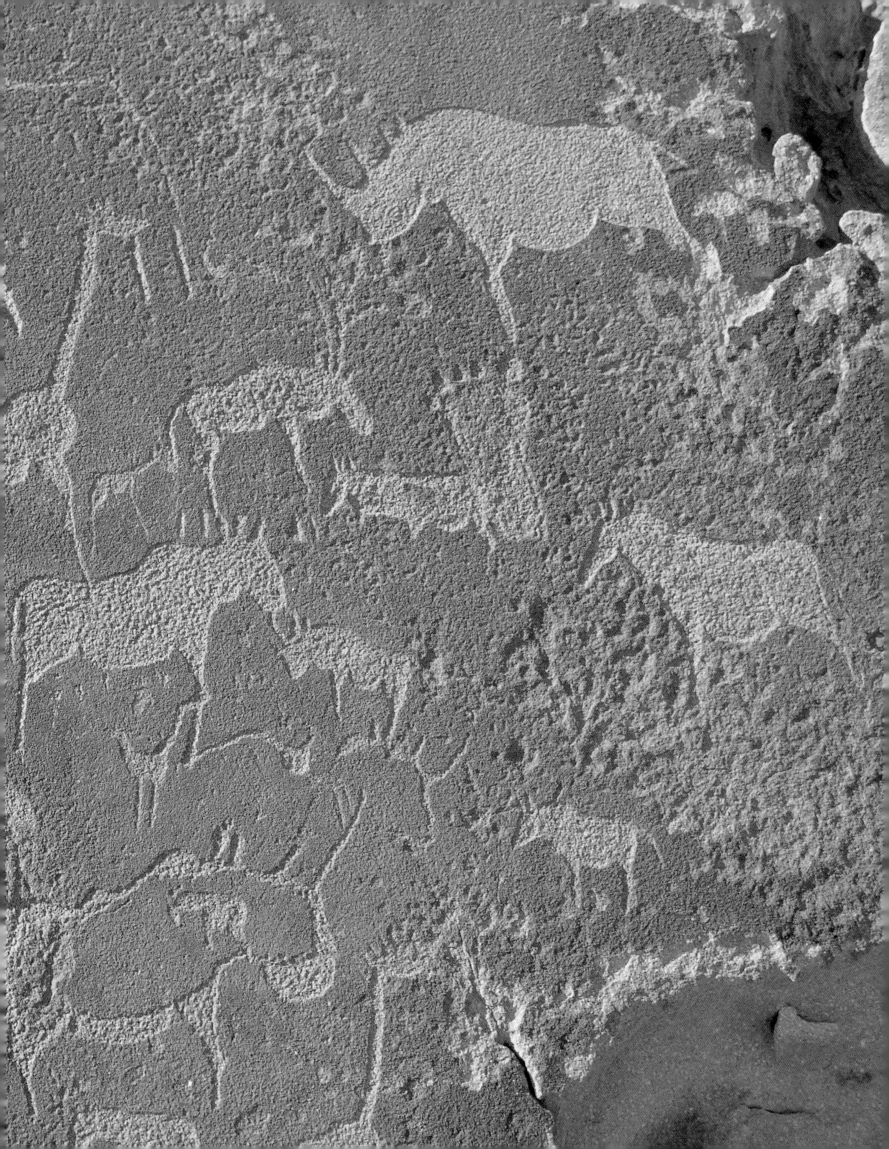

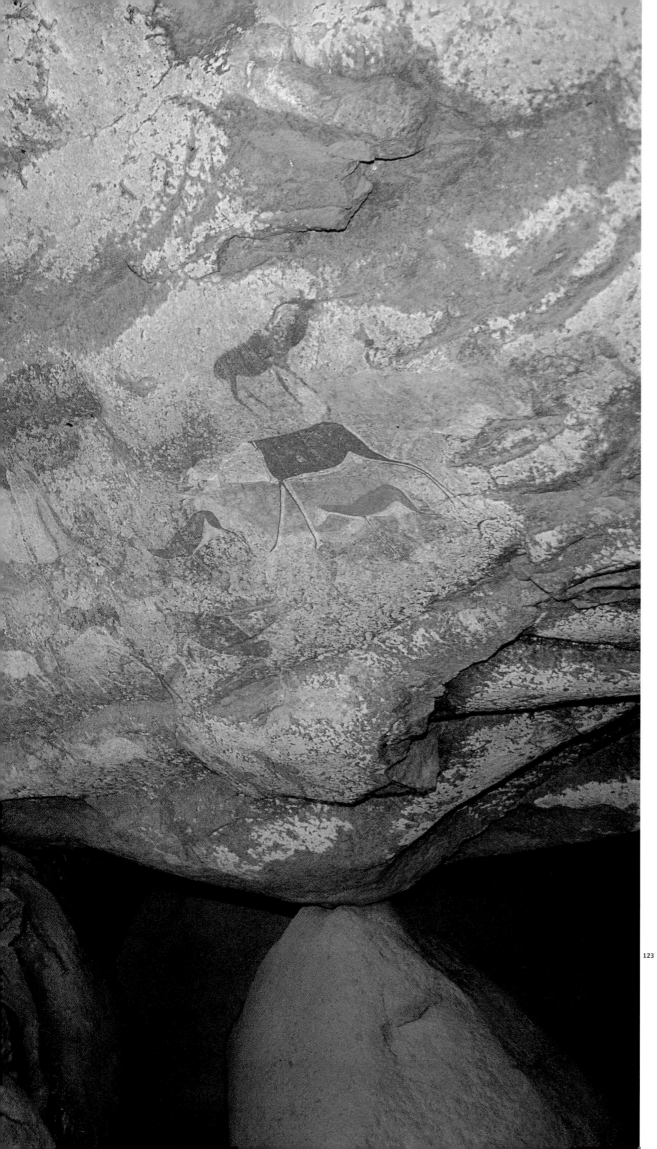

FIG. 123 **Panel from the upper shelters of the Brandberg, about 8,500 feet above sea level. Paintings reflect giraffe, antelope, other animals, and different types of people. Excavation in the shelter suggests some paintings may be about 1,900 years old. Other super-imposed human figures in a later style are younger.**

FIG. 124 Elongated human figures
dominate these animal paintings,
mainly eland with red bodies and
white foreparts and legs, in the
southwestern Cape.

FIG. 125 A painting of a galleon in
the southwestern Cape located in a
shallow overhang outside a cave
that is reached through
a tunnel. The lack of detail makes
the galleon's identification difficult,
but it may depict a Portuguese
vessel, perhaps dating to the
fifteenth or sixteenth century.
Whether the painting had an original
symbolic purpose or was merely
painted to communicate the vessel's
image is unknown. One flag flies
to the right while the other
three point to the left.

SOUTHWESTERN CAPE

The earliest paintings in the southwestern Cape have not been dated; however, charcoal associated with fallen slabs bearing fine-line paintings of people has been dated to 3,500 years ago. Fine-line painting may have started much earlier, perhaps about 8,000 years ago when the area was reoccupied after a long period during which it had been uninhabited. It is thought that fine-line painting ceased between about 1,500 and 1,000 years ago and finger painting then took its place. Finger paintings depict finger dots, crude human and animal figures, some geometrics, and numerous handprints (fig. 128). They sometimes superimpose fine-line paintings, but the reverse never occurs. A final epoch in finger painting includes colonial subjects, such as a galleon (fig. 125), wagons hauled by mules or horses, men on horseback with guns, and women wearing skirts and bonnets (fig. 63). The wagons probably date to the eighteenth or early nineteenth century.

Fine-line paintings employ, for the most part, the same symbols used throughout areas of Bushman painting and appear mainly to be involved with religious activity; but, the proportions of their imagery vary. Human figures account for about 60 percent or more of all images (fig. 127); eland make up 50 percent of animal paintings, followed at some distance by elephant. In the western coastal area depictions of handprints are as common as depictions of people. Paintings of domestic stock, found in mountainous rather than coastal areas, include only sheep and not cattle. Many paintings, particularly of eland, are extremely intricate (fig. 124); but generally speaking, southwestern Cape paintings are not as elaborate as those found in the Drakensberg.

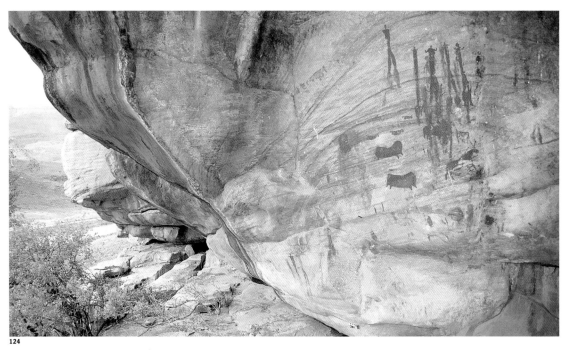

124

125

126

FIG. 126 **Complicated imagery on the low roof of a tiny hidden shelter in the western Cape. The central scene (fig. 127) is linked by "strings" to outlying human figures and apparently depicts a group of beleaguered people under attack from a line of armed men. Yet this scene does not seem to portray a real fight, but a metaphorical concept. Royden Yates, John Parkington, and Tony Manhire believe the double lines and white arrows suggest the symbolic struggle between good and evil. David Lewis-Williams, in a personal correspondence, expands this concept and relates it to the trance dance: "Who would the protagonists be in Bushman thought? At an interface between this and the spirit world, the human protagonists would be the shamans, while the evil protagonists would be the spirits of the dead. Unquestionably, that is how it is in Bushman belief: it is, principally, at the dance that such struggles take place."**

FIG. 127 **The central scene forming part of fig. 126.**

FIG. 128 **Red handprints in a cave in the southwestern Cape. These handprints were made by smearing palm and fingers with wet paint and pressing the hand onto the rock. In coastal areas between the Cederberg and the Atlantic Ocean, handprints and paintings of people occur in about equal numbers. Nowhere else in Africa is there such a plethora of handprints. While in trance, Bushmen hold sick people, believing healing is channeled through their hands; thus, handprints may be symbols of healing potency. Tony Manhire believes they may have been made by boys and girls at initiation ceremonies.**

127

128

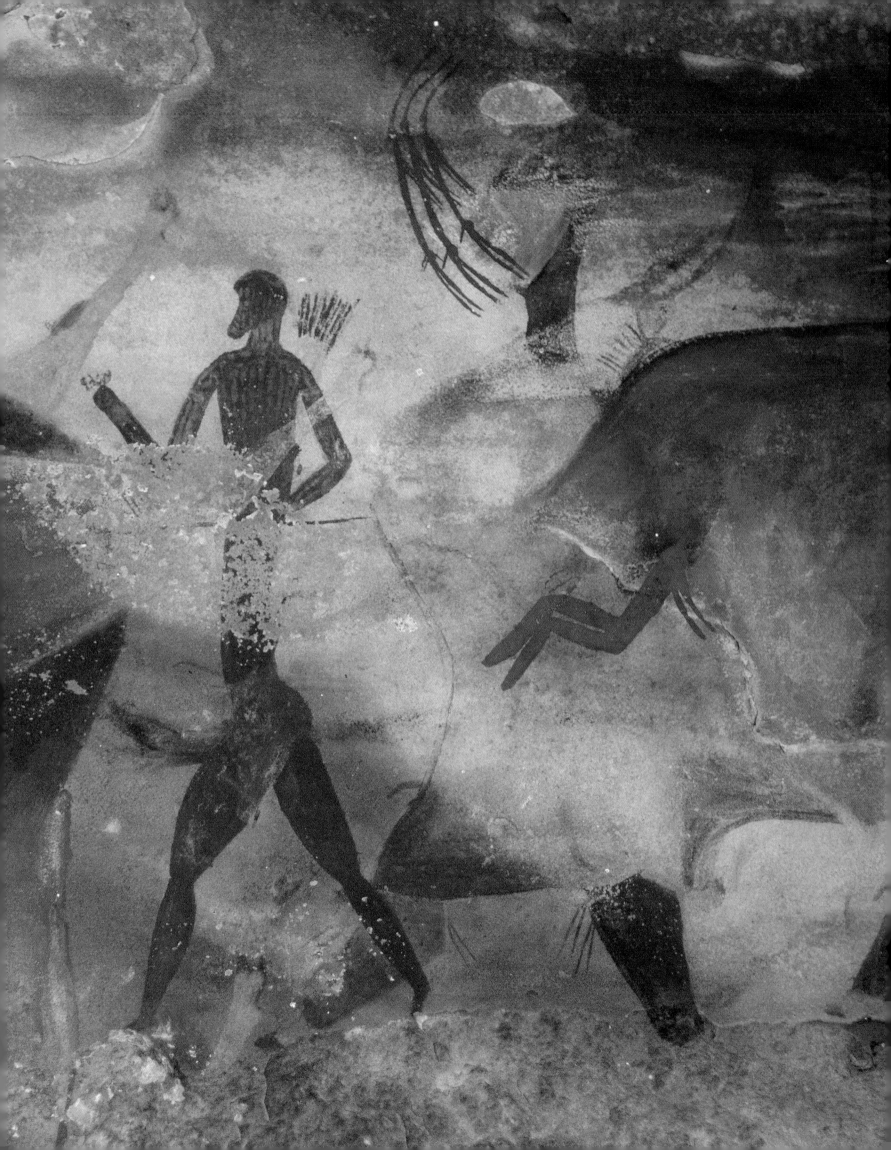

DRAKENSBERG AND MALUTI MOUNTAINS REGION

Nobody knows when rock painting commenced in the Drakensberg and Maluti Mountains region, but it must have been many millennia ago, perhaps as long as 10,000 years or more. Many paintings have now vanished, but the earliest of those that remain could date as far back as 4,000 years ago. The arrival of farming peoples, who settled the lower country about 1,500 years ago, slowly reduced the number of indigenous Bushman inhabitants: those who did not integrate into farming communities moved to higher ground. Thus, much of the later painting is concentrated in more rugged areas. By 1850 the few remaining Bushmen had retreated to the higher mountain valleys where they were still known to be painting in the 1880s. By 1900 they had disappeared and painting ceased. Unlike in the southwestern Cape, fine-line painting seems to have persisted in this region up until 1900, with no period during which finger painting prevailed.

As with all other Bushmen fine-line art, the paintings depict the Bushmen's conceptual vision of reality, their intertwined physical and religious worlds. The paintings are symbolic: depictions of eland do not portray the animal as such, but what the animal stands for in the Bushman's mind, in this case a facilitating power that enables humans to combat and overcome supernatural hurdles. Human figures account for about 53 percent of all paintings; among the animal figures eland (fig. 139) is the most commonly represented, followed by rhebok. Domestic animals include horses, cattle, sheep, and dogs. Many paintings thought to date within the last few centuries (fig. 129) are exceptionally elaborate, particularly those of eland, which employ several colors and careful shading.

David Lewis-Williams believes these paintings are shamanistic in nature and that they portray symbols used to express and explain Bushman rituals and beliefs, shamans' experiences in the spiritual world, and images of the supernatural. Other researchers see them as symbolic descriptions of human participation in religious events (the secular and religious are inseparable in the Bushman's mind) as they involve social roles, basic relations between the sexes and participation in ritual occasions, such as male and female initiation and the war against evil (fig. 126).

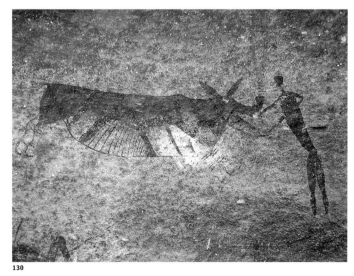

130

OPPOSITE FIG. 129 **A section of a large painted panel depicting two male figures in the Drakensberg. The faded white head of an eland super-imposes and fits neatly into the left man's thigh. To the left, a vertical eland extends horizontal legs, one superim-posing the man's chest. A second misty male figure superimposes a huge eland's neck. Three red schematic humans, arms strained back-ward, possibly symbolic of bows or the trance state, with lines flowing up from their heads, appear to rise through space. A fourth red reclining figure superimposes the misty human figure and the eland's neck. The three red figures may represent an out-of-body experience.**

FIG. 130 **A large mythical animal with jaws apart, described in the literature as a rain bull, is faced by a man who is apparently holding its lower jaw and either placing in or taking something from its mouth. Heavy black lines have been painted in a pattern over the animal's body while its stomach is highlighted by a series of thin red lines. This scene, from the eastern Cape, South Africa, has been inter-preted as a shaman in trance obtaining power from a mythical animal.**

FIG. 131 **A detail about 1 foot (30 cm.) wide from a shelter in the eastern Cape. A man painted in white brandishes a stick. A gray coiled snake with fish's tail rears up before him, its head and neck backed by a red cloud. On the right, an animal in white, perhaps a dog, stands with one foot on the snake's tail. The images are bright, suggesting a fairly recent date.**

FIG. 132 **A detail from a panel of paintings on a boulder in the Drakensberg. On the left, an animal or bird in flight has red-and-white streamers issuing behind it. White flecks adorn its body, while its head is outlined in white. On the right, an eagle stands with wings folded, red lines issuing from its body and a white protuberance emerging above its beak. David Lewis-Williams describes the left image as a trance-buck, a therianthrope, and believes it represents the Bushman's vision of himself in an out-of-body state while in trance. Modern Zhu Bushmen believe that people in trance can transform into birds. In this instance, the artist may have depicted himself as a bird with his spirit flying into the supernatural world.**

131

132.

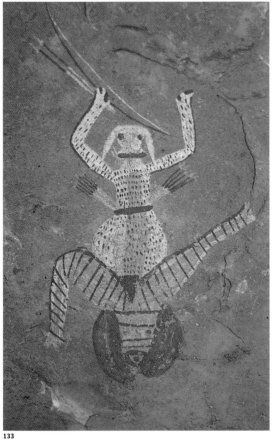

133

134

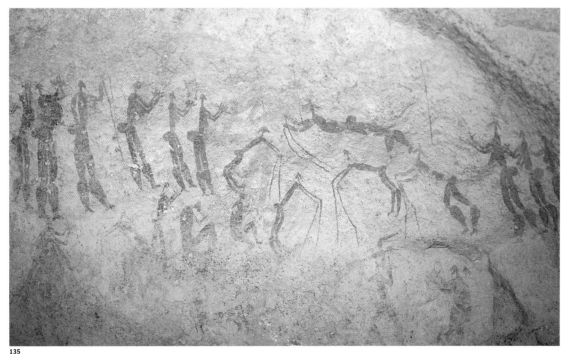

135

FIG. 133 A painting on a ledge above a long perpendicular drop into a river in the Drakensberg. Anne Solomon of the University of Cape Town has suggested that this is a female figure linked to female initiation. The bow and quivers of arrows relate to gender ambiguity of female initiates. Animal features—ears, hair, and paws—may reflect Bushman mythology, linking together animals and humans and the natural with the spiritual realm.

FIG. 134 Two figures, facing to the front, are painted to the right of a "dying" eland. The upper figure has an animal's head with pointed ears, but no horns, and wears a long skin cloak decorated with nested curves of white dots. The second figure, apparently elongated, is outlined by white flecks interpreted as hair standing on end and has an animal's head and antelope's hooves. These figures, probably painted within the last 400 years, suggest humans in supernatural form and may represent the embodiment of animals' mystical potency, which dancers harness when in trance and use for their community's benefit. Some researchers relate these half-human, half-animal figures to the Bushmen's time when animals and people resembled each other and could communicate, or even to the time before God divided humans from animals.

FIG. 135 A small painting of a dance in the Eastern Free State. Women (the figures with breasts) stand to the sides clapping while men are seated or move in a circle, their bodies elongated, leaning forward, and supported on sticks. In the Kalahari, such dances are still performed when men and sometimes women enter a trance state. Involvement of the whole community creates a spirit of unity among its members. The dancers describe feelings of weightlessness and elongation and believe they sometimes travel underground to water holes where contact is made with spirits and mythical animals.

136

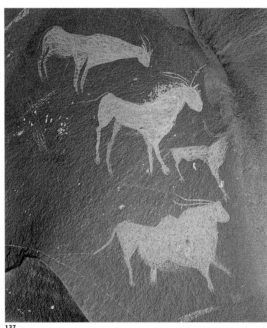

137

FIG. 136 A quiver tree (*kokerboom* or *Aloe dichotoma*) standing on a ridge in the northern Cape. The surrounding rocks have a dark patina, or desert varnish, caused by mineral staining, into which engravings have been scraped (fig. 137).

FIG. 137 Four antelope scraped into the brownish-black patina of a smooth dolerite rock in the northern Karoo, South Africa (fig. 136). The lowest antelope is an eland with a typically heavy body and shoulder hump. The species of the other animals are uncertain; however, numerous other engravings at this site represent mythical animals. The animal with a mane, second from the top, is almost certainly mythical, while the small animal in front of it has cow-shaped horns. The age of the engravings is uncertain but is probably less than 700 years.

FIG. 138 Looking toward the distant Maluti Mountains from a shelter in the Eastern Free State, South Africa. The shelter contains paintings of eland and a lion, now sadly all damaged by soot.

138

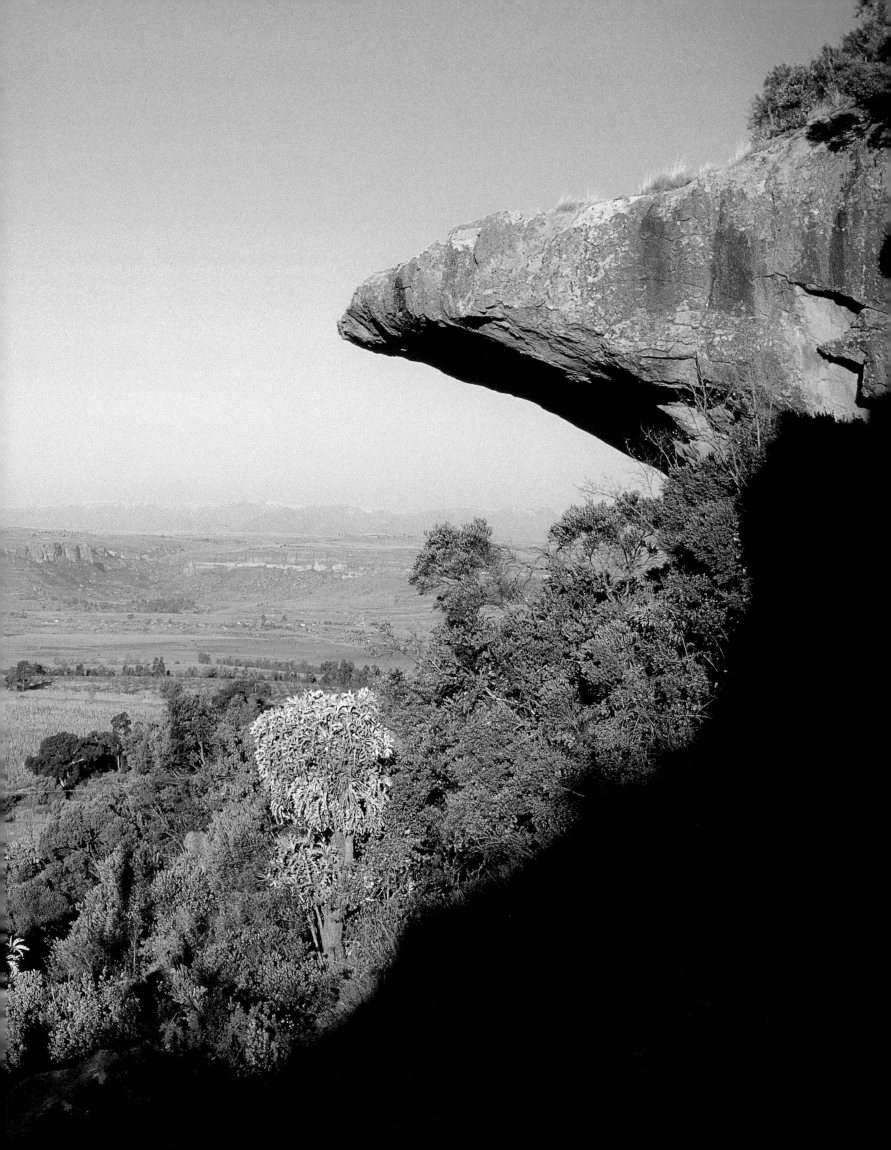

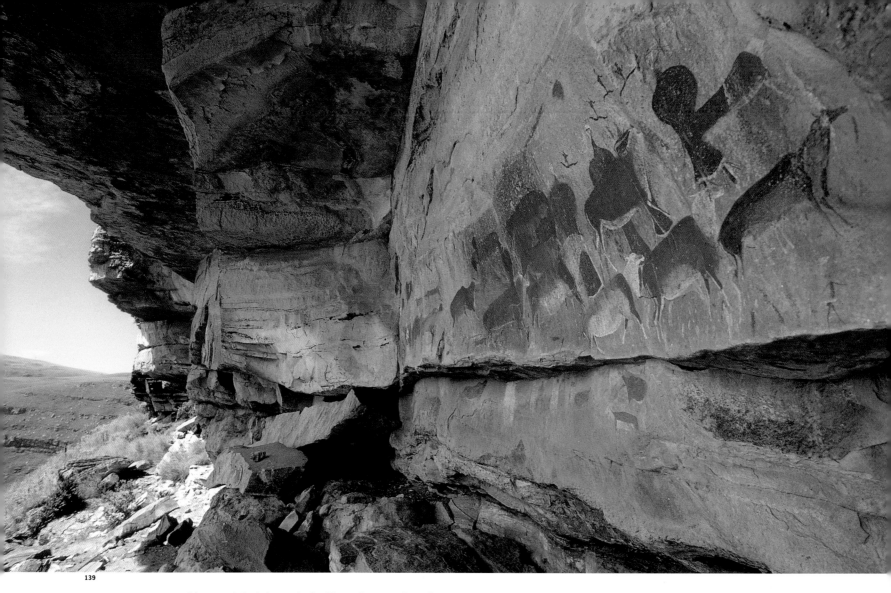

139

FIG. 139 **A large panel of polychrome eland and human figures overlies earlier paintings in the upper Drakensberg. Humans wear skin cloaks and have eland hooves instead of feet. Above and below the eland, five small figures armed with bows run to the right while, below, other figures also stride to the right.**

FIG. 140 **Engravings of rhinoceros outnumber all other species on a low hillock known as Thabasione (Zion's Hill) in South Africa. The age of the engravings is uncertain but predates 1400 A.D. and the arrival of Tswana agriculturalists now living there. Tswana recognize the engravings as having religious significance. The site is fenced and protected.**

OPPOSITE FIG. 141 **There are about 3,600 engravings carved into this pavement at two adjacent sites in this riverbed near Kimberley, South Africa. Ninety percent of the engravings comprise geometric designs; the remainder consist of animals and only twenty human figures. Many of these geometrics take the form of ovals and circles containing grids. Using geomorphological techniques to date channel erosion and determine when the pavements were exposed, Karl Butzer believes the engravings could only have been made either between 2,500 and 2,200 years ago or up to 1,300 years ago.**

140

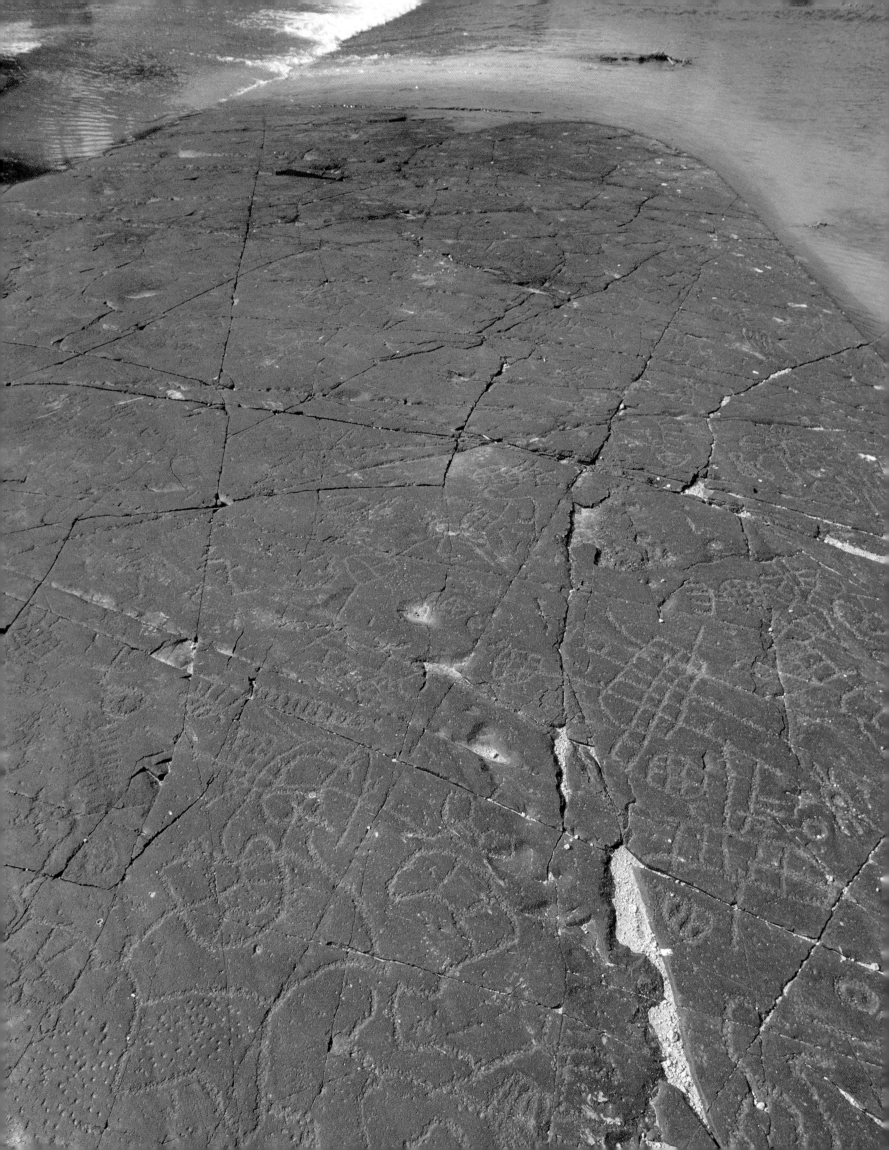

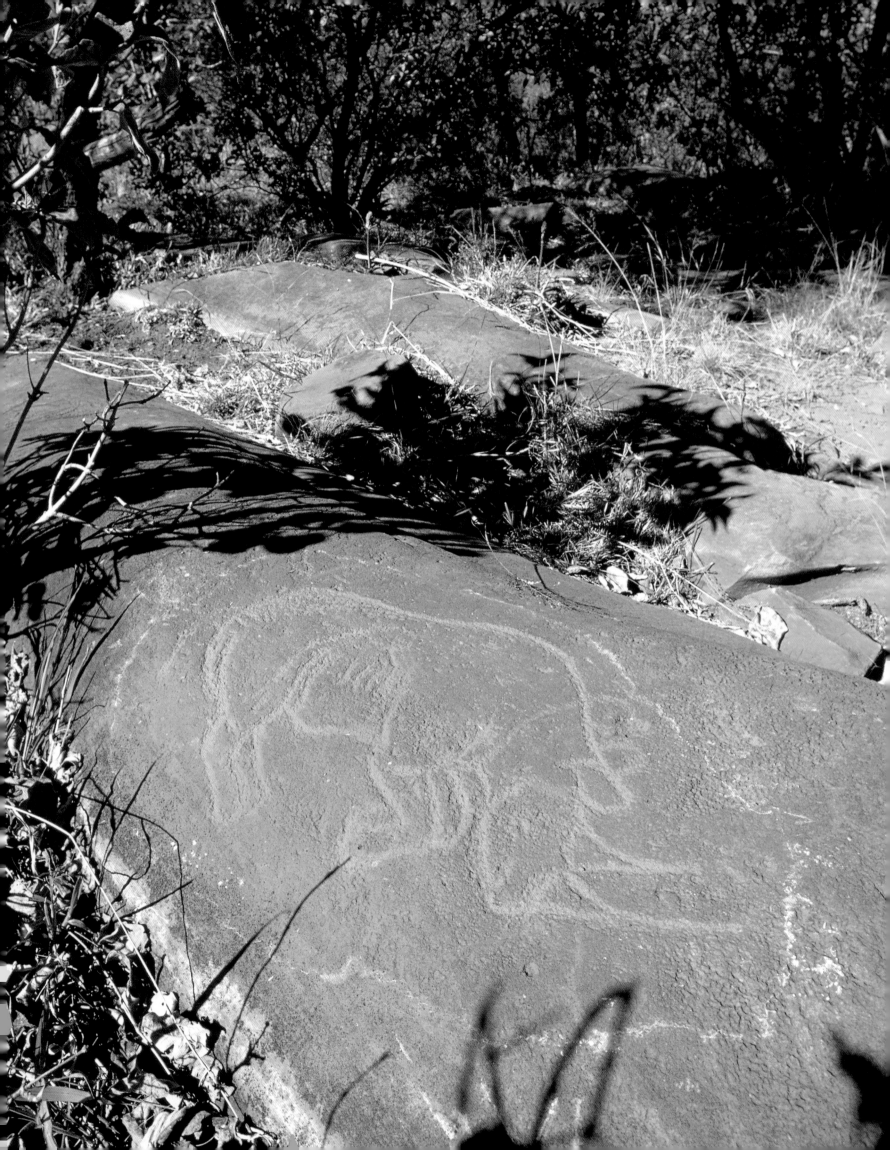

THE INLAND PLATEAU AND TSODILO HILLS

Various dates have been given for the engravings of the inland plateau. Fine-line engravings on stones (fig. 71) have been excavated in the Wonderwerk cave in South Africa, with the earliest dated to 10,200 years ago. Using comparisons of patination, David Morris and Peter Beaumont believe that some fine-line engravings on exposed rocks (fig. 72) may be about 4,500 years old, while some of the more common pecked engravings could date starting from 2,300 years ago while most of the scraped engravings (fig. 137) were made during the last 500 years. As late as the 1870s a Bushman was recorded as stating that his father had made engravings north of the Orange River.

Gerhard and Dora Fock have shown in some 20,000 engravings recorded in the northern Karoo that images of a wide range of animal species constitute 60 to 75 percent of the art, while human figures constitute only 10 percent. Generally, animals (fig. 42) and humans (fig. 79 middle) are depicted in isolation of each other, although some scenes do occur. Thomas Dowson believes that, like the paintings, the engravings are symbolic and part of religious experience, "linked to the trance dance and related beliefs." Geometrics are common. This is almost the reverse proportion of the fine-line paintings in which humans outnumber animals and geometrics are scarce.

Paintings are found in shelters in a number of isolated places on the plateau. Done mainly in dark red, but also in black, white, and orange, the paintings consist almost entirely of geometric designs and are similar to some of the youngest engravings.

In the Tsodilo Hills of northwestern Botswana some 4,000 finger paintings have been found, usually outlined in red and then filled in with the same or a lighter shade. In form and composition they resemble the engravings of the inland plateau, rather than fine-line paintings. Their proportion of images parallels the engravings with 50 percent animal depictions (fig. 150), 37 percent geometrics (fig. 93), and only 13 percent human figures (fig. 147). Giraffe is the most common animal species represented, followed closely by eland and rhinoceros. Perhaps most remarkable of all are the 160 depictions of cattle (fig. 289). The dates of these paintings are unknown, but cattle were common around the Tsodilo Hills between 800–1200 A.D., and as the cattle paintings are similar in style to the other animal depictions, this seems to be a possible date for much of the art.

While it is accepted that fine-line paintings and early engravings are the work of ancestral Bushmen, there is some doubt about the authorship of the handprints, finger paintings, and later engravings on the coast of the Cape. Much, if not all, of this art was made after the introduction of pottery into southern Africa about 2,000 years ago and the subsequent introduction of sheep and cattle. Many people believe that central Bushmen living in northern Botswana first acquired domestic stock as it came down from the north and carried pastoralism through southwestern Africa to the Cape, where they became known to European settlers as Hottentots or Khoikhoin. Possibly, the later geometric art (fig. 143) also came from the north (where some of it is not entirely dissimilar to Twa and Late White paintings), either preceding or accompanying the introduction of pottery. Thus, some researchers see ancestral Khoikhoin as the authors of the later art on the plateau (fig. 146) and in the southwestern Cape, but this has yet to be proved.

143

OPPOSITE FIG. 142 **An engraving of a rhinoceros on a low ridge near Klerksdorp, South Africa. The engraver has achieved the weight and power of a charging rhinoceros by use of simple outline and expressive imagery. The white marks surrounding the image are from scratches made by an archaeologist who casted the engraving in rubber latex. In the past, some smaller engravings were stolen from this site, while others were removed for "protection" to Johannesburg and Pretoria. The site is now proclaimed a national monument.**

FIG. 143 **A painting of a circle containing a grid in the Tsodilo Hills.**

OVERLEAF FIG. 144 **Three Zhu Bushmen look at Late White paintings in the Tsodilo Hills, Botswana, of an elephant, geometric designs, and human figures. These paintings were probably made by ancestors of Bantu-speaking farmers and used in initiation into adulthood ceremonies. The Bushmen believe the paintings were made by God.**

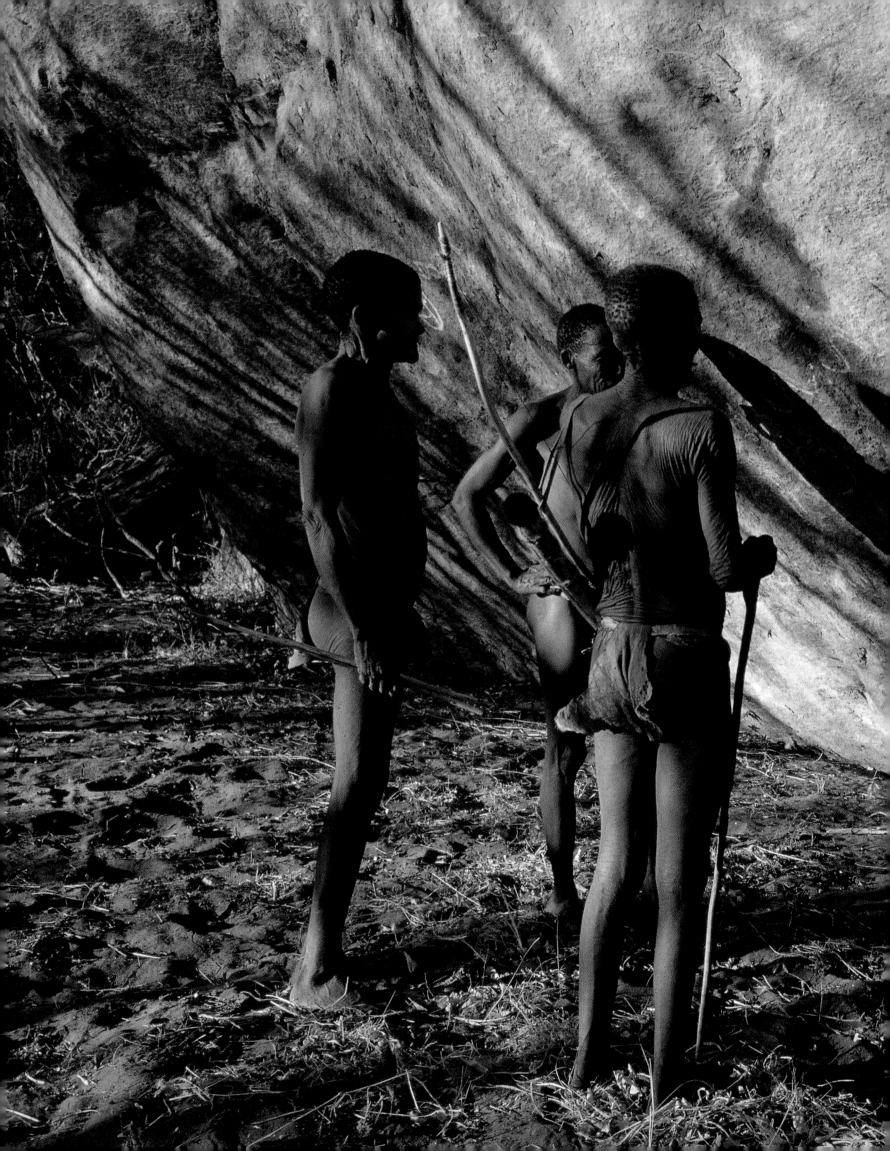

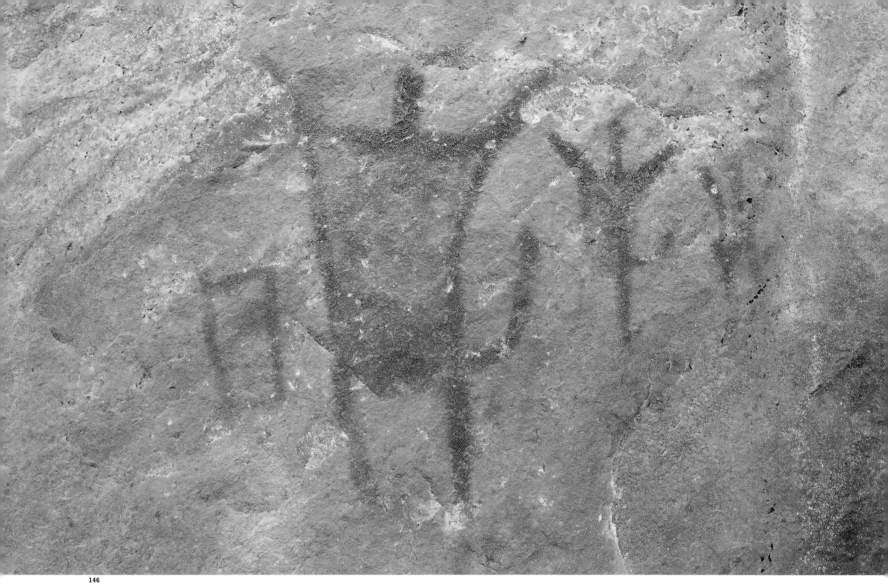

146

OPPOSITE FIG. 145 **Bold red outline paintings of a rhino, antelope, and ostrich from the Tsodilo Hills, Botswana. A projection above the painted slab has protected the middle of the panel, but rain on either side has created water seeps down the rock, obliterating parts of the paintings.**

FIG. 146 **Geometric designs comprise 37 percent of all images in the Tsodilo Hills. Some square geometrics, like these, are suggestive of human figures having heads, arms, legs, and penises. Fifty-three percent of Tsodilo geometrics are round and enclose gridlike patterns (fig. 143). If these are entoptic phenomena, one theory is that they may symbolize people in trance or the trancers' potency, with square shapes representing men and round shapes being women.**

FIG. 147 **A small painted panel above a high ledge in northwestern Botswana depicts thirty-five human figures, which include men with erect penises, two men with antelope heads, females with breasts, and females with breasts and two streamers behind them. Erect penises and breasts may merely distinguish males from females, as almost all male figures in the Tsodilo Hills have erect penises. This scene clearly represents a ceremony, but its purpose is uncertain.**

FIG. 148 **One of two painted panels from eastern Botswana in the fine-line style of neighboring Zimbabwe depicting herded flocks of fat-tailed sheep. The advent of domestic sheep in southern Africa remains somewhat of a mystery. Nick Walker, who traced this painting, has dated sheep remains in Zimbabwe to about 2,200 years ago, while dates obtained in Namibia and South Africa place their arrival a little later. Sheep probably filtered south with or through forager peoples to Zimbabwe about 2,000 years ago and then moved southwest through semiarid areas into the southern Cape.**

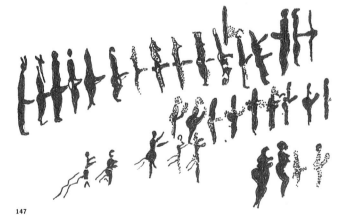

147

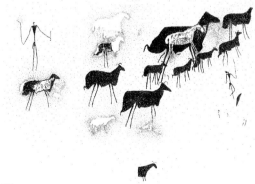

148

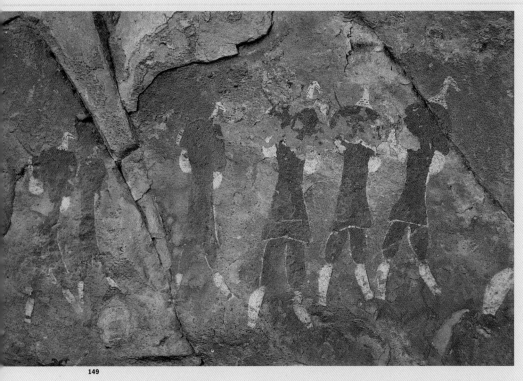

149

FIG. 149 A line of therianthropes
strides across a shelter wall high
above a racing Drakensberg stream.
These half-animal, half-human crea-
tures possibly symbolize shamans
imbued with animal power.

FIG. 150 A well-preserved frieze of
polychrome eland (fig. 75). At the
right, at least seven eland superim-
pose another great eland facing
downward. Two eland are painted
lying with legs postioned slightly
apart from their bodies, a typical
Bushman drawing convention.
Panels of polychrome eland are a
feature of, and are almost unique to,
the Drakensberg. Greater care was
taken in painting eland than other
animals, which suggests their
importance to the artists. Although
protected by the law, vandalism has
already destroyed several paintings
in this shelter (fig. 306).

NDEDEMA GORGE AND THE END OF A
LONG PAINTING TRADITION

April clouds drifted across the sky, hiding the
sun and swirling through upper Drakensberg
valleys, breaking here and there to give brief
glimpses of imposing rock walls rising a thou-
sand feet above us. A smell of rain hung in the air
as we reshouldered our packs after a horrendous
climb and started the slippery descent into
Ndedema Gorge (*ndedema* is Zulu for "echoes of
thunder"). Looking left and far below us, water
was occasionally visible through the tall trees that
lined the river and climbed the gorge's sides,
blanketing the feet of sheer cliffs that towered
above them.

Ndedema Gorge is now protected as a
national park administered by the Natal Parks
Board. We had paid an entrance fee at the gate,
discussed what we wanted to see with the warden,
and booked one of the few shelters without paint-
ings as a bedroom in case it rained which, of
course, it did. I had been here ten years before and

learned my lesson when we had lain in the open,
wet and freezing the night through, to find at
dawn the world above us white with snow. I had
wondered then and again was amazed to think
how people could have lived through the winter
in these high altitudes, snow blanketing the
ground, a bitter wind blowing, eating only what-
ever wild food could be found, and with only an
open rock shelter for a home.

We forded the river, sometimes up to our
waists in icy water, hanging on to boulders and
searching the bottom for safe footings. The climb
up the gorge's far side was easier, and we rested
above the first shelter, hiding our packs under
bracken and protea. We eased our way down the
steep bank hanging on to grass to stop ourselves
sliding a hundred feet into the river below, and
climbed sideways into Sebaaieni Shelter; *esibayeni*
is Zulu for "at the cattle byre." A file of more than
twenty human figures met our gaze, or were they
human? Although they were dressed in skin capes
and leggings, and some carried loads on sticks
over their shoulders, they all had antelope heads
(fig. 149). Comparing transparencies taken then
and ten years earlier, I could not help wondering
if the paintings were as bright as they had been
when I first saw them.

Farming peoples first entered South Africa
1,700 years ago and found Bushmen living on the
fertile slopes and coastal plains below the moun-
tains. At that time Bushmen only climbed to
upper valleys in summer to hunt eland and use the
painted rock shelters for ritual purposes. As the
centuries passed, the farmers steadily expanded,
eating up the Bushmen's land until, by 1800, they
occupied most of it, and the Bushmen were slowly
pushed up the lower Drakensberg slopes. A

terrible time for the Bushmen ensued, exacerbated after 1800 by the arrival of European settlers, who forced black farmers higher into what was left of Bushman land. Left with little food, particularly in winter, Bushmen were forced to steal cattle, sheep, and goats because the antelope they had always hunted were gone. Retaliation was swift, and many Bushmen were exterminated; those few who remained settled with farmers or hid themselves in the upper gorges and valleys of the Drakensberg.

That night we slept in Leopard's Cave and the next morning climbed over the ridge to the amazing Eland Cave. A small river flows out of the high berg and suddenly drops over the shelter roof into the deep gorge below, creating rainbows against the rock. Here we saw some of the most

magnificent art in all of South Africa, for more than 1,600 paintings of people, antelope, insects, therianthropes, and geometrics, many still in surprisingly fresh colors, adorn the back wall. Thrilled to see an amazing panel of eland painted against and over each other (fig. 150), we were appalled to note nearby where a thief had broken off and removed part of a painting. So high above the world, here a few intrepid Bushmen, unwilling to give up their way of life, made a last stand and then vanished forever, leaving only their spectacular paintings on the walls of now-empty shelters. ◙

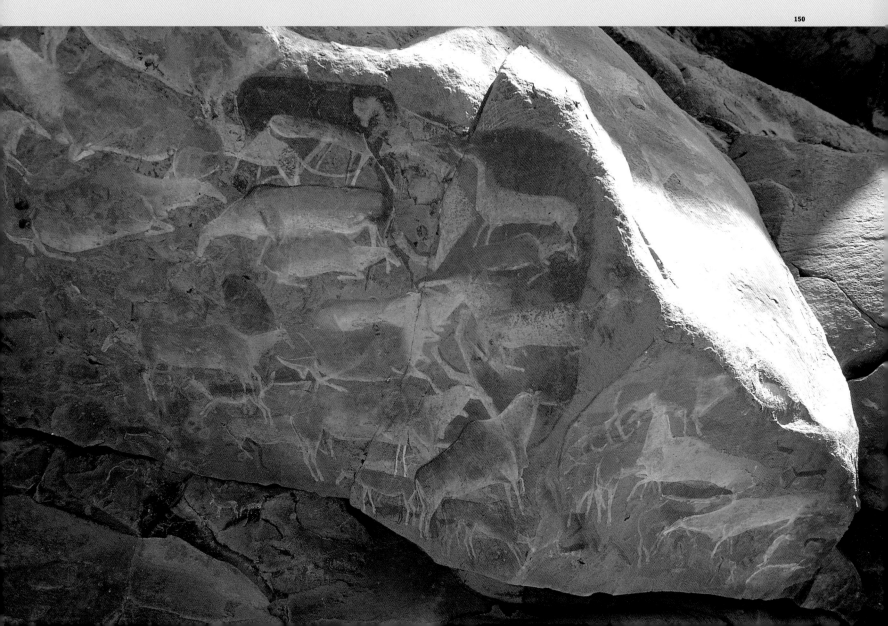

CHAPTER SIX

EASTERN AFRICA

152

PRECEDING PAGE FIG. 151 **A road through wild country in central Tanzania. We drove through tsetse-infested brachystegia woodlands with occasional views of huge granite outcrops rearing above the canopy. Below, some of these outcrops have rock paintings, probably made by ancestors of the Sandawe.**

FIG. 152 **Late White Paintings of a person mounted on a horse, two people facing forward with hands on hips, and three people with arms joined, possibly dancing. Similar paintings of people standing with hands on hips occur from Tanzania to Botswana and South Africa, and are attributed to Bantu-speaking peoples. (Redrawn from C. Ervedosa, 1980.)**

FIG. 153 **A detail from a painting in central Tanzania of a reticulated giraffe with lowered head. A schematic human figure wearing a headdress and perhaps a cape appears to float in space. The style and intensity of the color of both images suggest they were painted by the same artist and form a single picture.**

Most of eastern Africa, from the Zambezi River valley to Lake Turkana, consists of a massive inland plateau with a few isolated volcanic mountains and numerous granite exposures, much of it more than 4,000 feet above sea level. The Great Rift Valley, with its many long and narrow lakes, splits the area from south to north. The plateau's soils are relatively good, and rainfall averages twenty inches a year, which results in a land of dry forest, bush savanna, and occasional grassy plains. Both large and small species of wildlife, including elephant, giraffe, antelope, and ostrich, have always been fairly abundant. It is here, on the plateau, that almost all the rock art of eastern Africa is to be found.

THE ART CONSISTS MAINLY OF PAINTINGS—concentrated in central Tanzania, with a smaller concentration in eastern Zambia spreading into Malawi (map 6)—although a few engravings can be found in every country on the plateau. It is uncertain when the first paintings were made, but it could have been so long ago that by now they have disappeared and only those painted during the last eight or ten millennia are still visible. The paintings can be categorized as follows:

1 *Red Paintings:* Animals, people, and geometric designs (fig. 156) painted mostly in red, but some found in two or more colors.

2 *Pastoralist Paintings:* Cattle and related geometric shapes, usually painted in black, white, and gray, but also found in other colors (fig. 154).

3 *Late White Paintings:* Rather crude paintings (fig. 158), mainly in white, of people, animals, and geometric shapes.

4 *Meat-Feasting Paintings:* Designs, mainly in white (fig. 171), associated with meat-feasting ceremonies.

The few engravings occurring on the plateau have attracted little scientific interest. We have only looked at those found at the southern end of Lake Turkana and have divided them into two categories: 1) animals, humans, and some associated geometric forms related to more recent Saharan art (fig. 165); and 2) geometric forms apparently involving lineage symbols (fig. 163).

153

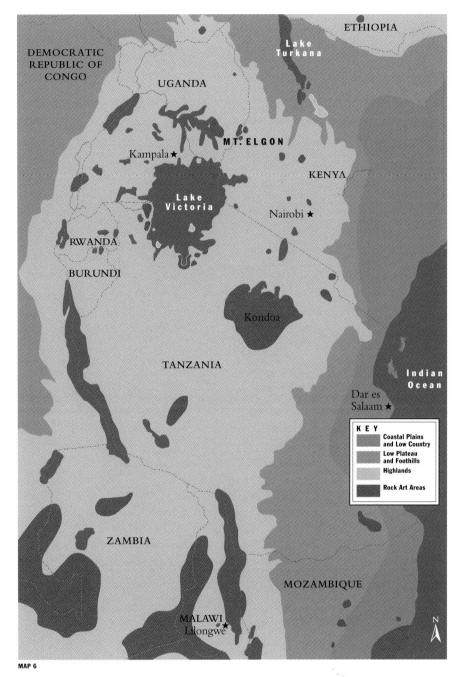

MAP 6

MAP 6 **Distribution of rock art in eastern Africa.**

FIG. 154 **Black, yellow, and white humpless cattle drawn from a painted panel (fig. 166). A stylized "elephant" is included at the right. The cattle demonstrate an interesting use of perspective with heads turned to face the viewer. Compare these cattle with those shown in figs. 155 and 168, which display a similar use of perspective.**

FIG. 155 **Paintings of cattle at two sites in Ethiopia. Although the body shape is different from fig. 154, the style and perspective used to depict the horns and heads are similar. Further north, in Ethiopia and Sudan, numerous cattle images occur, but, in the south, only two panels of cattle paintings are known. A relationship can be assumed between the paintings on Mt. Elgon (figs. 166, 168) and those in Ethiopia, suggesting a possible southward movement.**

154 155

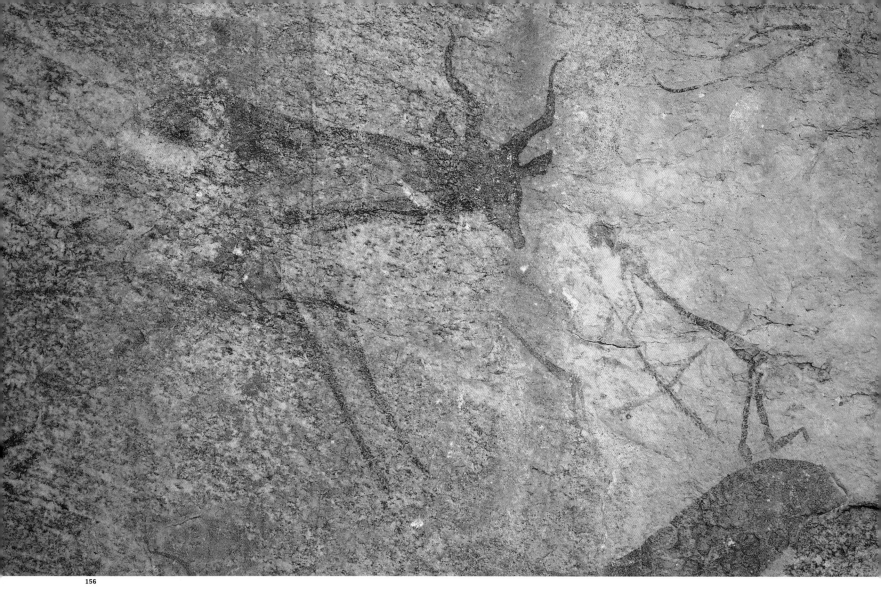

156

FIG. 156 **A profile of a kudu antelope in Tanzania drawn in twisted perspective showing two horns and ears, with front legs outstretched as though in motion. A person leaning forward faces the kudu, his knees bent and a rear apron flying out behind him. He appears to hold a bow or stick in his hand, making it not unlikely that this is a hunting scene.**

RED PAINTINGS

The red paintings can be subdivided into those found in central Tanzania, some of which may have been made by Sandawe and Hadza ancestors; and those found in a broad band stretching from Zambia to the Indian Ocean, which are thought to have been painted by Twa.

The Tanzanian paintings include early large, naturalistic images of animals (fig. 157) with occasional geometric patterns and later images of people and animals, sometimes in apparent hunting and domestic scenes. People are drawn wearing skirts, with strange hairstyles and body decoration (fig. 159), and sometimes holding bows and arrows. The Tanzanian red paintings have been quite extensively studied, first by Mary and Louis Leakey in the 1930s and 1950s and then by Fidelis Masao and Emmanuel Anati, all of whom have recorded numerous sites, divided the art chronologically into broad categories and dozens of styles, proposed dates, and made tentative interpretations about meaning.

The Sandawe and Hadza, who claim their ancestors were responsible for some of the later art, live in the general area of Tanzania's rock art concentration and speak languages employing click consonants distantly related to Khoisan. These peoples have practiced, until very recently, a hunter-gatherer economy and even today some Sandawe spend time in the forest collecting honey and wild food and hunting small animals.

The Zambian rock art can be divided into two categories: animals, with a few images of humans, and geometrics. Drawings of animals are usually highly stylized and often superimposed with several rows of dots (fig. 170). Geometric designs include circles, concentric circles, circles with radiating lines, parallel lines, and ladders. They are invariably

157

painted in red, but sometimes the remains of the filled-in white are still visible. Zambia's animals and geometrics are not similar to the Tanzanian red paintings.

David Phillipson divided Zambian red paintings into earlier images of naturalistic animals (fig. 169) followed later by geometric gridlike designs, which sometimes superimpose animal paintings, and arrangements of finger dots (fig. 170). Benjamin Smith, who recorded more than 500 sites, built on Phillipson's earlier work. He has studied ethnographic records of Zambian

FIG. 157 **A painting of a large antelope in Tanzania. Probably one of the earliest extant paintings, the outline of the animal was drawn first in red and then cream coloring was spread over the interior with the palm of the hand. Emmanuel Anati believes similar paintings could be over 28,000 years old.**

FIG. 158 **Late White paintings attributed to Bantu-speaking farmers in Tanzania, probably made during the last 700 years. A monuments guard stands on a pile of earth excavated by Tanzanian treasure seekers who have dug and even dynamited below rock art sites believing a hoard of gold was buried there by Germans during World War I.**

158

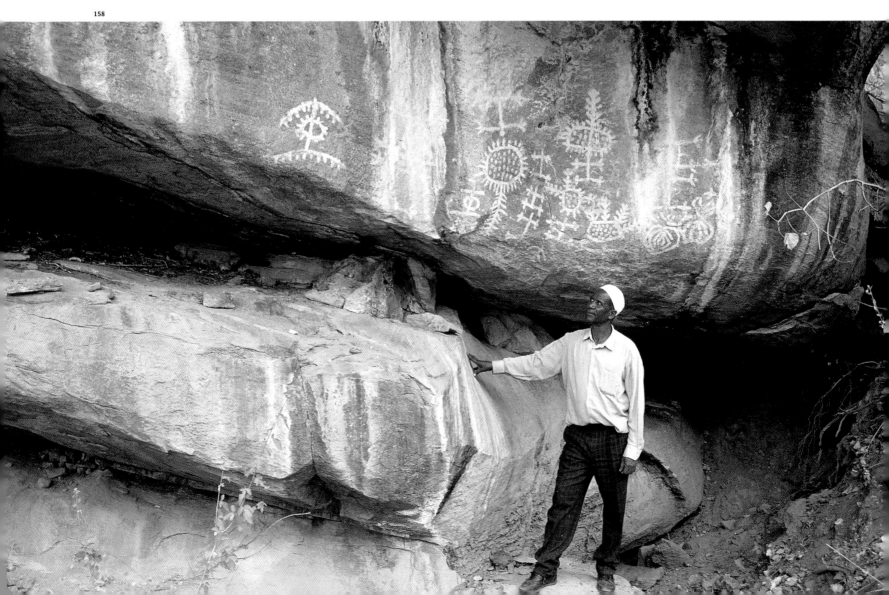

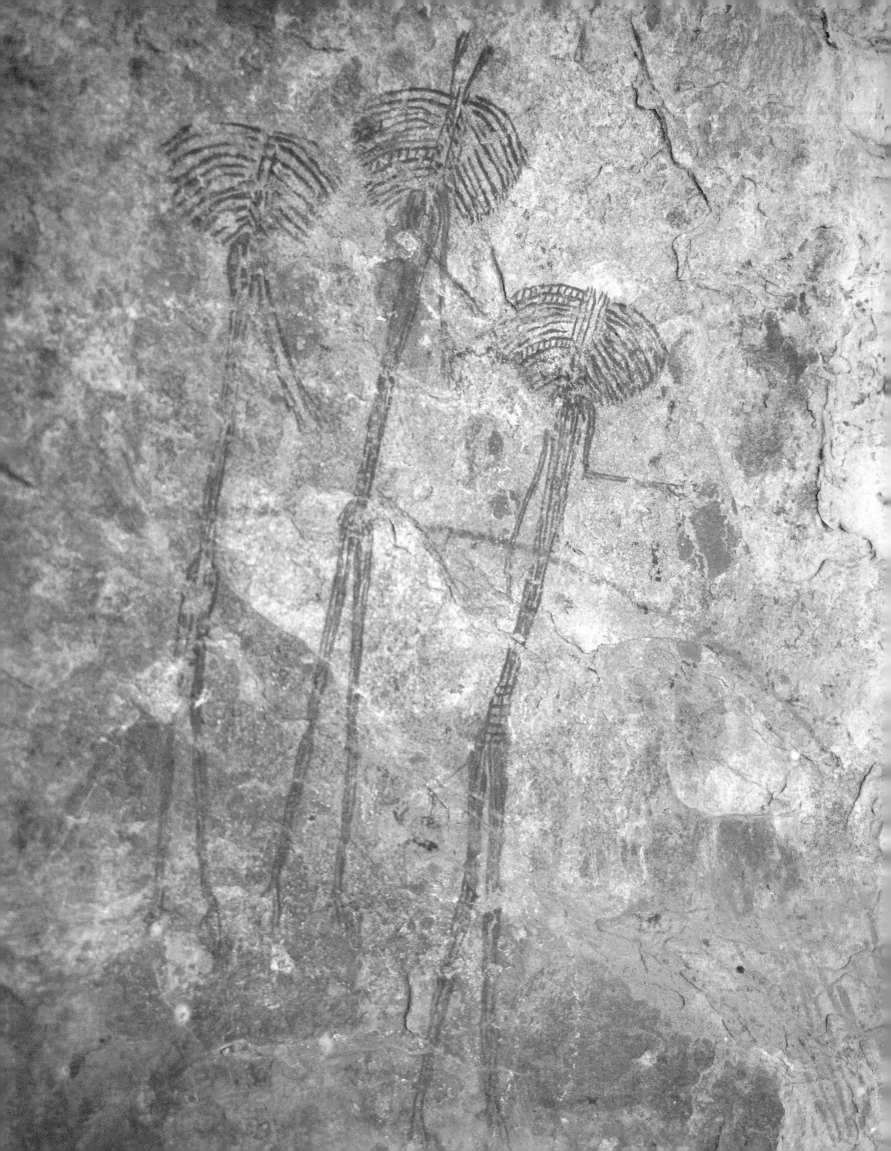

160

161

OPPOSITE FIG. 159 **Three schematic human figures in a large hillside shelter in central Tanzania. These figures of humans and animals formed by use of multiple thin parallel lines appear to be unique to this area. The shape and formation of heads suggest either head-dresses or elaborate hairstyles.**

FIG. 160 **A dancing figure found near Kolo, Tanzania. The body is painted in solid red and the head is outlined and filled in with closely hatched lines. The feet, are small, slender, and arched. Mary Leakey has speculated that these may represent mythical figures.**

FIG. 161 **This painting from central Tanzania of a woman with a round head wearing a dress, and possibly a wig, is similar to paintings found in Chad. The date is unknown.**

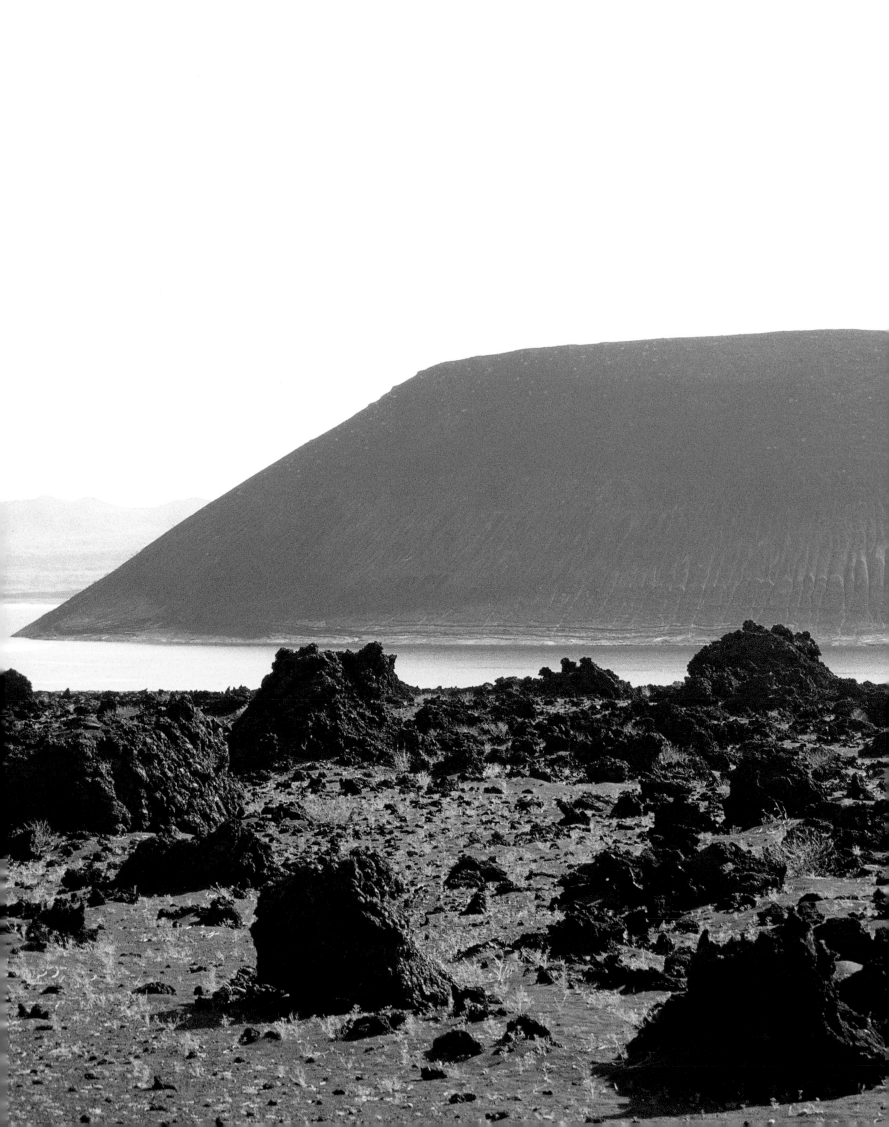

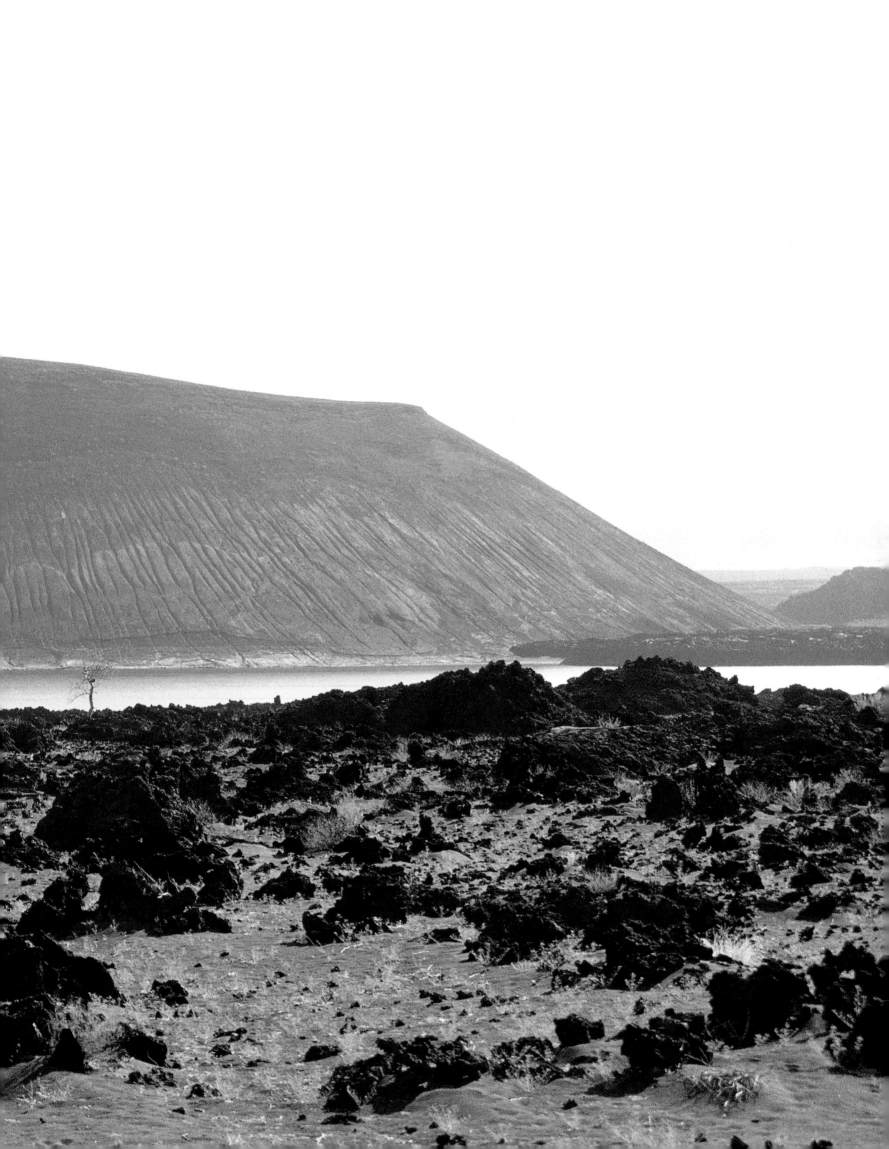

FIG. 163 **Engravings on rocks and on stones placed on human graves (dated to 2,300 years ago) near the south end of Lake Turkana. Local Pokot and Samburu peoples recognize the symbols as their lineage markers but deny authorship of the engravings. Turkana pastoralists still sometimes inscribe these symbols on the hides of favorite cattle and camels (fig. 171). (Drawn after Mark Lynch.)**

peoples and shown that geometrics were made by women for controlling the weather. He bases his hypothesis on a comparison of these geometric designs with those of neighboring modern Pygmy women made on bark for the purpose of affecting the weather. The designs are so similar that there is little doubt this hypothesis is correct.

PASTORALIST PAINTINGS

Pastoralist paintings are very rare with two known sites in Kenya and other possible sites in Malawi. They involve small outlines, often filled in, of cattle and occasional schematic designs painted in black, white, gray, yellow, and sometimes in both red and white (fig. 168). Pastoralist paintings mainly were made during the period from 3,200 to 1,800 years ago and ceased to be painted after Bantu-speaking peoples had settled in eastern Africa.

Similar paintings have been found in Ethiopia (fig. 155) but not in southern Africa, which suggests the artists had a northern origin. Possibly, they were pastoralists from the area of the middle Nile who moved south as the population increased with immigrants from the western desert escaping the Sahara's escalating desiccation.

LATE WHITE PAINTINGS

Late White paintings are attributed to Bantu-speaking, iron-working farmers who entered eastern Africa about 2,000 years ago from the west. In their travels from their original homeland on the borders of Nigeria and Cameroon some of them filtered through areas occupied by

Twa, from whom they may have learned the use of symbols painted on rock, on skin and bark cloth, and in sand.

The paintings are usually white or dirty white, painted with the fingers rather than a brush, and are often quite large, crude representations of wild animals, mythical animals, human figures, and numerous geometric motifs, including a variety of patterns made from rectangles, curves, circles, zigzags, series of dots, and other flowing designs (fig. 158). Chewa peoples, Bantu-speakers who live in modern-day Zambia and Malawi, say their ancestors made many of the more recent paintings for use in rites-of-passage ceremonies (fig. 275). Chewa paintings may well help us interpret similar art in other areas of eastern and southern Africa.

163

164

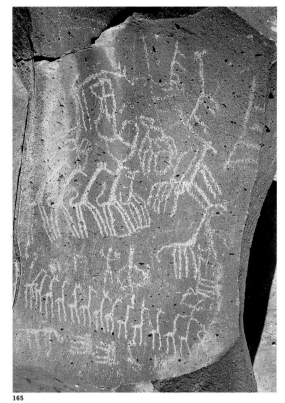

165

FIG. 164 A waterhole near Surima in northern Kenya. The river flows over a step, cutting a gorge through the basalt rock, and then falls down the eastern escarpment to flow into the southern end of Lake Turkana.

FIG. 165 Engravings of giraffe in a low basalt cliff on the old floor of Lake Turkana. These engravings, in a style reminiscent of the central Sahara, suggest ancient links to the north. This site was almost certainly under water until about 2,300 years ago, giving this as a maximum age for the engravings.

FIG. 166 The entire wall of this shelter in the foothills of Mt. Elgon, Kenya, is layered with paintings, many so faint that the paintings underneath are barely or no longer decipherable. The earliest paintings are in red and probably date to earlier than 2,000 years ago while later paintings are in white, brown, black, and yellow. Decorated sherds found in the shelter are similar to modern Teso pottery.

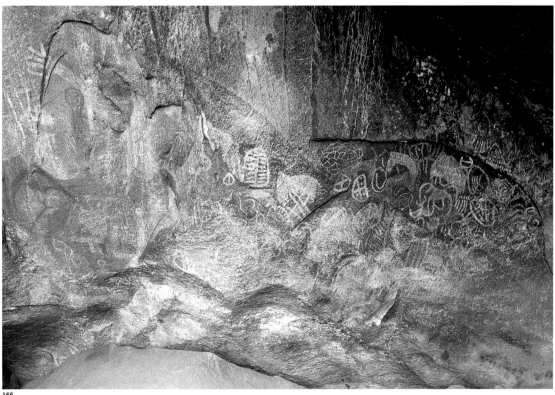

166

MEAT-FEASTING PAINTINGS

Adult male Maa-speakers (Nilo-Saharans who include the Maasai, Pokot, Samburu, and other eastern African pastoralists) are not permitted to eat meat in their homes; thus, they gather at small rock shelters in the bush where they kill and feast on animals, preferably cattle.

Maa-speakers burn symbols or brands into the hides of cattle and sometimes camels. Most symbols represent their owners' lineages, but they can also indicate an animal has been doctored for a particular disease. Different symbols may be used for male and female animals.

During or after feasting, they paint on the shelter ceiling in white—or, less often, red—the symbols of the animals they eat (figs. 171, 172). Over the centuries these symbols have been covered by soot from cooking fires and superimposed by more recent symbols until some shelters have acquired so many layers that the earlier ones are now indistinct or obliterated. Meat-feasting shelters exist from northern Tanzania through Kenya to Lake Turkana, where the practice of feasting continues to this day. Unfortunately, few have been recorded and their distribution has not been mapped.

HISTORICAL PERSPECTIVES

Tanzanian red paintings have many similarities with southern African fine-line rock paintings, leading some researchers to think they may be linked in some way: both involve similar subject matter, portray naturalistic animals with twisted perspective, use similar colors and fine-line techniques, and reflect a few similar styles. However, Zambian Twa red animal paintings and geometric designs differ in many ways from both Tanzanian red paintings and from the fine-line paintings of southern Africa; thus, this Zambian rock art forms a barrier stretching across Africa, clearly dividing the art of north and south. Benjamin Smith points out that, although it is not known how old this barrier may be, it means that if a connection between the art of southern and eastern Africa does exist it is from such a long time ago that interpretations used for explaining southern art cannot be applied in the same way to eastern art.

FIG. 167 This tall rock, standing on a granite outcrop in eastern Uganda, is well known as a rainmaking site. The paintings, all in red and covering about 85 square feet (8 square meters) near the people at bottom left, consist of numerous geometric designs, such as squares and ovals containing grids, concentric circles, curved and crossed lines, and elongated ovals. Under the south side of the boulder, the edge of a thin protruding shelf of granite (visible at bottom right) has been ground smooth in three places, possibly by dragging a skin across it, and is reported to be a rock gong.

167

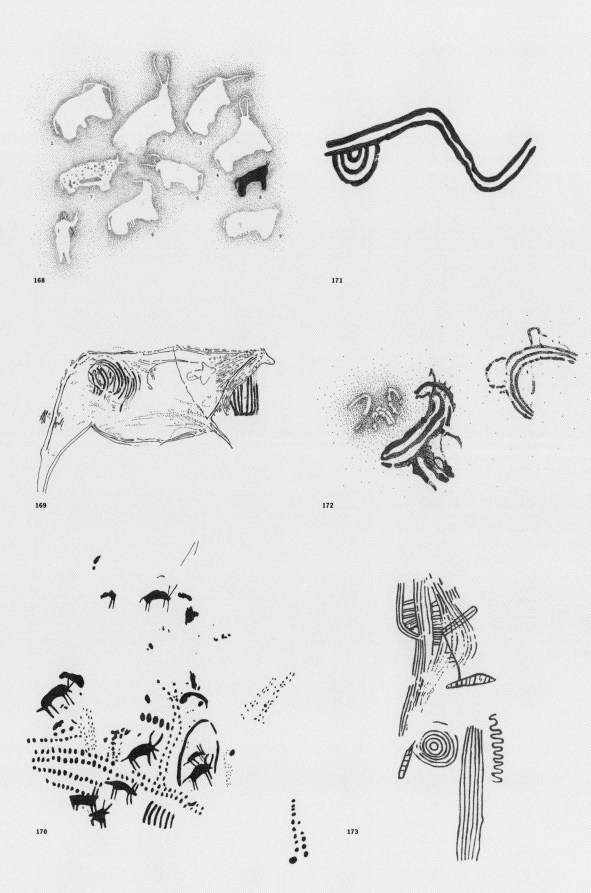

FIG. 168 Paintings of cattle, here drawn as a group, are scattered over a shelter wall on Mt. Elgon, Kenya. Cattle nos. 1–6 are drawn in white, no. 7 in white and red, and no. 8 in red. The human figure is drawn in white with a red head. Note the similarities between these cattle and those in fig. 155 from Ethiopia. (Reproduced from a tracing by Graham Boy.)

FIG. 169 A painting in red of a stylized animal from Zambia. Note the geometrics, one superimposing the animal's hip and the other underlying the neck. (Redrawn after Willcox, 1984.)

FIG. 170 Fairly large stylized paintings in red of animals and dots attributed to Twa. Benjamin Smith, who made the tracing, says, "The careful but simple style is so typically and uniquely Zambian. It hides the subject but suggests a purpose." (Reproduced from Smith.)

FIG. 171, 172 Paintings in white on cave roofs in northern Kenya. These symbols are probably "brands" on cattle killed and eaten at a Maa meat feast.

FIG. 173 A geometric painting in red, which has been described as a pregnant woman, from northern Malawi. It can most likely be attributed to the Twa. Note similarities between this and other geometrics found in eastern Uganda. (Redrawn from Desmond Clark in Summers, 1959).

168

171

169

172

170

173

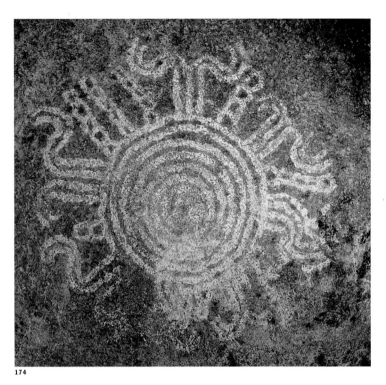

174

FIG. 174 A decorated nest of concentric circles on the underside of a toppled rock, supported at both ends to provide a shelter, high on a granite outcrop in eastern Uganda. Other similar, although less intricate, paintings in red and white surround it. The custodian told us that, as a child, he had heard that the site had been used until recently (about 1890) as a place for making rain.

FIG. 175 This shelter wall in eastern Uganda bears two major painted panels, both involving concentric circles and what have been described as "people sitting in canoes." Bold lines of the paintings are executed in red, while chalky white pigment once filled in the outlines of the canoes, people, and sometimes concentric circles; however, now rain seepage has washed away or spread much of it. The site has been excavated, but nothing was found to help date the paintings.

FIG. 176 A freehand copy of engravings on a pavement in Zambia. These engravings have been attributed to the last millennium, although they are similar to red geometric paintings thought to be Twa in origin. (Redrawn from a photograph taken at an oblique angle by J. H. Chaplin.)

176

175

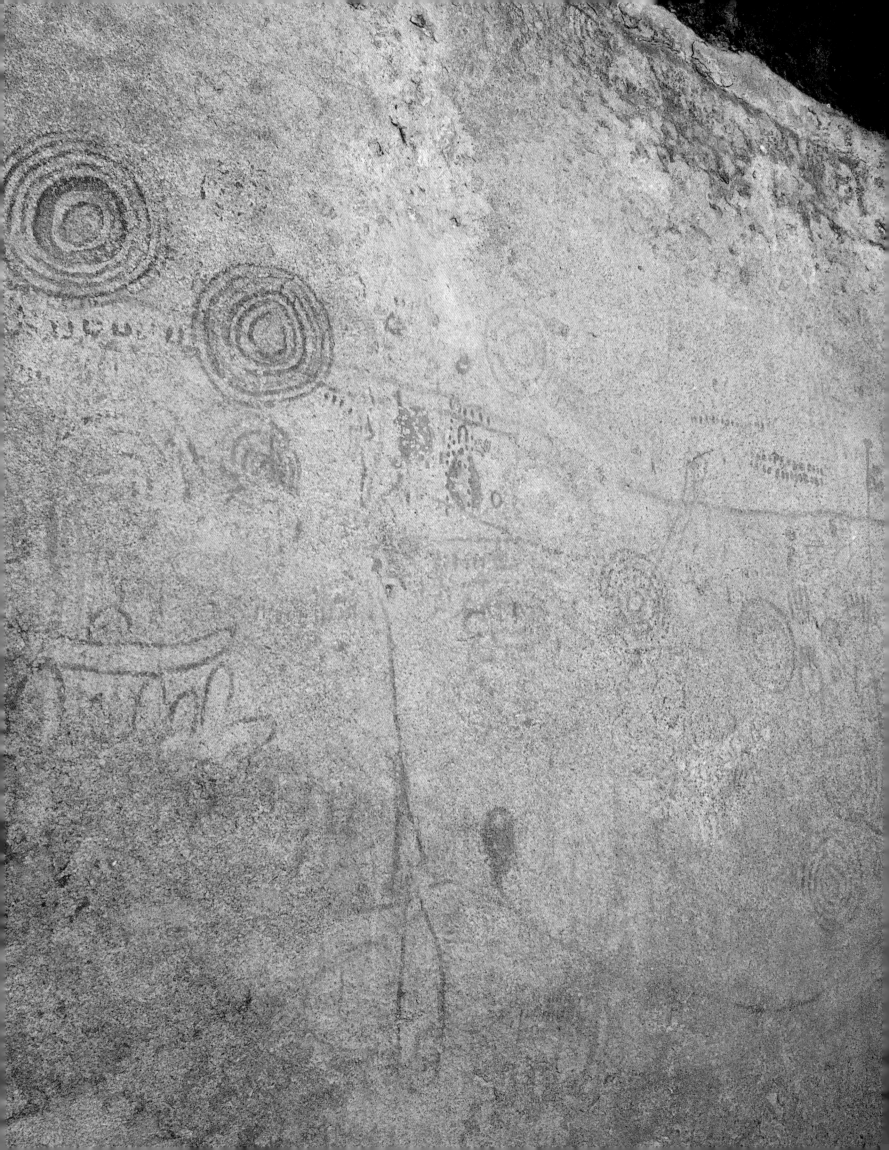

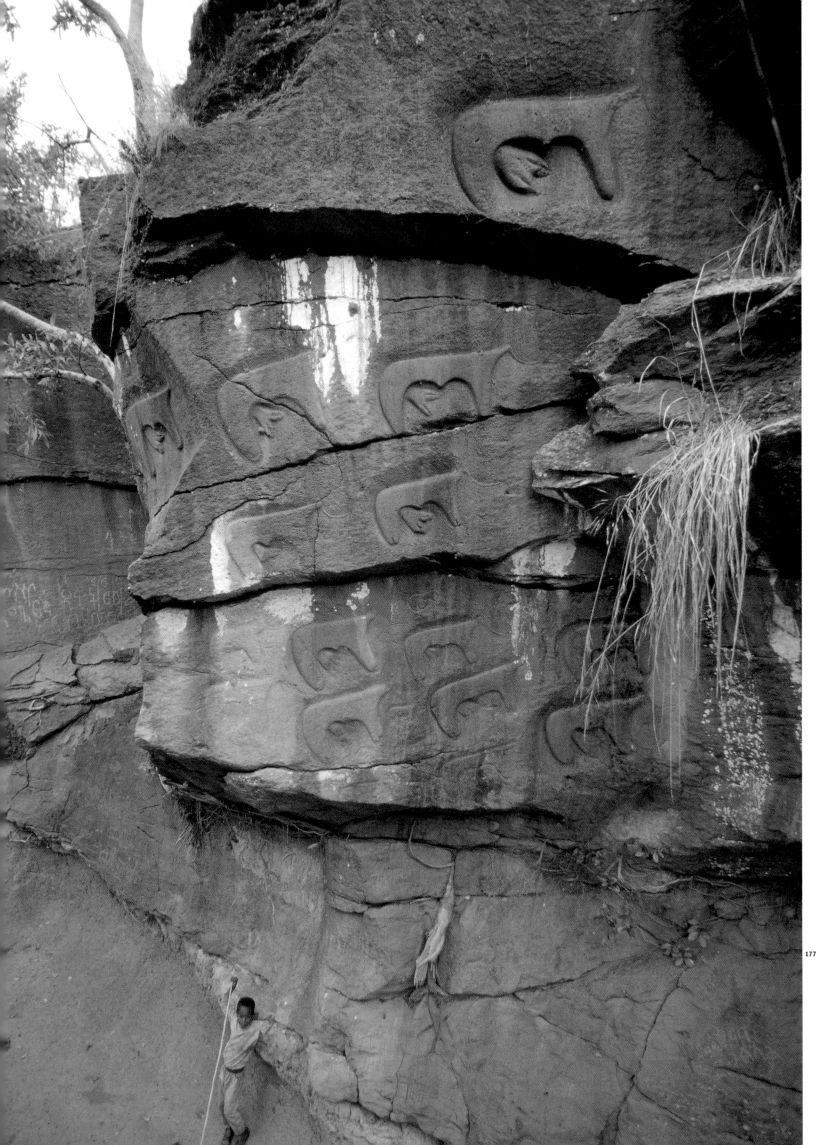

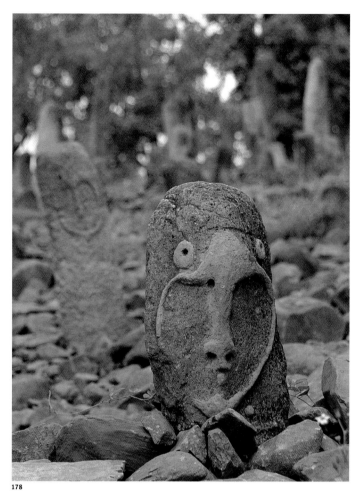

178

FIG. 177 **Around 50 images of cattle are engraved in bas-relief into the sandstone wall of a gorge in the Sidamo region of Ethiopia. All the engravings face the right and the cows' udders are prominently displayed. Similar engravings of cattle, all close to flowing water, occur at five other known sites in the area, although not in such large numbers. The engravings are somewhat similar to paintings of cattle in Eritrea, Djibouti, and Somalia and may be 3,500 years old.**

FIG. 178 **About 300 stelae, some 6 feet high (about 2 meters), are fixed into a thick carpet of stones on a hilltop near the town of Dillo, southern Ethiopia. Each stela appears to mark human burials below the stones. The stela with the anthropomorphic face has recently been repaired and reerected. People living at the site ask its spirits for good harvests.**

FIG. 179 **This funerary megalith, carved in rhyolite, was moved from the Shoa District in Ethiopia to its present position in the gardens of the Cultural Museum in Addis Abeba. It stands about 8 feet high (2.4 meters) and is decorated with swords and geometric designs that may relate to the deceased on whose grave it originally stood. Some 200 cemeteries containing these funerary stelae have been found in southern Ethiopia and date from the tenth to fourteenth centuries.**

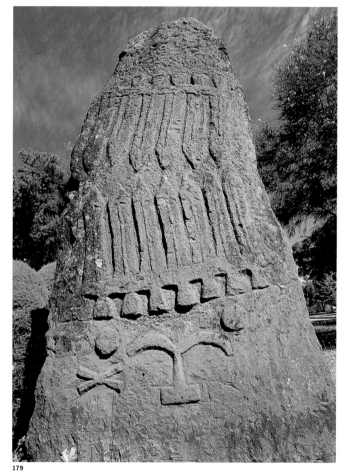

179

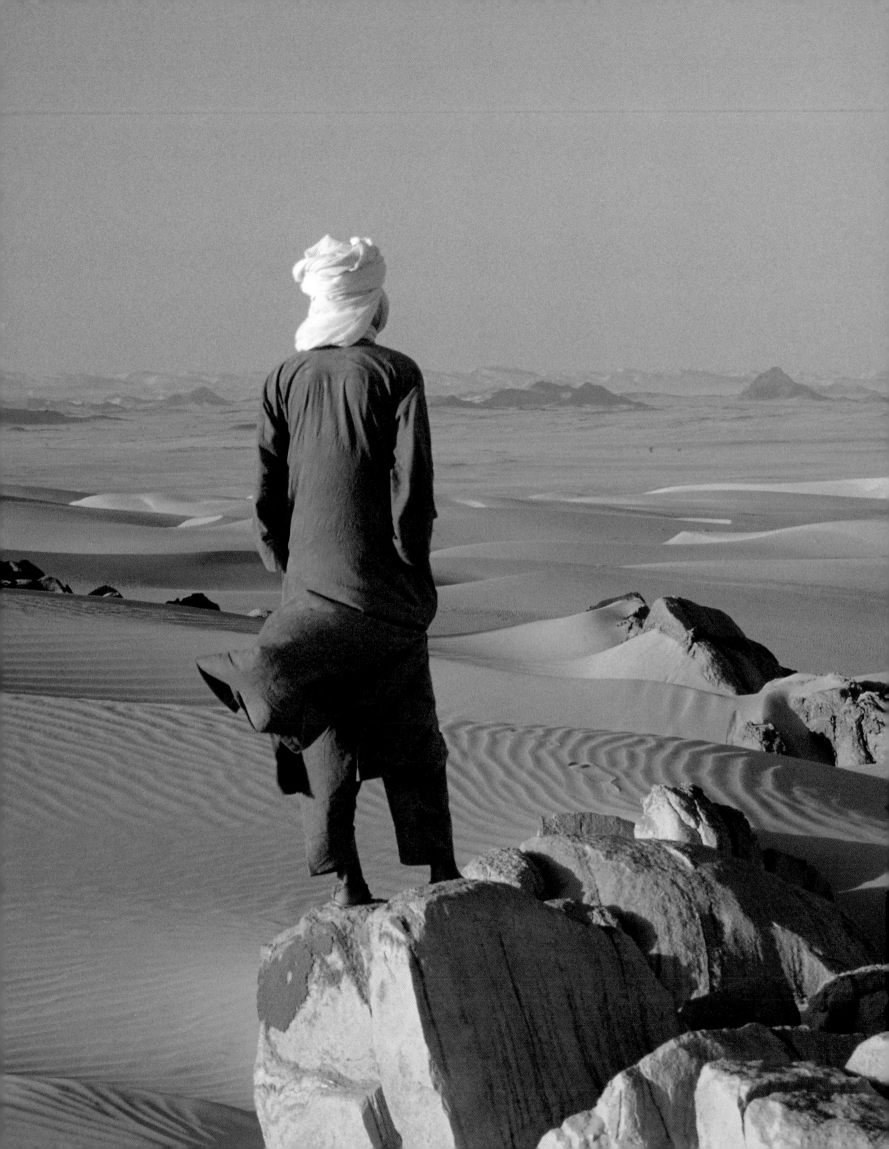

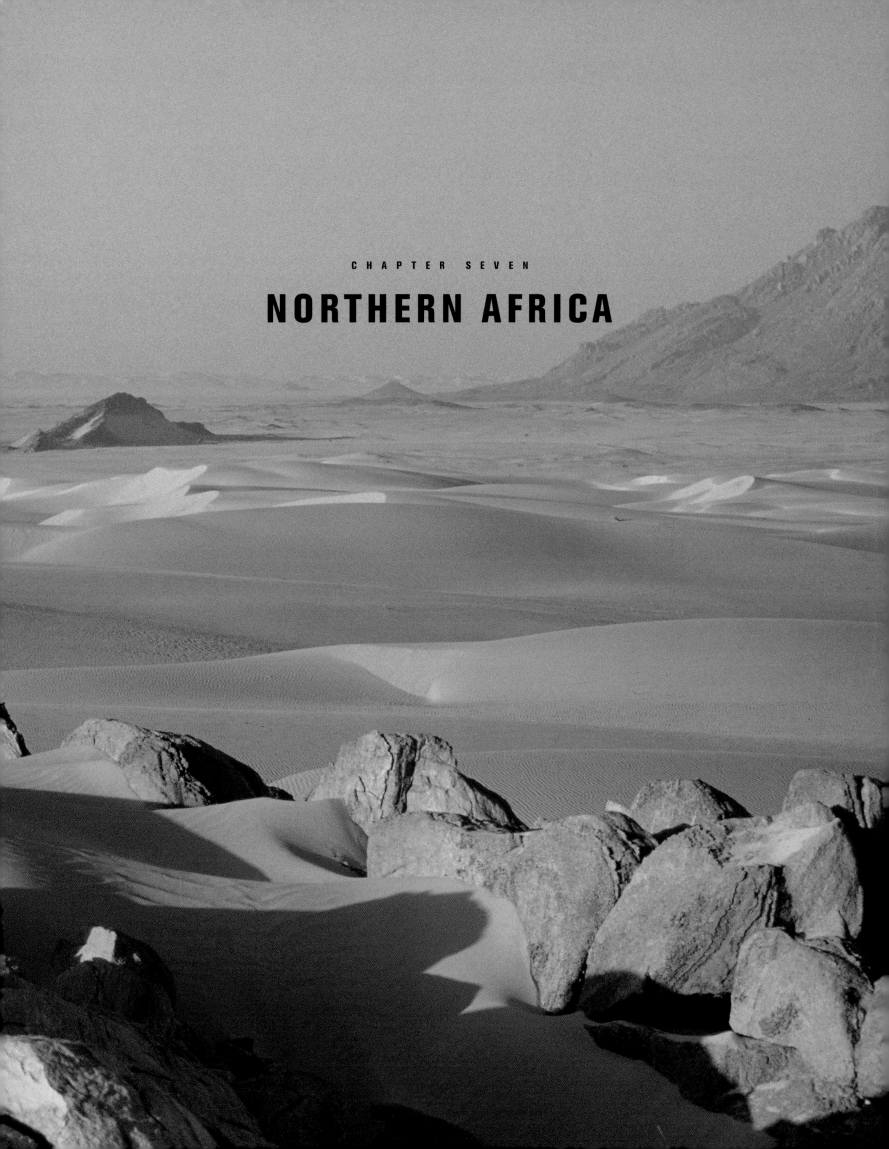

CHAPTER SEVEN

NORTHERN AFRICA

PRECEDING PAGE FIG. 180 **A Tuareg gazes across Ténéré Desert in Niger. In Temasheq Ténéré means "nothingness within the desert." Along its western boundary with the Aïr Mountains, Ténéré is a maze of windblown dunes; but further east, it hardens into a flat plain stretching for 155 miles (250 kilometers) northward to the Djado Plateau and more than 370 miles (600 kilometers) to the Tibesti Mountains in Chad. Fossilized fish vertebrae found on the sand speak of wetter periods thousands of years ago.**

OPPOSITE FIG. 181 **A hunter with Negroid features, about 5.5 feet (1.7 meters) in height, holds an arrow in his right hand and a heavy bow in the left in Tassili n' Ajjer, Algeria. He wears a skullcap on his head and is followed by a heavy, but unarmed, person wearing a loincloth. A painting of a small antelope appears in the background. This scene has been ascribed to the early Pastoral Period.**

The Sahara is one of the most fascinating areas on earth, a huge dry land stretching across Africa from the Nile Valley almost to the Atlantic Ocean: a world of sand and rocks, mountains eroded by the wind, empty lake beds, endless dunes, and ancient river courses now long dry, the calcified bones of fish and crocodiles lying thinly scattered along their banks (fig. 182). Over hundreds of millennia, the Sahara's landscape has swung back and forth, shifting slowly from extreme aridity, its usual state, to intervals when the equatorial monsoons expanded northward, changing its face from dry desert to verdant pasture.

AS THE NORTHERN HEMISPHERE Ice Age peaked about 20,000 years ago, a long arid period struck the Sahara creating conditions similar to today's. Lakes and rivers dried up, some areas became very arid, while others still received sufficient moisture to maintain scattered human and wildlife populations, mainly in rockier terrain. Most large animals disappeared. After the Ice Age thawed, about 12,000 years ago, rains returned to the Sahara, vegetation slowly recovered, and large animals began to spread into areas that had, for thousands of years, been virtually bereft of life.

We know from excavated stone tools and human refuse that after the change in climate about 12,000 years ago, people again occupied much of the Sahara. In the central Sahara big grindstones (fig. 194) dating from about this time suggest humans were finding new uses for seeds, and microlithic stone tools found in many areas suggest new ways of utilizing resources and perhaps new ways of thinking. It was at about this time that foragers in the central Sahara started to engrave the rocks with pictures of animals. These engravings, sometimes several feet high, appeared suddenly, already exhibiting a degree of skill that leaves us wondering where and how the art commenced.

Who were these foragers living in the central Sahara 10,000 years ago? Earlier depictions of human figures are so schematized that no identification of race is possible; however, Fabrizio Mori has pointed out that some of the first naturalistic paintings, dated after about 8,000 years ago, include only images of people with Negroid features (fig. 181); no light-skinned people are depicted, suggesting that the artists were black.

About 10,000 years ago or less, pottery appeared, spreading from the middle Nile Valley as far west as Mali, although its advent did not herald the arrival of new peoples. A thousand years later, the aurochs, a huge wild Saharan bovid with forward curving horns (fig. 191), was domesticated in southeast Egypt. A short arid phase about 8,000 years ago may have started a westward movement of domesticated cattle, which had spread throughout much of the middle Sahara by 6,500 years ago.

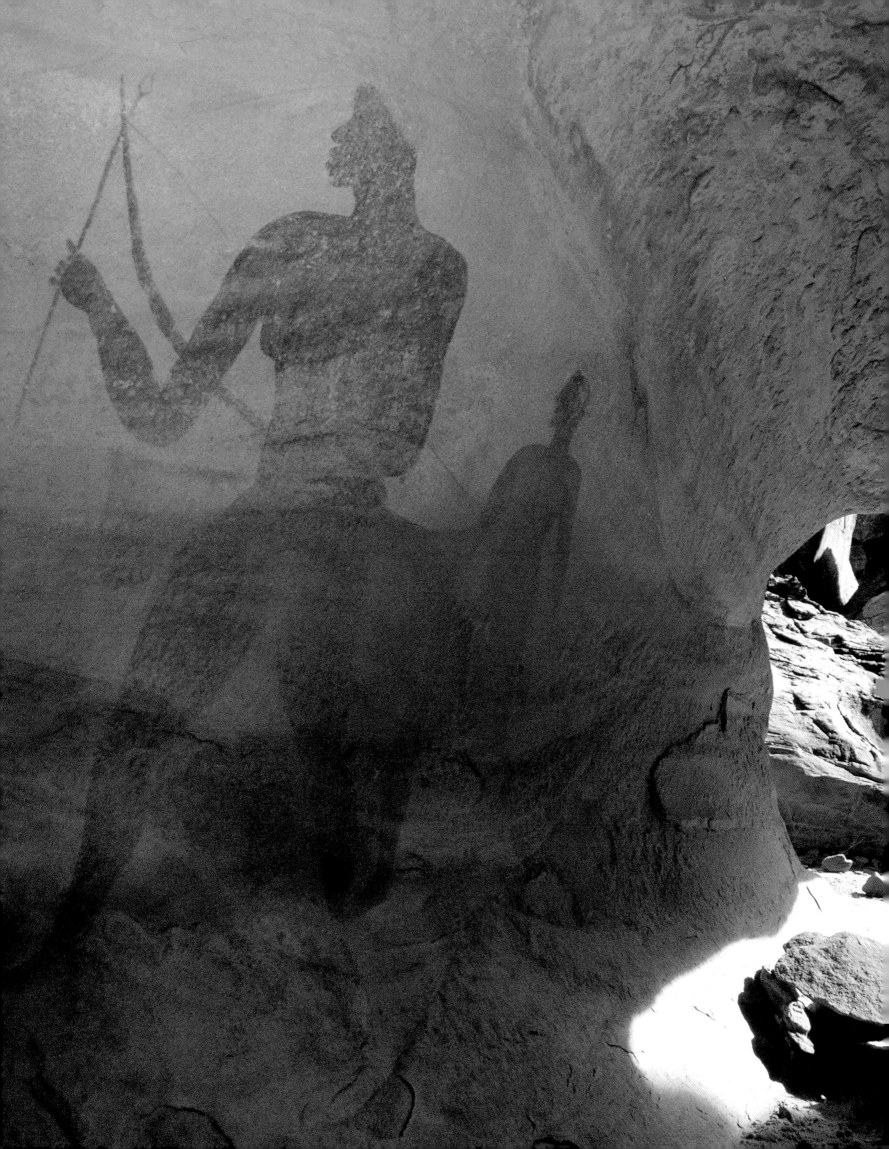

FIG. 182 Carved just below the top of a flat rock in the Messak, Libya, this amazing crocodile appears to swim on the water's surface. The engraving belongs to the Bubalus Period and could be 10,000 years old or more. Certainly, this crocodile must have been engraved during a wet period when large pools lined the Messak wadis and lakes lay below the plateau. The extra grooved eye may have been added below the original at a later date. The rock has already fractured in several places and is in danger of disintegrating. The crocodile is 7 feet (2.1 meters) long.

FIG. 183 A hippopotamus engraved in the Messak, Libya. Another unfinished engraving, below, may have been abandoned by the artist, or be a later copy.

183

182

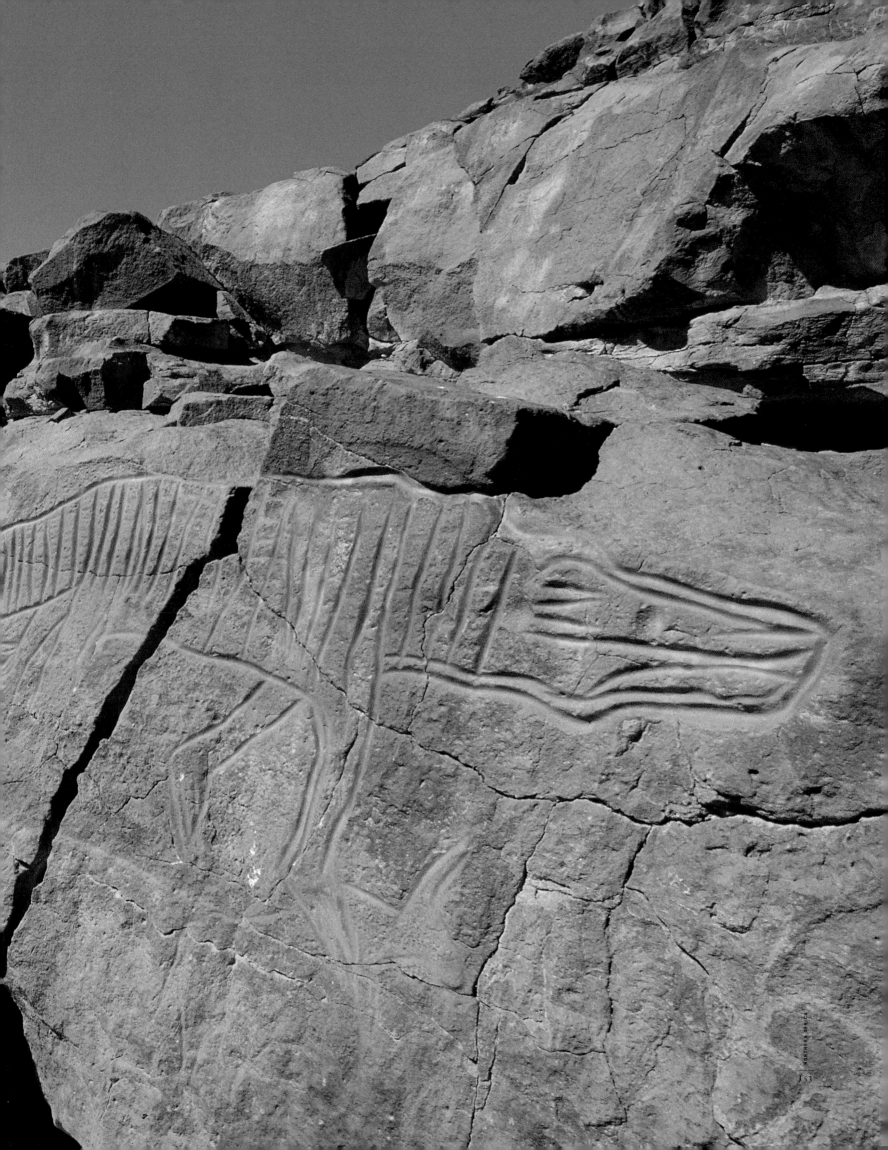

Small numbers of sheep and goats were introduced from the near east into Africa earlier than 7,500 years ago and they spread westward as well. We know that during this

184

FIG. 184 **Bifacial pressure-flaked arrowheads made of agate, tuff, chert, and obsidian lie scattered along the borders of the eastern Ténéré Desert and date to about 6,000 years ago when rivers flowed, lakes abounded, and grass covered the desert plain.**

FIG. 185 **A painting of a masked man, called by Henri Lhote "The Negro Mask," is superimposed over an earlier white Round Head figure. From Tassili n'Ajjer, Algeria, it is about 5 feet (1.5 meters) high. The mask has horns and ears similar to those of a cow, mushroom-shaped objects project from the shoulders and thighs, and a white loincloth hangs from the waist. The mask has been likened to modern Senufo masks of western Africa and the mushrooms are believed to be hallucinogenic, suggesting states of ecstasy and even shamanism. Its date is uncertain, but Lhote suggested that the masked figure belongs to the Round Head Period.**

time some people lived in small groups on rivers and lakes, where they fished and collected riverine foods, trapped small animals, and occasionally hunted larger species.

The climate remained relatively humid until about 4,500 years ago when a final arid period closed the Sahara to widespread pastoralism. Hardier peoples remained in rockier areas, but most took their livestock and started drifting south, following the retreating tsetse fly, or moved east onto the plains along the Nile Valley.

It appears possible, and even probable, that many of the peoples who moved south from the Sahara were ancestors of the once-nomadic Fulani, who today live across the Sahel, the semidesert southern fringe of the Sahara. Pastoral Period rock paintings in the Tassili n'Ajjer and Akākūs Mountains depict, in addition to Negroids, tall, light-skinned people, some with long, straight, braided hair (fig. 196) like that of modern Wodaabe (a pastoralist subgroup of the Fulani), and robes similar to those still worn by Fulani peoples. Even the paintings of reddish-brown cattle with long upsweeping horns resemble modern Fulani cattle (fig. 190). Among Tassili n'Ajjer paintings are images of masks and dancing dress (fig. 185) similar in style to those used by some western Africans today, although direct parallels have never been made.

The next important event for the Sahara was an invasion of the Nile Delta in 1680 B.C. by Hyksos warriors from southwest Asia. They conquered lower Egypt, introducing bronze working, metal weapons, horses, and wooden, horse-drawn chariots. By 800 B.C., Lybico-Berber–speaking peoples living around the

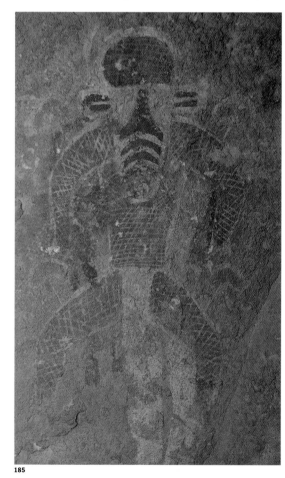

185

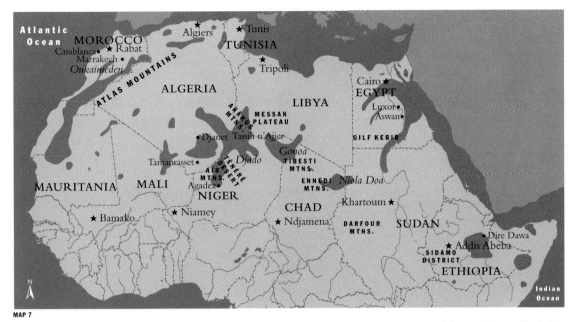

MAP 7 **Rock art in northern Africa.**

MAP 7

Fezzan of modern Libya acquired chariots and metal weapons. These wild peoples, called the Garamantes, were armed with spears and are said to have driven their chariots (figs. 244, 249) westward through the Sahara, fighting, robbing, and trading their way far into the desert. Herodotus describes how Garamantes slaughtered troglodytes, whose language sounded like the "screeching of bats," whom they found living in the desert. The identity of the troglodytes is uncertain, but they were probably remnant groups of forager populations.

However, chariots were not to last. Difficulties of dragging wheeled vehicles through sand and rocks soon saw them replaced by riding horses (figs. 245, 250) and eventually domesticated camels, which were led into the Sahara (figs. 195, 227) about 2,200 years ago or earlier. Strong and able to live for weeks without water, by 500 A.D. the camel had spread far to the west and had become the main means of desert transport and a highly valued possession of all pastoralists. Even today, caravans involving a thousand or more camels still cross Niger's Ténéré Desert, transporting salt southward to the Sahel, and grain in the opposite direction (fig. 199).

THE ROCK ART

Why the practice of rock engraving apparently started in the central Sahara is still unknown. Perhaps, as humidity increased after the long arid period and large animals started to reappear, the improved climate may have prompted new attitudes toward nature and allowed man wider opportunities for expressing his most profound feelings. In any case, small groups of foragers began to engrave in rocky and wetter areas.

Experts generally agree on five major art periods, but argue over the commencement date and whether the five periods follow in linear progression or tend to overlap each other; they almost certainly overlap. There appears to be little doubt that an early period, when foragers made large engravings depicting wild animals, commenced after Saharan conditions began to

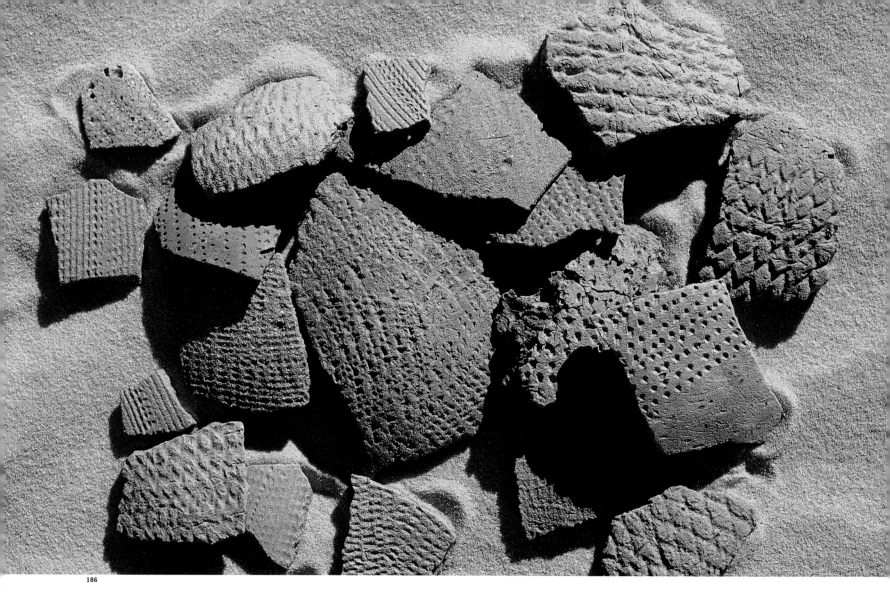

186

FIG. 186 **Many sites in the Sahara are called Neolithic because the presence of pottery led some researchers to believe that food production had by then commenced. In fact, pottery spread throughout the Sahara from the middle Nile some 10,000 to 9,000 years ago, before the advent of pastoralism and crop growing. Pottery sherds, stone arrowheads, millstones, and chipped rock are scattered in areas extending sometimes over several acres. The pottery illustrated here was found at a site on a dune in the western Ténéré Desert.**

improve about 12,000 years ago. Changing climate and the adoption of pastoralism by some people caused succeeding changes in the art.

ART PERIODS	APPROXIMATE TIMESPANS
Bubalus Period	12,000 to 8,000 years ago
Round Head Period	10,000 to 8,000 years ago
Pastoral Period	7,500 to 4,000 years ago
Horse Period	3,000 to 2,000 years ago
Camel Period	2,000 years ago to the present

The earliest period, known sometimes as the Large Wild Fauna, or Early Hunter Period, or Bubalus Period (Bubalus was a giant buffalo that became extinct about 5,000 years ago; fig. 207), probably commenced about 12,000 years ago or somewhat earlier and was the work of foragers. In the central Sahara, huge engravings of large animals depicted in a naturalistic manner exhibit a wonderful knowledge of animal stance, movement, and anatomy, suggesting a close relationship between artists and subjects. Elephant, rhinoceros, buffalo, giraffe, antelope, hippopotamus, lion, and crocodile are all featured, while small human figures, apparently male and often holding boomerangs, clubs, axes, and sometimes bows, may appear in front of or behind animals, suggesting inferior importance (fig. 212). Bubalus Period art lasted for 4,000

years or considerably more and spread across the Sahara, although the magnificent large engravings of the central highlands were not replicated elsewhere.

The Round Head Period (figs. 201, 206) commenced slightly less than 10,000 years ago and lasted for 2,000 years or more. For the most part confined to the Tassili n'Ajjer and the Akākūs Mountains, the art consists of paintings, often of gigantic size—one figure stands more than eighteen feet high (fig. 263). A large proportion of Round Head paintings portray strange people with round featureless heads and formless bodies, sometimes appearing to float or swim through space as though experiencing out-of-body travel (fig. 204). Women are depicted with raised hands, as though seeking blessings from the huge male figures that tower above them (fig. 7). These seem to portray a gentle and ethereal world where man bows to the lords of nature. The Round Head artists were almost certainly foragers as no images suggestive of pastoralism are found in the paintings, nor have excavated domestic stock bones been dated to this period.

The Round Head Period seems to end shortly before the appearance of domestic stock in the central Sahara, perhaps 7,500, or more, years ago. Final phases include paintings of people wearing elaborate headdresses and decorative clothing (fig. 192), after which images of cattle begin to dominate both paintings and engravings (fig. 187).

The Pastoral Period (also called the Cattle Period) probably commenced about 7,500 years ago and lasted until the Sahara dried up, about 4,000 years ago or a little later. Dramatic changes

FIG. 187 **A late Pastoral Period scene with cattle and fine-featured people from Tassili n' Ajjer, Algeria. Three figures with elaborate hairstyles and loincloths stand, one drawing another toward a fourth, who is dancing, while a fifth reclines, watching the dancer. The figures are about 10 inches (25 cm.) high. An orange cow is circumscribed by an outlined larger animal. Henri Lhote noted the hairstyles and the actions associated with cattle and was told by a Fulani prince that the scene reflects a ceremony still practiced by his people living some 900 miles to the south. The painting may date to about 5,000 years ago or more.**

187

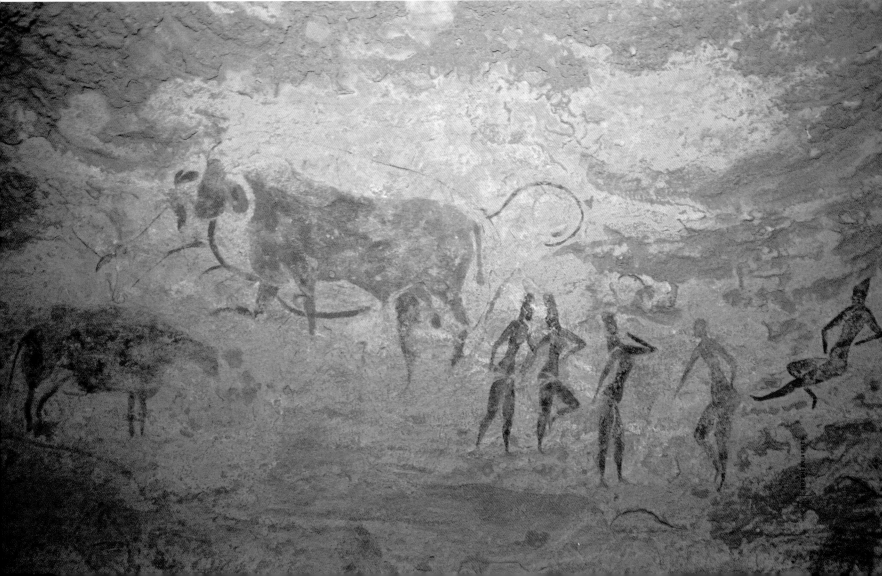

188

FIG.188 A painting of what appears to be a bear about 6 feet (almost 2 meters) long in Tassili n' Ajjer, Algeria. Bears are not known to have inhabited northern Africa, but an engraving of what may also represent a bear is reported by Rudi and Gabriele Lutz in the Messak, Libya.

FIG.189 A detail of fig. 190 showing a flute player painted in white.

FIG.190 Looking out from the back of a decorated cave in Tadrart, Algeria. A steep, 16-foot climb protects the cave from wild animals. Much of one wall and adjacent roof bear paintings of cattle and people. Visible in the top center, is a seated man playing a flute. Various artists may have painted here over a considerable period before the Sahara became desiccated.

189

190

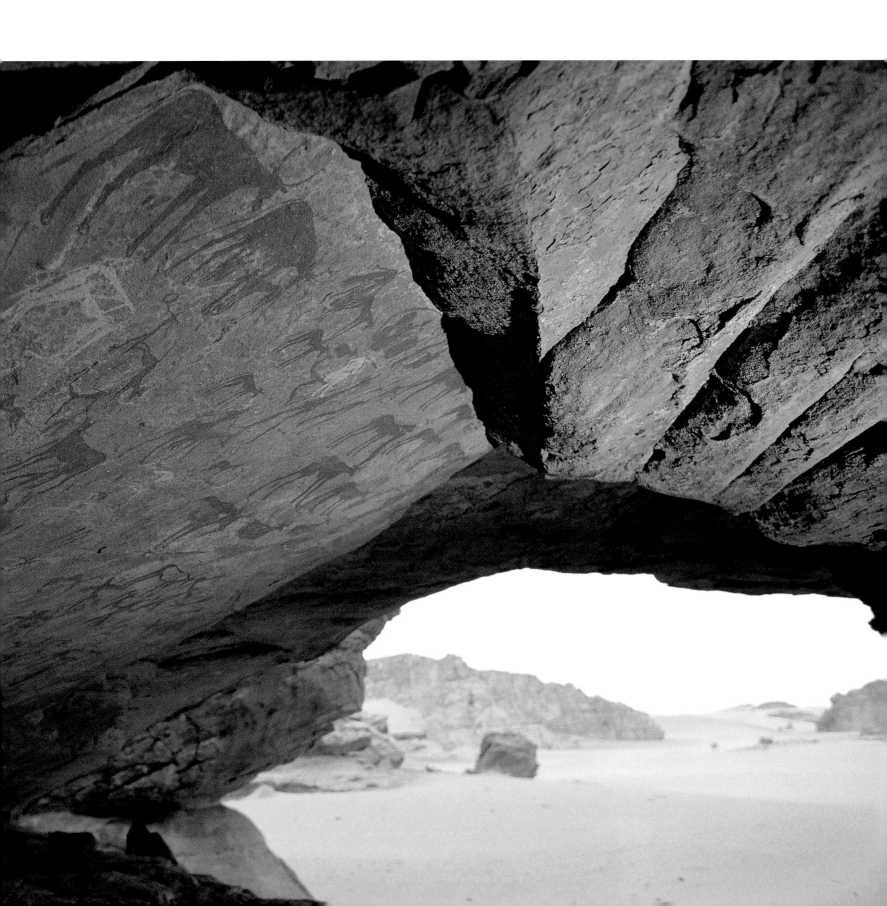

191

took place in the art that suggest changes of attitude toward nature and property. Man becomes much more important, and human figures play a central role in the art (fig. 187). Perhaps man is no longer a part of nature, closely allied to other animals, but is now above it and able to derive much of his sustenance from his stock. Both engravings and paintings continue to depict wild animals, but domestic stock, mainly cattle but also sheep and goats, predominate, expressing man's affinity with his beasts. Men are now armed with spears and bows, and domestic scenes, such as herding cattle and dancing, are more common. Unfortunately, artistic standards fall, and gone is the immense drama experienced in the pre-Pastoral art of the Bubalus and Round Head periods. Animals are drawn smaller and in more rigid styles, often lacking the details seen in earlier art. We cannot with any certainty identify the artists of the Pastoral Period. Some may have been descendants of foragers who acquired livestock while others could have been immigrants from the east and north spreading westward with their livestock.

The Horse Period commenced about 3,000 years ago in the eastern Sahara, spread west, and lasted about 1,000 years. It tends to depict horses and horse-drawn chariots (figs. 244, 245), warriors with metal weapons (fig. 257), and armed men mounted on flying horses. Wild animals are still shown, particularly giraffe, Barbary sheep, and ostrich, although on a much smaller scale, and cattle still form a considerable part of the art. Human figures are drawn in highly conventionalized styles: the bodies are often formed by two triangles joined at their apex, with round heads surmounted by three plumes (fig. 256), while spears have become the common weapon. Occasionally, the art is accompanied by statements in Tifinagh script, which suggests the art was done by Berber artists, although modern Tuareg are unable to read it. It is unknown how much of the art was merely communication or whether it served some unrecognized purposes.

It is still not absolutely certain that actual chariots were driven along the routes where their depictions occur, from the Fezzan in Libya through the Aïr of Niger into northern Mali and then westward to the Atlantic coast: remains of chariots have never been found west of the Fezzan. There are more images of chariots west of the Aïr Mountains than to the east, and it could be that chariots were first transported westward by boat and then driven inland before being manufactured in northwestern Africa. Or, it may have been merely the chariot symbols that were carried westward; the artists may never have actually seen the vehicles themselves. If this is the case, chariot symbols must have had some special meaning for the artists' communities.

The last rock art phase, the Camel Period, commenced in the eastern Sahara some 2,000 or more years ago and, spreading westward, has lasted until the present day. Although images of horses and cattle still occur in decreasing numbers, the major theme in both engravings and paintings is the camel. Earlier paintings are often beautifully executed, depicting white camels almost flying above the sand bedecked with red trappings and ridden by spear-brandishing warriors (fig. 226), but the artistic standard deteriorates steadily, and later engravings are often crude, portraying little other than camels, sometimes mounted. The drawings of human figures deteriorate even further and many are merely faceless caricatures. Swords appear quite early in the period, followed by firearms. Camel Period engravings seem to be little more than statements of fact,

192

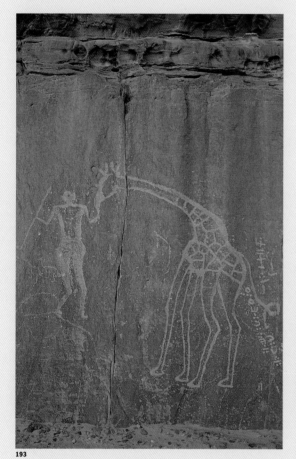

193

FIG. 192 Three separate but linked panels of figures from Algeria. A thin line, now barely visible, joins the left panel to the central panel with the tall male and smaller females with breasts. The right panel shows a female in the background and two men bent forward. The scene may represent stages of a dance culminating (with the bent-forward figures on the right) in a state of trance. The date is uncertain, but Henri Lhote places the scene in the Round Head Period, describing it as, "Evolved and with Egyptian Influence." If it does belong to the Round Head Period, earlier than 8,000 years ago, then the painting predates Egyptian art and the influence, if any, would have been from the central Sahara to Egypt.

FIG. 193 A large engraving of a man with a spear holding a giraffe by its tongue in Tadrart, Algeria. A number of guineafowl (two of which are visible) and an elephant, which were possibly inscribed later, are below the man to the left. On the right, a vertical column of Tifinagh script parallels the giraffe. Associations between man and animal do not necessarily imply domestication; they could reflect a religious or mythical association. The metal spear and script date the engraving to less than 3,200 years ago.

FIG. 194 A broad wadi extends to the sandstone cliffs, Tadrart, Algeria. A freestanding rock with a ground hollow like a huge mortar, stained red inside, is surrounded by chunks of red hematite and pottery fragments. Clearly, red pigment has recently been prepared here, but the hollowed stone, known as a kettle, could be 8,000 years old and was perhaps originally made for a different purpose.

194

such as "a caravan halted here," and many of the more recent works could well have been inscribed by children. However, the earlier paintings, which evince an atmosphere of both movement and serenity and display considerable artistic skill, may be more than just drawing for the sake of communication.

From the Tifinagh script and subject matter, we can assume that the artists were ancestral Tuareg who, since the general exodus began more than 4,000 years ago, have most likely been the major inhabitants of the Sahara together with a few remnant hunter-gatherer groups. We believe they were responsible for some of the art as most of the Tifinagh inscriptions occur with, rather than as graffiti on, the engravings.

A stratified, pastoral, nomadic people who raised camels, small stock, and sometimes cattle, Tuareg kept large numbers of slaves, which freed them from most domestic and pastoral chores. They extracted tribute from subservient peoples, provided armed escorts to caravans, or else plundered them, raided their neighbors, and lived on milk, meat, wild food, and grain either harvested or traded from the south in exchange for salt, which was gleaned from the few remaining lakes.

Tuareg were converted to Islam in the eleventh or twelfth century; it remains unclear whether they practiced Christianity before their conversion to Islam. Traditional Tuareg religious beliefs are uncertain but probably involved the forces of nature and a goddess of fertility named Tanit, although they may once have had a polytheistic system (fig. 222). They believe in good and bad spirits who inhabit particular areas and cause trouble, and sometimes practice the sacrifice of sheep. Francis Rodd, who visited Aïr in the early 1920s, wrote that the most powerful spirits are identified with certain Aïr Mountains.

Tuareg are believed to be descendants of pastoral Berber with some admixture of Nilo-Saharan and Phoenician blood (fig. 12). Ancestral Berber-speakers probably entered Africa from southwest Asia 7,000 or more years ago, settled first in Libya, and then spread along the north African coast. From there some moved southward onto the plains and highlands of the Sahara, where they practiced a pastoral economy and came into contact with black Nilo-Saharans, who also were stock raisers.

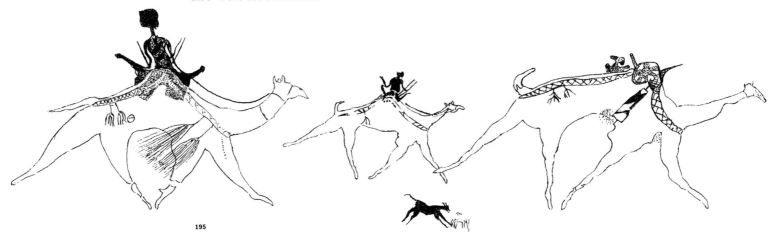

195

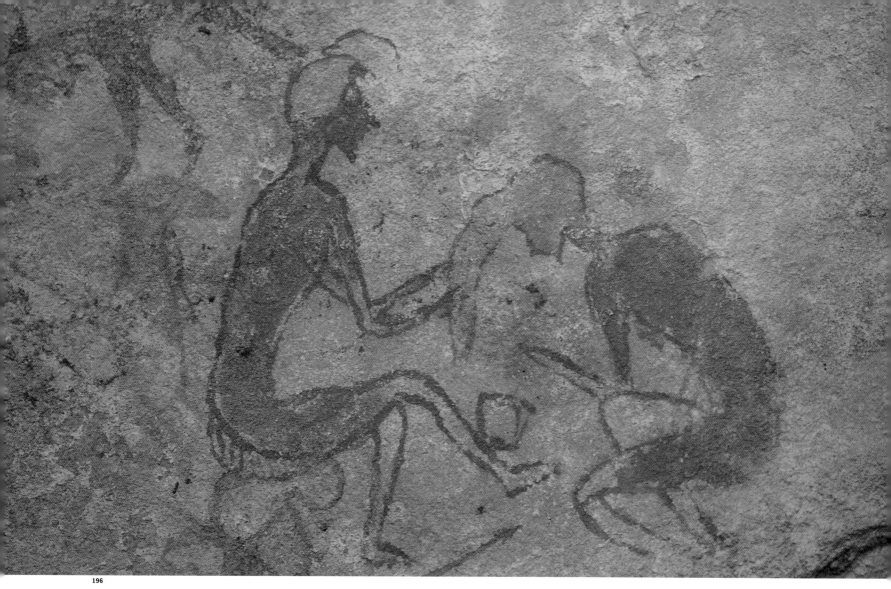

196

When the Sahara began to dry up about 4,500 years ago, some Berber moved further south into the Sahel, where they intermarried with Nilo-Saharans, while others slowly withdrew into wetter areas, particularly the rocky highlands of the central Sahara and southern Morocco. When the Phoenicians began to settle the northern African coast, about 3,200 years ago, some Berber practiced a farming economy along the more humid Mediterranean coast, while Saharan Berber were mainly pastoralists. The Phoenicians came to control the coast and coastal Berber, and to organize tribute and trade with the pastoral Berber of the Sahara. Today the name Berber is applied to certain peoples of Caucasoid stock who speak related Afro-Asiatic languages. The Tuareg language, Temasheq, has a written form called Tifinagh, meaning "characters," that may have originated in southwest Asia, influenced by Phoenician script.

CONCLUSIONS ABOUT SAHARAN ART

Vast records of northern African rock art have been compiled, styles defined, and chronologies prepared, but what conclusions can we draw about the artists and the meaning of their work? These are questions that have vexed researchers for more than half a century and led most of the less adventurous to stick to recording art rather than attempting to interpret it. Yet some conclusions and interpretations have been made. For instance, although researchers continue to argue among themselves over certain points, there now appears to be little doubt of the following points.

FIG. 196 **Hairdressing in the Akākūs Mountains, Libya. This painted scene of a seated man working on the hair of a figure crouching before him reflects the lifestyle of modern Fulani peoples, particularly the Wodaabe of Niger, who dress their hair in similar manner, and may link the paintings with their ancestors. Fabrizio Mori has dated the painting to 6,000 years ago, but a spear with what appears to be a metal blade lying between hairdresser and client could indicate a more recent age.**

FIG. 197 **A painting from eastern Chad, probably less than 3,000 years old, depicting three women wearing dresses and elaborate hats standing to the left of a cow. Below, a woman with a similar hat stands to the left of a horse and foal that are marked like cattle. The relationship between women and female domestic animals appears to be intentional.**

The earliest known rock art, made by foragers in the highlands of central Sahara, involves large engravings of wild animals, dates back 12,000 years or even more, and was a spontaneous initiative. The art often had magnificent simplicity of line and expression, portraying the essence of its subjects rather than their formal shape, a simplicity recognized and adopted by modern masters.

Over time, artistic practice spread from the central Sahara westward to the Atlantic coast and eastward to the Nile Valley, and was probably a base from which some Egyptian art arose. Egypt was not the exporter of an art tradition to the Sahara.

Early forager art was symbolic, not necessarily portraying the obvious. In particular, Round Head Period paintings make us sharply aware that those early artists had highly developed concepts of reality and moral values, even though it used to be believed that they were merely primitive hunter-gatherers.

The art reflects succeeding changes in human attitudes toward the natural environment, from self-recognition as man forming a part of nature to recognizing man's position above and outside nature. Exactly what influenced these changes remains uncertain, but altering climates, introduction of pottery, and shifts from purely forager to pastoral and agricultural economies must all have played their part. Over time, the powerful drama of the earlier art deteriorates as it becomes more naturalistic and mundane.

Underlying conceptions of Saharan rock art forms spread south to influence the plastic arts of Negroid western Africa, while styles of cattle paintings spread to the Nile and were then taken south along the Great Rift into Kenya; however, Saharan art forms in general never spread south of Lake Turkana.

197

Such conclusions tell us something about the development of northern African art, but little about its interpretation, an area in which northern and eastern African research lags behind work being done in southern Africa. While we recognize that interpretation of earlier art forms will always reflect guesswork, we believe too little use has been made of Tuareg, Tubu, and Fulani ethnographies and that greater study of these applied to recent rock art might prove fruitful.

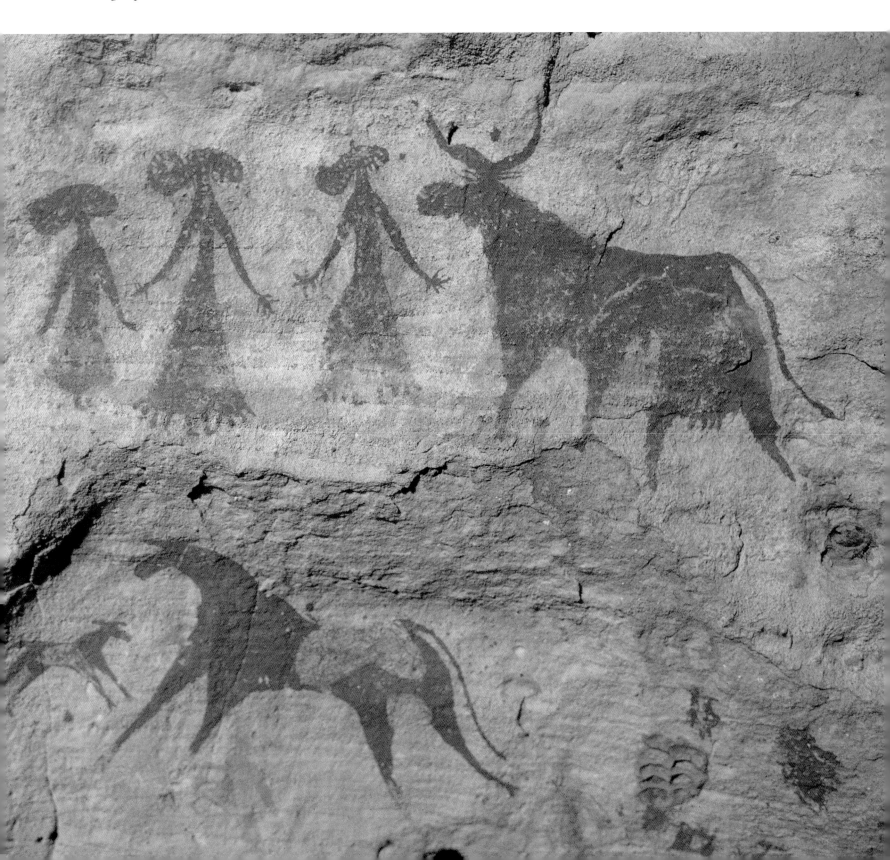

198

FIG. 198 An 80-foot-high sandstone arch, given scale by the tiny
figure, frames columns of rock, fluted by rain during wetter times.

FIG. 199 Camels in caravans are roped nose to tail in long strings. Lead camels set the pace
and slower animals are forced to keep it, sometimes traveling from afternoon to just before
dawn. Some carry loads of fodder for the journey, but the water is for the people
only: camels manage the 370-mile (600-kilometer) journey without it.
This caravan numbered about a thousand strong.

OVERLEAF FIG. 200 On the right, a larger than life-size man holding a triple-bent bow faces
six other figures, from Algeria. One figure is seated, holding the foot of another figure, who
is apparently swimming. Above, the largest figure, wearing a headdress with four spikes,
appears to fly through space. On the left, two figures in red, facing in opposite directions,
stand somewhat isolated from the main panel. Henri Lhote recognized negroid features
in the largest "flying" figure. The whole scene could symbolize natural figures involved in
supernatural experiences, which might include out-of-body travel. The paintings
belong to the Round Head Period and may date to nine millennia ago.

199

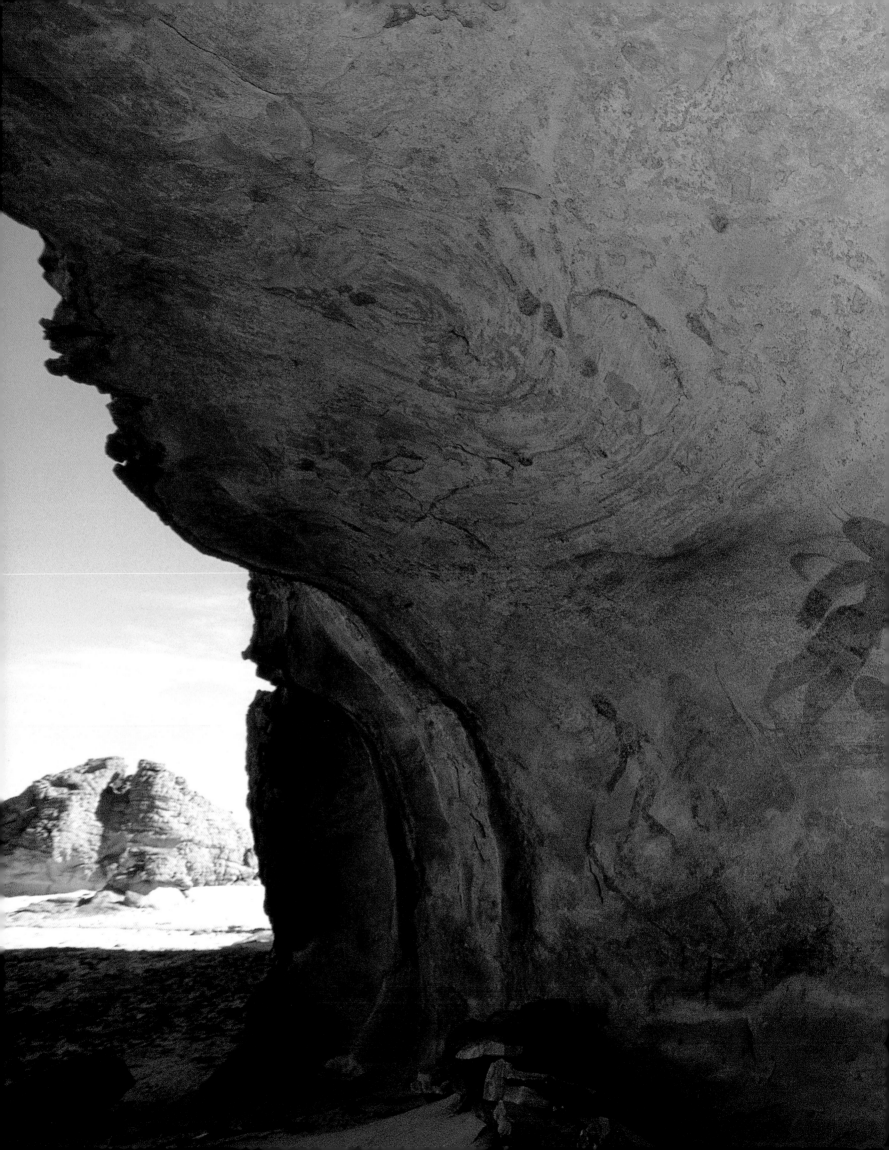

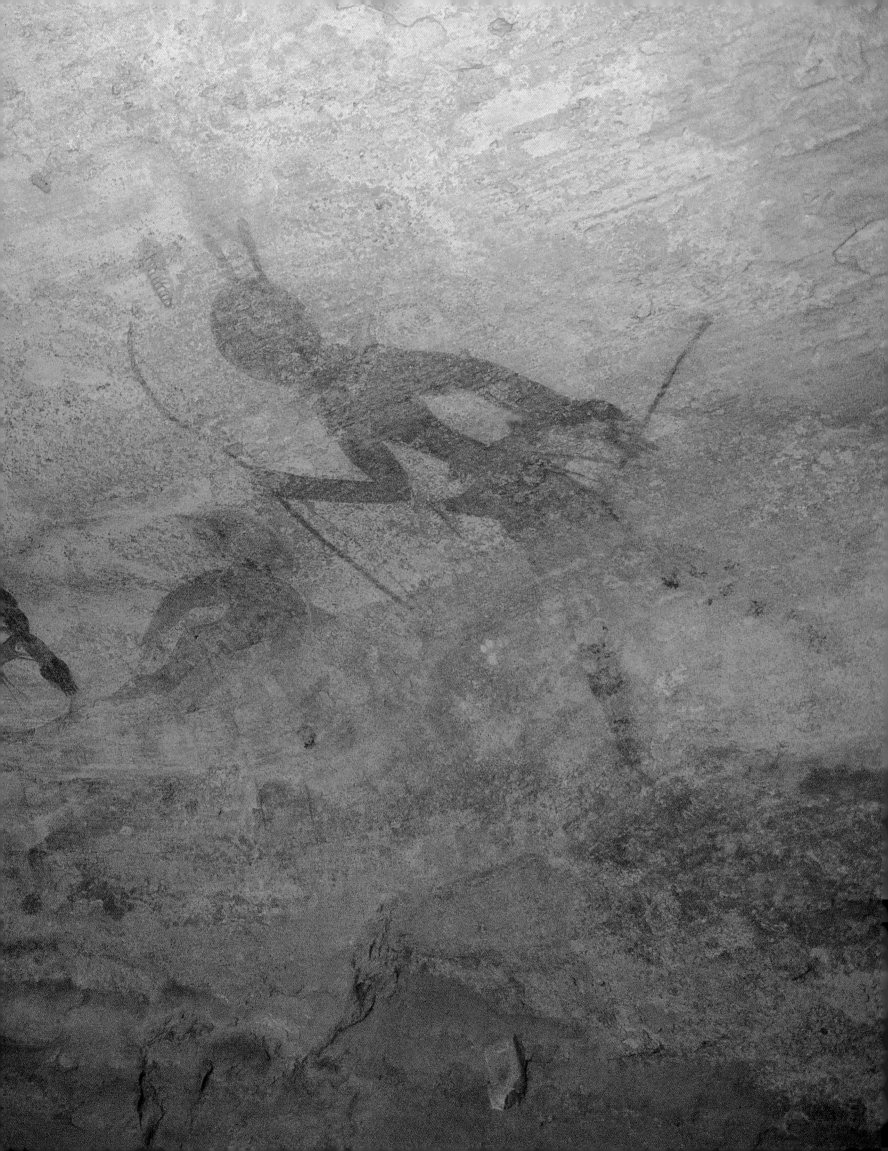

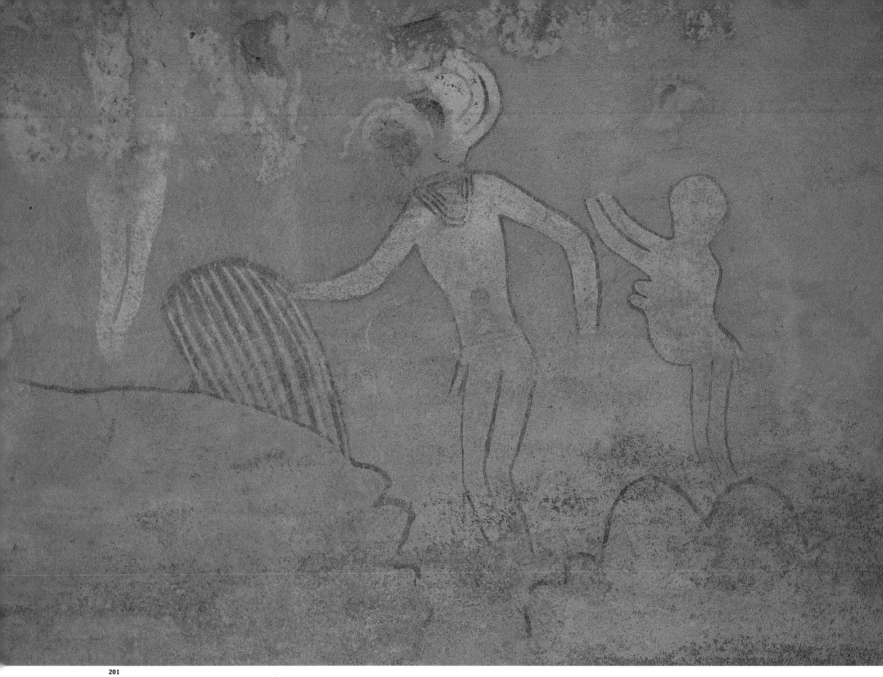

201

FIG. 201 On the left, a figure facing forward appears to float in space. In the middle, a man with plumes bent over his head and wearing necklaces holds in his right hand a geometric shape half hidden by an outlined object. On the right, a woman raises her arms as though in supplication. The central man is 23 inches (60 cm.) high. Such scenes evoke feelings of reverence and peace and belong to a time when man created the gods of nature in his own image. The painting is from Tassili n' Ajjer, Algeria, and is ascribed to the Round Head Period.

OPPOSITE FIG. 202 A detail from a vast painted panel on the Tassili n' Ajjer Plateau, Algeria, from the Round Head Period. The shelter, contained within a huge freestanding boulder, appears like a natural isolated gallery. Layer upon layer of paintings present a complex pattern of animal and human shapes dominated by two almost life-sized adult figures, tightly clothed and elaborately bejeweled, followed by a child. Below is a Barbary sheep with intricately painted horns while a row of white sheep overlays the legs of the upper figures. An oval geometric with a hanging veil has been described as a "jellyfish." The "dinosaur" at bottom left is said to be a caricature of a bull with horns turned forward. The overall impression given by the panel is of an ethereal scene with two richly adorned people of uncertain sex dominating a medley of natural and mythical life.

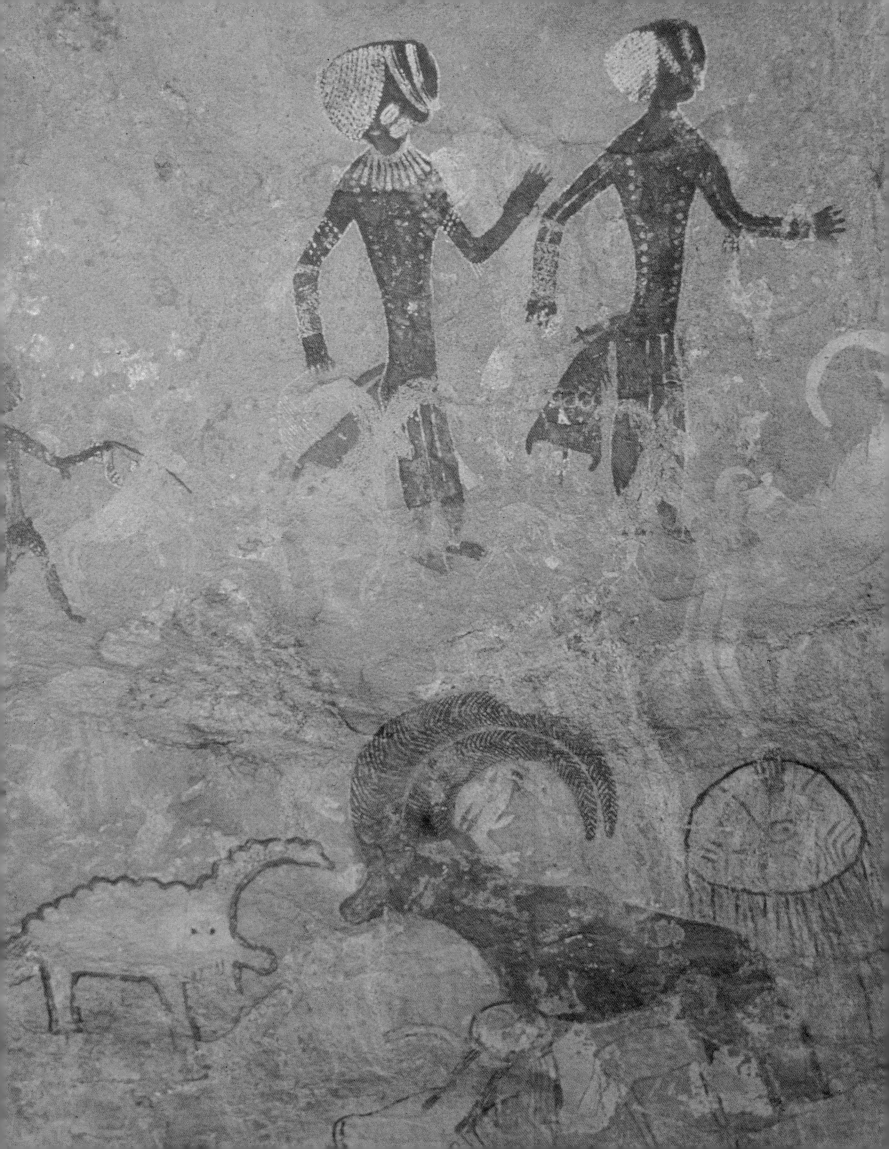

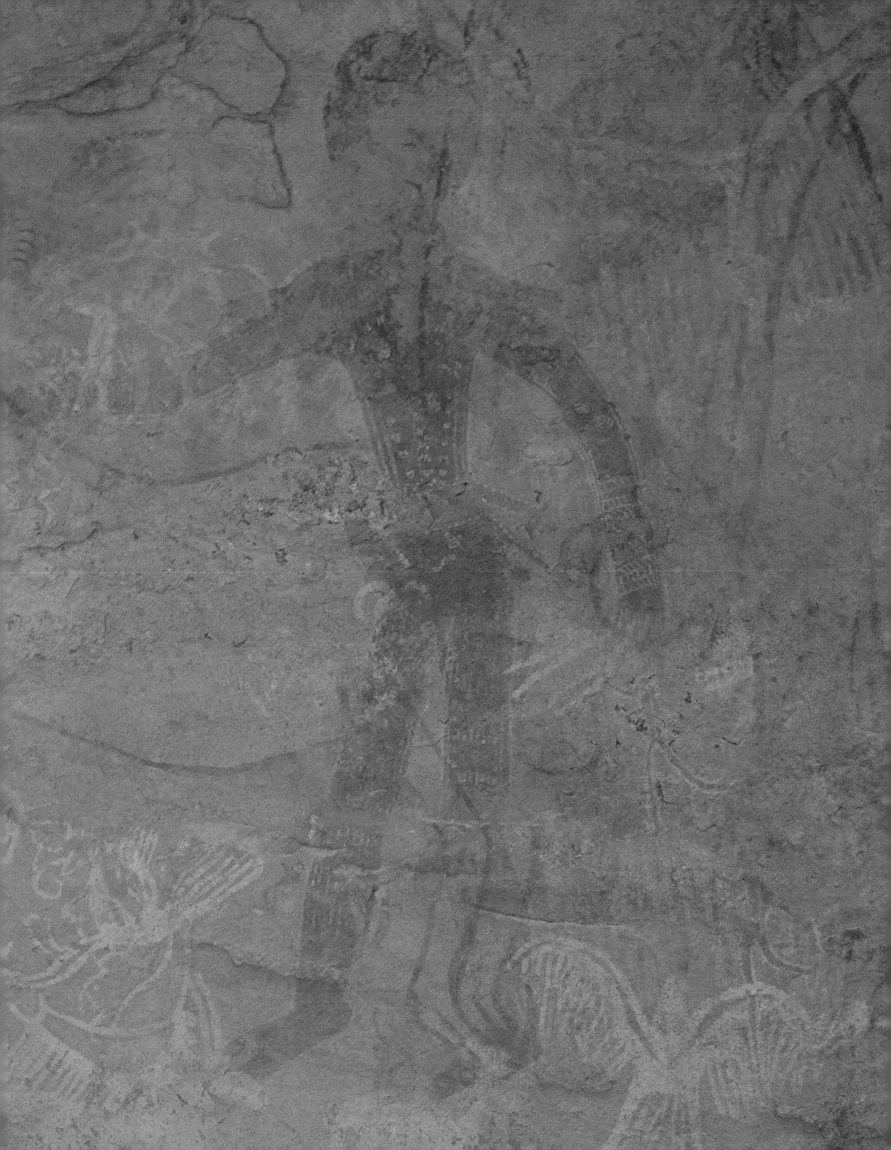

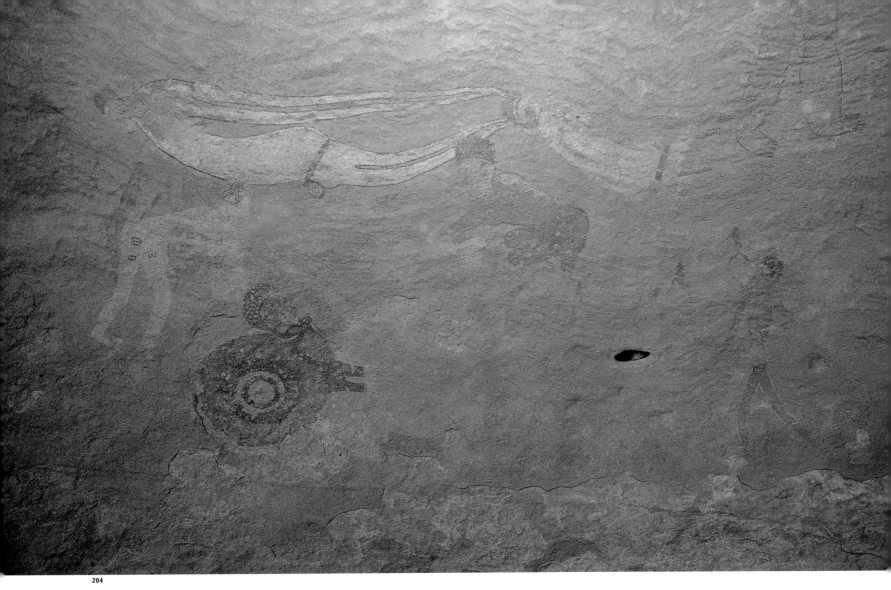

204

OPPOSITE FIG. 203 **A Round Head figure from Tassili n' Ajjer, Algeria, with one arm extended, wearing clothes decorated with white "beads" on the wrists and shoulders, superimposes a white animal out-lined in red, perhaps a mythical rhinoceros. A tall person with striped torso and circular head lurks behind the figure's right shoulder while at his feet are delicately painted animals in white, including a bird, antelope, and insects.**

FIG. 204 **This scene from Algeria is more than 4 feet (1.3 meters) long. A horizontal, elongated female figure appears to float through air or water, towing an unconscious male figure in a fetal position. The caps of two men bent toward each other just superimpose her stomach and lower leg. Below, a circular geometric supports a symbolic human torso wearing a similar cap. At bottom right, a sexless figure, naked except for a waistband, appears to sway, gazing upward. The two small figures on the right are later additions. Henri Lhote saw this scene as reminiscent of an Egyptian religious theme and dates it to less than 4,500 years ago.**

FIG. 205 **Negative handprints surround a remarkable queen-like figure with red hair, nearly one foot tall, in Algeria. Red scarves are wound around her neck and waist. The prints were probably made by wetting the rock and spraying hands held against it. Similar handprints occur in the Paleolithic art of Europe.**

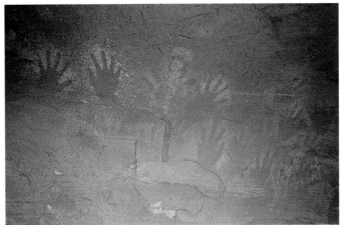

205

FIG. 206 **A typical Round Head Period painting in ocher of a human figure outlined in red dating to about 9,000 years ago from Tassili n' Ajjer, Algeria. Henri Lhote was the first to call this style of figure "Martian" and the term stuck.**

FIG. 207 **A huge engraving of a Bubalus (Bubalus antiquus or Syncerus caffer antiquus) from the Messak, Libya. The Bubalus, which became extinct about 5,000 years ago, is thought to have been a relative of the African buffalo. Rudiger and Gabriele Lutz suggest that styles of Bubali engravings have developed over time and have proposed a chronology, into which this engraving fits at between 7,000 and 6,000 years ago. Even so, many early engravings of Bubali were later touched up and their features altered, making positive identification of style difficult.**

206

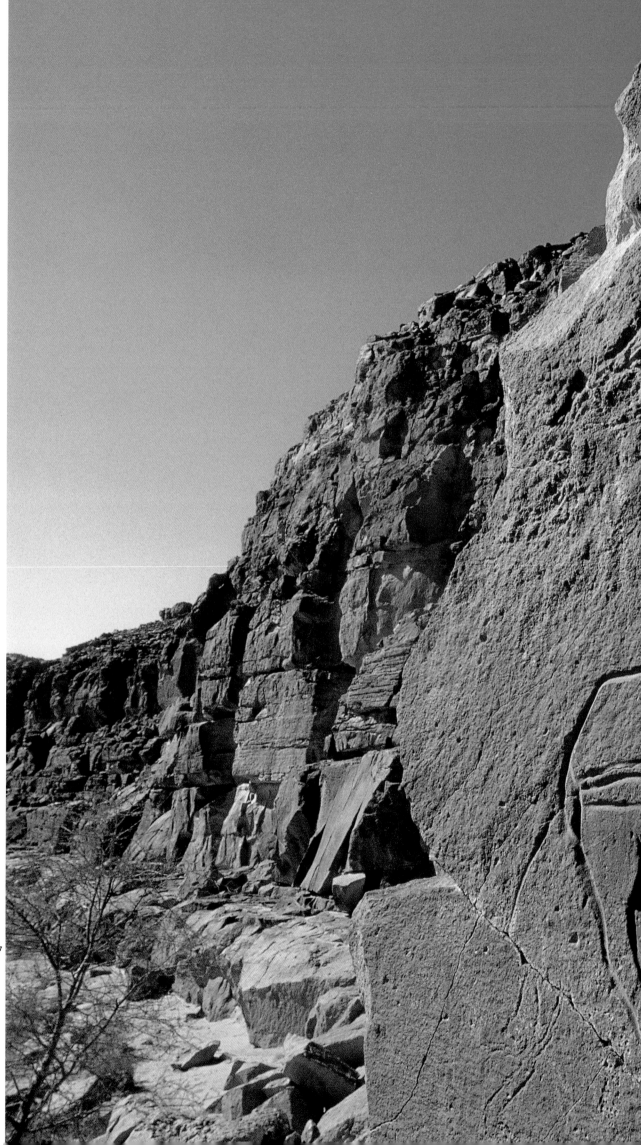

207

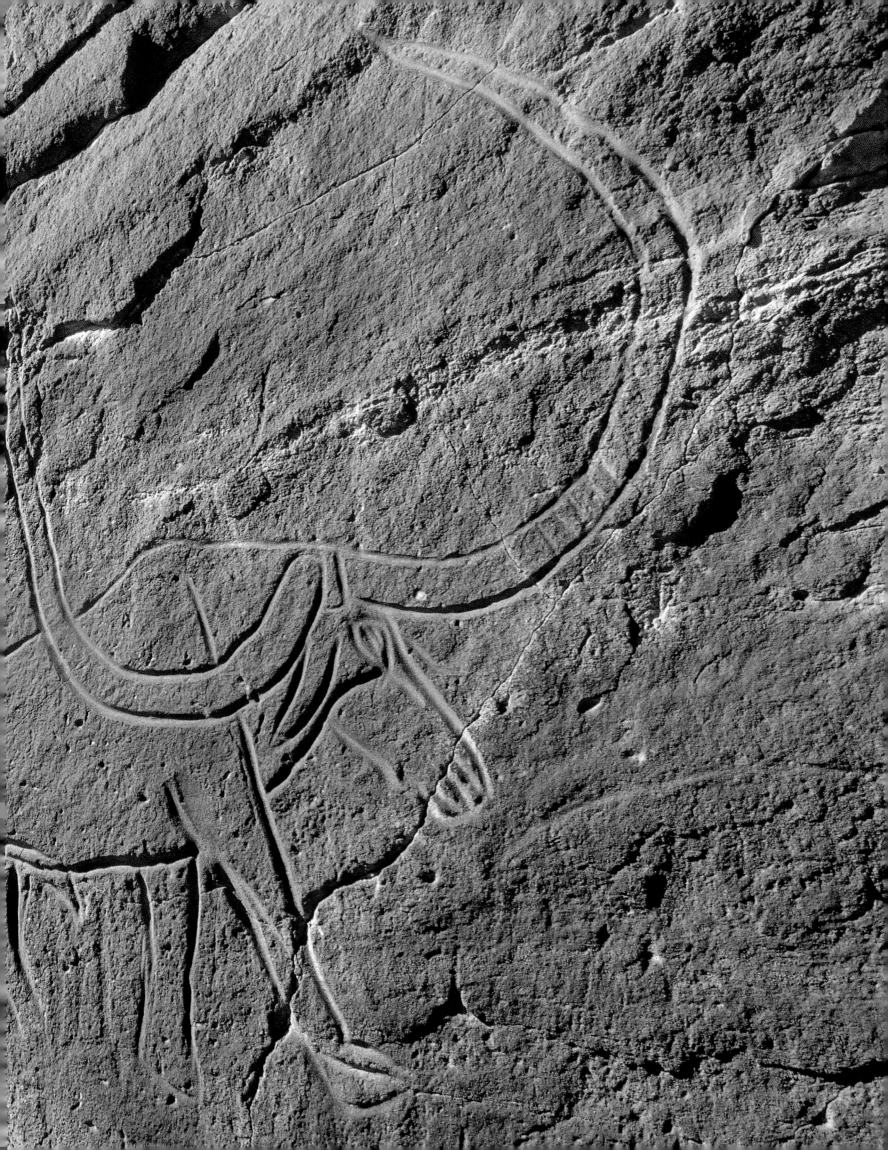

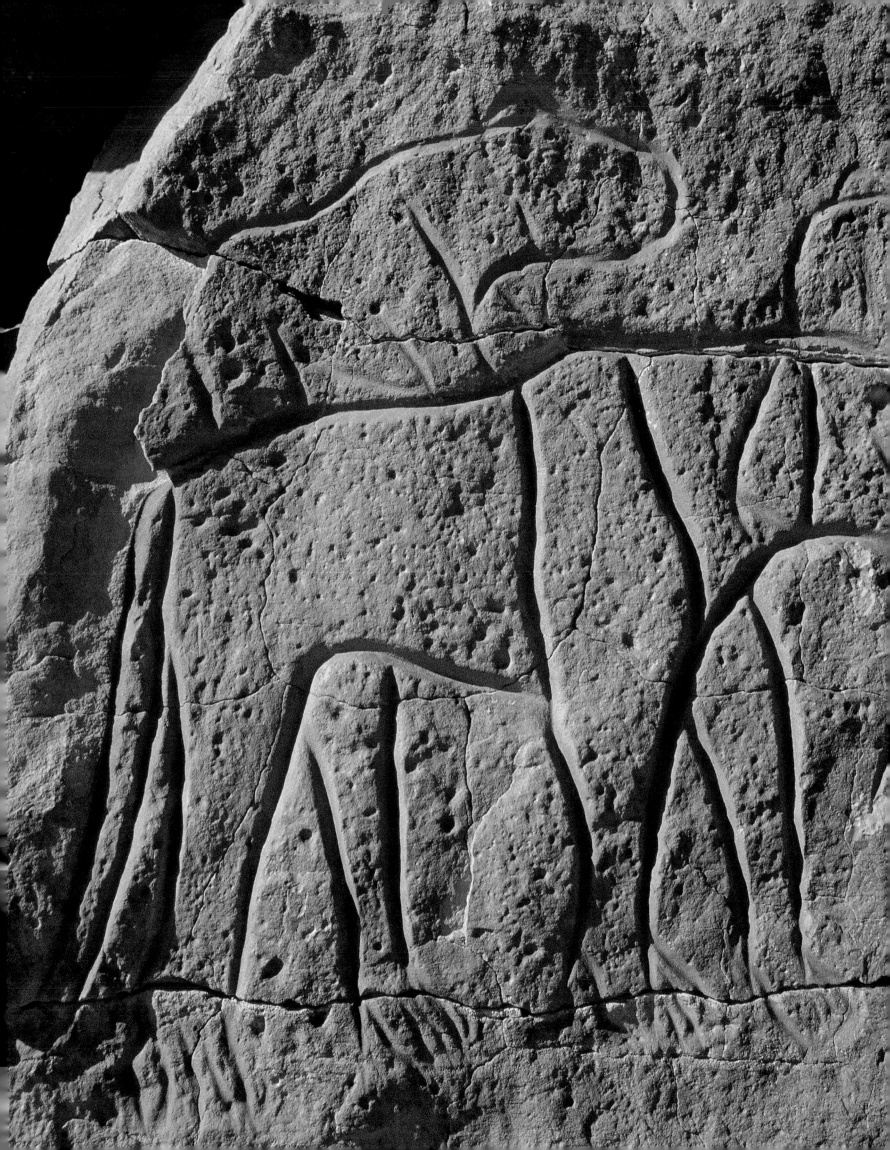

FIG. 208 Two maneless lions engraved on a cliff above a wadi in the Messak, Libya. The lower animal has been described by Felice Cesarino as a mastiff dog, which it could be. It is superimposed over an elephant and has two eyes, the lower one perhaps being part of the original engraving while the other is a later addition.

FIG. 209 An engraving of a hunter with bow and arrow, about 15 inches (40 cm.) high, in the Messak, Libya. Rudiger and Gabriele Lutz describe this engraving as belonging to the Young Hunter Period (6,000 to 7,000 B.P.) it is probably not less than 6,000 years old.

209

208

FIG. 210 **An elephant engraved on a rock later cut from the bank of the Nile River near Abu Simbel and then transported to Aswân, Egypt, before Lake Nasser was flooded. The combination of a large animal and a small human figure suggests a fairly early date, probably in the Bubalus Period, but later than early central Saharan large animal engravings. The base of a Roman kiosk, also moved before the lake flooded, appears in the background.**

FIG. 211 **Engravings of animals on a rock taken from the Nile River near Abu Simbel and now lying outside the Temple of Kalabsha in Egypt. The animals, possibly gazelles, have outlines partly incised, while the bodies have been pecked, leaving the unengraved areas to give them shape. Their original location and careful engraving suggest a date prior to Egypt's earliest Dynastic Period, more than 5,000 years ago.**

211

210

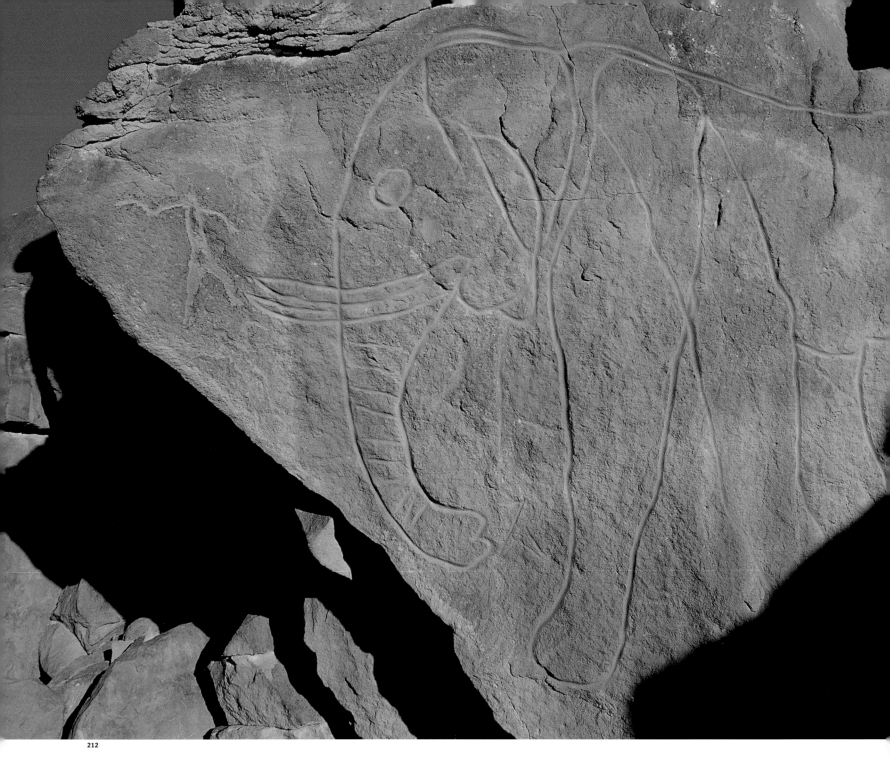

212

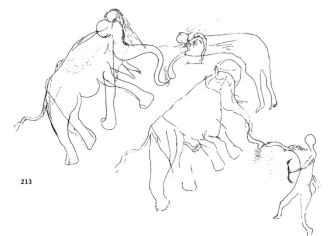

213

FIG. 212 An elephant from the Messak, Libya, about 6 feet (1.80 meters) long. It dates from the Bubalus Period and may be 10,000 or more years old. Two tiny hunters stand before the elephant, the upper one wielding a boomerang. See the similar but much smaller scene at Aswân (fig. 210), and also note the scene in northeastern Niger (fig. 213).

FIG. 213 An engraving less than a meter wide hidden behind a boulder in a shelter on a cliff face, in northeastern Niger. Two human figures hold curved objects, rather like boomerangs, to the tips of the elephants' trunks. The scene suggests a ritual in which people obtain some form of power from elephants and is reminiscent of southern African rock paintings of people with large animals. The date is uncertain, but the engraving may belong to the Pastoral Period.

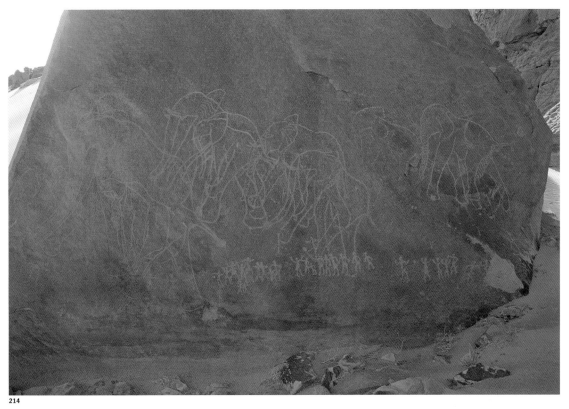

FIG. 214 In the Tadrart, Algeria, a herd of elephant moves to the left and the animal on the right defecates while running. The elephant herd dates from the Bubalus Period, but the line of sexless human figures engraved below is a later addition.

FIG. 215 Two sparring catlike figures (a third is around the right side of the rock) engraved on a boulder at a cliff top in the Messak, Libya. The figures are joined by a cord through four small ostrich engraved between them. One researcher describes the large figures as monkeys or monkey-men. Probably they are representations of mythical beings. Their dominant position above all other engravings in this valley and their visibility from a distance must be important. In the Messak, engravings of small ostrich sometimes accompany large animal depictions, particularly those of Bubali.

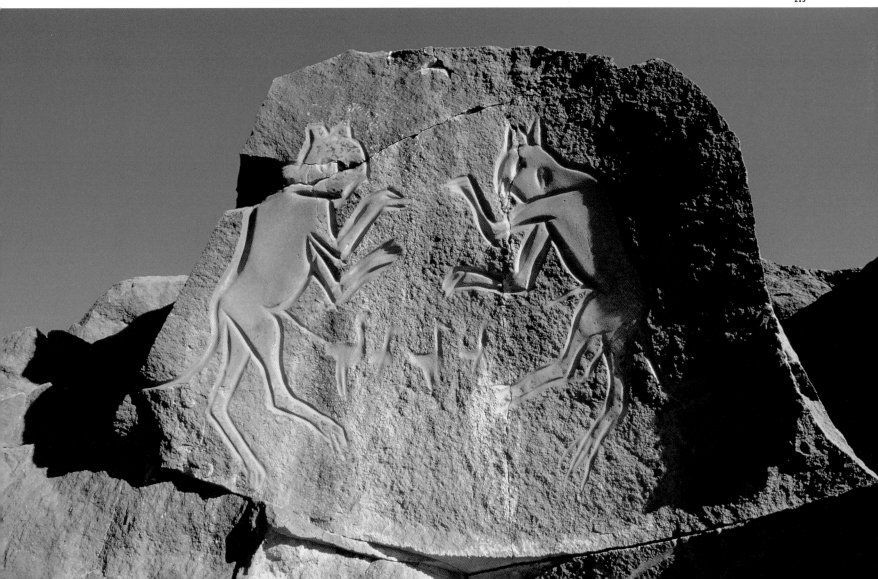

PRECEDING PAGE FIG. 216 **A part of a frieze of thirty giraffe from the Messak, Libya. Engraving details differ from one animal to another, with larger animals usually less well drawn than smaller ones. Some have hooves, while the legs of others end in points. Faces have been hollowed and polished. The panel may have been engraved over time by several artists and is likely less than 7,000 years old. This superb panel has recently been damaged by a line of bullet holes.**

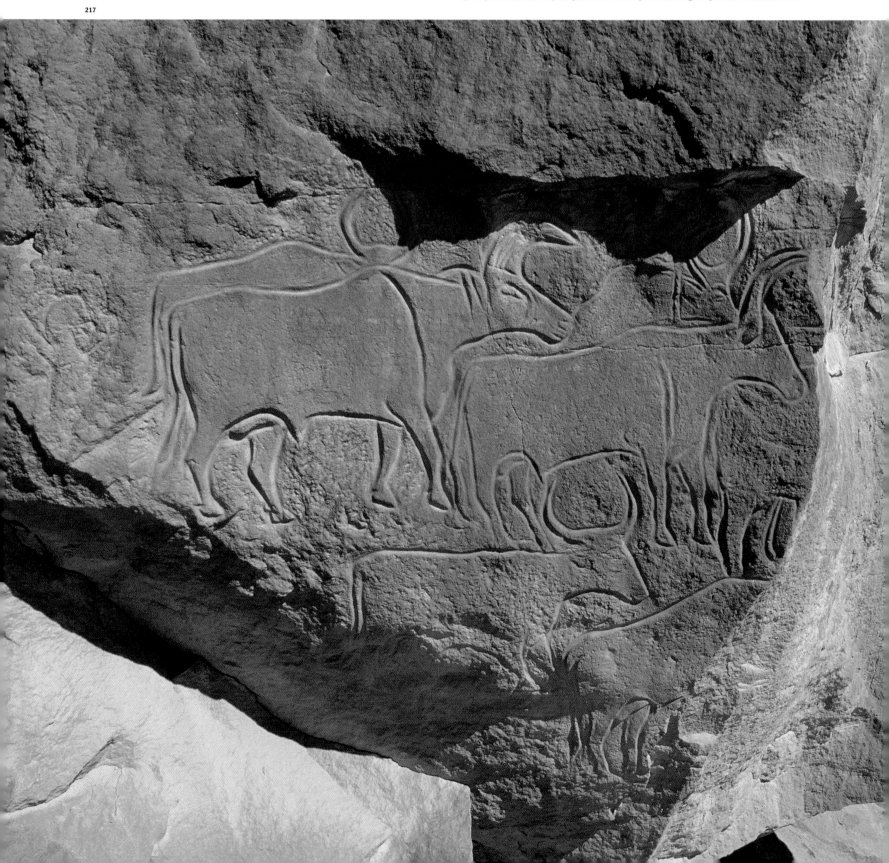

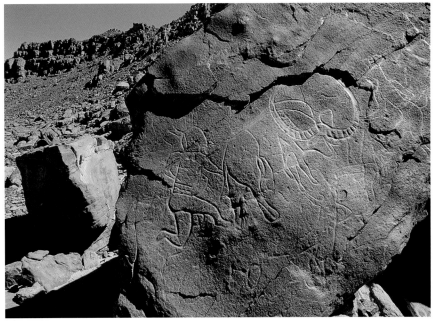

218

FIG. 217 **A group of bulls in the Messak, Libya. After about 7,000 years ago, when rainfall in the Sahara increased and surface water was abundant, numerous engravings of domestic cattle were made. It is not clearly understood whether cattle images symbolized human sexual differentiation or whether they were engraved merely for cattle's importance to communities. Here, the engraved outlines of the bulls are cut deep and kept simple, depicting shape and spread of horns. Pecking within bodies and legs has been carefully polished and may once have been colored, although the coloring is no longer apparent.**

FIG. 218 **A magnificent engraving of a bubalus surrounded by "dog-headed" men in the Tassili n' Ajjer, Algeria. Engravings of dog-headed men also occur in the Messak of Libya where Rudiger and Gabriele Lutz describe them as "symbols of vigour and power." They believe they may represent "hunting deities," and date them to the onset of the Neolithic era.**

FIG. 219 **An engraving of cattle heads in the Messak, Libya. Faint outlines of earlier engravings of cattle heads can be seen to the left of the head with horns. Close examination suggests that at least three of the heads have been re-engraved at some point.**

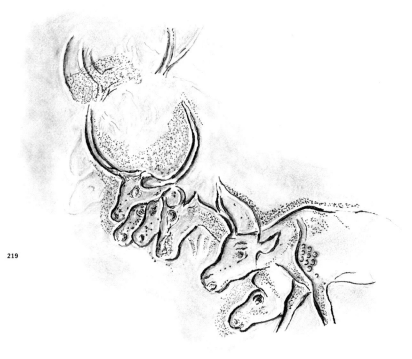

219

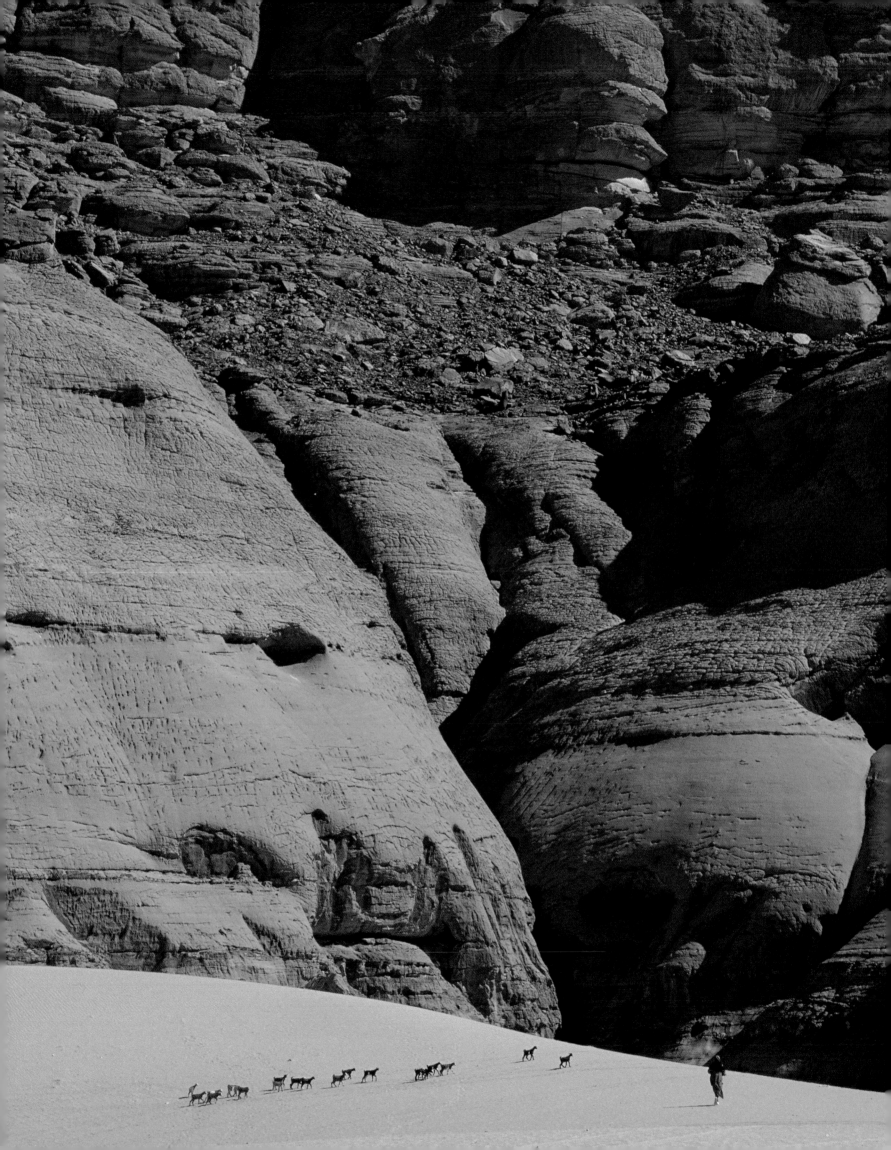

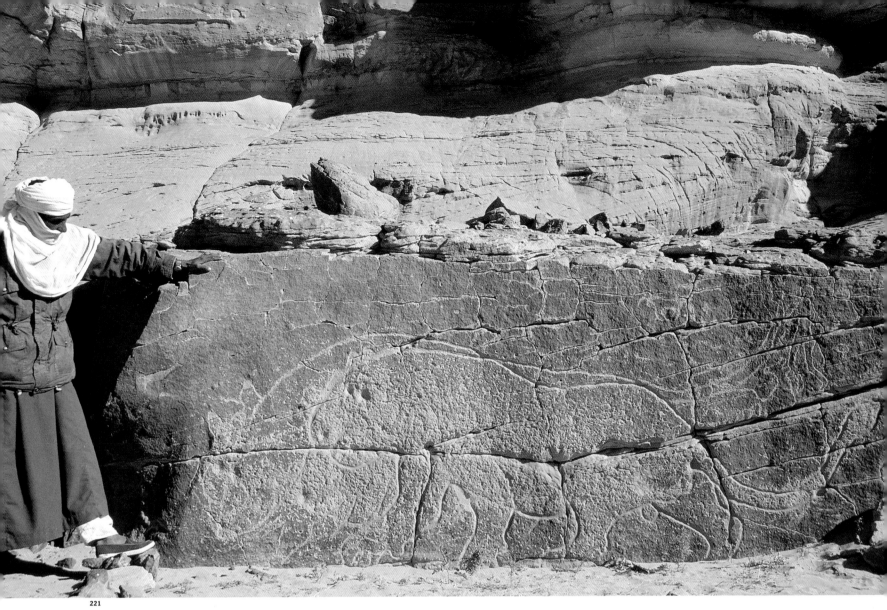

221

221

OPPOSITE FIG. 220 **A woman walks her goats through a valley in the Akākūs Mountains, Libya. Wind has carved many small overhangs, shelters, and even caves into the walls of the wadis, creating ideal places for painting and engraving.**

FIG. 221 **An engraving of a lion superimposing another of a hippopotamus in the Akākūs Mountains, Libya. The tail of the large hippo, facing left, is held by a small man looking in the opposite direction (at top right of the panel). The lion, originally engraved in deeply cut outline, may have had much of its body pecked and an extra eye added at a later date. The original engraving dates from the Bubalus Period.**

FIG. 222 **Two human figures, one with a dog's head, copulate with two women. Above, a figure with a cat's head and a huge hanging penis faces to the front. The figure with the dog's head has been likened to a jackal and thereby related to the Saharan fable of the jackal's wedding, which involves fertility and rain. The catlike figure facing forward has been described as the Egyptian god Bes. This scene from the Akākūs Mountains, Libya, belongs to the Pastoral Period and could be associated with ancestral Berber peoples. Note the Arabic and Tifinagh graffiti.**

222

FIG. 223 A painting of wild sheep being hunted by men armed with bows and arrows and using domesticated dogs from the Akākūs Mountains, Libya, probably dating from the Horse Period. Similar hunting scenes, always involving sheep and dogs, are found in southern Algeria and neighboring Libya but are less common elsewhere. The number of these paintings suggests that sheep hunting may have been a ritual activity here, particularly as similar scenes involving species other than sheep are very rare.

FIG. 224 A painting, mainly in red, of a mythological scene, described by Alfred Muzzolini as "mythological combat with baboons against dog-headed men." This scene, from Tassili n'Ajjer, Algeria, may depict a mythological encounter between human and animal spirits before people became mortal and suffered death. It most likely dates from the Pastoral Period. (Redrawn from a photograph by J. Kunz in A. Muzzolini's Les Images Rupestres du Sahara.)

224

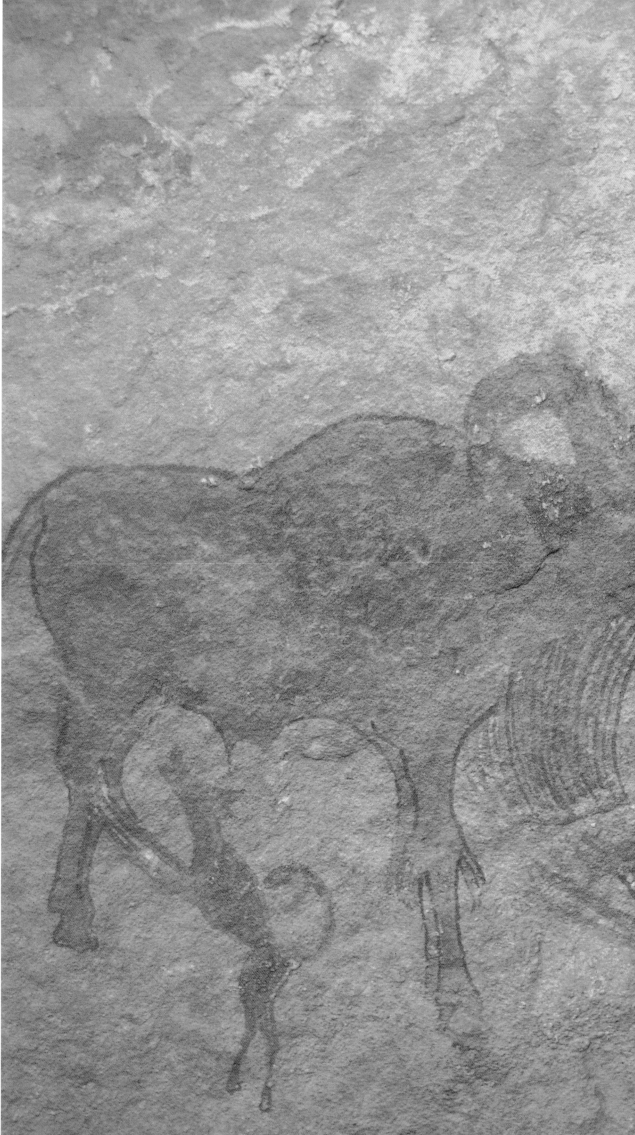

223

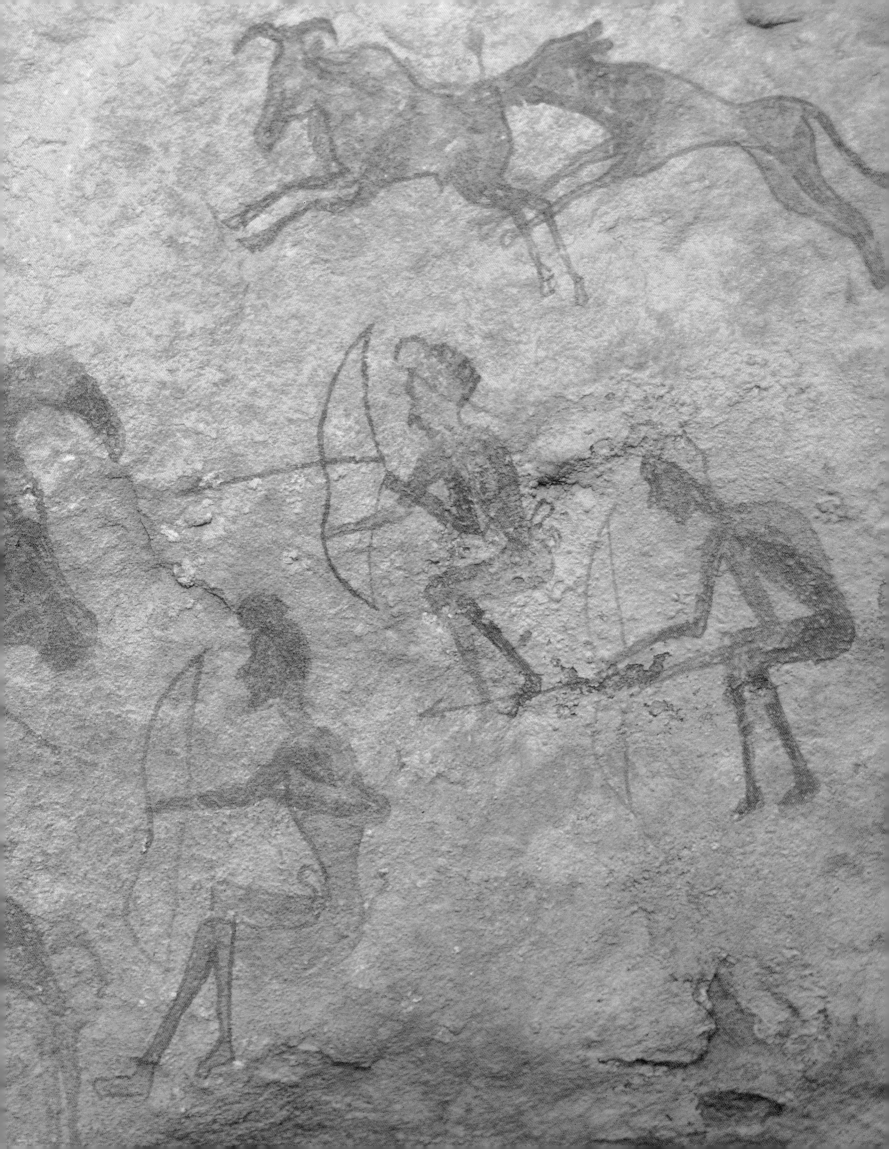

FIG. 225 **A detail from a profusely painted shelter wall in the Akākūs Mountains, Libya, of three people wearing dresses dancing and holding what may be gourd rattles in their left hands. Below, a figure wears a headdress with three plumes and holds a white object in the right hand. A carefully drawn white ostrich stands between two of the dancers. A large shape, red enclosing white, appears to have a handle and a decorated spout, meaning it may be a water container. Numerous bichrome cattle with curved horns are painted below the dancers. The panel may depict a pastoral ritual and probably dates from the Camel Period.**

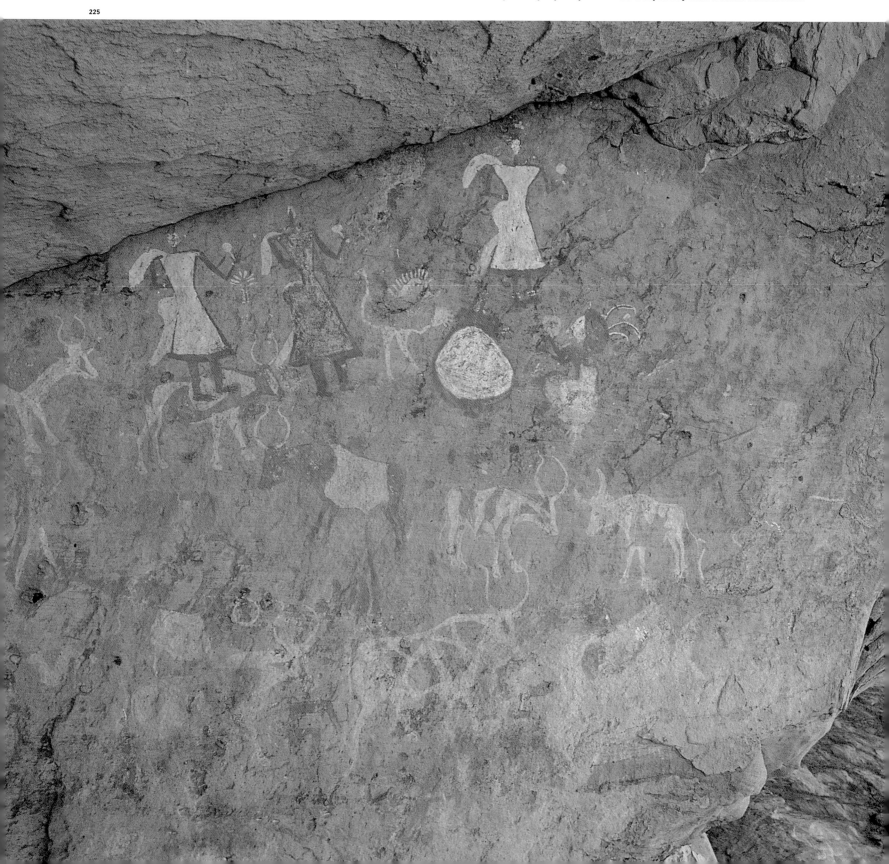

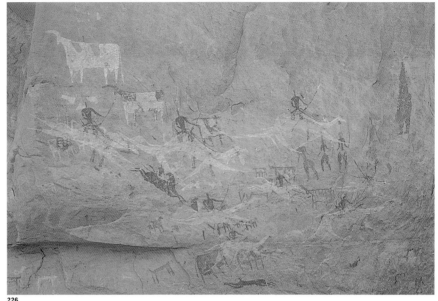

226

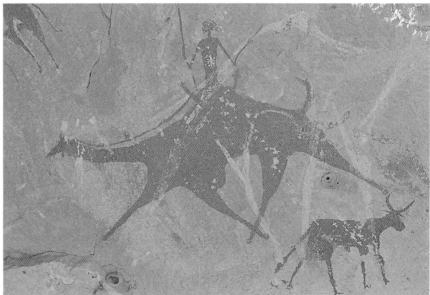

227

FIG. 226 A huge shelter wall in eastern Chad is covered with layers of paintings. Cattle with horns curved up and forward are painted in two and three colors. At the top left, a cow has lost one color, leaving blank patches. Ghostly white camels with red riders seem to float across the wall while a horse lands from an enormous leap, looking back at its rider, who carries a lance (fig. 245). The dates of the paintings cover a long period, but the camels are 2,000 years old or less.

FIG. 227 A red painting in eastern Chad of a camel with an armed rider superimposed by a white outline image of another camel. Below, a cow walks to the right. The painting is less than 2,000 years old.

FIG. 228 This frieze of almost life-size cows followed by an enormous bull is engraved around the base of a cliff in western Chad. Each cow has been carefully decorated with geometric patterns and people filling the spaces within their outlines (fig. 229). Three giraffe complete this panel. The date is uncertain but is probably less than 3,000 years old.

FIG. 229 A detail of one of the engraved cows from fig. 228. Note the inset engraving of a human figure with a "mushroom" head and metal spear, which dates to the Horse Period. The penis was a later addition to the cow.

229

228

FIG. 230 Faint but still visible large animal paintings in white, with red human figures superimposed over them, from a shallow cave in western Chad. A row of men faces left, each holding a hunting bow crudely painted in a darker color. Several pairs of figures include two "lovers" in the middle dressed in patterned cloth and holding hands.

FIG. 231 Detail of the "lovers" (fig. 230).

231

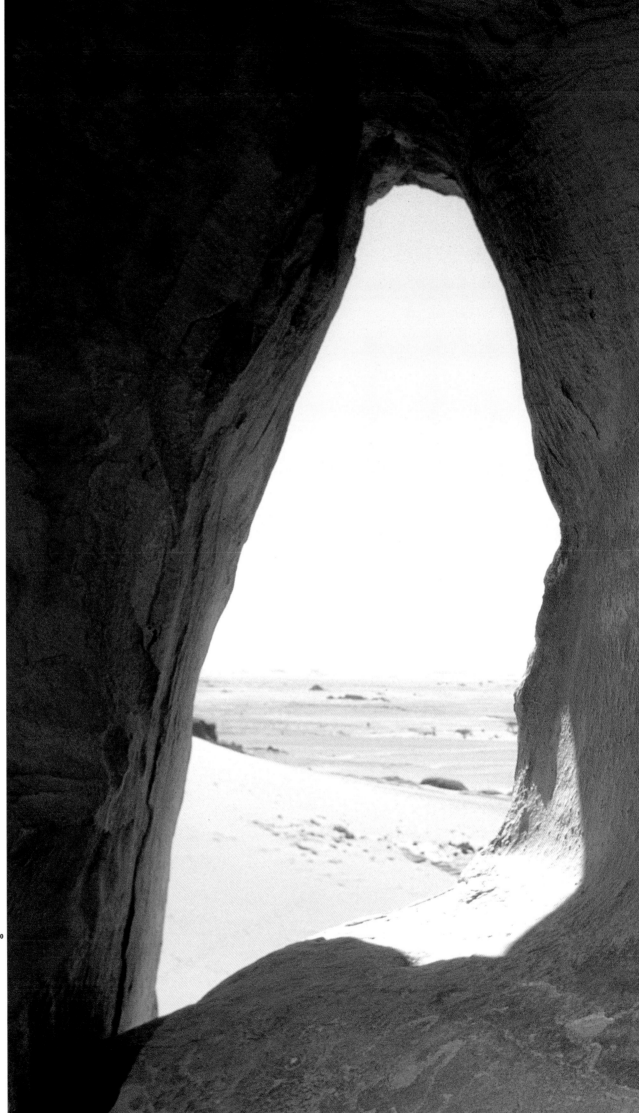

230

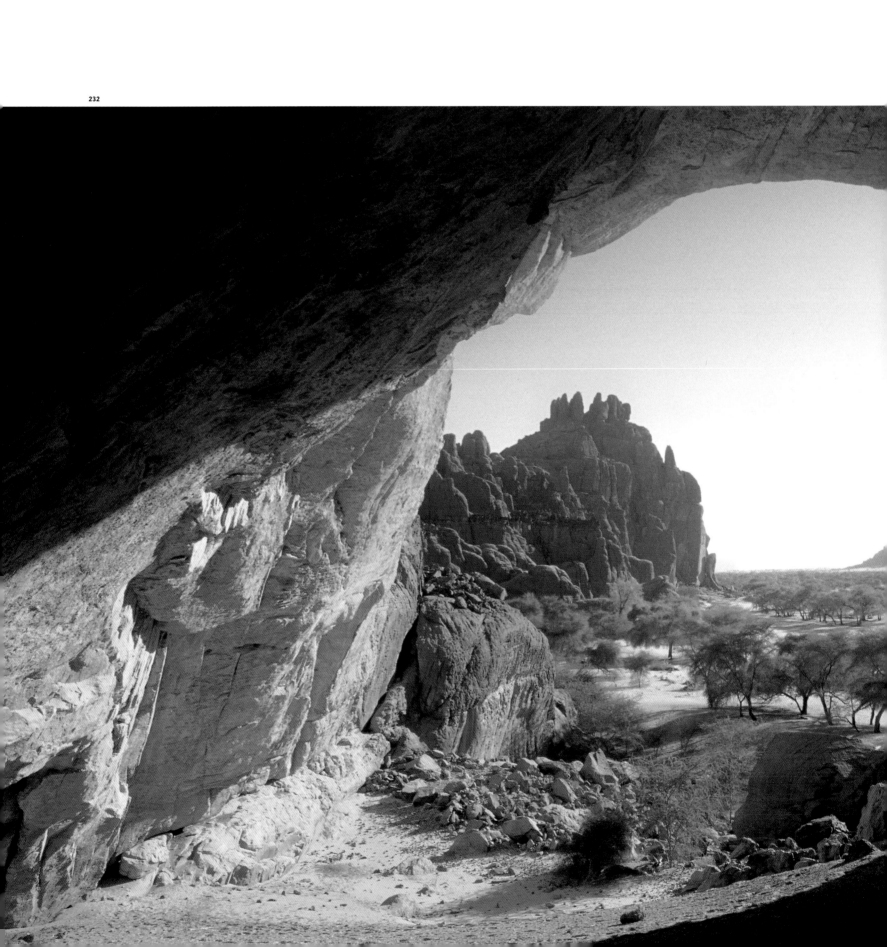

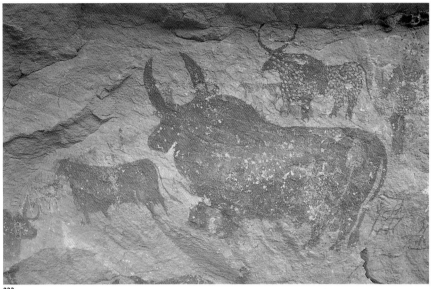

233

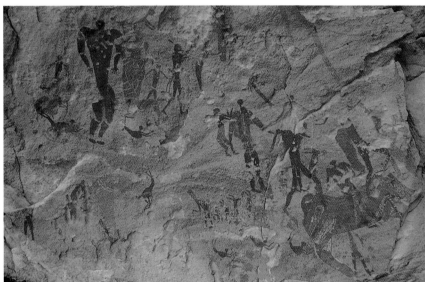

234

FIG. 232 A huge cavern at Archei, eastern Chad. Behind it, a spring still fills a canyon floor with water where we saw hundreds of camels drinking. Stunted crocodiles occupy a neighboring pool. Our guide told us a nearby cavern was once used to hold 1,000 slaves while caravans rested their camels on their long journey to the Mediterranean.

FIG. 233 A massive red bull dominates a cattle scene with a herdsman painted on the outer wall of a cave facing down a dry and empty wadi in the Tassili du Kozen, northern Chad. In Temasheq Kozen means "place of many trees." The silhouette paintings, executed in outline and filled in, belong to the Pastoral Period and are probably more than 4,500 years old.

FIG. 234 A detail from a large panel of paintings in Wadi Sura (now better known as the "Cave of the Swimmers," although it's not the actual cave that was used in the film *The English Patient*). This painting from southwest Egypt forms a link between early Egyptian and Saharan art. (Photograph by Giancarlo Negro.)

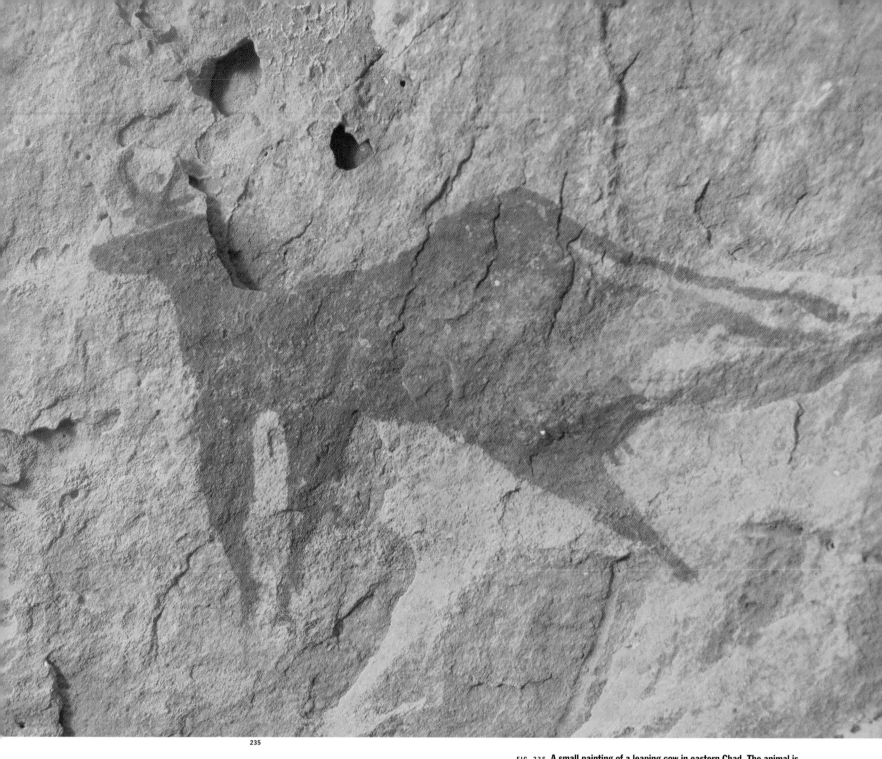

235

FIG. 235 A small painting of a leaping cow in eastern Chad. The animal is seen from the side and in profile, but note the twisted perspective that shows four teats on the udder, two horns and ears, and both sections of each hoof.

OPPOSITE FIG. 236 A small painting in red from Ennedi, Chad, of a figure facing forward, holding a stick in its right hand. The head, outlined in strong red with a plume rising from the top, is filled in with a slightly lighter shade. The figure, which lacks breasts or any other determining features, is probably male.

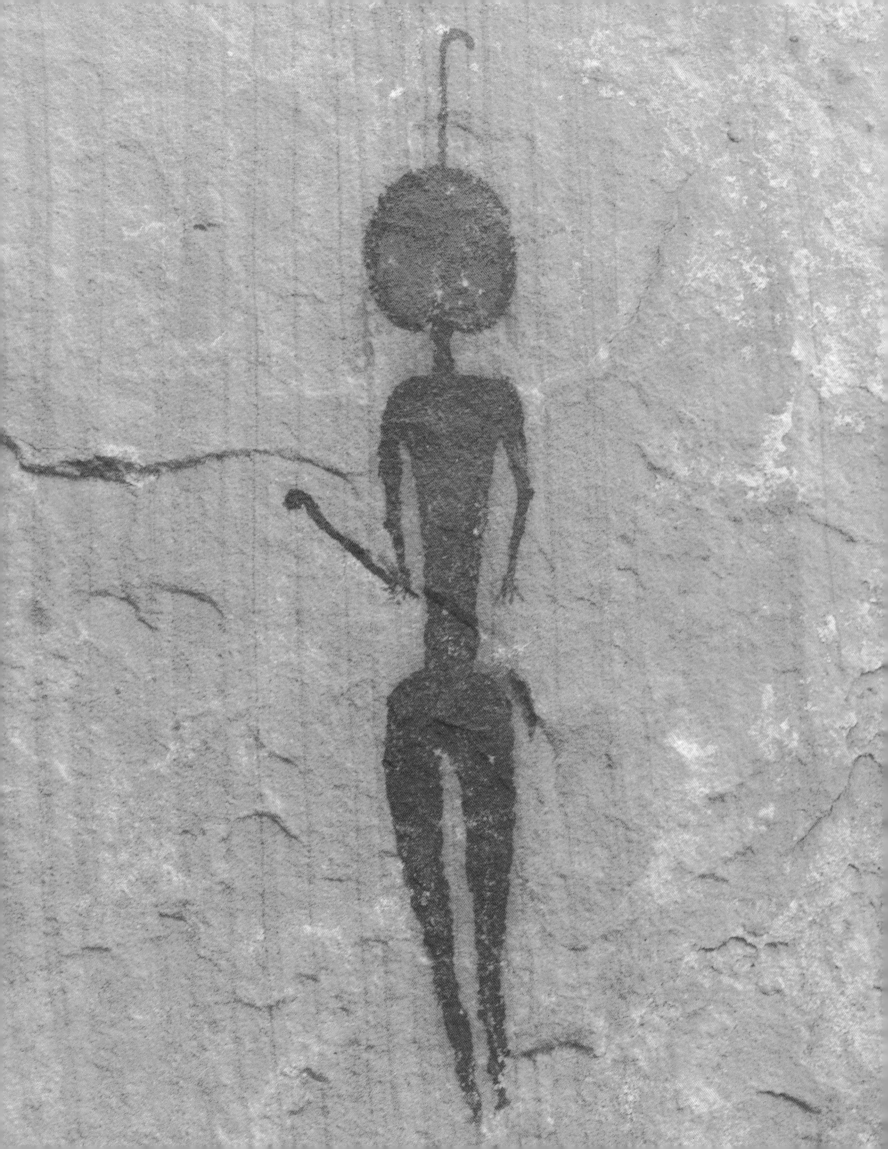

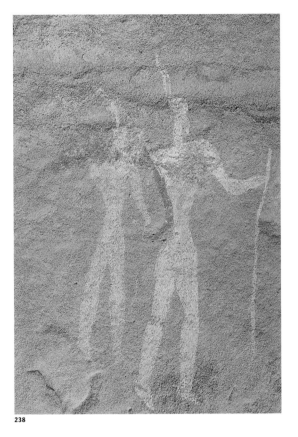

238

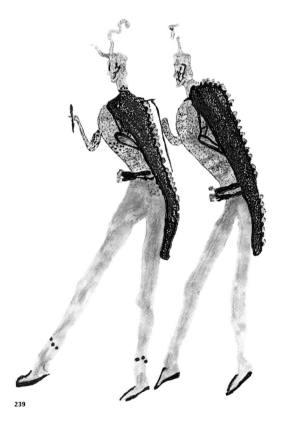

239

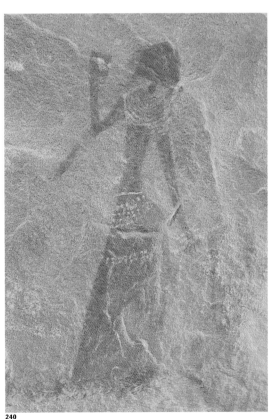

240

OPPOSITE FIG. 237 A painting from eastern Chad of two warriors facing forward, holding long spears, with possibly metal blades, in their right hands. They appear to wear busbies and finely decorated clothing. It dates from the Horse Period.

FIG. 238 A painting of two dignified bearded men walking with long sticks in their hands from the Akàkūs Mountains, Libya. Each man has a plume rising from a skullcap or a band around his head and is dressed in tight-fitting apparel. The left arm of one man is painted in red. They appear to be Mediterraneans, possibly Berbers. The painting may date from the Horse Period.

FIG. 239 A painting from Tassili n'Ajjer, Algeria, of two men wearing tight-fitting clothing, decorated cloaks, and hats with plumes. Alfred Muzzolini described the men as pastoralists of Mediter-ranean stock, probably Berber, and dated the painting to the end of the Pastoral Period or the early Horse Period.

FIG. 240 A painting from eastern Chad of an elegant woman with an elaborate necklace, headdress, and patterned clothes, similar to attire worn in dynastic Egypt. The date is uncertain, but adjacent paintings in similar styles of men holding metal weapons could place it in the Horse Period.

FIG. 241 **A painting of a boat with five people from the Pastoral Period in Chad. A large figure with arms extended stands in the prow, perhaps giving a blessing or seeking supernatural help. A dead lake bed within sight of the painting may have lost its water more than 4,000 years ago. Bones of fish and crocodile were found in the painted shelter, which is high in the cliff face.**

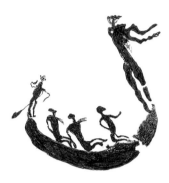

241

FIG. 242 **One of several engraved boats with a flying bird, possibly an ostrich, in Egypt's Red Sea Hills. The engraving may date to 3,500 years ago. Compare this boat with central Saharan paintings of boats (figs. 241, 243), both of which probably date to 5,000 or more years ago. There is a growing belief that the origins of Egyptian art lie in the central Sahara rather than vice versa and that some Saharans, escaping arid periods and moving east, introduced their culture and art to the Nile Valley. The symbolism involved is uncertain, but Feki Hassan has suggested that engravings of boats found in Egypt may represent the journey to a new life after death.**

FIG. 243 **A painting of a boat and people from the Pastoral Period in the Tassili n'Ajjer, Algeria. A similar painted boat is described by Henri Lhote as "Pre-dynastic Egyptian" and dated to more than 5,000 years ago. The archers within the boat, with lithe figures and fine-featured faces, have a possible Mediterranean origin, while those outside it could be Negroid.**

243

242

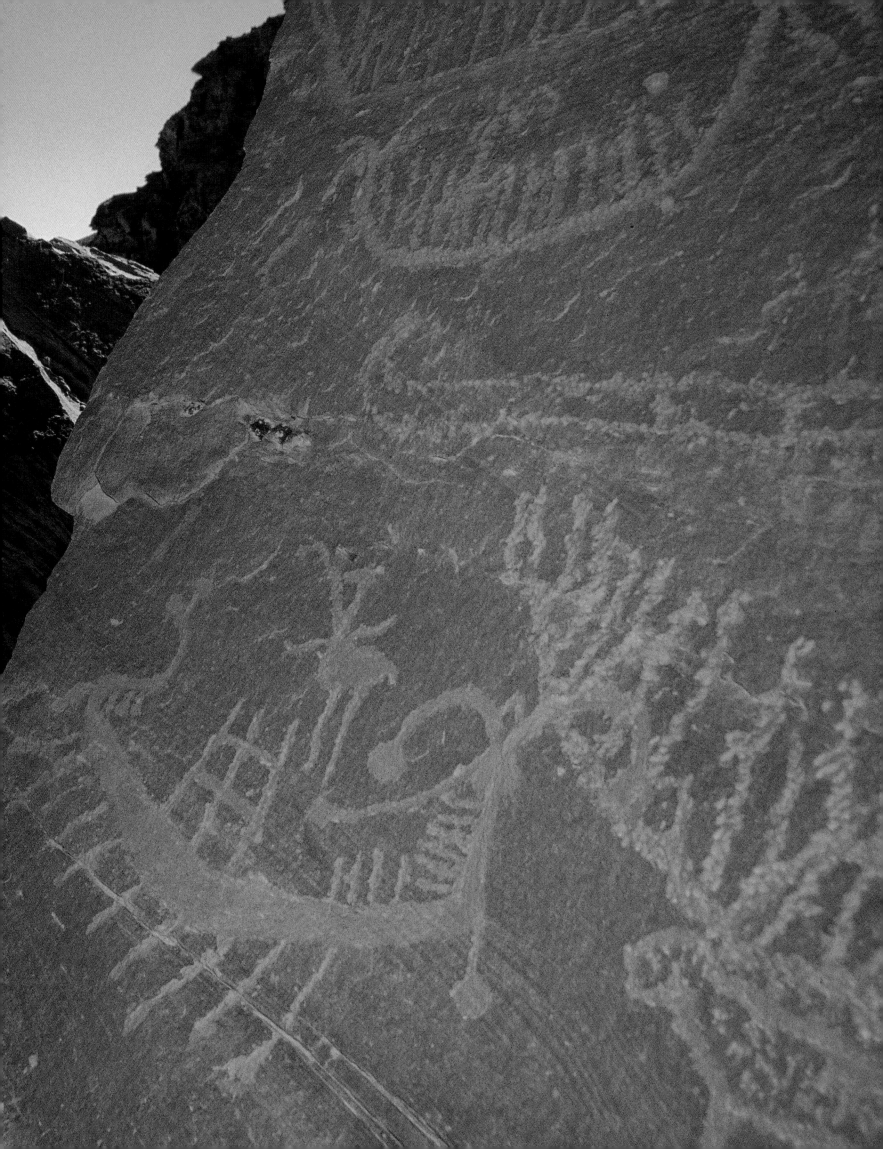

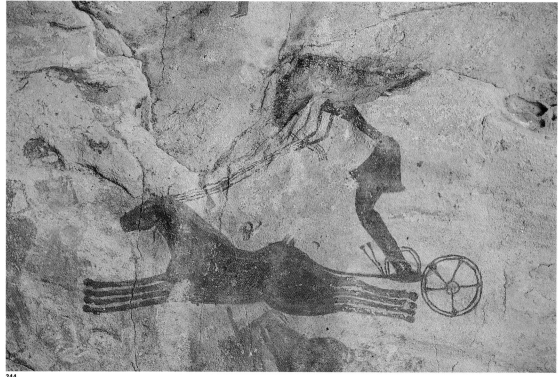

FIG. 244 **A painting in southern Algeria of a two-horse chariot driven by a man wearing a skirt and holding two sets of reins. Although the horses are depicted in profile, the chariot is seen from an angle so that both wheels and the standing platform are visible.**

FIG. 245 **A detail from fig. 226. The horse and rider are superimposed by white images of camels, suggesting the horseman was painted before the camels.**

244

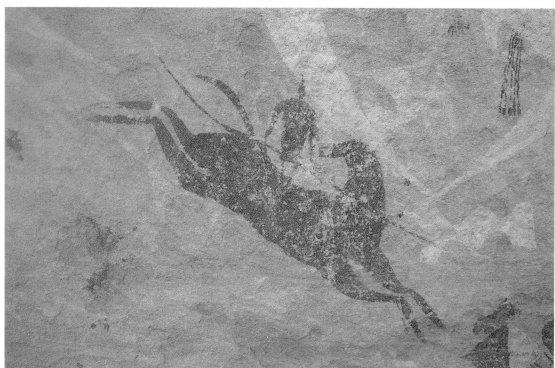

245

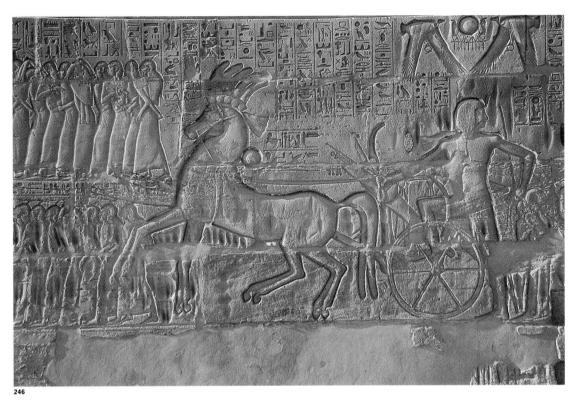

246

247

248

249

250

FIG. 246 An engraving in the north wall of the Temple of Karnak at Luxor, Egypt. This chariot also closely resembles paintings and engravings of horse-drawn chariots found in the mountains of south-western Libya and southern Algeria.

FIG. 247 An aerial view of an engraved chariot drawn by cattle rather than by horses in northeastern Niger. Although pictures of chariots can be found stretching right across northern Africa, it has yet to be determined whether the vehicles themselves traversed the continent or whether their symbols were merely carried across the desert.

FIG. 248 Painting in white of a man riding a horse in eastern Chad. The man appears to be carrying a cross and lance. Crosses occur in Tuareg jewelry, lending some credence to the theory that Tuareg were Christians before their conversion to Islam 800 years ago. However, this has yet to be proven.

FIG. 249 A small painting from Algeria of a light, two-horse chariot. Paintings of horse-drawn vehicles have been found as far west as Algeria and northern Mali, but there the paintings cease, although engravings of chariots continue west to the Atlantic and also have been found in the Canary Islands. Alfred Muzzolini points out that there is more chariot art in the western than in the eastern Sahara.

FIG. 250 A small painting in red of four "flying" horses, two mounted and two riderless, followed by the figure of a "flying" person, from Ennedi, Chad. Painted human flying figures occur throughout Africa. It has been suggested that flying or floating figures in southern Africa may represent the trance experience and out-of-body travel.

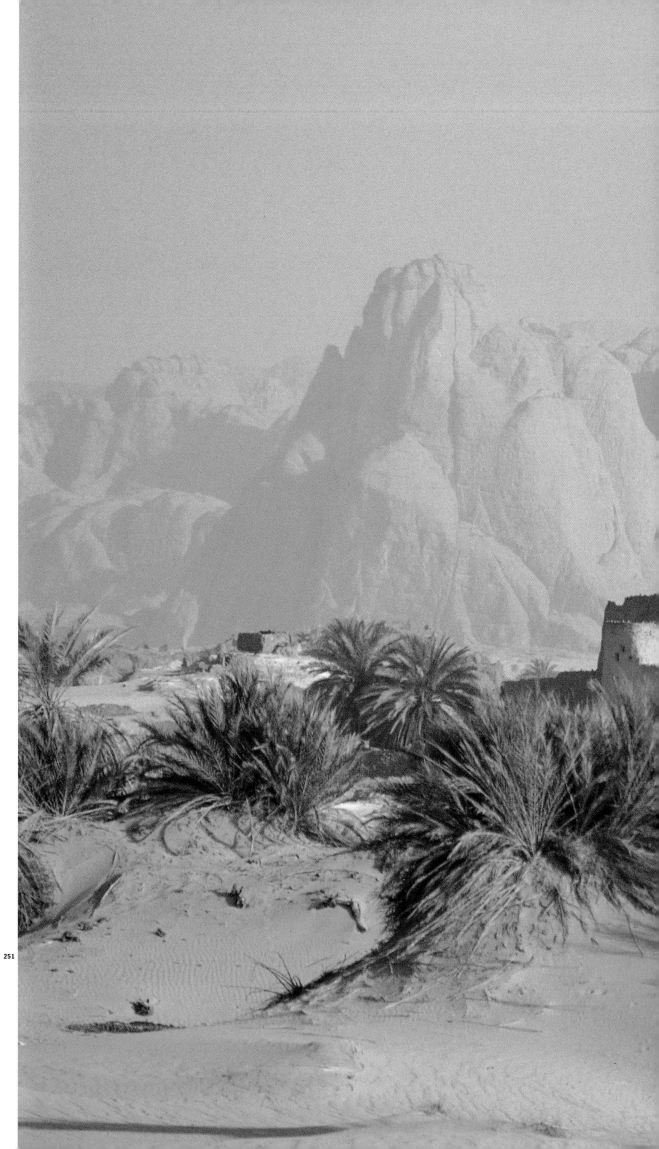

FIG. 251 The old town of Djaba sits on a rock near the Djado Plateau in northeastern Niger with the Pics d'Orida in the background. Originally established at least 600 years ago and once having an estimated human population of 1,000, Djaba became a major trading center on caravan routes crossing the Sahara. At the base of the hill, a walled enclosure once provided a market and a well with fresh water. Narrow passageways lead upward through covered staircases to the summit. About 1920 Djaba was abandoned after a malaria epidemic and now, uninhabited, slowly crumbles to dust.

251

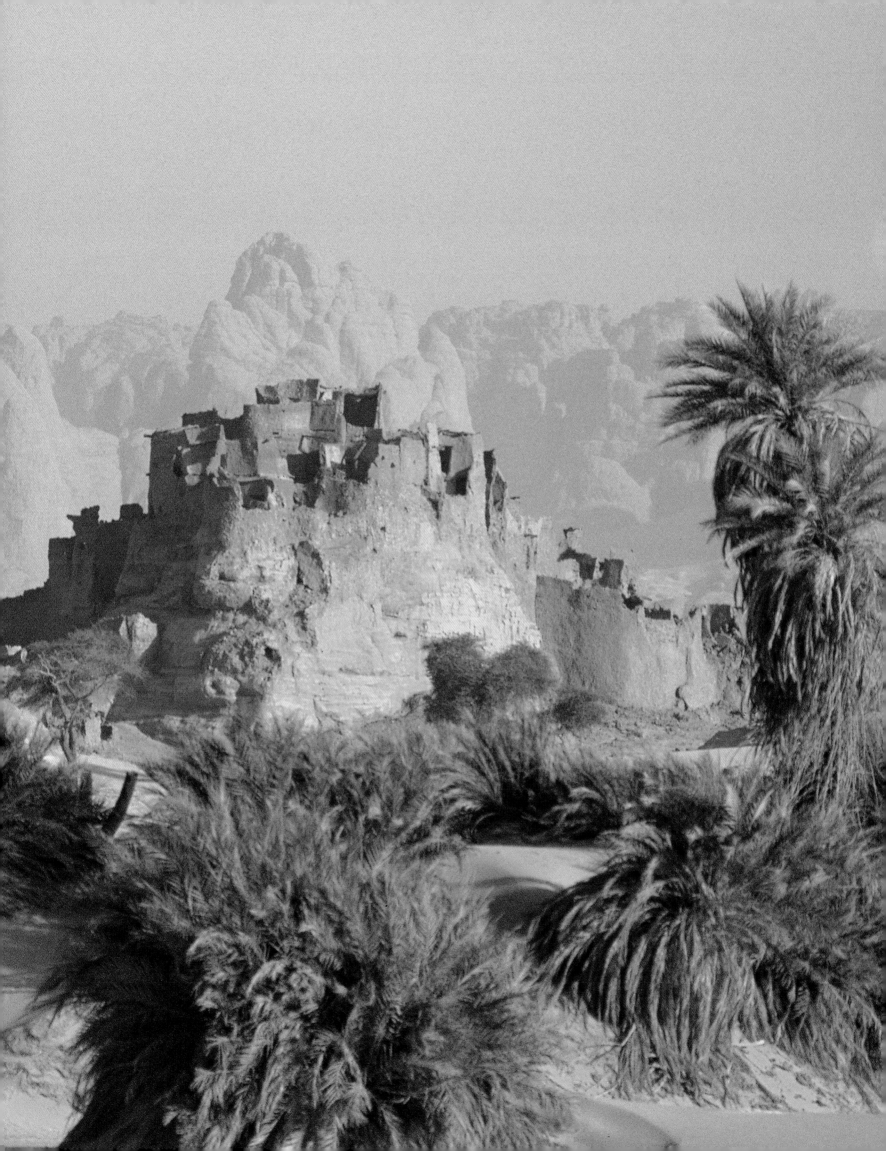

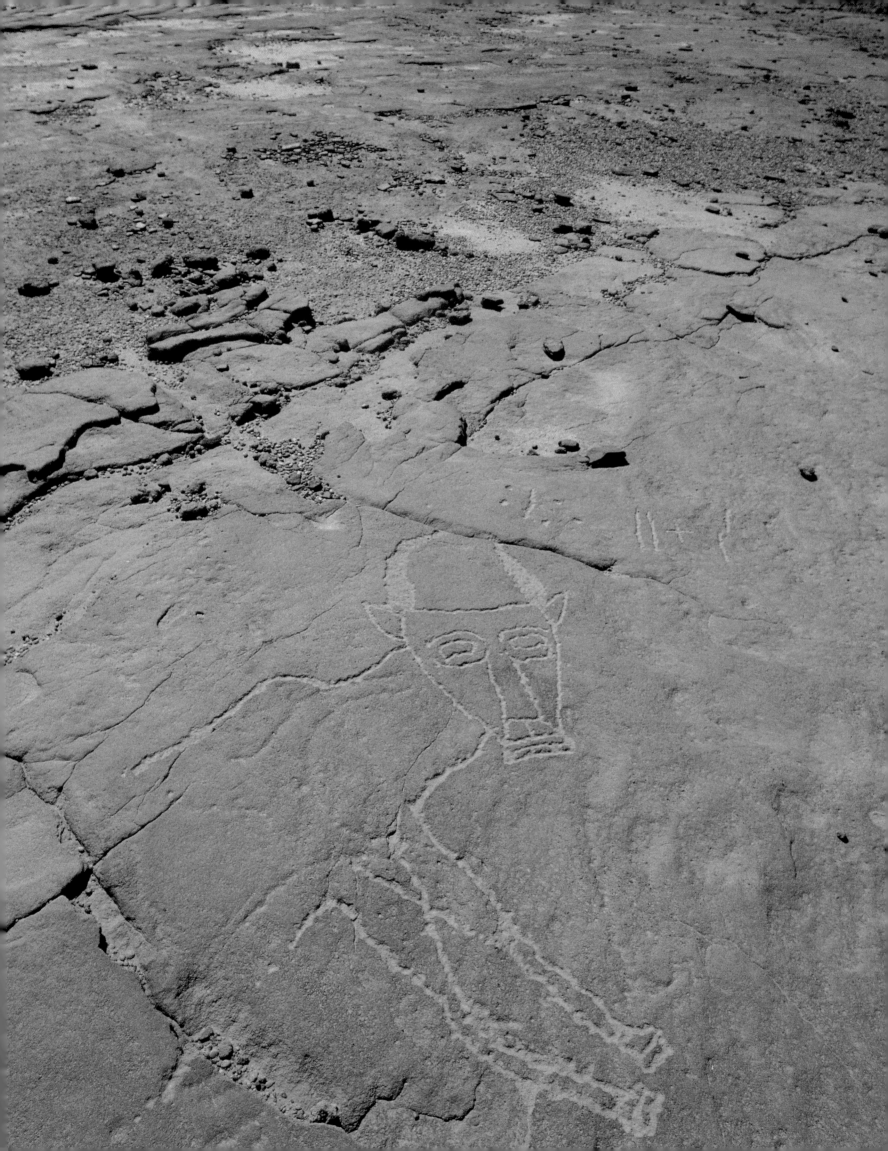

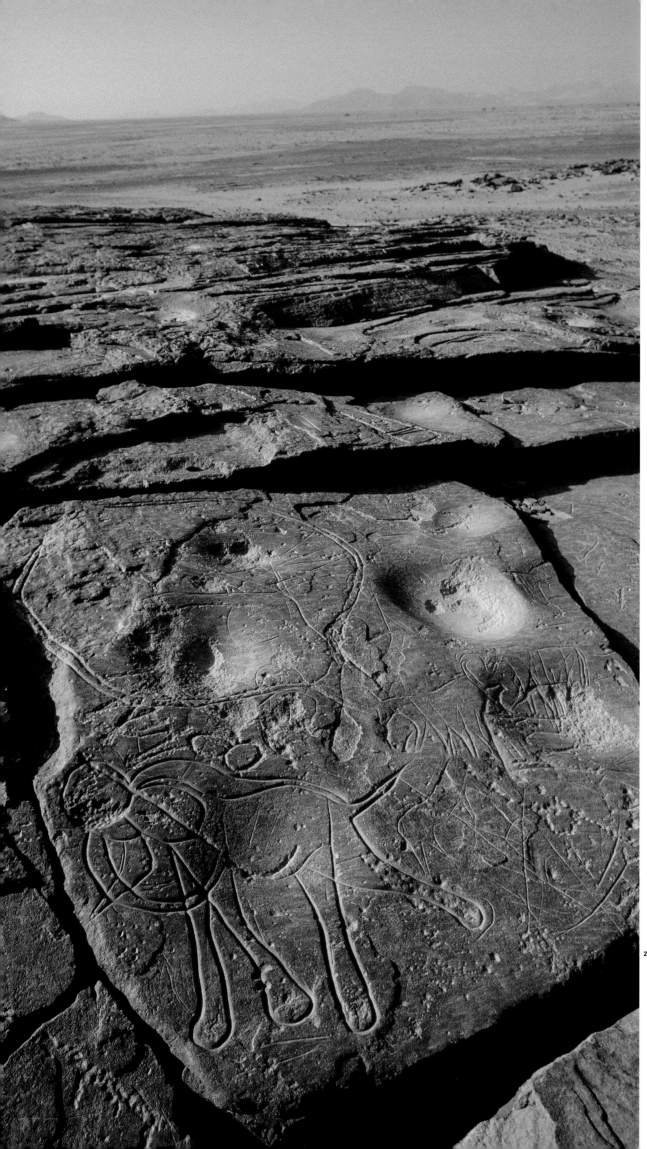

OPPOSITE FIG. 252 **At the summit of a long, gently sloping rock slab in Niger, an amazing figure takes shape. At first the engraving appears to resemble a cow, but its stance on hind legs, front legs out-stretched, and head turned toward the viewer suggest a human figure in cow's form. Other large human engravings found on the slab tend to reinforce this supposition. Adjacent Tifinagh script suggests a date with-in the last 3,000 years.**

FIG. 253 **Long ago, numerous large depressions were ground into the surface of a flat outcrop standing in the confluence of two wadis in Niger. Years later, a running elephant with both ears visible was engraved in Tazina style into the rock, its body deliberately superimposing one of the depressions.**

253

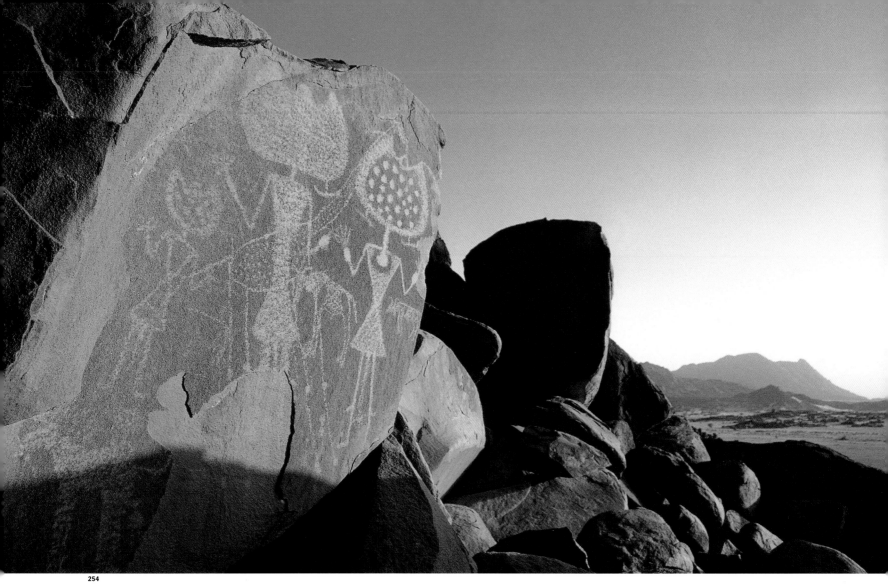

254

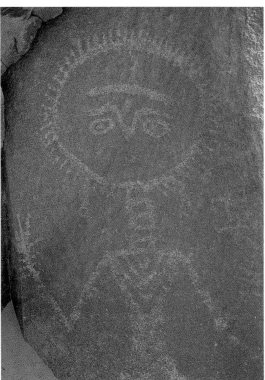

255

FIG. 254 Warriors with double triangle bodies and trilobular heads with a giraffe in northern Niger. Two large human figures have been deliberately engraved in considerable detail over the giraffe, while engravings of cattle also occur in a similar style. The panel was once larger, but a piece has broken from the right side of the rock taking part of the engraving with it. Its possible date is the early Horse Period.

FIG. 255 An engraving of a person's head and shoulders in the Libyan Warrior style in northern Niger. A Wodaabe, seeing a photograph of a similar engraving and noting the dress and earrings, told Carol Beckwith that it represents a woman performing a traditional greeting dance with arms outstretched and about to clap. Such statements suggest that ethnographies of Fulani peoples might assist in an understanding of the more recent central Saharan rock art. The engraved head and neck bear some similarity with western African Asante dolls.

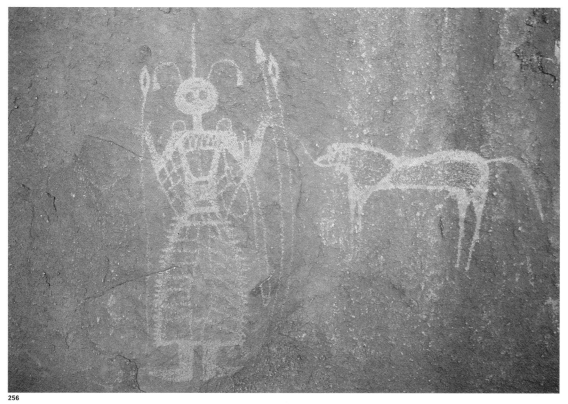

FIG. 256 An engraving of an armed man leading a horse in northern Niger from the Horse Period. The man wears a decorated shirt hanging to below his knees, has three plumes on his head, and holds spears with metal blades in either hand. Francis Rodd has compared this dress in similar engravings to the leather shirts formerly worn by the Tuareg and to paintings of Temehu Libyans found in an Egyptian tomb.

FIG. 257 These engraved figures in northern Niger with double triangle bodies, sometimes holding metal spears, were named Libyan Warriors by Henri Lhote and have been associated with Garamantes' raids perhaps 2,500 years ago. Francis Rodd believed some of these figures represent Tuareg (fig. 256).

256

257

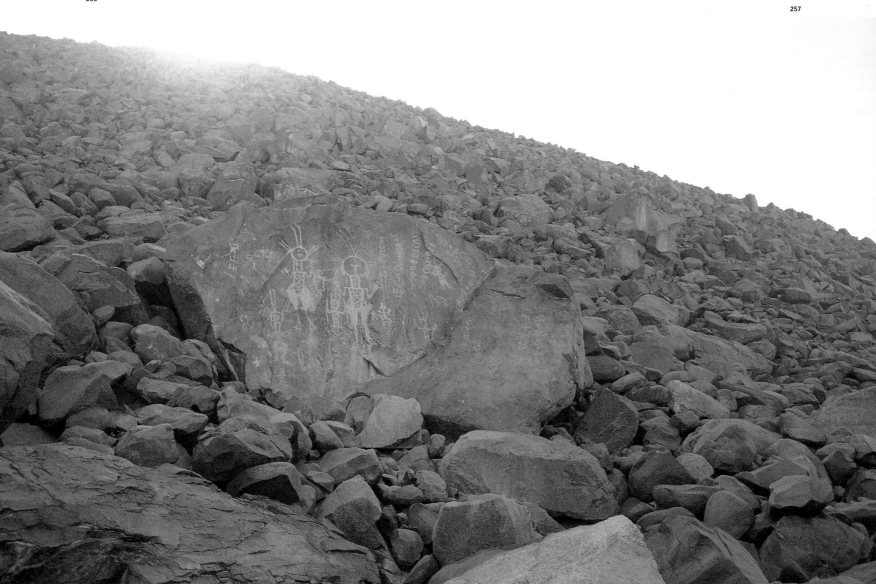

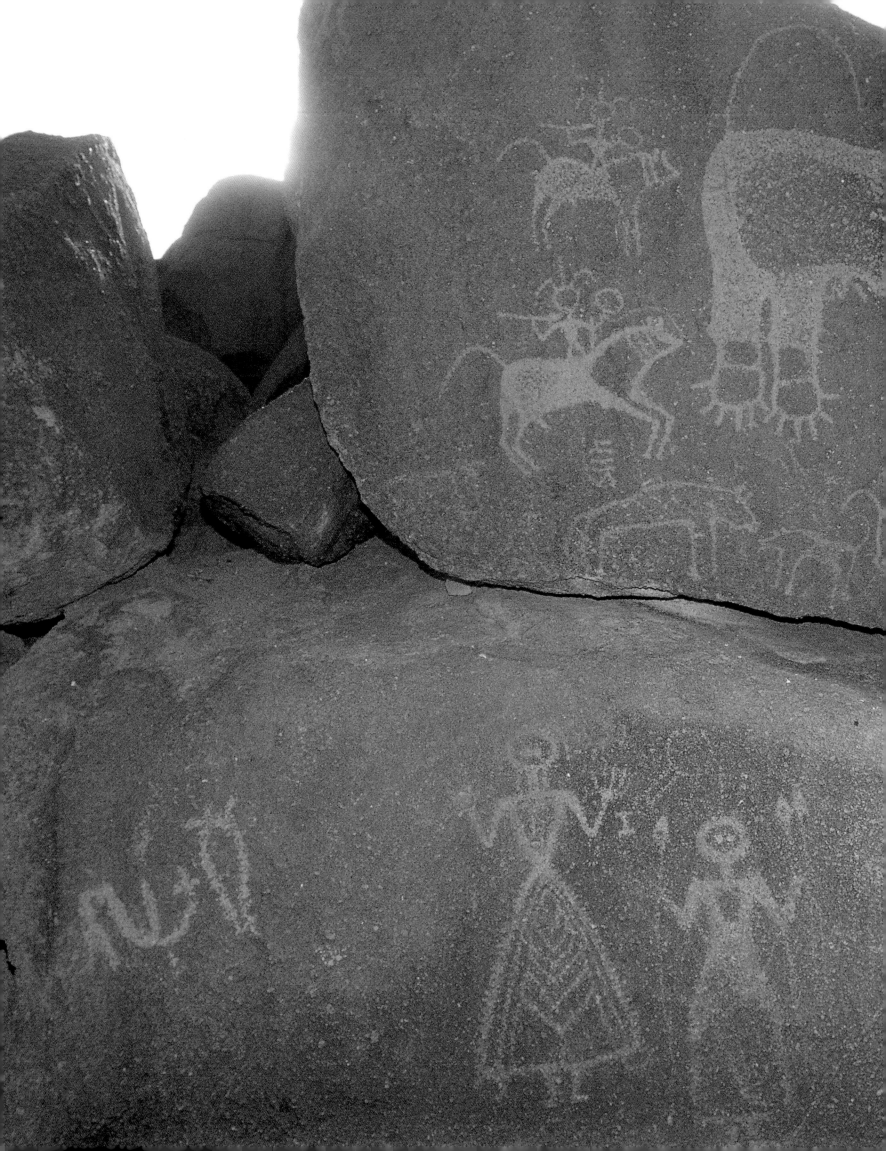

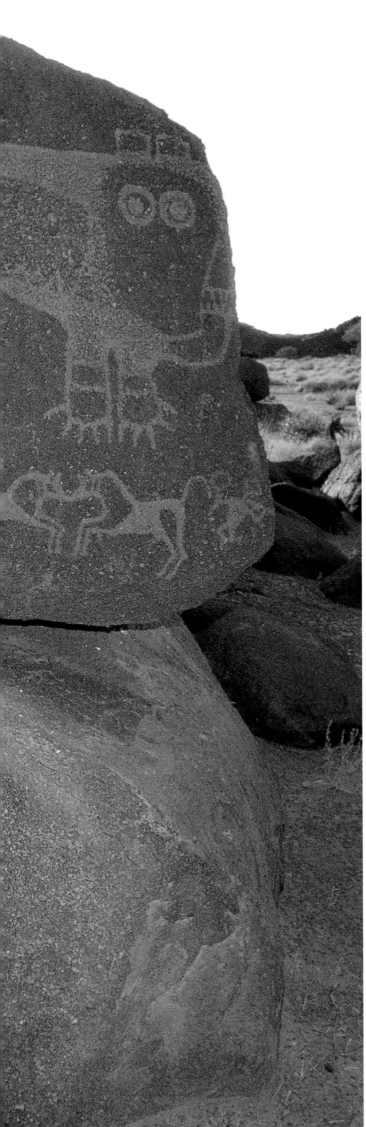

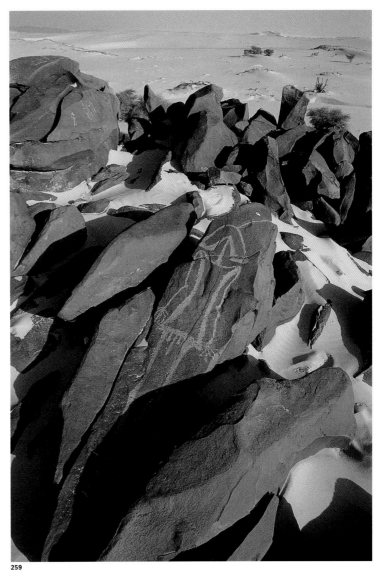

259

FIG. 258 Two horsemen with spears and shields, engraved in the style of Libyan warriors, approach a huge lion with tail erect. Note the lion's head is turned to the front, displaying two eyes and ears, while its front paws have five claws and the back have six claws. Below, two people face forward, one holding a spear in the right hand and two in the left, suggesting he is male. The engraving is from Niger and dates from the Horse Period.

FIG. 259 An engraving of a figure with a "mushroom" head, about 6 feet (190 cm.) in length. Note the bare legs and genitalia. The shape of the head suggests a date of 3,000 to 2,000 years ago. Mushroom-head engravings are mainly confined to valleys leading eastward out of the Aïr Mountains into the Ténéré Desert, Niger.

258

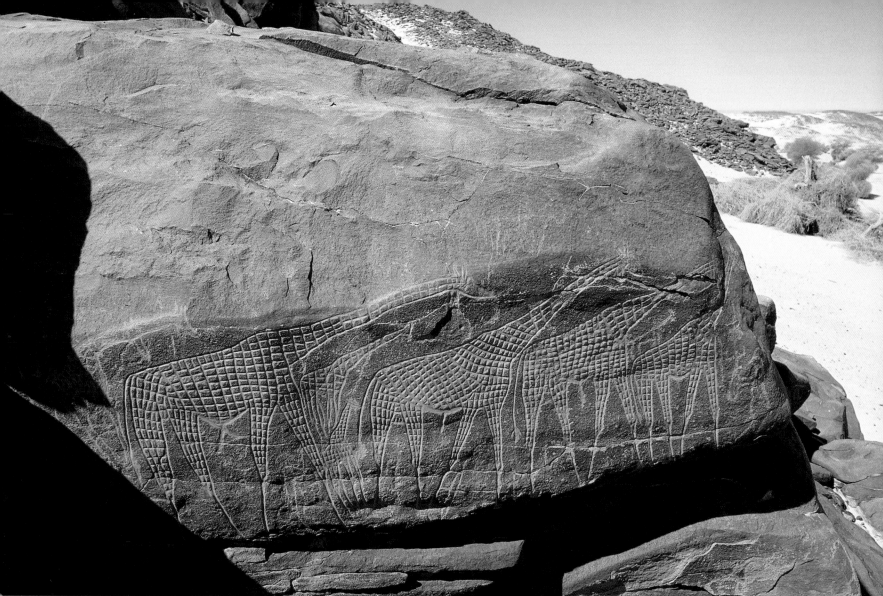

260

FIG. 260 A part of a row of carefully engraved giraffe on a rock in Niger, about 30 feet above the ground and facing northeast. The patterning on the giraffes has been achieved by cross-hatching, using deliberate lines rather than by the more random technique usually employed. The date is uncertain but is probably less than 4,500 years old.

FIG. 261 A scene of giraffe, people, and cattle on a split boulder, Niger, from the Horse Period. The four giraffe facing left may date to an earlier time than other engravings on the panel. A figure (possibly a woman) places a hand on one beast's rump, while another stands between the legs of a giraffe, balancing on her head a large load fitted into the cavity of the animal's stomach. On the right, a panel engraved with cattle, a giraffe, antelope, and birds has broken from the main rock. The overall composition and lack of superpositioning suggest a single integrated scene, even if they were not all engraved at the same time.

OPPOSITE FIG. 262 Two huge giraffe are engraved into a sloping slab, the larger one measuring almost 18 feet (5.4 meters) from hoof to horn. The engravings, probably between 8,000 and 6,000 years old, are accompanied by numerous images of other giraffe and cattle. The Trust for African Rock Art has arranged for the engravings to be molded for purposes of preservation and to publicize the Sahara's incredible art heritage. A cast of the giraffes has been mounted at the Mano Dayak International Airport, Agadez, Niger while others have been exhibited in Europe and the United States. In 2,000 the site was listed by UNESCO as one of the world's most endangered monuments.

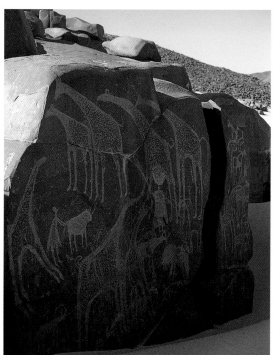

261

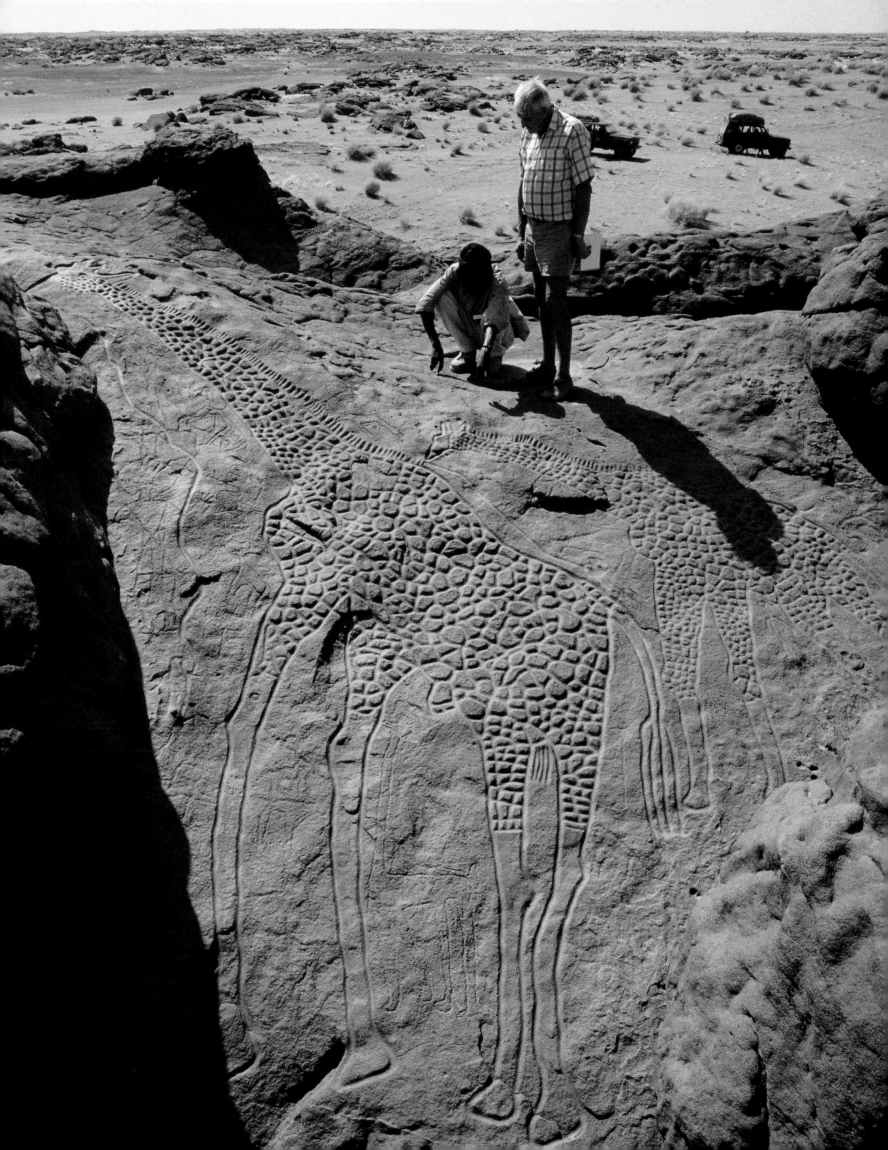

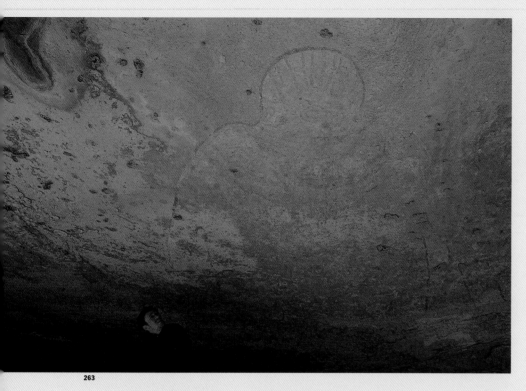

263

FIG. 263 Henri Lhote's "Great Martian God." Pier Paolo Rossi sits gazing up in wonder at this 18-foot-high (5.4 meter) huge Round Head figure looming over him in the Tassili n'Ajjer, Algeria. Huge painted figures, categorized by Lhote as belonging to the "evolved phase of the Round Head Period," probably date from the ninth millenium before the present. Eric von Daniken saw this painting as a real-life depiction of an "alien."

THE LOST WORLD OF THE TASSILI

After a week of waiting, the Algerian Consul in Agadez, Niger, issued visas to enter his country. We drove for two days across the Ténéré Desert. Our southern guides told us this name means "Desert within a desert" or "Nothingness within a desert," and how true this is, for its surface is flat, hard, endless sand, the circular horizon around us stretching unbroken to the sky.

After crossing the border into Algeria, a mere line on a map, for it is unmarked on the ground, we reported to the first army camp we encountered. "Do you have medicine?" they asked. We had medicine and they plied us with fresh dates and thanks. We drove on through the vast desert to the little town of Djanet set in the foothills of the huge plateau called Tassili n'Ajjer.

Here we found the temporary offices of ONAT, the Algerian National Tourist Association, and explained what we wanted. Great excitement erupted for we were the first tourists to visit Djanet in several years. Madame Aicha Foughali spoke perfect French and some English. She

found us a donkey-master and ten donkeys, blankets, and a cook, organized permits to enter the Tassili National Park, and phoned the park's director for us, Dr. Sidi Ahmed Kerzabi, with whom David had been in correspondence.

Kerzabi took us that evening to an incredible rock engraving of cattle at the base of an inselberg (fig. 4). Called Les Vaches qui Pleurent, the engraving is perhaps one of the world's finest masterpieces. He showed us how the artist must have studied the rock face for months before starting work; the depth and thickness of every engraved line had been carefully gauged to ensure that evening shadows falling in each groove gave the cattle incredible shape, mass, and movement. Double lines with areas recessed and internal polishing suggested color and evoked feelings of depth and density. Kerzabi pointed out how, by engraving into the stone face, the artist had emulated a sculptor's achievements when carving something out of stone. What amazed us most was the artist's incredible understanding of light and shade and how they could be used to create images so simple and yet so dynamic. These engravings are probably 7,000 years old and stand almost alone in a vast wilderness of rock. How did this artist acquire his skill with nobody to teach him?

We set out the next day for the plateau summit with our entourage, including our incredible guide, Aisa Ag Almad, who knew every rock of the immense plateau. We took the path upward, stepping slowly from stone to stone, gazing at the great battlements far above us, and wondering how we would ever reach the top. The path twisted and turned, creeping ever higher, following the sides of runnels, skirting huge rocks, and clinging to ledges below towering cliffs. We crossed an open amphitheater and plunged into a canyon with walls that rose up and up until they appeared to brush the clouds above. The canyon cut deep into the plateau, the path crawling along its floor

and then arching steeply up one wall. Six hours after we started, we saw the rim and staggered exhausted onto the summit.

Another hour's walking brought us to a *guelta*, a natural spring of water, where we saw vegetation lining the bottoms of shallow gorges in the plateau floor, pink oleander, a jagged-leafed plant like hibiscus, and, to our amazement, a cypress tree with an immense trunk that Aisa said was maybe 2,000 years old.

The donkeys arrived by a different path, just before dusk, and camp was made in a shelter where long ago pastoralists had built low walls of stone to protect themselves from the mountain wind. We put our beds beside the walls and crawled into our bags to escape the ceaseless wind and bitter night cold, thankful for the extra blankets we had been given in Djanet.

For ten days we wandered across the plateau's undulating stony plain, descending into shallow labyrinths of rocky passageways that divided the summit and once formed the upper reaches of large drainage systems. Our path threaded through these mazes, down narrow clefts, around buttresses, and under natural arches of rock until we lost all sense of direction and time. It was like wandering the streets of an ancient and deserted town. Henri Lhote, who recorded many of the paintings in the 1950s, described these mazes of ravines, cut crisscross into the sandstone summit, as "forests of stone." Wind and water had hacked thin passageways, carved out incredible arches (fig. 198), left high-pillared rocks standing like sentinels against valley walls, and carved series of undercuts at the cliff bases, making wonderful shelters with black walls sometimes as smooth as canvas.

One day we were wending our way down a passage when it opened abruptly into a small amphitheater. From the wall opposite, a huge painted male figure gazed toward us, with women on his left, arms raised in supplication. On his right stood a red roan or sable antelope, superimposed by a supine woman with a distended stomach (see fig. 7). We climbed down and approached this vast panel with awe. Later we discussed our feelings about Le Grand Dieu de Sefar (The Great God of Sefar), foremost of which was our sense of great reverence, sublimity, and silent drama. No interpretation seemed possible, but we agreed that here we were seeing man subservient to nature in an age before possessions robbed him of modesty.

Fabrizio Mori, who has excavated Akākūs shelters with these Round Head figures painted on their walls, reports that humans often have used these shelters but that their remains are always found alongside, never in front of, these magnificent yet gentle paintings, suggesting people throughout history have held them in continuous awe.

We climbed out of the maze and walked east, the biting wind blowing into our backs, treading on multicolored schist. We saw brown, red, purple, violet, green, and yellow-ocher slabs lying in thin layers across the summit. When we scraped them across a rock, the richly colored streaks exactly resembled the paintings' hues. This was their paint shop.

The cold wind blew all day, and that night we crept behind stone walls that may have been thousands of years old. Around the fire, we watched Mani bake bread in charcoal-heated ash and sand, and talked about the plants Aisa had collected in the gorges. One, with the Temasheq name Sasaf, was for washing your eyes when they become sticky and pink; another, called Ta sa tebaremt, was used for an upset stomach; and another, called Tikmzteu, is boiled for tea. Alec showed them a fearful-smelling plant he had found and they all started laughing. "Wipe it on your face and the devil will leave you alone," they told us.

That night it froze, and in the morning a wall of windblown sand glittered in the early sunlight. It was ablaze with tiny particles of ice. ◉

GEOMETRIC DESIGNS AND LATE WHITE PAINTINGS

PRECEDING PAGE FIG. 264 **Looking out of a decorated cave into the Brachystegia woodland in central Tanzania. Areas of roof and the north wall are profusely decorated with Late White paintings (fig. 158) made by ancestors of Bantu-speaking peoples. More recent paintings superimpose older ones, suggesting long use of the cave. Images of people standing with hands on hips and facing forward are found from Kenya to South Africa and may be of fairly recent origin.**

FIG. 265 **A very small painting in red of a "vortex" from Algeria. There is no certainty that this is an entoptic phenomenon; however, it is difficult to see what else it could represent.**

265

e look at geometrics and Late White paintings together because, for the most part, they are found in the same general areas and both occurred during the last 2,000 years. Also, geometrics make up a large proportion of the Late White painted art, and the distribution of both may have been initiated by the migrations of Bantu-speakers beginning about 3,000 years ago.

GEOMETRICS

Both painted and engraved geometric or schematic designs (often called non-representational art) are found all over Africa. For simplicity, recorders have named them in terms of their own cultural knowledge: circles, suns, grids, finger marks, spirals, and so on (figs. 143, 176, 266–272), which are adequate terms provided they are discarded when research begins into the actual purposes of the art.

Geometric designs are more common south of the equator than they are to the north and, in the southern half of Africa, they are more common on flat open country in the west than in the hilly or mountainous areas of the east. Generally, geometrics tend to occur less frequently than animals and human figures, except for certain areas in the south where they sometimes dominate the art.

Many attempts have been made to explain the uses of geometric art, with explanations ranging from sympathetic magic or symbols of climate and fertility to grooves for sharpening spears. Geometrics occur in many different configurations and have been produced over thousands of years by peoples with different cultures living in very diverse environments. It is difficult, if not impossible, to compare all the geometric art on the continent; therefore, as space in this book is limited, and the great bulk of geometrics occurs south of the equator, we will concentrate on the geometric art in southern Africa and its connection to the Bushmen healing dance.

David Lewis-Williams believes that many geometric shapes depicted in rock art represent the glowing images (known as entoptic phenomena) seen by people experiencing other states of consciousness, particularly the trance state. As people enter a trance they pass through stages; during the first stage, shapes such as arrays of dots, zigzags, grids (fig. 26), nested curves (fig. 282), and patterns of lines (fig. 271) are seen hanging in space before their eyes. In the second stage, these shapes are translated in their minds into everyday objects important to them, such as animals, water, rain, rocks, and bowls. In the third stage, the trancer is drawn into the imagery and may see a vortex (fig. 265) and feel as though plunging into it, rather like entering a hole in the ground.

266

269

271

267

FIG. 266 **A painted spiral in red from Zimbabwe (see fig. pp. 70–71).**

FIG. 267 **Bright paintings from Niger of concentric circles in red, black, and white, with faint red figures. A Tuareg claimed his ancestors created these paintings. Elsewhere in eastern and southern Africa, concentric circles are associated with girls' initiation ceremonies.**

FIG. 268 **A particularly complicated geometric from Male Hill in Tsodilo, Botswana, painted in white on a cave roof in a cliff face almost 550 feet above the ground.**

FIG. 269 **An engraved spiral from Morocco.**

FIG. 270 **An engraving on a shelter wall in Zaire surrounded by inferior engravings and crudely painted geometrics designs. Protrusions on the rock face appear to have been incorporated into the engraving. Elaborate engravings suggesting weaving occur in Zaire and southward into Angola (fig. 284). They do not resemble Twa art and their age is unknown. (Redrawn from H. Breuil and G. Mortelmans,** *Les Dessins rupestres graves ponctues et peint du Katanga: Essai de synthese.***)**

FIG. 271 **A painted spiral design in red from Algeria.**

FIG. 272 **Paintings from Niger of grid shapes and joined concentric circles in red and black.**

268

270

272

FIG. 273 A red geometric design in a tunnel-shaped granite shelter in eastern Uganda. Traps for catching cane rats lean against the shelter wall and decorated pottery sherds lie on the floor. Local people claim the traps, but have no knowledge of the pottery. Oral history proclaims the geometric to have been painted by hairy yellow dwarfs. Similar paintings in the region are said to have been associated with rain-making rituals.

FIG. 274 A human footprint, 13 inches (33 cm.) high, engraved on a vertical rock in northern Namibia. The footprint superimposes what appear to be a human figure, two animals, and a geometric design. Nowhere else have we seen a human figure superimposed either by a footprint or a geometric design.

Lewis-Williams's theory suggests that some geometric designs could be trancers' representations of their trance visions. Trancers knew what the visions meant for them but needed to reproduce them graphically for all to see and experience. Today, we can only guess at the meanings of the images, but for the trancers and their communities, they may have been symbols to explain or relate their mystic experiences in terms of the natural world. Geometric art can be extraordinarily complicated (figs. 268, 270) and may indeed derive from entoptic phenomena; however, if it does, the artists have developed it to a point beyond original recognition.

If the geometrics were symbols representing abstract concepts, such as supernatural potency obtained from spirits during trance, then inscribing them on rock could have maintained their power and provided a means to use these powers for healing, creating harmony, and making rain, aspects important to small communities depending on natural resources for their livelihood. They also may have been used rather like Tibetan mandalas, images on the walls of monasteries on which novices fix their concentration and which help them to obtain uplifted states of prayer.

The question remains whether it is possible to apply a theory on ancestral Bushman art to all rock art. For instance, can we apply Lewis-Williams's theory to explain similar concentric circles painted by pastoral Lybico-Berbers during fairly recent times (fig. 267), and to explain

273

274

275

those painted by Twa hunter-gatherers more than 1,000 years ago (fig. 273). When trying to find the meaning behind geometric designs, Lewis-Williams's theory should be kept in mind but not applied before more about the artists is known.

SOUTHERN AFRICA

Much of southern Africa's engraved art occurs on the inland plateau between the Orange River in South Africa and Namibia's northern border, although it spills over into Angola. Over this wide area, many thousands of geometric, animal, and sometimes human figure engravings are concentrated in particular boulder-strewn places, on low hills on the veld, and on flat rock

riverbeds (fig. 141). In some places, a thousand or more engravings occur in an area extending over only a couple of acres. Depictions are relatively small, rarely more than twenty inches across, and usually face upward. In western Botswana similar depictions occur, but as paintings rather than as engravings (fig. 26). Most of this art has been attributed to ancestral Bushmen.

Karl Butzer, using dates of the historical wet and dry periods to determine when flat rock riverbeds and nearby rocks were open to engraving, believes that the earliest engravings, excluding fine-lines, in South Africa's northern Karoo and southern Kalahari probably date to about 3,000 years ago, or a little earlier, and that between 1,200 and 800 years ago there was a "wild explosion of geometrics." David Morris and others think the same engravings are 2,000 years old or less. Benjamin Smith has proposed that the geometric art found in Zambia was the work of Twa. He sees many similarities between Twa geometrics and the patterns modern Pygmy women paint on bark-cloth and use to divine climate and fertility. He proposes that Twa geometric art also may have been the exclusive domain of women, who used it for similar purposes.

Geometrics also are found in the painted art in more mountainous areas close to South Africa's coastline and in Zimbabwe, but nowhere do they occur in the same concentrations as they do on the flat country of the inland plateau, nor in the same stylized forms.

FIG. 275 Late White paintings of birds and animals by Chewa people for Nyau society rituals in Malawi. The central animal superimposes an earlier red geometric. (Drawn from H. E. Lindgren and J. Schoffeleers.)

FIG. 276 An engraving of a human footprint in southeastern Botswana. One of twenty-nine footprints said to have been left by Matsieng, the one-legged giant ancestor of the Tswana, when he emerged from underground.

FIG. 277 A drawing by a modern Naro Bushman, Nxabe Eland, of Quaqua's ancient engraved footprints. (Reproduced from *Quaqua: A San Folk Story Told by Coex'ae Qgam.*)

FIG. 278 Geometric designs in red in central Tanzania that were painted above and superimpose an outline of an animal.

276

277

278

Thus far, we have looked only at the earlier geometrics, which were painted or engraved by foraging peoples such as ancestral Twa and Bushmen. Bantu-speaking people spread through Twa areas to settle the eastern and southern continent. Although there are design differences between the geometric art of Twa and Bantu speakers, it appears possible that the latter were influenced by the former. At the same time, some Late White geometrics display remarkable similarities with the so-called Bushmen engraved geometrics of southern Africa. Bantu-speakers are known to have been responsible for much of the Late White painting south of the equator and have continued to paint up to the 1960s.

FIG. 279 A drawing of the
engraving in fig. 280, possibly
of a snake with a horse
standing on its neck.

FIG. 280 A narrow cutting
paved with long slabs of rock leads
through weathered cliffs into a huge
amphitheater in western Chad. Long
ago, shallow depressions had been
ground into the slabs, and, later
still, an engraver pecked out a
geometric pattern that could
represent a snake (fig. 279).
The date is probably within
the last 3,000 years.

279

Although more evidence is needed to be certain, it seems possible that the art of the hunter-gatherer peoples about 2,500 years ago both influenced Bantu-speakers on their migration, and also diffused southward through ancestral Bushmen to eventually "explode" about 1,200 years ago on the southern plateau. If this theory is ever substantiated, we will be able to say that much of the engraved geometric art in southern Africa involves symbols that may have been used in rainmaking and fertility divination.

THE TSODILO HILLS

The Tsodilo Hills rise out of the Kalahari Desert in northwest Botswana and contain some 4,000 red finger paintings composed of about 50 percent animals, 37 percent geometrics, and 13 percent highly stylized human figures. The geometrics are mainly either rectangles with appendices (fig. 146) or circular images containing grids (figs. 26, 146, 268), the latter being somewhat similar to engraved geometrics found stretching from Angola and Zambia south to the Orange River in South Africa.

The animal paintings include about 160 images of cattle, painted in the same styles as the wild animals, which is an enormous number of cattle images compared to any other region of southern Africa. It is clear that the same artists are responsible for the geometric, wild animal, and cattle paintings and that geometric and cattle images had major importance to them.

The identity of the artists is uncertain, but they probably originated in the north of the region and may have been responsible for introducing the first cattle into northern Botswana. In any event, they must be linked with the artists who made the more recent engravings in southwestern Africa and could be ancestors of central Bushmen, who have a long history of cattle raising in the area.

GEOMETRICS AND THE UNDERWORLD

It is not always easy to understand the positioning of rock art. Often suitable areas are empty of art while an image nearby has been placed in such a way that a rhino's horn stops against a crack in the cliff, or a geometric is painted within a recess. Sometimes one or more engravings are located in a small area while surrounding areas are bare of art. Although they may be incomprehensible to us, these placements were deliberate and may have had relevance to the rock behind or below them, or may have acted as doorways into the supernatural world, which many peoples believed existed inside the earth.

The Tswana and Bushmen of southern Africa have oral legends for footprints engraved into rock that may offer some clues to a better understanding of engravings. Perhaps one of the most interesting comes from Botswana, where human footprints are engraved at a number of places in the Kalahari Desert, from the Orange River to central Angola. The Tswana claim one of these sites (fig. 276) as their place of origin and believe their first ancestor, Matsieng, emerged here through a hole in the still-soft rock from his home below the ground, followed by his

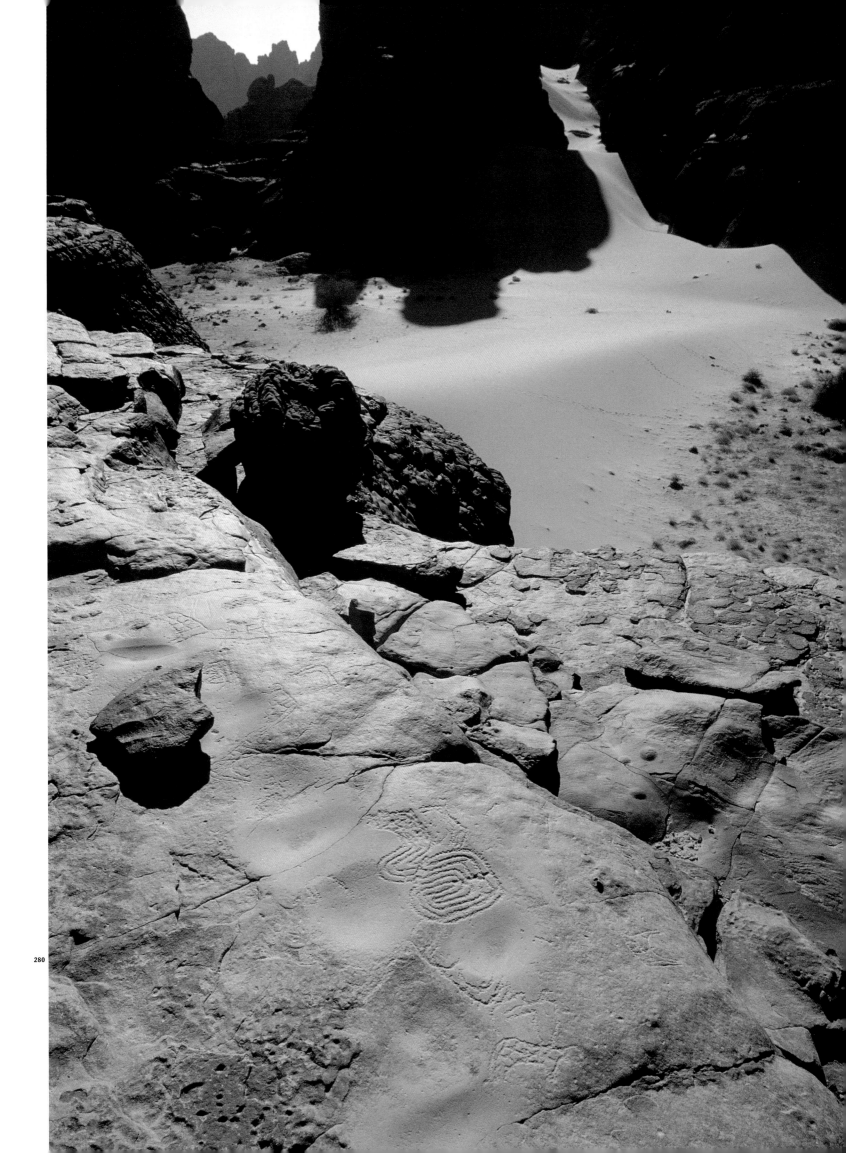

FIG. 281 An engraving of an oval with grid and rays on a river pavement in Kimberley, South Africa. See also fig. 141, which shows part of this vast site with its huge number of geometric engravings.

281

people, livestock, and wild animals. Legend has it that he and the animals left their footprints in the rock: twenty-nine human footprints engraved around the hole remain as evidence. The Tswana have used the same hole as a rainmaking site.

This story has two points of interest: first, Tswana claim the hole as their place of origin, although their oral history describes an ancient homeland in the north; and, second, the site has been used for rainmaking. Thus, the rock art marks an entrance into the mythical world and is a place where rain can be summoned. However, we know that the engravings must well predate the arrival of Tswana in the area some 400 years ago and that they were almost certainly made by ancestral Bushmen. The Tswana's claim of origin may be based on their need to establish a mythical relationship with the land. Nobody knows how the story originated; it could have been borrowed from early hunter-gatherer beliefs. While this story relates only to one site, it may be possible to extend to other sites the idea of an entrance to the mythical world through the decorated rock. Certainly, many rock art sites as far north as Uganda are used for rainmaking, and some Bantu-speakers believe red paint taken from rock paintings increases the potency of rain medicines.

Naro Bushmen in the central Kalahari Desert associate footprints in rock with their mythical ancestor, Qauqaua, who killed her husband after he murdered her mother for slandering him. Qauqaua's brothers-in-law chased her through the veld until they caught and killed her. Qauqaua turned into a shiny rock. Today, Naro believe Qauqaua left her footprints in the rocks of Mamuno, Botswana (fig. 277).

LATE WHITE PAINTINGS

Most Late White paintings are believed to be the work of Bantu-speakers who, even spread over a very wide area of central and southern Africa, tend to structure their societies along similar lines and hold similar cosmological views. They also recognize a close association between people and the earth and believe in the ability of autochthonous peoples to control the elements through their access to spirits within the earth.

Late White paintings were made with the finger rather than a brush or other implement and occur mainly in shades of white, or, less frequently, black, yellow, brown, red, and pink. They are found almost wherever Bantu-speakers passed through in their migrations southward. A few also are found on the flatland of southern Africa's interior plateau where Bantu-speakers had not penetrated.

The images—it is difficult to call them art because most, particularly the animals, are poorly executed—involve geometric patterns, sometimes intricately drawn (fig. 268); wild animals or, less often, domestic stock such as cattle and goats; and schematic people, who often are facing forward and sometimes have large penises hanging between their legs.

A few matrilineal groups of Bantu-speakers claim that their ancestors were responsible for some of the paintings, but most disclaim knowledge, saying they were painted by "the people of long ago," perhaps by hunter-gatherers who used bows and arrows, such as the Twa of Zambia,

282

283

284

FIG. 282 An engraving of "nested curves" from southern Namibia. Such engravings have been described by David Lewis-Williams as entoptic phenomena seen by people entering the trance state. At the same time their purpose, like that of a mandala, may have been to help initiates enter the trance state by staring fixedly at them.

FIG. 283 Numerous plans of Iron Age villages, mainly engraved in fine-line technique, have been found in a band passing north and south of Pretoria, South Africa, and probably date to after 1600 A.D. The engravings also include images of Tswana shields and therefore may be the work of Tswana. (Tracing by R. Steel in Iron Age Settlement Plan Rock Engravings, Magaliesberg Valley.)

FIG. 284 An engraving on an exposed pavement in Angola. This and similar engravings in Angola have been attributed to Bantu-speakers; however, nowhere else have similar designs been attributed to them. (Reproduced from C. Ervedosa, "Arte Rupestre," Segunda Parte.)

FIG. 285 Part of a large panel of Late White paintings, almost 40 feet long (12 meters) in Zambia. The paintings superimpose earlier drawings in red. (Redrawn from a photograph in Phillipson, 1972.)

FIG. 286 Punctuate engravings from Zaire of a predator animal and a bird. They appear to be unique to this country. (Redrawn from H. Breuil and G. Mortelmans, *Les Dessins rupestres graves ponctues et peint du Katanga: Essai de synthese.*)

285

286

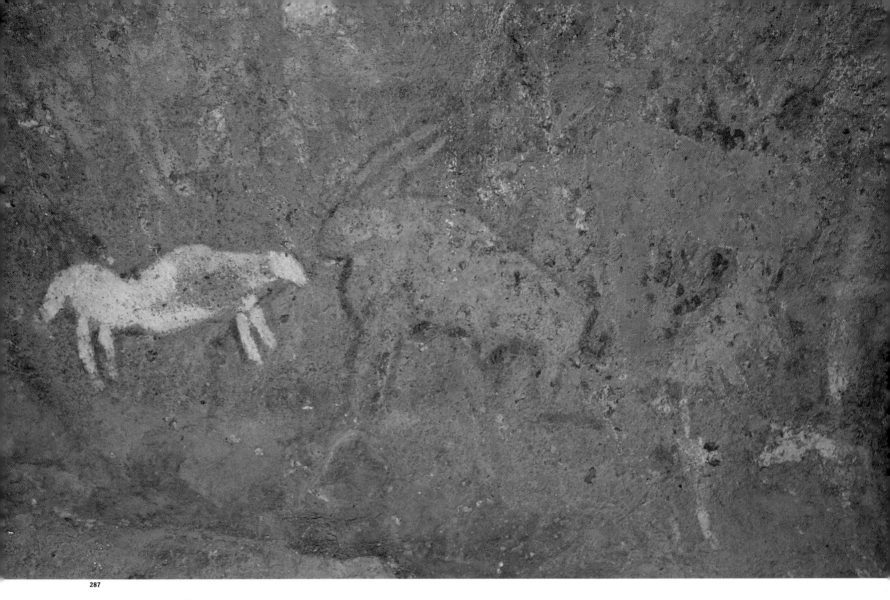

FIG. 287 Crude, but striking, animal images from the Wonderwerk Cave in South Africa thought to have been painted by pastoral Khoisan-speaking people a few centuries ago. The cave has been extensively excavated, is a national monument, and is protected by a caged entrance with a locked gate.

FIG. 288 Late White paintings in western Tanzania that have been identified as cattle viewed from above.

FIG. 289 A Late White painting in black of a domestic cow superimposed by a painting in white in Botswana. Similar white paintings occur in Tanzania (fig. 288), where they have been described as "cattle seen from above" and as human figures.

288

289

the Akafula of Malawi, the Kisi of Angola, and the Ngona of South Africa. The matrilineal Chewa of Zambia and Malawi, Bantu-speakers who are believed to have lived in association with the Twa for more than 1,000 years, say their ancestors made many of the more recent paintings for use in various rites-of-passage ceremonies. Smith and others have described these drawings as being part of girls' initiation and first pregnancy ceremonies; transition ceremonies, such as death and the appeasement of ancestors; activities performed by men's closed Nyau societies (fig. 275); and rainmaking. During the ceremonies images were used for instruction in proper behavior: there are water and fertility images for women's rituals and Nyau mythical figures (people dressed in basket-work costumes) for men's rituals (see fig. 59).

These painting traditions have ceased, but the ceremonies of which they formed a part are still practiced, and the meanings of the symbols are still remembered. While the women's paintings may have considerable time depth, the men's paintings are thought to date between 1850 and 1964, a time when the Nyau ceremonies were suppressed, first by the conquering Ngona and later by missionaries and colonial administrations. Thus, we know something about the purpose of the paintings, but we know little about their symbolic values and how they were actually used.

CONCLUSION

Although more evidence is needed before any definite statements can be made, it is now possible to make some suggestions about the spread and authorship of geometric art in the subcontinent. First, we see that much of the geometric art occurs in a wide band down the western subcontinent, from the Congo to the Orange River in South Africa, and that similar designs, whether they are engraved or painted in red or in white, are found throughout this area. Their proximity and, to an extent, similarity both suggest that at some place and time these geometric designs had some ancient relationship to each other. What follows must remain a theory unless much more evidence is found.

Between 3,000 and 2,000 years ago, Bantu-speakers spread from their homelands east and south through the rain forests where Twa—ancestral Pygmies—lived. Perhaps they used the Twa, and Twa rock art, to give them a certain stability in new and unaccustomed lands and with time incorporated Twa symbolism into their religious practices, using white paint rather than red.

This same movement may have created ripples in front of it, pushing Twa east toward the Indian Ocean and pushing south some hunter-gatherers living on the borders of Twa lands. Such movements could have carried geometrics eastward into Malawi and southward into South Africa, places where they are now found, and would account for their similarity and the relatively recent date of 2,000 years ago when the Karoo engravings were first made.

This theory suggests that the greater part of southern Africa's engraved geometric art, including Tsodilo's painted geometrics, as well as Bantu-speakers' Late White geometric paintings, all stem from ancient Twa art. If this is correct, then most southern African geometric engravings and paintings are probably associated with rainmaking and fertility rites.

FIG. 290 A Late White painting of a grid and circle superimposing an earlier red rhinoceros in Botswana. Circles containing grids occur from Kenya to South Africa, although in the south usually as engravings. Deliberate superpositioning of such geometrics is common, suggesting imposed paintings gain something (perhaps power) from those beneath or vice versa. In Botswana, the artists of the white paintings may have been Bantu-speakers but also could have been pastoral Bushmen.

290

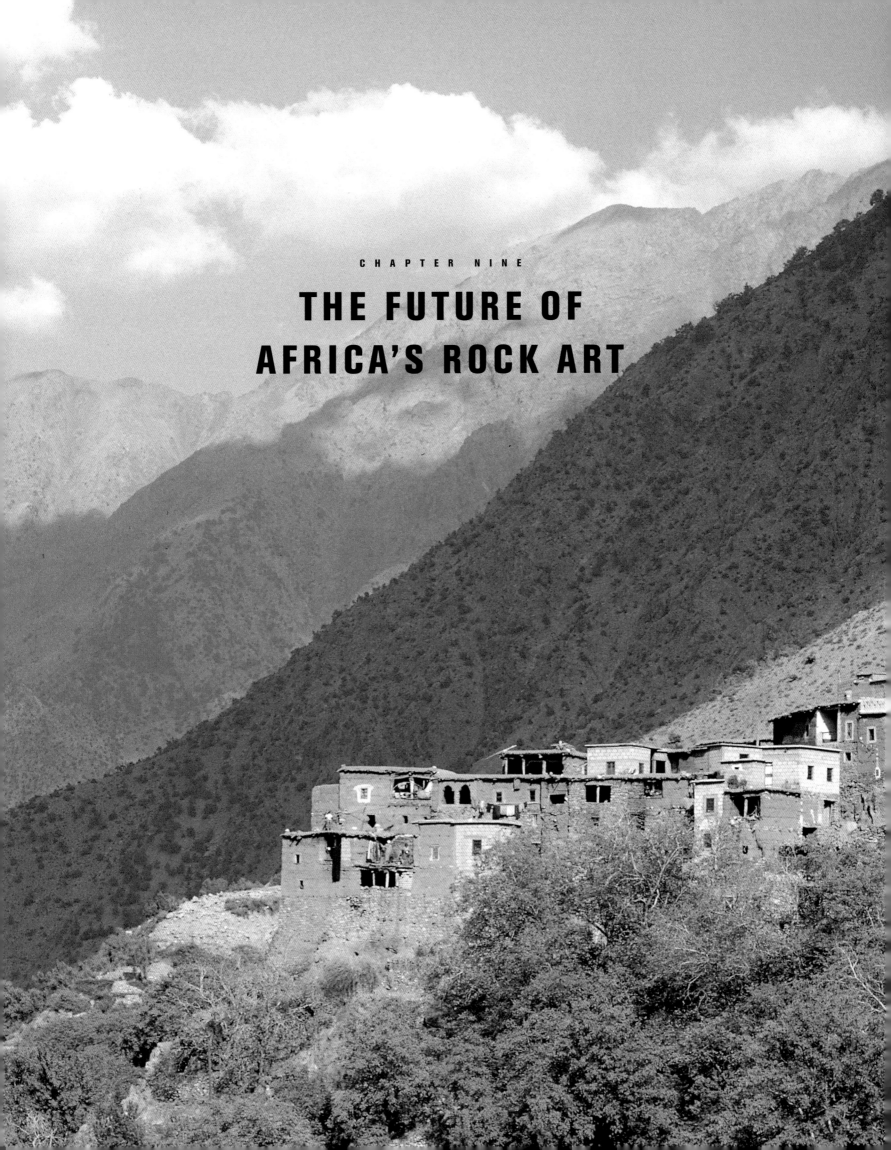

THE FUTURE OF AFRICA'S ROCK ART

The task of ensuring a future for Africa's rock art is enormous and, to be successful, will require concerted efforts not just by governments, scientific institutions, and researchers but also by nongovernmental organizations, landowners, and individuals. Considerable strides have been made across the continent: laws protect national heritage; some sites have custodians or are protected on private land, in a park, or on a reserve that has controlled entry; and museums and universities in both Africa and Europe research and record rock art and publish their findings.

THE COUNTRIES OF SOUTHERN AFRICA have made considerable strides toward creating inventories of their rock art sites and recording individual images. In an exercise lasting almost four years, more than 80,000 paintings were photographed in Lesotho (although this number represents less than half of its estimated total). South Africa has established specialized rock art recording centers. Botswana, Malawi, Namibia, and Zambia have listed most of their sites; Zimbabwe has been recording sites for more than forty years.

Organizations such as UNESCO (United Nations Educational, Scientific, and Cultural Organization), World Heritage, and ICOMOS (International Council on Monuments and Sites) are promoting a better worldwide understanding of rock art while a large number of nongovernmental organizations such as SARARA (Southern Africa Rock Art Research Association) and Rocustus (Friends of Rock Art) are working at a regional or national level.

The future of Africa's rock art hangs in the balance. If the art is to survive more or less intact into the twenty-first century, governments must take drastic action now. Unfortunately, it is not just governments and their financial policies that are to blame for the failure to look after a national heritage: it is the politicians, civil servants, commercial developers, tourists, and the public, all of whom have their own agendas, on which rock art features at the bottom. Many countries may manage to preserve only the art in protected parks or reserves or on privately owned land.

Before looking directly at the problems, we want to take you with us around Morocco, a beautiful country with magnificent scenery, modern towns, fine museums, fascinating people, a tourist industry, and plentiful rock art. An open country with easy access from Europe, or from anywhere else for that matter, Morocco is already facing problems and not doing much to solve them. The problems Morocco is facing will soon be shared by other countries.

In South Africa, the University of the Witwatersrand has established the Rock Art Research Institute in its Department of Archaeology, which both records sites and offers degree courses in rock art studies. The Southern African Rock Art Project (SARAP), organized

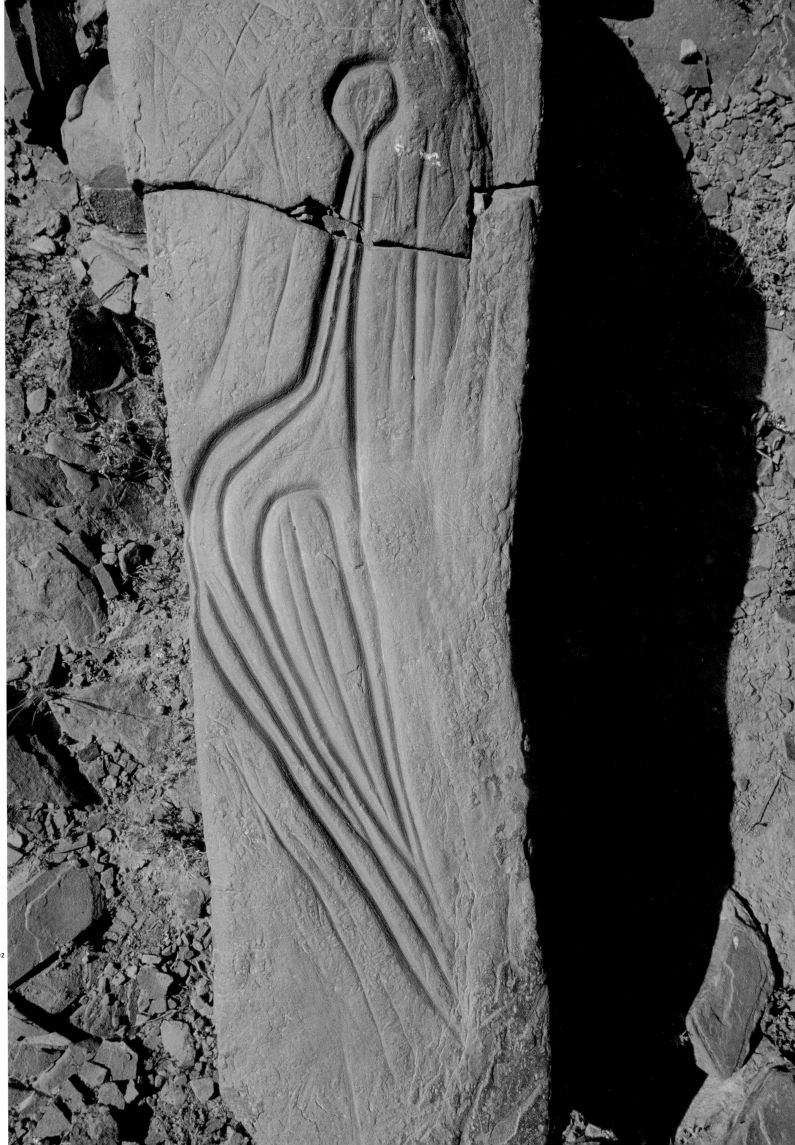

through the National Monuments Council, South Africa, was initiated to provide assistance to eleven southern African countries in preparing a serial nomination of rock art sites for the World Heritage List. Out of this initiative has developed a series of short courses offering guidance to decision makers in the field of rock art and training to site managers in protection and management of their sites. In the north, the Trust for African Rock Art (TARA), working with the Niger government, has succeed in having the Dabous Giraffes (fig. 262) listed under the World Heritage Convention, and guards stationed at the site.

MOROCCO

FIG. 293 At a bend in a dry river course in southern Morocco, numerous circles, concentric ovals, and patterns of zigzag lines are engraved into almost every rock. Both pecking and grinding techniques have been used. Some engravings appear relatively fresh while others are barely visible.

This is the only country we were able to visit in northwestern Africa. Flying in, and later driving from Marrakech to the Atlas Mountains, we saw how European the country appears, quite unlike the Africa we know lying to the east and south. The ground is firm and well vegetated, orange groves line the roads, and there is little dust. Later, after crossing the High Atlas and

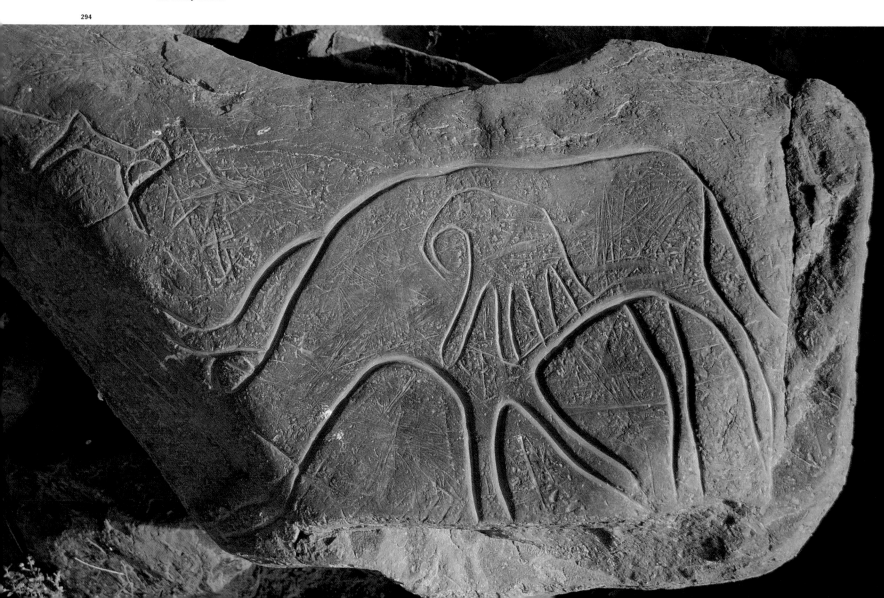

295

descending to the rocks and sand beyond, we realized that the mountains divide the country into two parts: The north could just as well be Spain as Morocco but the south has foothills that give way to rocky outcrops, long stony expanses, dry wadis, and sand dunes that disappear into the distance. We knew we were back in Africa.

We had been taken under the wing of Abdellah Salih, director of Morocco's southern monuments, who acted as our guide for our entire stay in his country. We soon realized that he is fighting a difficult battle since he has only six caretakers to look after literally thousands of rock engravings scattered over a wide area, poor transport, and few funds to manage his huge estate.

We drove first over the High Atlas and down into Tazzarine, a little town in the foothills facing the Sahara. The engravings here, mostly of animals, are schematic rather than naturalistic, with curved lines cut and polished into the rock (figs. 292, 294). Walking along a rocky ridge banked by sand, Abdellah showed us numerous engravings of cattle, lions, rhinoceros, antelope, and ostrich cut into large but movable rocks (figs.

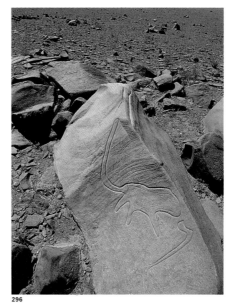

296

OPPOSITE FIG. 294 **An engraving of a rhinoceros on a loose rock, Tazina style, in southern Morocco. A small elephant is depicted within the outline of the rhinoceros while another animal, most likely a dog, faces it from above. Both elephant and dog are probably more recent additions. The date of the rhinoceros engraving is uncertain, but it could be 6,000 years old.**

FIG. 295 **Curvilinear engravings on the upper face of a low cliff in southern Morocco. Over 400 such engravings, unique to Morocco, occur at a single site. The engravings span a considerable time period and are thought by Elizabeth Searight to be about 4,500 years old.**

FIG. 296 **A Tazina-style engraving of a lion faced by a weapon, perhaps an ax, a boomerang, or even a snake, in southern Morocco. The date of this engraving is uncertain.**

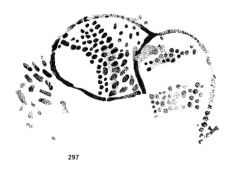

297

296, 299). We made no special count, but engravings of rhinoceros in the Tazina style (named after the site in the Ksour Mountains, in southern Algeria, where engravings were first recognized as part of a style widespread throughout central and western Sahara) appeared to dominate the wild animal engravings, suggesting they may have had some particular importance to the artists, just as eland have importance to Bushmen in southern Africa.

Sometimes Abdellah would point to a hole in the ground and tell us that a rock with an engraving had been there two years ago. At other times he pointed to engraved rocks that had been broken and discarded when thieves had tried to pry them from the hillside (fig. 296). "These thieves come with their trucks at night," he said. "They pay the local peasants, who have little money anyhow, to help them steal. The engravings are sold in Europe." We asked who buys them and were told rich collectors and even museums. One group of thieves is thought to have been Belgian. They were seen by a nomad boy who ran for help, but help was far away and arrived too late; the thieves were gone.

There are few rock paintings in Morocco, but Abdellah had heard of, although never seen, a site quite close to our route. We stopped in a village and Abdellah asked for a guide. He was tersely refused and told that these sites are secret and not to be shown to strangers. Eventually, the villagers contacted the police by radio, Abdellah's credentials were verified, and we were taken

298

to the site. The paintings, on the outside roof of a small cave involve only two patterns of red dots (fig. 297) not dissimilar to art in some European caves, such as Lascaux and Chauvet. Most other Moroccan paintings are similar but the European paintings are fifteen to thirty thousand years earlier.

We left the desert and took a winding road zigzagging up the mountains. Little villages surrounded by orchards of almond and peach cling to the mountainside. As we drove higher, we passed banked-up narrow terraces green with winter wheat. High in the mountains are valleys filled with meadows and overlooked by the ruins of tiny stone houses. In summer, peasants bring their stock to feed here, leaving when the first snows fall.

Eventually, we reached Oukaimeden, a holiday and ski resort, at an altitude of about 8,500 feet. Walking between the houses, hotels, and stores perched on the hillside, we looked at engravings of Bronze Age daggers, spears, axes, halberds, and boomerangs (fig. 305) cut into the rock perhaps as long as 3,000 years ago. Sadly, when the resort was built, nobody cared about the engravings on which piles of stone, rubble, and

cement were dumped. Even today, no interest is taken by the wealthy owners of these holiday homes, although the area has been protected by law.

David found a polished Neolithic ax lying on a path between houses, which tells us about earlier inhabitants. It is thought that the first visitors were probably ancestral Berber pastoralists who retired into the Atlas foothills from the western Sahara as the area dried up. During summer, they took their stock to the high mountain valleys and engraved cattle, and a few wild animals, into the meadow rocks (fig. 302). Later, but probably not much later, they were joined by people coming from the north bringing their own stock with them. How relations stood between these two peoples is unknown. The new arrivals carved into the rock weapons and strange anthropomorphic figures, some of which held daggers in their hands and were protected by square shields (see fig. 305). One anthropomorph also has a fish under his left arm (fig. 308).

We also saw numerous circular engravings, often highly decorated (fig. 307). These have variously been interpreted as shields from the Bronze Age and as suns. The daggers, which were the main weapons of European pastoralists, are thought to represent the relationship between man and livestock. Daggers also have been likened to fish and to lightning, with its dazzling and destructive nature. One researcher believes that five of the anthropomorphic figures reflect a cult that practiced human sacrifice by piercing the body with arrows. Excavations in Morocco have yielded minimal copper and bronze artifacts, and it has not yet been determined whether the artists actually owned such weapons or whether they were symbols brought with them from afar, as there does not appear to have been a Bronze Age in Morocco. The engravings of daggers and halberds are certainly similar to engravings found in Spain (fig. 38) and are dated to the Bronze Age II, about 3,100 to 2,700 years ago, which suggests a possible date and place of origin.

Did painting and engraving originate in Europe, as many people believe, and later spread to Africa? Morocco would appear to be an ideal channel, and some early rock engravings in Morocco can be compared to a few European engravings, but the dates of these engravings are actually far apart since the European engravings were probably made 10,000 years earlier than those in Morocco. As we also have seen, similar engravings of Bronze Age weapons are found in both Spain and Morocco, and it is possible that these particular symbols spread from Europe, but these are only 3,000 years old. Archaeology suggests that the earliest rock art of Morocco was made by pastoralists living to the south of the Atlas Mountains more than 4,500 years ago and that the art had spread from the southeast, out of the Sahara. The Bronze Age art may have an origin in Europe, but the Tazina engravings are definitely African in nature.

Our emotions were mixed when we left Morocco. There is a law to protect prehistoric art and someone has been appointed to enforce it. Many villagers recognize their heritage and are not prepared to see it destroyed. But Abdellah has no money to work with, and at higher levels there is little interest in rock art. We asked Abdellah if there is a future for the art. "Of course there is," he answered.

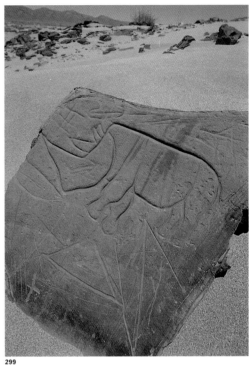

299

FIG. 297 **A geometric painting composed of red dots. Morocco's rare rock paintings usually depict animals or geometric patterns of dots.**

FIG. 298 **Straddling a low wall below a cave in southern Morocco, a local villager looks up at a geometric painting composed of red dots. Rock paintings, usually depicting animals or patterns of dots, are uncommon in Morocco.**

FIG. 299 **A Tazina-style engraving on a loose rock of a square-lipped or "white" rhinoceros in southern Morocco. The geometric graffiti are later additions.**

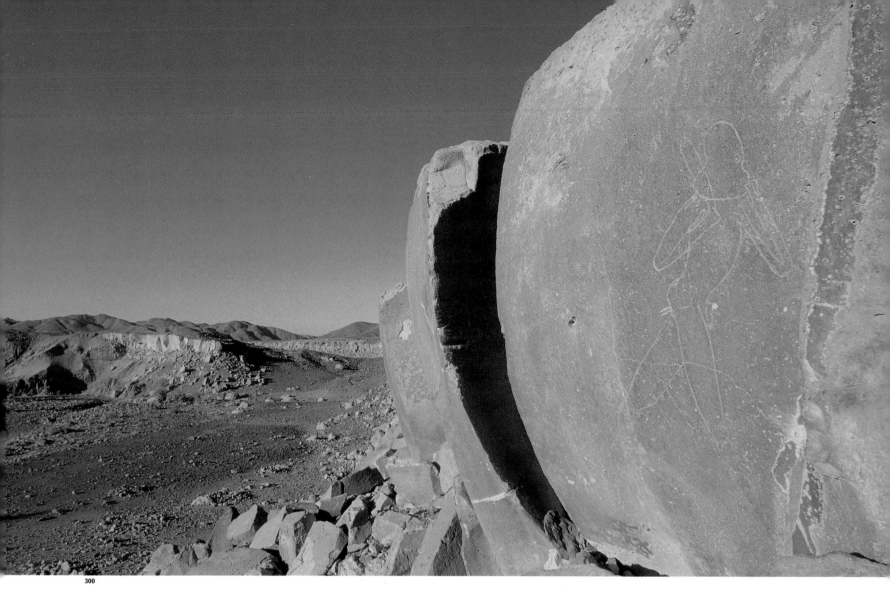

FIG. 300 **L'Homme de Gonoa in northern Chad faces up the wadi as though he owns the numerous huge images of elephant and rhinoceros engraved on its silent cliffs. With his right arm bent up and his left fist raised to a mask over his head, he stands 6.5 feet (just over 2 m.) from heel to forehead. This painting would add luster to the world's greatest art galleries; sadly, it has been disfigured by pornographic additions.**

FIG. 301 **Abdellah Salih holds a piece of engraving broken off during an attempted theft. A young nomad spotted the thieves and ran for help, but the thieves escaped in their vehicle. Salih says that 80 percent of this site's engravings have been stolen.**

THE FUTURE

We want people to enjoy Morocco's art but also to remember that what is there today will not be there tomorrow unless the Moroccan government takes a more positive attitude toward its heritage. The same applies to other African countries. South Africa has all the legislation it needs and spends a little money on heritage protection, but nowhere near enough if it wants to preserve the rock art for the future. As it is, nongovernmental organizations and private individuals often shoulder the heaviest load.

The last hundred years have seen appalling damage done to rock art, some of it thousands of years old, almost entirely wrought by human activity. The next hundred years could see magnificent works, as fine as paintings in the world's greatest galleries, disappear forever, destroyed by a lack of official attention, ignorance, vandalism, and greed.

Lack of official attention is a serious problem. Most African countries inherited colonial laws covering protection of archaeological remains. Sadly, governments budget minimal financing toward conservation of national heritage

301

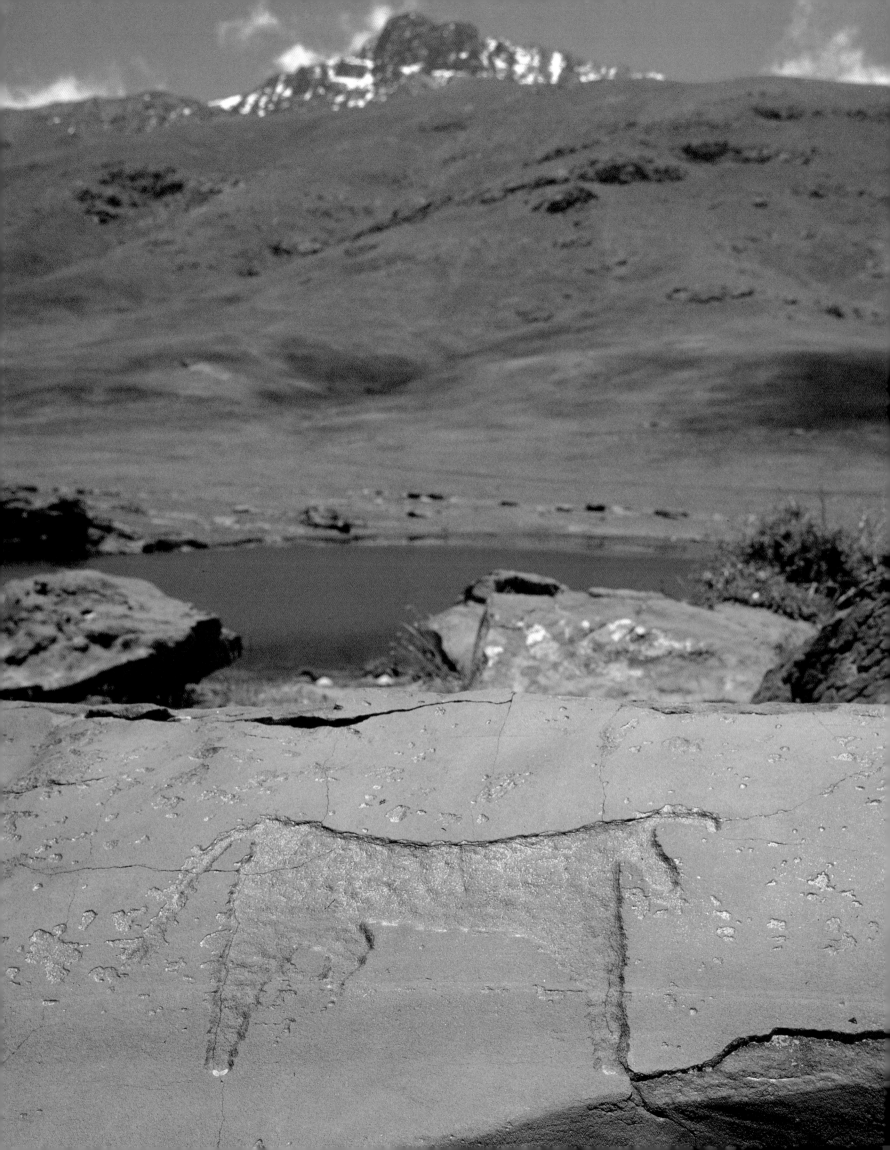

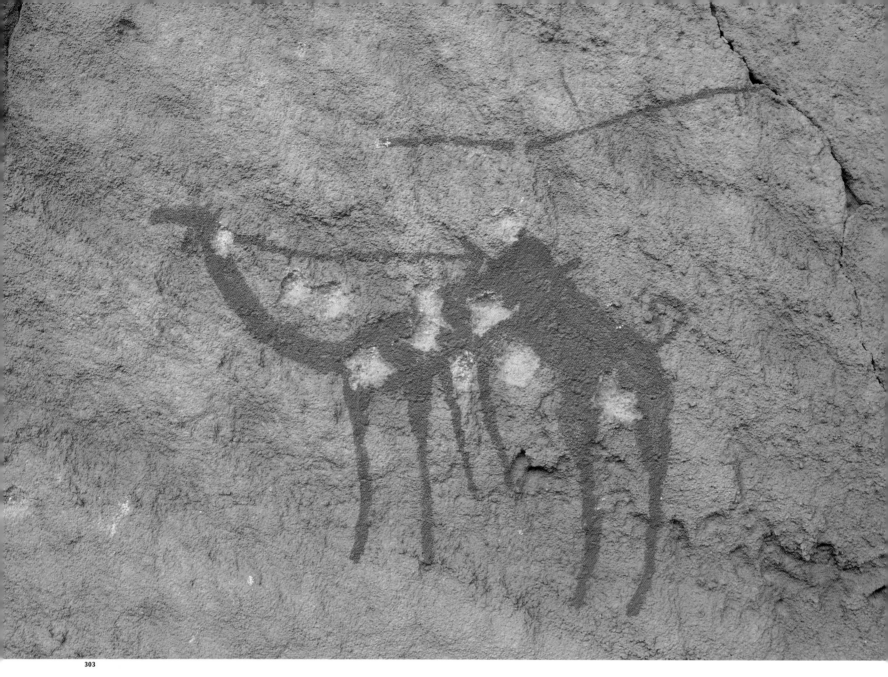

303

PRECEDING PAGE FIG. 302 **An engraving of a cow or bull with horns turned forward in the High Atlas Mountains of Morocco. Images of cattle are rare in the Atlas, as opposed to other northern African areas, and are replaced by depictions of Bronze Age weapons, particularly daggers (fig. 305). By 5,500 years ago, Neolithic pastoralists had found these pastures in the upper valleys, which in the spring still provide summer grazing for cattle, sheep, and goats. The engravings here are endangered by an expanding ski resort.**

FIG. 303 **A burst of automatic rifle fire has peppered a painting in eastern Chad, leaving ten bullet holes across the image of a camel.**

and, in particular, to rock art. Park departments, museums, and monument commissions receive insufficient financing to fulfill even the tasks stipulated by the laws of their countries. Universities sometimes conduct research and recording programs, but they also have few funds, so much of this work has largely been left to private researchers. Public awareness programs, where they are undertaken at all, often fall to the lot of private rock art societies.

Thus, important rock art sites are neither explained to the public in brochures or on notice boards nor are they guarded. The result is vandalism: Pubic hairs and indications of air coming from the anus were carved by an unknown vandal onto L'Homme de Gonoa, a huge and very old engraving of a masked man on the rocks of northern Chad (fig. 300); a tourist in Botswana attempted to erase ancient white superimpositions over red paintings, thinking they were recent graffiti; engravings on portable rocks are stolen from Morocco and South Africa (fig. 301); bullets have riddled both paintings and engravings in the Sahara (fig. 303); everywhere, names and messages are scrawled over and carved into the art; and visitors regularly pour water, carbonated drinks, and even urine on paintings to enhance, for a brief moment, their colors for photography.

Not least of the culprits are rock art recorders themselves. In earlier years when the art was little known and its fragility not well understood, many thought paintings would last forever. One now-famous recorder describes how paintings were "swabbed down" with sponge and water to enhance the images for tracing, not realizing that water applied with a sponge can seriously harm in minutes what has survived for 8,000 years. Other recorders and photographers have marked engraved lines in white chalk, not appreciating that future technology may reveal new ways to date their varnish or determine whether they were once painted. To this day, professional recorders have been known to outline faint paintings in pencil to make their shapes more visible through tracing paper.

Developments also are taking their toll. Mining activities and construction of roads, reservoirs, and spas have already damaged the art. Before Egypt's Lake Nasser was filled in 1970, a few rocks with engravings were removed from the banks of the Nile River and piled beside the reerected Temple of Kalabsha, where they still lie untended (fig. 210), but much of Egypt's earliest art was inundated. Prospecting for oil in the Messak of Libya is currently (as of 2000) creating a grid of square kilometers separated by tracks bulldozed across the plateau and through wadis with cliffs lined with huge engravings, although one company is making efforts to prevent further damage. In Tanzania, in their search for German gold, local treasure hunters have excavated pits below paintings, destroying layers of human refuse that one day might have helped to date the paintings (fig. 158). In Namibia, quarrying granite slabs for city buildings has threatened 1,000-year-old paintings and in 2000 a huge tourist lodge was built against the engraved site of Ceremonium Plaza, completely destroying the site's integrity. In southern and eastern Africa, red paint is chipped from images to be used for added potency in ritual medicines (fig. 306). Monument guards and inspectors are so sparse in Africa that one might well say they do not exist. Nobody wants cages erected in front of decorated shelters (fig. 309), but this may be the only way to protect them.

We know that the art cannot last forever; water seepage over rock, exfoliation, and natural erosion of sandstone and granite will eventually destroy the images. However, it is possible to prolong the art's life by adding artificial drip lines above paintings, stabilizing delicately balanced engraved rocks, and, perhaps, one day protecting paintings with some form of varnish that has yet to be developed.

There is a need for research. Recording the art is important since copies then remain even when the images have disappeared from the rocks, but programs to do so often lack government backing. Cultures are changing and oral knowledge is disappearing. There is a need to learn how local people view the art in their areas, how it may have been used in the recent past, and how it fits into their inherited

FIG. 304 A Tuareg safari operator indicates graffiti covering paintings of cattle, wild animals, and humans in a large shelter in Tassili n' Ajjer, Algeria. The shelter is a halting place on a trade route, and some of the graffiti, made by travelers and not tourists, is perhaps hundreds of years old.

FIG. 305 Engravings of Bronze Age weapons: two daggers, spearhead, halberd, boomerang, and rectangular shield. The blades of the daggers and halberd have been decorated. Actual prehistoric bronze objects have yet to be found in Morocco.

305

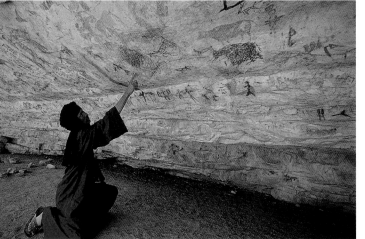

304

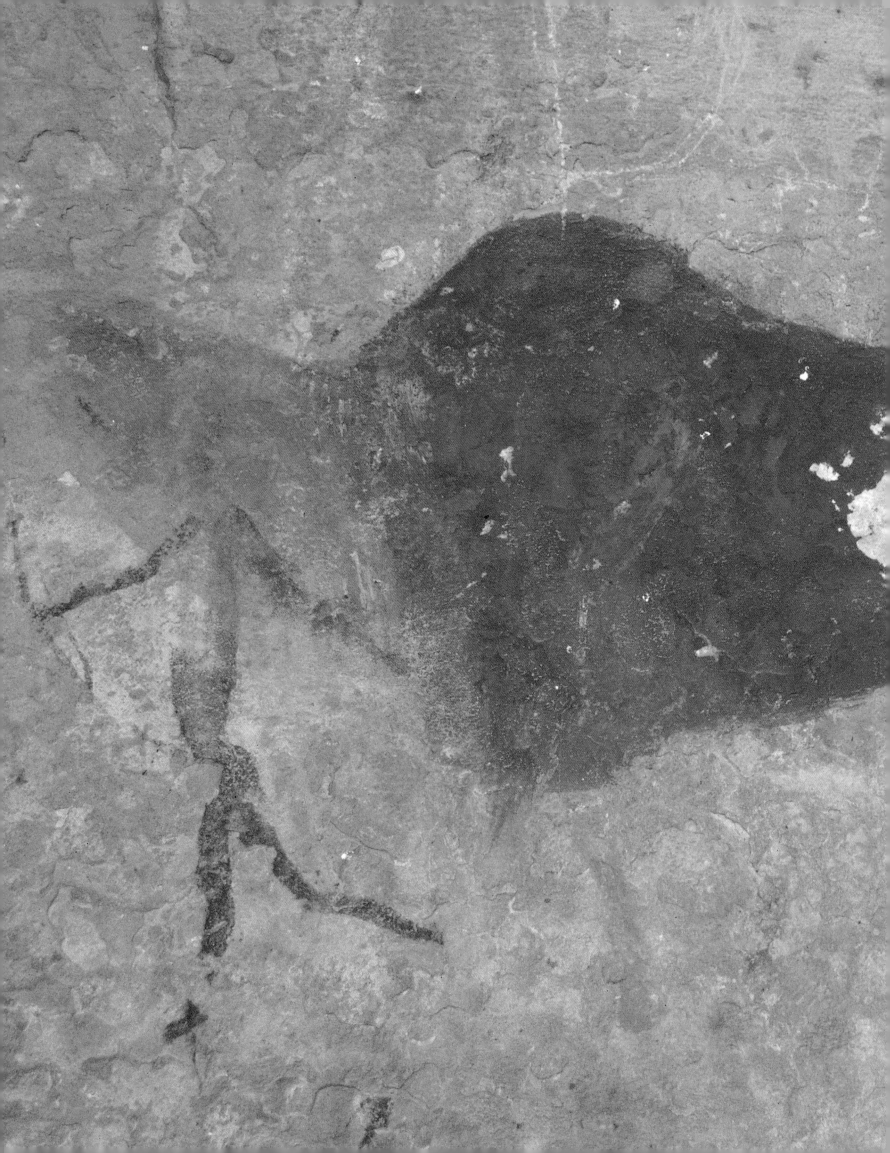

FIG. 306 **A polychrome painting in reddish black of an eland and a man with a bow in South Africa. Note the gouge in the eland's side where pigment has deliberately been removed. Such pigment is believed to retain magical power and is highly valued as an ingredient in medicines and rainmaking. Similar defacements in southern and eastern Africa suggest a widespread problem.**

FIG. 307 **An engraving from the High Atlas Mountains believed to represent a Bronze Age shield or a sun. Engravings of Bronze Age shields in Europe depict them mainly as rectangular.**

FIG. 308 **An engraving of an anthropomorph, about 5.5 feet (1.7 m.) long, in the High Atlas Mountains. The figure has a penis, wears padding (like armor), holds a dagger and spearhead in his hands, and carries a shield. A fish may be engraved under his left hand.**

307

308

306

FIG. 309 **Tourists stand outside the cage (erected in the 1950s by the management of the nearby Uis Mine) protecting the painting of the White Lady in the Maack Shelter (figs. 33, 34), Namibia. It is no longer possible to see the figure's carefully painted details, mainly because years of spraying with liquids has blurred the image. Will all great rock art eventually be reduced to this?**

conceptions of reality. There is a need to learn how to stabilize the art against rapid deterioration, to discover enhanced methods for dating it, and even how to present it to the public so that visitors gain maximum satisfaction.

Rock art is unique; it remains the earliest form of human communication left to us today, much of it predating literacy and even food production, and provides insights into the way early societies lived, thought, and visualized their world. Once lost, it can never be regained.

It may play an important role in the development of tourism and its associated industries in Africa; but without an effective infrastructure already in place before visitor numbers increase, rock art will suffer. Especially important is the need to ensure that local people are included in developments involving their heritage. Africa has already seen what happens to wildlife when local communities are excluded from its benefits. Local people will only protect rock art if they are encouraged to participate in its conservation and to derive benefit from its use by foreigners.

This leads to the second aspect of preserving rock art: public awareness. Few children are fully educated to value cultural heritage, and even fewer recognize the unique value of rock art. Visitors to the Tate Gallery or the Louvre do not scratch their names on the art; why then should visitors to an open-air gallery deface its treasures? Only when local communities and visitors alike understand the value and fragility of rock art will it be safe. Without this understanding, whatever regulations and physical protection governments may afford will simply not be enough.

Readers will have noted that names and locations of sites are generally not mentioned in this book. Unfortunately, this is becoming a necessary practice. In countries such as South Africa and Zimbabwe, a few sites are posted and visitors are encouraged, but that is only because these sites have been documented and are properly protected. For the most part, sites are unprotected, and, therefore, publishing their locations invites destruction. Out of a thousand visitors, it takes only one person to ruin a painting by scrawling across it.

We hope that those of you who have never seen rock art in situ will be encouraged by this book to go and see it for yourselves.

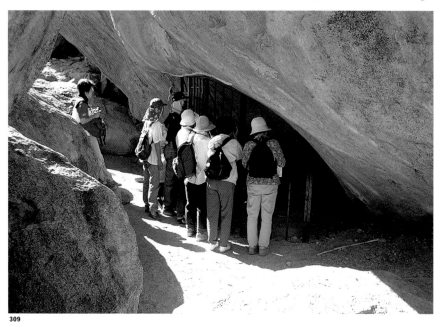

309

ACKNOWLEDGMENTS

Our interest in rock art goes back many years during which we have been accommodated on countless occasions, shown numerous sites, given maps, descriptions and photographs, and learned so much from our hosts, friends, and acquaintances that it is now impossible to list everyone who has helped us.

We have received enormous encouragement from many people, particularly the late Mary Leakey who proposed this book and the late Sir Laurens van der Post who told us to make an immediate start. From the outset, people have been incredibly helpful: experts and others have given freely of their knowledge, farmers have gone out of their way to make sure we saw sites on their land, people have found books and papers no longer easily obtainable and even given us their own copies. A number of researchers have allowed us to use their rock art tracings and photographs, which is much appreciated. It is not sufficient just to say we are grateful–without help from all these people, this book would never have come together.

Large organizations have made specific grants to the Trust for African Rock Art (TARA), which sponsored this book. We are especially grateful to the National Geographic Society, the Getty Conservation Institute, the Anglo-American and De Beer's Chairman's Fund, and to the Robert H. and Ann Lurie Family Foundation, and the Ford Foundation, all of which have given us invaluable support. Private individuals have also helped with funding, most of whom prefer to remain anonymous; however, the exceptional generosity of three people must be mentioned. We would like specifically to mention Joan Root, honorary trustee of TARA who, along with Seymour Marvin, was one of the first to give us serious support. We are hugely indebted to Jennifer Small, whose major donations kept us going through difficult times and for her unswerving faith in our project. We thank Ermitage of Jersey for managing TARA's trust accounts.

We acknowledge with real pleasure and gratitude those who read through early drafts of the manuscript: Roberta Simonis and Giancarlo Negro, David Lewis-Williams, Mike Main, and Nick Walker. All have given us advice, corrected errors, and been far more than just helpful. In particular we must single out Roberta Simonis, who also took enormous trouble finding books and papers for us, giving us advice on the Sahara, and cheerfully answering endless questions, and John Kinahan, who showed us sites in Namibia and gave us excellent advice. Whatever mistakes we have made, and there are bound to be some, are our fault, not theirs. We take the blame if we have incorrectly quoted anybody, and for any errors made in preparation of the ink drawings that accompany the text.

Two people made an outstanding contribution to the northern African fieldwork: Joan Root recorded thousands of individual photographs at one site after another; and Pier Paolo Rossi organized our visits to four countries, took us through them, and made certain that nothing went wrong in the depths of the Sahara. We are tremendously indebted to both of them.

We are particularly grateful to our publisher's staff at Harry N. Abrams: to Ellen Nidy, our editor, whose skill and patience are amazing; she rearranged and tightened up a rambling manuscript in spite of our endless changes and additions. To Ray Hooper who initiated the layout organization; and to Madeleine Corson, who skillfully designed and produced the book.

We express our profound thanks to all the following people who have also given freely of their help and advice. We apologize to those whose names we have inadvertently omitted, please know that without your help this book would not have been possible.

THE AMERICAS

BERMUDA Andrew Bickham.

BRAZIL John Byers, and Seymour and Pamela Marvin.

UNITED STATES Neville Agnew, Bill Allen, Megan Biesele, Miguel Angelo de Corzo, Martha Delmas, Jim Denbow, John Echave, Janet Ecker, Susanne Georges, Rick Gore, Robert Hefner III, Donald and Lenore Johanson, Peter Keller, Carolyn Higgins, Tom Hill, Bob Hitchcock, Pat House, Donald and Lenore Johnson, Peter Keller, Bruce Ludwig, Ann Lurie, Fiona Marshall, Candice Millard, Bob Morton, Elise Pearlstein, David Peterson, Larry Robbins, Edward Roski (Jnr), Bruce and Alex Schnitzer, Margaret Sears, George Stuart, Joan Travis, Michael Turner, Victoria Waldock, Susan Welchman, and Ed Wilmsen.

EUROPE

FRANCE Francis Anfray, Jean and Renée Clottes, Alain Decoster, Stephane Frison, Pierre Mérindol, Jean Philippe Rigaud, James and Diana Tamlyn, and Claude Tribouillard.

GERMANY Rainer and Sylvia Jarosch, and Eckhard and Cathy Klenker.

ITALY Raffaella Costabile, Piero Rava, and Pier Paolo Rossi.

UNITED KINGDOM Maria Alexander, Eve Arnold, Carol Beckwith, James Bottomley, Richard Campbell, Mavis Coulson, Hugh Ellerton, Elsbeth Court, Angela Fisher, Sean Ford, Sheila Fraser-Milne, Mary Claire Gibson, Rugnon Hall, Chilli Hawes, Cecilia Kershaw, Isabelle Long, Damon de Laszlo, Eva Monley, John Robinson, Peter Robinson, John Selborne, Tony Spates, Colin Toovey, Barney Wan, and Nigel and Shane de Winser.

NORTHERN AFRICA

ALGERIA Ms Boukadum, Aicha Foughali, Sidi Ahmed Kerzabi, and Aisa Ag Ahmad, Mohamed Ixa, Kilikili Miluli, Tayeb Miluli and Tachmeda Oxa.

EGYPT John and Debbie Darnell, Linda and Allan Pfotenhauer, Maria Golia, Mark Linz, Walid Ramadan, Mostafa Solieman, and Kent Weeks.

ETHIOPIA Hugo Raybaudo, Worku Sharew, Yohannes Zeleke, Gizachew Abegazi and Dr. Z. Chemma.

LIBYA Abdulaziz, Giorgio Martignoni, Hakim Tailamun, Mohammed, and Akmed.

MOROCCO Moustafa Blaoui, Alan Keohane, and Abdellah Salih.

NIGER Mohamed Ag Boula, Rhissa Ag Boula, Richard Graille, Aboubecar Ibrahim, Sidi Mohammed Ilies, Ahmed Mellakh, Cheikh Mellakh, M Harouna Niandou, Mai Manga Oumara, Chafighou Achokall, Virginie Train, Ramdan Ag Inbela, Barbro Owens-Kirkpatrick, Ritchie and Suzette Miller, and Thomas Norman.

CHAD Djimmy Mohamed and driver Lamine.

EASTERN AFRICA

KENYA Rick and Bryony Anderson, Anne Brown, Gordon Boy, Tangus Cheminingwa, Mike Eldon, Anthony Fagin, Caitlin Fraser, Johnny Havelock, Janet Hurt, Philip Leakey, Richard Leakey, Val Leakey, Maeve Leakey, John Millard, Karen Morey, Pauline Mousley, Charles Nightingale, Billie Nightingale, Iapan Nkope, Ian Parker, Gilfred Powys, Patricia Powys, Mehmoud and Sean Qraishy, "Jilo" Qraishy, Litsa-Ann Shewan, John and Inez Sutton, Rupert Watson, John Waweru, and Don Young.

TANZANIA Robin Hurt, Peter Jones, Stephanie Kuna, Charlie and Serena Mason, Juma Mohamed, and Amini Mturi.

UGANDA Ikara Erimano, Ephrahim Kamuhangire, Meddie Kimera, and Kelly MacTavish.

SOUTHERN AFRICA

BOTSWANA Janet Hermans, Tim and June Liversedge, Kerstin Jackson, Mike Main, and Tjako Mpulubusi.

SOUTH AFRICA Malcolm and Anne Badham, Geoff Blundell, Les and Jill Bradfield, Mrs John van der Byl, John and Veda Carver, Janette Deacon, Ed Eastwood, John and Sandy Fowkes, Tom Huffman, Patrick and Veronica Johnston, Margie Keaton, David Lewis−Williams, John Liguori, Tobina Mackenzie, Tim Maggs, David Morris, Karel Nel, Jannie Niewoudt, Peter Openshaw, Elizabeth Orford, Neil and Veralith Orford, Sven Ouzman, John Parkington, Hugh and Jane Patrickson, Gerritt Pretorius, Frans Prins, Hyme and

Jenni Rabinowitz, Nicholas Rabinowitz, Ian Rossenrode, Mary Slack, Ben Smith, Denis de Souza, Wendy Stroberg, and Keith and Irene Whitelock.

NAMIBIA Rod and Sigi Braby, Dannie Craven, Helmut Erni, Wilfred Erni, Chris Eyre, Dora Fock, Ernst and Heidi Grashop, Ms Hausemann, Margie Jacobson, John and Jill Kinahan, Herman Kinghorn, Tilman Lenssen-Erz, Pieter Mostert, Jock and Rosie Orford, Garth and Maggie Owen-Smith, Shirley-Ann Pager, Amy Schoeman, and Johan van Schalkwyk.

ZIMBABWE Henk and Tracey Botha, Kurt and Jenny Braunstein, Anthony Chennels, Bob and Arlene Fernandez, Peter Garlake, Peter Genge, Rolf and Jenny Hangartner, "Doobie" McLachlan, Roy and Judith Stevens, Lorraine Swan, Caroline Thorpe, Carona Thorneycroft, Norman and Gill Travers.

PHOTOGRAPHY, DRAWING, AND MAP ACKNOWLEDGMENTS

We have endeavored to obtain permission to use copyright material; the authors apologize for any errors or omissions and welcome these being brought to our attention. All drawings not listed here were prepared by Alec Campbell from projected transparencies.

FIG. 3 Traced by Mary Leakey and with permission of Maeve Leakey.

FIG. 16 Photograph of giraffe, Botswana by Tim and June Liversedge.

FIG. 20 Photograph by Jean Clottes, Ministére de la Culture, France.

FIG. 28 Copy by Robert Jacob Gordon and by permission of Riksmuseum, Amsterdam.

FIG. 29 Drawing by Alfred Dolman (1924).

FIG. 30 Drawing by Andrew A. Anderson (1888).

FIG. 31 Drawing by George Stow (1905).

FIG. 32 Redrawn from Heinrich Barth (1857).

FIG. 33 Tracing by Harald Pager by permission of Shirley-Ann Pager.

FIG. 37 Redrawn from A. Beltran (1982).

FIG. 59 Redrawn from Lindgren and Schoffeleers (1978).

FIG. 71 Drawn from a photograph, *South African Panorama* November, 1967.

FIG. 72 Tracing by C. van Riet Lowe and by permission of Peter van Riet Lowe.

FIG. 73 Photograph by John Kinahan, State Museum, Namibia.

FIG. 103 Drawing by W. van der Elst in *South African Archaeological Bulletin VII* (25) page 48, and by permission of the South African Archaeological Society.

FIG. 113 Tracing by John Kinahan and with his permission.

FIG. 148 Redrawn after Nicholas Walker (1991) and with his permission.

FIG. 152 Redrawn after Carlos Ervedosa (1980).

FIG. 155 Redrawn from Paolo Graciosi (1964).

FIG. 163 Redrawn after Lynch (1978).

FIG. 168 Redrawn after G. Boy and with his permission.

FIG. 169 Redrawn after Alex Willcox (1984).

FIG. 170 Tracing by Benjamin Smith (1997) and with his permission.

FIG. 173 Redrawn after J. Desmond Clark in (ed) R. Summers (1959).

FIG. 176 Drawn from a photograph by J. H. Chaplin.

FIG. 224 Drawn from photograph by Jürgen Kunz in Alfred Muzzolini (1995).

FIG. 234 Photograph from *Cave of Swimmers, Egypt* by Giancarlo Negro.

FIG. 248 Redrawn from a photograph by Francois Soleilhavoup (1988).

FIG. 270 Redrawn after Breuil and Mortelmans (1952).

FIG. 275 Redrawn after Lindgren and Schoffeleers (1978).

FIG. 277 Taken from a woodblock print by Nxabe Eland in *Qauqaua* told by Coex'ae Qgam and with permission of Kuru Development Trust.

FIG. 283 Tracing by Robbie Steel (1988) by permission of the Department of Archaeology, University of the Whitwatersrand.

FIG. 284 Redrawn after Carlos Ervedosa (1980).

FIG. 286 Redrawn after Breuil and Mortelmans (1952).

FIG. 288 Redrawn after J. H. Chaplin (1974).

MAP 2 Adapted from a map by David Phillipson (1993).

MAP 4 Compiled from maps by J. and I. Rudner (1973), A. Wilcox (1984), A. Muzzolini (1995), and those of other researchers.

MAP 5 Compiled from maps by J. and I. Rudner (1973), A. Wilcox (1984), and those of other researchers.

MAP 6 Compiled from maps by B. Smith (1997) and those of other researchers.

MAP 7 Compiled from maps by J. and I. Rudner (1973), A. Muzzolini (1995), and those of other researchers.

GLOSSARY

Acheulean Period. Refers to the latter period of the early Stone Age in Africa, overlapping into the middle Stone Age, lasting from about 1.4 million to about 100,000 years ago. It is characterized by bifacial hand axes, which were first recognized at St. Acheul, France (see Hand Ax).

Afro-Asiatic. African linguistic group comprising peoples of Caucasian stock who spoke Semitic, Egyptian, Berber, Cushitic, and Chadic languages. Their descendants include modern Tuareg.

Anthropomorph. A term used in rock art studies to describe mythical figures with human attributes.

Aurochs. *Bos primigenius,* a long-horned wild ox, an ancestor of domestic cattle, now extinct.

Barbary sheep (aoudad). *Ammotragus lervia,* a species of wild sheep not related to domestic sheep.

Bovid. A collective term for cattle, buffalo, antelope, sheep, and goats.

B. P. An abbreviation meaning "before the present" that is added to a number to indicate years before the present time: 2,000 B.P. means "2,000 years ago."

Bubalus. *Bubalus antiquus,* a species of extinct wild buffalo.

Bushmen. A collective name, anglicized from the Dutch *Boschjesmanne,* used for the earliest modern peoples indigenous to southern Africa. Bushmen have also been called "San" by scientists, but some people consider both terms derogatory. Bushmen have no collective name for themselves and many have recently expressed the wish to be called "Bushmen" rather than "San."

Camel Period. The final period of Saharan rock art lasting from soon after the introduction of domestic camels into Africa, about 2,200 years ago, to the present day. Images of camels form the major subject of the art.

Carbon Dating (also known as radiometric dating). A scientific technique for determining when organic remains such as charcoal, bone, shell, and plant material died. Organic matter contains radioactive carbon-14 isotopes, which decay over time at a known rate. Carbon dating measures the remaining volume of carbon-14 isotopes in matter, providing an approximate age since death. Although often pigments used in rock painting contained an organic binder such as blood, there is usually too little pigment remaining on the rock to make direct dating possible.

Chewa. Bantu-speaking peoples who today live in Zambia and Malawi, and have closed societies called "Nyau."

Chronology. The order in which events are placed, irrespective of a time scale. Thus, rock art periods are listed in order of occurrence, although precise dates are unknown and considerable overlap occurred.

Cro-Magnon People. Ancestors of modern Europeans who evolved in Africa. Some of them migrated to Europe, between about 100,000 and 50,000 years ago, and a few reached Western Europe by 40,000 B.P.

Engravings. Also known as "petroglyphs," engravings are pictures, patterns, or designs cut into rock faces by pecking, scraping or grinding with a tool.

Entoptics. Recurring geometric patterns that appear to float before the eyes of persons experiencing other states of consciousness, particularly when entering a trance.

Finger-painting. Paintings made with the fingers and palms of the hands rather than with a brush or other implement.

Guelta. An Arabic word for a natural open hole or depression, usually in rock, which holds water for an indeterminate period.

Hand Ax. A usually large stone "tool" made by chipping a rock all over on both sides into a pear- or "ax"-like shape dating from about 1.4 million to 100,000 years ago. One end is pointed and the other curved as though made to be held in the hand and not mounted in a handle. The aesthetic symmetry often displayed in hand ax manufacture far exceeds the needs of tool utility, suggesting that the objects we refer to as "hand axes" may have been made for purposes other than tools, perhaps for tokens.

Horse Period. A period in Saharan rock art commencing sometime after 3,000 B.P. and the introduction of horses and chariots into Egypt and ending with the Camel Period, which began in the eastern Sahara about 2,000 years ago.

Hottentots. A derogatory name used by early Dutch settlers in southern Africa to describe indigenous pastoralists found there who spoke a Khoisan click language. The name distinguished Hottentots, who were thought to keep cattle and sheep, from Bushmen who were believed to subsist only by foraging. We retain the term Hottentot only because it is widely known and for most people has no derogatory connotations (see Khoikhoin).

Ice Age. The cold period between about 110,000 and 10,000 years ago when polar icecaps expanded, and the sea level fell by up to 500 feet.

Images. The term preferred by many archaeologists for, and instead of, "paintings" and "engravings."

Khoikhoin. The name used by Hottentots to describe themselves. In Nama, a Hottentot dialect, *Khoikhoin* means "the real people." Khoikhoin derisively called Bushmen "San," meaning "gatherers of wild food."

Khoisan. A manufactured collective name for languages with many dialects spoken by Bushmen and Hottentots. It combines the Hottentot words *khoi* meaning "person" and san meaning "gatherers." These languages employ click sounds for some consonants.

Later Stone Age. The period in Africa commencing in different regions between about 40,000 and 20,000 years ago, when very small stone tools (mounted in wood or bone handles) predominated. Metal began to replace stone tools in the north after about 2,500 years ago, and metallurgy spread south, slowly ending the Stone Age. In southern Africa, some Khoisan-speakers continued to make stone tools into the eighteenth and early nineteenth entries. Early, Middle and Later Stone Ages refer to peoples' cultures. The periods overlap, and one does not necessarily end as the next commences.

Lybico-Berber. Ancient Berber languages once spoken in northern Africa by peoples of Caucasian stock. Today, Tuareg peoples speak Temasheq, a language derived from ancient Lybico-Berber (see Temasheq and Tifinagh).

Microliths. Very small stone tools that were mounted in wood and bone handles and used as arrowheads, drills, and scrapers for working skin and wood, and as knives, sickles, and engraving tools.

Neanderthals. Descendants of *Homo erectus,* Neanderthals survived in Europe up until between 30,000 and 25,000 years ago. The bone structure found in contemporaneous skeletons suggests that Neanderthals may not have been direct ancestors of modern people, but a separate hominoid branch that was replaced in Europe by modern people and themselves became extinct.

Neolithic Period. The term used in this book for the period in northern Africa that commenced between 12,000 and 8,000 years ago, and lasted into the time when iron was first smelted, about 2,500 years ago. In English, the Neolithic Period means the time during which food production evolved; but in French it refers more to the introduction of polished stone tools and pottery.

Nyau. A men's closed society organized by the Chewa peoples of Zambia and Malawi. Nyau performed rituals associated with rites of passage such as initiation into adulthood and funerals, and people don masks and dance.

Ochre. A soft stone containing various oxides of iron (hematite, limonite, etc) that, when crushed, burnt, or mixed with a liquid binder, was used as paint.

Painting. Images left on rock by the application of paint. Paintings, sometimes known as "pictographs" because they are usually drawn rather than painted, include patterns, designs, pictures, and handprints.

Pastoral Period (also known as the Cattle Period in English and the *Bovidian* Period in French). A period in northern African rock art commencing somewhat before 7,000 B.P. and lasting until the Sahara began to dry up about 4,500 years ago. Most Pastoral Period images are naturalistic, displaying cattle,

clothed human figures, and domestic activities.

Rock Shelters. Natural recesses in rock created by erosion. Shelters often occur at the base of cliffs, have wide mouths, and extend back several feet below the overhanging rock. Those offering protection from wind and rain were occasionally used by people as living sites. Sometimes a shelter's protected walls, roofs, and internal rocks bear paintings and engravings.

Round Head Style (also known in French as *Têtes Rondes*). An art period referring mainly to the painted art of Tassili de Tamrit and the Akākūs Mountains and dated to about 10,000 to 8,000 B.P. The paintings are often large and exude an atmosphere of "detachment from physical reality" (Mori). The numerous ethereal human figures have featureless round heads and their bodies are generally shapeless and appear to float in space.

Sandawe. A group of people living in central Tanzania who practiced, until recent years, a foraging economy, and still speak a click language distantly related to Khoisan. They believe their ancestors painted on the rocks.

Shaman. A term used by anthropologists to describe a person who, by entering a trance state, can communicate with supernatural beings to heal, bring rain, and determine the future.

Site. A location where associated archaeological remains occur. Thus, a rock art site may consist of a single rock shelter containing one or more paintings or engravings, or such images occurring more or less continuously on exposed rock over a considerable area.

Superimposition. The (normally deliberate) painting or engraving of a new image over an existing image. This does not include reworking, retouching, or repainting an existing image without altering its original form.

Tassili. A Temasheq word meaning "mountainous plateau." In English, it sometimes refers to huge eroded rock formations on plateaus.

Tazina Style. A widespread style of

engravings named after Tazina, a site in the Ksour Mountains, western Algeria. The style is homogeneous and represented by smaller stylized images, usually of animals, but also of geometrics and human figures, employing incised and polished lines rather than the more usual pecking.

Temasheq (also Tamasheq). A language with several dialects spoken by modern Tuareg of northern Africa. See also Tifinagh.

Teso. A group of people who migrated from the north and now live on the Kenya/Uganda border, and speak a language related to Turkana.

Tifinagh. An ancient script in which Lybico-Berber languages were written. It is still used by modern Tuareg and usually employs twenty-five consonants and the vowel "a," and can be read from left to right, right to left, and upward or downward. As a spoken language, consonants are pronounced with different vowel sounds inserted between them until sense is achieved.

Therianthrope. An image of an upright figure having both animal and human attributes: usually a human figure with an animal's head.

Tuareg. A member of three closely related groups of pastoral peoples who inhabit the more fertile areas of the Sahara stretching from southwestern Libya through southern Algeria and northern Niger and Mali to the mountains of Morocco. Tuareg is a derogatory Arabic name referring to people who have either abandoned, or are lax in, religious habits. Tuaregs have no collective name for themselves, but often use the general term "nomads," or "Blue People."

Twa. A Bantu noun stem meaning a person without property who lives by collecting wild food. It implies an inferior status. Today, Bantu-speakers of central and eastern Africa describe Twa as short, hairy people who used large bows and arrows and collected honey. They recognize Twa as earlier inhabitants of the areas they themselves settled. The forms *Abatwa* and *Basarwa* are used by southern Bantu-speakers when referring to Bushmen.

Wadi. An Arabic word meaning "river," "dry river," "riverbed," or "fossil river valley."

BIBLIOGRAPHY

We have consulted numerous books and hundreds of scientific papers about African rock art published in English, French, German, Italian, and Portuguese. For brevity's sake, we have omitted most publications in foreign languages, out-of-print books, and scientific papers. The following sources are categorized according to main emphasis, but each also falls into a region of Africa, and most deal with more than one of the art's aspects. Where not obvious, the country or region concerned is listed in brackets after the entry.

AFRICA: HUMAN HISTORY AND ENVIRONMENT

Bench, R. M. & K. C. MacDonald. *The Origins and Development of African Livestock: Archaeology, Genetics, Linguistics and Ethnography.* London: University College of London Press, 2000.

Deacon, H. J. & J. Deacon. *Human Beginnings in South Africa.* Cape Town: David Philip, 1999.

Newman, J. L. *The Peopling of Africa: A Geographic Interpretation.* New Haven: Yale University Press, 1995.

Nicolaisen, J. & I. Nicolaisen. *The Pastoral Tuareg: Ecology, Culture and Society* 2 Vols. London: Thames and Hudson, 1997.

PREHISTORIC ART (GENERAL)

Anati, E. *World Rock Art: The Primordial Language.* Volume XII, Third English Edition. Italy: Studi Camuni, 1994.

Bahn, P. *The Cambridge Illustrated History of Prehistoric Art.* Cambridge: Cambridge University Press, 1998.

DATING ROCK ART

Bednarik, R. G. "Methods of direct dating of rock art." *Sahara* 8 (1996): 43-52.

Morris, D. "Engraved in place and time: A review of variability in the rock art of the northern Cape and Karoo." *South African Archaeological Bulletin* 43 (1988): 109-121.

Phillipson, D. *The Later Prehistory of Eastern and Southern Africa.* London:

Heinemann, 1977.

Walker, N. J. "The Dating of Zimbabwean Rock Art." *Rock Art Research* 4 no. 2 (1987): 137-149.

Wendt, W. E. "'Art Mobilier' from the Apollo II Cave, South West Africa: Africa's Oldest Dated Works of Art." *S. Afr. Arch. Bull* 51 (1976): 5-11.

LOOKING FOR MEANING IN ROCK ART

Clottes, J. and D. Lewis-Williams. *The Shamans of Prehistory: Trance and Magic in the Painted Canvas.* New York: Harry N. Abrams, Inc. Publishers, 1998.

Davis, W. "Representation and knowledge in the prehistoric rock art of Africa." *The African Archaeological Review* 2 (1984): 7-35.

Deacon, J. & T. A. Dowson. *Voices from the Past: Xam Bushmen and the Bleek and Lloyd Collection.* Johannesburg: Witwatersrand University Press, 1996. (South Africa)

Guenther, M. *Tricksters and Trancers: Bushman Religion and Society.* Bloomington: Indiana University Press, 1999. (Southern Africa)

Kinahan, J. "Towards an archaeology of mimesis and rain-making in Namibian rock art" in *The Archaeology and Anthropology of Landscape*, edited by P. J. Ucko & R. Layton. London: Routledge, 1999.

Le Quellec, J.–L. *Symbolisme et Art Rupestre au Sahara.* Paris: L'Harmattan, 1993.

Lewis-Williams, D. *Believing and Seeing: Symbolic meaning in southern San rock art.* London: Academic Press, 1981.

--------. "Quanto: the issue of 'many meanings' in southern African San rock art research." *South African Archaeological Bulletin* 53 (1998): 86-97.

Lewis-Williams, D. & T. Dowson. "The Signs of All Times: Entoptic Phenomena in Upper Palaeolithic Art." *Current Anthropology* 29 no. 2 (1988): 201-245.

Lindgren, H. E. and J. M. Schoffeleers "Rock Art and Nyau Symbolism in

Malawi." *Malawi Government, Dept of Antiquities*, Publication No. 18 (1978).

Ouzman, S. "Spiritual and Political Uses of a Rock Engraving Site and its Imagery by San and Tswana-Speakers" *South African Archaeological Bulletin* 50 (1995): 55-67. (South Africa)

Qgam, C. and Kuru Art Project. *Qauqaua: A San folk story from Botswana.* Johannesburg: The Artists' Press, 1996.

Walker, N. "In the footsteps of the ancestors: the Matsieng creation site in Botswana." *The South African Archaeological Bulletin* 52 (1997): 95-104.

Yates, R., J. Parkington & T. Manhire. *Pictures from the Past: a history of the interpretation of rock paintings and engravings of southern Africa.* Pietermaritzburg: Centaur Publications, 1990.

RESEARCH AND CONSERVATION

Various. "Rock art: conservation, preservation, protection and site management." *Pictogram* 9 no. 2 (1997): 1-60.

Bednarik, R. G. "Rock art researchers as rock art vandals." *Sahara* 4 (1991): 166-8.

Lewis-Williams, D. "Current South African Rock Art Research: A Brief History and Review." *INORA* 20 (1998): 12-22.

Muzzolini, A. "North Africa : Some Advances in Rock Art Studies" in *Rock Art Studies: News of the World I.* Edited by P. G. Bahn & A. Fossati. pp. 59-69. Oxford: Oxbow Monographs 72, 1996.

Prins, F. E. & H. C. Woodhouse "The State of Rock Art: Rock Art in Southern and Tropical Africa. The Last Five Years" in *Rock Art Studies: News of the World I.* edited by F. G. Bahn and A. Fossati. pp. 71-84. Oxford: Oxbow Monographs 72, 1996.

Soffer, O & M. W. Conkey. "Studying Ancient Visual Cultures" in *Beyond Art: Pleistocene Image and Symbol.* Edited by M. W. Conkey, O. Soffer, D. Stratmann & N. G. Jablonski. pp. 1-16. Memoirs of the California Academy of Sciences Number 13 (1997).

Solomon, A. "Ethnography and method in southern African rock-art research" in *The Archaeology of Rock Art*. Edited by C. Chippindale and P. S. C. Tacon. pp. 268B284. Cambridge: Cambridge University Press, 1992.

ROCK ART: AFRICA AS A CONTINENT

Brentjes, B. *African Rock Art*. London: J. M. Dent & Sons, 1969.

Ritchie, C. I. A. *Rock Art of Africa*. London: Thomas Yoseloff Ltd., 1977.

Willcox, A. R. *The Rock Art of Africa*. Johannesburg: Macmillan South Africa, 1984.

SOUTHERN AFRICA

Various. *Contested Images*. Edited by T. A. Dowson & D. Lewis-Williams. Johannesburg: Witwatersrand University Press, 1994.

Cooke, C. K. *Rock Art of Southern Africa*. Cape Town: Books of Africa Cape Town, 1969.

Deacon, J. *Some views on rock paintings in the Cederberg*. Cape Town: National Monuments Council, 1994.

Dowson, A. T. *Rock Engravings of Southern Africa*. Johannesburg: Witwatersrand University Press, 1992.

Fock, G. J. & D. Fock. *Felsbilder in Südafrika*. Three volumes with an overview in English by Karl Butzer in vol. 3. Vienna: Bohlau Verlag, 1989.

Garlake, P. *The Hunter's Vision*. Harare: Zimbabwe Publishing House, 1995. (Zimbabwe)

Johnson, R. T. *Major Rock Paintings of Southern Africa*, Second Edition, edited by T. Maggs. Cape Town: David Philip Publishers, 1991.

Lewis-Williams, D. *Discovering Southern African Rock Art*. Cape Town: David Philip Publishers, 1990.

Lewis-Williams, D. & T. Dowson. *Images of Power*. Johannesburg: Southern Book Publishers, 1989.

Pager, H. *Stone Age Myth and Magic as documented in the rock paintings of South Africa*. Graz: Akademische Druck-u, Verlagsanstalt, 1975.

--------. Ndedema. Graz: Akademische Druk-u, Verlagsanstalt, 1971.

--------. *Rock Paintings of the Upper Brandberg*. Part 1: *Amis Gorge*, Part 2: *Hungarob Gorge*, Part 3: *Southern Gorges* and Part 4: *Umuab and Karoab Gorges*. Cologne: Heinrich-Barth-Institut, 1989, 1993, 1995, 1998. (Namibia)

Pager, S. A. *A Visit to the White Lady of the Brandberg*. Windhoek: Shirley-Ann Pager, 1999.

Rudner, J. & I. Rudner. *The Hunter and His Art: A Survey of Rock Art in Southern Africa*. Capetown: C. Struik, 1970.

Scherz, E. R. *Felsbinder in Südwest-Afrika*. Three volumes. Vienna: Bohlau Verlag, 1970, 1975, 1986.

Solomon, A. *Guide to San Rock Art*. Cape Town: David Philip Publishers, 1998.

Summers, R. (ed). *Prehistoric Rock Art of the Federation of Rhodesia and Nyasaland*. Salisbury: National Publications Trust, 1959.

Walker, N. *The Painted Hills: Rock Art of the Matopos*. Gweru: Mambo Press, 1996. (Zimbabwe)

--------. "Botswana's Prehistoric Rock Art" in *Ditswa Mmung: The Archaeology of Botswana*. edited by P. Lane, A. Reid & A. H. Segobye. Gaborone: Pula Press & The Botswana Society, 1998.

Willcox, A. R. *The Rock Art of South Africa*. Johannesburg: Thomas Nelson and Sons, 1963.

Woodhouse, B. *The Rock Art of the Golden Gate and Clarens Districts*. Johannesburg: William Waterman Publications, 1996.

--------. *The Rain and its Creatures: As the Bushmen painted them*. Johannesburg: William Waterman Publications, 1992.

EASTERN AND CENTRAL AFRICA

Anati, E. "Cultural Patterns in the Rock Art of Central Tanzania," Proceedings of XIII International Congress of

Prehistoric and Protohistoric Sciences, Edited by G. Aumassip, J. D. Clark & F. Mori. Forli-Italia, *The Prehistory of Africa* 15 (1996): 15-68.

Gramly, R. M. "Meat-feasting Sites and Cattle Brands: Patterns of Rock-Shelter Utilization in East Africa." *Azania* 10 (1975):107-121.

Gutierrez, M. "The Rock Art of Angola" in *Rock Art Studies: News of the World I*. Edited by P. G. Bahn & A. Fossati. Oxford: *Oxbow Monograph* 72, 1996: 85-93.

Leakey, M. *Africa's Vanishing Art: The Rock Paintings of Tanzania*. London: Hamish Hamilton/Rainbird, 1983.

Masao, F. T. *The Later Stone Age and the Rock Paintings of Central Tanzania*. Wiesbaden: Studien zur Kulturkunde 48, Franz Steiner Verlag, 1979.

Masao, F. T. "The Rock Art of Kondoa and Singida: A Comparative Description." National Museums of Tanzania *Occasional Paper No. 5* (1982).

Phillipson, D. W. "The Rock Paintings of Eastern Zambia." *The Prehistory of Eastern Zambia: Memoir 6 of The British Institute in Eastern Africa*. Nairobi, 1976.

Smith, B. W. *Zambia's Ancient Rock Art: The Paintings of Kasama*. Livingstone: The National Heritage Conservation Commission of Zambia, 1997.

NORTHERN AFRICA

Catalogue des Sites Rupestres du Sud-Marocain. Rabat, Ministère d'État, Charges des Affaires Culturelles. 1977.

Gauthier, Y. & C. Gauthier, A. Morel, T. Tillet. *L'Art du Sahara: Archives des Sables*. Paris: Editions du Seuil, 1996.

Grazciosi, P. "New Discoveries of Rock Paintings in Ethiopia." *Antiquity* 38 (1964):91-98 and 187-190.

Hachid, M. *Le Tassili des Ajjer. Aux sources de l'Afrique 50 siècles avant les pyramides*. Paris: Mediterranée, 2000.

Lhote, H. *The Search for the Tassili Frescoes: The story of the prehistoric rock-paintings of the Sahara*. London: Hutchinson, 1959.

Bibliography Continued

-----. "Rock Art in the Sahara." *National Geographic* 172 no. 2 (August, 1987): 180–191.

Lutz, R. & G. Lutz. *The Secret of the Desert: The Rock Art of Messak Sattafet and Messak Mellet, Libya.* Innsbruck: Universitats-buchhandlung, Golf Verlag, 1995.

Mori, F. *The Great Civilisations of the Ancient Sahara.* Rome: L'Erma di Bretschneider, 1998.

Muzzolini, A. *Les Images Rupestres du Sahara.* Toulouse: Alfred Muzzolini, 1995.

Negro, G. A. Ravenna & R. Simonis (eds). *Arte Rupestre nel Ciad: Borku – Ennedi – Tibesti.* Milan: Pyramids, 1996.

Striedter, K. H. *Felsbinder der Sahara.* Munich: Prestel, 1984.

LATE WHITE PAINTINGS

Prins, F. E. & S. Hall. "Expressions of fertility in the rock art of Bantu-speaking agriculturalists." *The South African Archaeological Review,* 12 (1994): pp. 171–203.

OTHER

Chauvet, J-M, E. B. Deschamps and C. Hillaire. *Dawn of Art: The Chauvet Cave: The Oldest Known Painting in the World.* New York: Harry N. Abrams, Inc. Publishers, 1996.

Willett, F. *African Art.* London: Thames and Hudson, 1991.

INDEX